VANISHING AFRICA

Mirella Ricciardi

DESIGNED WITH BARNEY WAN

REVISED EDITION

HOLT, RINEHART AND WINSTON

NEW YORK

Library of Congress Cataloging in Publication Data
Ricciardi, Mirella.

Vanishing Africa.
Includes index.
1. Kenya—Description and travel. I. Title.
DT433.52.R53 1977 779'.9'96762 77-571
ISBN 0-03-021591-9

Revised edition first published in the United States
in 1977.

Printed in Switzerland

10 9 8 7 6 5 4 3 2 1

PUBLISHER'S NOTE TO THE REVISED EDITION

This book was first published in 1971 and subsequently ran through several impressions. However in 1974 the need to remake the photogravure cylinders for the illustrations, and unprecedented increases in world manufacturing costs, have made it necessary to convert certain plates from colour to monochrome. These are those on the plate pages numbered 45, 63, 76, 106, 122, 125, 150, 158, 168, 170, 192.

THE DIARY

		PAGE
I	In Search of Beauty	10
II	Initiation	15
III	The Indian Ocean	25
IV	Island of the Veils	30
V	Lake Rudolph	36
VI	Nomads	42
VII	Home	48

THE PHOTOGRAPHS

	PLATE
The Face of Africa	1
A Maasai Ceremony	35
Mother and Child	69
The Fishermen of Lake Rudolph	95
Nomads	125
Bajun Islanders	159
Love and Beauty	169
Dance	193

INDEX

I dedicate this book to my mother and father,
MARIO AND GISELLE ROCCO

and I would like to thank:
Monty Ruben for having given me the idea
Jack Block for making it work
Mr Nyachae, Provincial Commissioner, Rift Valley,
for his substantial help in difficult moments
Francesco Bisletti
Erica and Igor Mann
My sister Oria
Shaibu and Kimuyu for standing by me
and last but not least
Lorenzo (my part-time husband) who spent two long
lonely years in St Tropez, Rio de Janeiro, St Moritz
and Acapulco waiting for me to come back.

FOREWORD

The Rt. Hon. Malcolm MacDonald O.M.

This book is as timely as it is attractive. It places on record in vivid writing and brilliant photographs some of the traditional customs and ceremonies of important tribes in Kenya which are disappearing from their lives, and from the face of Africa, in our swiftly changing modern world. They should be preserved, and indeed cherished, in historical memory. Such simple and yet grand people as the unspoilt native Maasai, for example, will never be seen again, although it is to be hoped that after the ancient customs here described have vanished from their society, successive, new, more sophisticated generations of Maasai will still retain the fine rather aristocratic qualities which distinguished their forefathers. Knowing some of the tribe's contemporary leaders and youngsters I believe this will be so.

My admiration for Mirella Ricciardi is immense. She has shown not only very friendly understanding of the various African peoples who appear in this book, but also personal courage, literary talent and photographic genius in its preparation. The result is a beautiful volume packed with interesting information which possesses abiding value.

ETHIOPIA

TURKANA

Lake Rudolph

Fergusson's Gulf ⑤

Lodwar

TURKANA

BORAN

RIFT VALLEY

TURKANA

RENDILLE
BORAN

⑥ Marsabit

NORTH EASTERN

UGANDA

SUK

Baragoi ①

EASTERN

Kapenguria

SAMBURU

Maralal

① Wamba

BORAN

Kitale

Baringo

Solai

Archer's Post

River Tana

SOMALI REPUBLIC

Kenya

Gilgil

Nyeri

Naivasha

EASTERN

Narok

Nairobi

COAST

②

BAJUN

MAASAI

ORMA

Lamu

Magadi

TANZANIA

GIRIAMA

AUTHOR'S JOURNEYS THROUGH

KENYA

③ Malindi

Kilimanjaro

① = chapter number

INDIAN OCEAN

| Miles | 0 | 50 | 100 |

Mombasa

| Kilometres | 0 | 50 | 100 | 150 |

THE DIARY

CHAPTER I IN SEARCH OF BEAUTY

Samburu I have had lots of ideas, some I follow up, others just fade away. This one fell into place by itself. I talked to a friend who had a friend who is a publisher; the publisher was interested and we met. He liked my proposal, handed me a cheque and sent me off on my assignment. I packed my bags, bought a ticket and landed in Nairobi before I had time to realise what I had let myself in for. I was committed. To photograph the "Vanishing Tribes" of Kenya, a whole way of life that's changing and slowly dying, to be replaced, for better or for worse, by a Westernised civilisation – abolishing tribal life and customs in favour of a more European civilisation and culture, building schools and urging or obliging parents to have their children educated. Soon shorted and shirted Africans will replace the near naked man who for centuries has lived, and thrived or died, at the whim of nature.

I felt like a painter in front of an empty canvas. Dry, hard, arid Africa, beautiful and terrible – immense – timeless – unending – stretched out before me, filled with mystery, bearing a million different expressions on her face. I was to capture all this in her people, their lives, their features, their bodies, their dress, all moulded by her. The fight for survival for both man and beast is the code by which they live. I felt a bit scared.

Of over fifty distinct tribal groups in Kenya there are really only six left whose traditional way of life remains almost untouched by the ever spreading marks of Western civilisation. I chose from these, the Samburu, the Maasai, the Rendille, the Turkana, the Bajun and the Gala Boran for my great fresco. I hoped to capture the strange beauty of the nomadic herdsmen driving their livestock across the plains in constant pursuit of rain – for rain means water and water means life – the hidden mystery in the black veils that float around the Muslim women, the pride and virility of the young warriors, the grace of the women, the resignation of the old.

I bought a Toyota landcruiser from a friend – a second-hand one for £800 – and had a luggage rack fitted to the roof and two jerry can holders on the front bumper bar. I bought camping equipment from someone leaving the country; a tent and all the camp accessories; folding tables and chairs, oil lamps, camp beds, cooking utensils, tin boxes for carrying food, a primus stove, ropes, tarpaulins. From my mother's house on Lake Naivasha I scrounged the extra odds and ends: plates, cups, glasses, cutlery.

I asked my sister to come with me for the first leg of the safari. Living under canvas in the bush is a tricky business, one must be very careful of one's company. Taking my sister was like taking myself.

Two weeks of preparation. Finally we set off, everything packed tightly into the car. Kimuyu, our cook, is now my safari boy. He has been with us since he was ten, all he knows he has learned from us. Bright, good-natured and hard-working, he loves the idea of a safari. The car is checked for oil, water, petrol, tyre pressures. The whole family comes out to say goodbye and wish us luck. My little girls are left behind in the care of my mother and father. We are on our way to Maralal and the Samburu – the first step has been taken.

Maralal is the commercial centre of the Samburu district. We arrive just before sunset

and set up camp under a big tree near a *manyatta*, a thorn bush enclosure in which the Samburu live and corral their livestock at night. The tent is pitched, water collected from a dam, firewood stacked before night falls. One by one the inhabitants of the *manyatta* drift over to have a look and seem astonished and amused to find two white women. Men, women and children cluster round at a respectful distance. We hear muffled whispers and giggles. The older men squat in silence to one side looking like vultures, watching us with their piercing eyes. Every few minutes they spit. I get up to greet them: "Supa haleng". They are surprised that I speak their language. I shake each hand that is held out to me. They don't move their position. Several of the younger men come over to help us, grab a rope, hold a pole, drive a peg into the ground. It's fun for them; they are fascinated by the putting up of our tents. Excited chatter starts up.

By the time the work is finished we have acquired twelve pairs of hands. Kimuyu prepares a great fire and everyone clusters round to get warm. The nights here are very cold. By now we are all good friends. Lots of questions are asked, explanations given. An excellent sign. Friendly people. Just as well, for a start.

We sleep fully clothed because of the cold. Kimuyu is scared by his first night in the open and refuses to sleep alone in his tent. He settles down in the back of the car and insists on a lamp being left alight to ward off wild animals. My sister and I laugh at him, but then we've done this sort of thing before.

It's strange how frightened the Africans are of animals – probably it comes from an inborn sense of self-preservation dating back to times when game really was an ever-present danger. In fact, during the night, an amazing number of animals pass back and forth around our camp. A pounding of hoofs, hundreds of zebra gallop by only a few yards from the tent. Elephant leave the forest to feed on the crops growing round the *manyatta*. Women drive them off by beating sticks on tin cans. Hyena are everywhere and their shrill icy laughter, dying into a melancholy groan, is alarming to anyone who doesn't know what it is. One hyena ventures into the camp where a leg of meat is hanging on a tree. He jumps up at it and falls onto the cooking utensils underneath, making an awful racket that wakes us up with a start. Kimuyu is terrified and we go out to reassure him. He's shining his torch at us through the closed windows of the car, a knife clutched tightly in his right hand. Poor Kimuyu is being broken in to safari life.

The Samburu are friendly people. A branch of the Maasai, they have very much the same customs and physique. The warriors are tall and slender with fine features and long limbs. Their hair is worn long, rolled into hundreds of twisted strings covered in red ochre that hang down to their shoulders. A piece of red or white cotton is tied under their armpits and falls straight to mid-calf. The women age prematurely; they do all the manual work in the *manyatta* and always seem to be either pregnant or feeding a baby, their breasts are flattened and deformed. They wear necklaces that look like a row of collars made of tiny multi-coloured beads intricately sewn and woven together. Their arms and legs are wound round with copper wire – the more the ornaments, the richer the husband. They bring their children to the camp for medical attention – infected eyes covered with flies, coughs and colds, horrible burns, for the babies often fall, or crawl, into the open fires. They never cry when I treat them, clean their wounds and pour iodine on them. Don't

they feel the pain or are they much braver than we are? One could never do that to a European child. Because they live so closely with their cattle flies are everywhere and in everything, but somehow their wounds heal, even without medicine. I pop a sweet into their mouths and we are all friends.

The girls are pretty. Their lovely slim, rounded bodies have provocative breasts that stick out from beneath their beads. The skin is taut and gleaming. Women and girls wear long leather skirts made from cow hide beaten until it is thin as paper and rubbed with fat to make it soft and pliable. The top of the body is bare, and young girls have their head and shoulders plastered with red ochre like the warriors. A thin chain attached to a beaded leather headband falls to either side of the nose, goes round each eye and is tied behind the head. The women's heads are shaved until after the birth of a child.

The Samburu are nomads and live much as their cattle do. Women exist to reproduce; babies, like calves, enrich the family. Children are considered a gift from God – the more children, the greater the blessing.

The warriors pass their days doing nothing – hanging around preening themselves. They spend hours plaiting their hair and painting their bodies or faces with red ochre. Our camp provided a great diversion. They were fascinated by us and by everything we did. Above all they loved patting and stroking our long hair, their faces showing amazement and envy. They wanted us to let them roll it like their own. My cameras too were an endless source of pleasure and entertainment. They loved peering at each other through the telephoto lenses. So, when they had nothing better to do – and that was the greater part of the day – our camp became a gathering place. This immediate friendly relationship which had sprung up between us helped me, allowing me to work among them with the greatest freedom and informality.

One day, with about twenty girls and *murran* – young warriors – jammed into the car and onto the luggage rack, we set off for a huge salt lake which they wanted to show us. Any occasion presents an excuse to sing, swaying in rhythm to the chant, and the trip on the roof of my car provided just such an excuse. The women intoned in their high-pitched voices. The warriors replied in solemn and raucous unison.

When we arrived at the lake we saw thousands upon thousands of head of cattle wading around and drinking the salt water. My passengers climbed down and set off towards the lake without saying a word. The men on one side, the women on the other, they undressed and washed themselves. The bathe lasted a good hour and was followed by a much longer session of re-doing their make-up. The girls sat by the water's edge while the warriors decorated their faces with red clay. I wandered about without disturbing them. My camera was warming up. I felt that things had begun well. It seemed too easy, but I realised that this was because they had accepted me. My African childhood among these people helped me. I was not treated as a suspect, a white come to steal from them, but as a friend with whom they could speak as equals.

Every evening the women and men danced and sang until nightfall when they disappeared into their huts in small groups or in pairs. The *murran* often visited us after our evening meal. We talked for long hours round the great fire; my sister and I sitting in our camp chairs, the *murran* squatting on their heels, their spears stuck in the ground in front

12

of them. We asked them endless questions about their life, their customs and traditions.

They answered us without hesitation. They told us how the girls usually marry men much older than themselves and much importance is attached to their virginity. Nevertheless, before marriage young girls have frequent physical contact with the younger men and this takes place in groups of at least two couples so as to inhibit the actual act which is forbidden by tribal custom. But since the married women are often attracted to the younger warriors they sometimes sleep with them illicitly. The couple have to meet at night without the husband knowing and the warrior will knock lightly on the ground with his spear outside the hut (pretending to look at the cattle or to take a breathe of air). The girl will then join him at their rendezvous and make love under some bush. All this has to be done with the greatest secrecy for if they are discovered the lover risks being killed or expelled from the *manyatta*. On the other hand if a friend visits a couple of the same age group the husband is obliged to give up his hut and to sleep elsewhere, leaving his friend with his wife for the night.

They also told us how, if a girl becomes pregnant before marriage, the other women arrange her abortion. They collect the cow dung from the enclosure, mix it with water and leave it out in the sun to ferment. When this brew is warm and fermented, they make the girl drink it until she aborts. Afterwards she is expelled from the *manyatta* unless some older man can be found to take her for his wife.

The grace and almost feminine quality of the Samburu's movements led us to ask them if homosexuality existed among them. They didn't understand what we meant; we tried to explain. At first they didn't reply, looking at us with an expression at once disgusted and amused. Then, all together, they spat on the ground as a sign of distaste, vehemently shaking their heads, and then broke into peals of laughter.

In this way we spent the evenings in front of our tent, till, for no apparent reason, the *murran* would rise, salute us with their spears, and disappear into the night, while I stayed on watching the fire die.

One day we set off for Wamba, a small village 120 kilometres from our camp. The road wound round distant blue hills. The weather was perfect. Huge white clouds hung in the transparent blue of the sky. I travelled on the roof of the car so that I could better see the enormous landscape. My sister was driving. Beside her, two young *murran* called Hamisi and Tipitano, who were coming with us, chatted to a soldier we had picked up on the way. We drew near the area where there had been fighting between the *shifta*, terrorists from Somalia, and the Samburu. This area had been closed to travellers for security reasons. We had to get special permission to go there. The soldier we had picked up told us that there had been a raid that very night. Three killed, two wounded.

On our way back from Wamba that evening we stopped in a small village. Round a parked jeep a group of Africans were talking excitedly. We went to see what was going on. In the back of the jeep lay a youth of twenty, covered with an old blanket. Only the top of his head was showing; there was a large stain of blood on the blanket. They told us he was one of the victims of the *shifta* – that the entire lower part of his face had been blown off by a shot, and that he'd been there in the back of the jeep since six that morning. There was no mattress, not even a pile of hay to protect him from the bumps and holes in the road. It was now six o'clock in the evening. He didn't move. There was only the rasping sound

of his breathing through the hole in his face. He must have been unconscious, probably dying – we almost hoped so. While the driver of the jeep often stopped along the way to have a drink and chat with friends, the wounded man lay suffering in silence.

The extraordinary face of an old Samburu man who came to look at him stood out from the rest. An emaciated profile of infinite dignity. A bony hooked nose made him look like some Egyptian mummy (plate 8). The look he cast towards the wounded man showed the fatalism that only age and the wisdom of the bush can impart. I took out my 200 mm lens, but was only able to take one shot. He heard the "click". He was gone. We climbed back into the car and night fell. We were still far from the camp, and in *shifta* country it was foolish to travel on lonely roads like this one.

We were all shaken by the scene we had just witnessed, and drove in silence, each with his own thoughts. Suddenly a leopard crossing the road with an animal in its mouth stood out in the headlights of the car. We saw it drop its prey and escape, frightened. We jumped out. There on the side of the road lay a terrified baby eland, covered in blood. It wasn't more than a week old. It had tooth marks on its neck and stomach but otherwise seemed more scared than anything else. We put it in the car and took it back to the camp. The little creature lived with us in our tent for the rest of our stay. He was tame from the start. We gave him tinned milk from a coca cola bottle with a rubber teat bought in a small shop in Maralal. He adapted himself immediately to his new life, sleeping outside under a tree during the day and under our bed at night. His wounds healed quickly. We called him Sirwa, which is the Samburu name for eland.

Two hours after getting back from Wamba, we saw the jeep carrying the wounded man pass on the road in front of our camp. Our friends told us next day that the little hospital at Maralal had been unable to treat so serious a case and had sent him on to another town three hours further off, where there was a larger hospital. We heard no more of him. Perhaps he never arrived.

We stayed in the neighbourhood of Maralal for three weeks. Then we returned home to get more provisions, develop film and wash our filthy clothes which were covered in red earth. We got back at dusk. Everyone at home was impatient to hear the saga of our first expedition. On a farm like ours, where each day is as monotonous as the next, the sky always the same blue, the days the same length, and where human contact is often limited to members of our family and the Africans who work for us, the least happening becomes an event. Our car, covered in dust and mud, our filthy clothes and our sun-tanned faces were sufficient indication that we had much to tell.

The rolls of films in thin plastic bags were sent at once to the laboratory in Nairobi.

I waited impatiently and anxiously for the results. At last the photos arrived – sheets and sheets of contact prints, little boxes of colour transparencies, envelopes of developed film. I took the big brown paper parcel and shut myself in my bedroom. I felt my heart beat, my hands trembled. I lit a cigarette, took out a magnifying glass, and, holding my breath, devoured the contact prints, photo by photo, sheet by sheet.

I spent the next two days with my sister choosing photographs for enlargement, and mounting the transparencies. A first sifting, then a second, and so on to the final choice – about twenty altogether.

My sister left me a few days later. I would have to face the rest of my journeys without her. *Maasai*
I'd be on my own but I could not call it off now.

I set out again after another ten days having seen prints of all the photos and sent the first batch to London. I took Chengo, my father's farm driver. The next stage was to Narok in the country of the pastoral Maasai. I felt that this expedition would not be an easy one. The Maasai are the proudest and the most self-reliant of all the tribes of Kenya, cautious of strangers, and submitting unwillingly to any interference from the white man, the missionaries or the government. Before the arrival of the European they were renowned for their bravery and skill in defending their herds from neighbouring raiders and often themselves engaging in cattle-raids in return. A youth wishing to become a *murran* (warrior) must show no fear of death and it is not uncommon for a herdboy of ten to fifteen years old to kill a lion with his spear in defence of his herds.

I knew that they loathed being photographed, and that their mood changed from one moment to the next, and that they could not abide opposition. An English friend of mine had been struck down by a spear because he had gone off with a warrior's favourite cow. He had been sent by the government to retrieve stolen cattle. Among the herd was this cow. The warrior begged my friend to let him keep it and offered two other cows in exchange. The Englishman would not hear of it; they discussed the problem for hours. The warrior went away without further argument, then turned round and hurled his spear at the Englishman who died on the spot. The warrior was hanged. It was to these people that I was going. Their most important ceremony was due to take place soon. I had to be there. I had no idea how things were going to work out. I had some misgivings. It was certainly something too rare and important to miss and anyway I would have to confront them sooner or later.

On my arrival at Narok, a small commercial centre in the Maasai reserve, called after the "clear-watered" river that flows through the town, I went straight to report to the District Commissioner to inform him of the purpose of my journey. I showed him my permit, issued by the Ministry in Nairobi, which authorised me to photograph the tribe. The D.C.'s H.Q. was typical of the government outpost the British had built and left behind them. In the centre of the lawn the Kenya flag floated in the wind, high on its mast. The flag is raised and lowered mornings and evenings on the dot of six, to the sound of the national anthem. Whether this was in the desert, in the jungle or in Maasai territory, the style was that of Buckingham Palace.

About twenty men in khaki uniform, well ironed and starched and whose brass buttons glinted in the sun, stood around. They were select men, chosen and trained from the tribe which I was going to photograph in its natural surroundings. All spoke perfect English and were the embodiment of the ideal which the heads of the administration envisaged for the rest of the tribe.

I greeted them in their native tongue. They answered with delighted smiles. I went to the

15

District Commissioner's office. Politely he invited me to sit down and asked me how he could help me. His uniform was the same as that of the subalterns waiting outside, but had in addition several decorations and ribbons. I told him, as briefly as possible, what I wanted and the purpose of my journey. He asked to see my permit, studied it for a moment and then handed it back, crisply informing me that it was not valid, and that I would therefore be unable to continue. I insisted that there must be a mistake. I had been given permission at the Minister's office in Nairobi. I had been in other regions on the same permit, its validity had always been recognised. He shook his head, saying that the signature was not the right one. I asked him to phone the Minister in Nairobi to confirm what I had said. It took three quarters of an hour for the call to come through and when it did I was told that the person in charge was out. I would have to go back to Nairobi to get another permit. That meant a trek of 250 miles on rough tracks. I said goodbye and went into the sun, climbed into my car and set off for Nairobi. I was mad.

When I applied for a new permit I encountered obstacles which took me a whole month to overcome. Because of a minor incident earlier, in which my films had been confiscated, the Minister of Information had been told of my activities and the news must by now have reached even more powerful ears. I had to start all over again from scratch; going from one office to another filling up endless forms explaining in detail why I wanted to take photographs, and the purpose for which they would eventually be used. Ten days passed without news. At night I stared up at the sky. I knew the ceremony would begin when the moon reached a certain position in the sky. I had very few days left. Finally I phoned the Minister in person only to be told that my request for a permit had been refused.

I jumped into my car and set out for Nairobi again. There I met with a point blank refusal, but I just had to get my permit. For three days I waited for an interview with the official on whom the destiny of my book rested. Then, after passing through an interminable number of ante-rooms, I was shown into his office. He received me with the courtesy and charm that one finds only in men who are at ease with themselves. He asked me to sit down opposite his elegant desk, and with a trusting and confident smile enquired what he could do for me. I told him the whole story starting with the talk in London with my publisher and ending with the incident at Norak.

At the end of my story I said "That's all. You must help me."

For a moment, a moment which seemed endless, he was silent, then smiling he replied, "Yes, I think that I really must help you." He told me why he had refused the permit. There had been incidents in the past when journalists, photographers and film makers had come to Kenya; and afterwards when their work appeared in their home countries, it was found to show only the bad and retrograde aspects of the country. Because of this he had decided to bear down heavily on such people so as to prevent any further occurrences of this sort. He spoke in perfect English. He had not been aware of all I had told him. I had convinced him. Two hours later I left his office with the permit in my hand. He bade me farewell and made it clear that he trusted me. Now it was a question of honour. It was essential for me to be worthy of his trust. I thanked him warmly.

Soon I was again on the road to Narok. This time I knew almost every bend, every bump and every pothole, and exactly where I had to slow down and where I could put on

speed. Around me the immense plains of golden grass. Giraffe stood out against the skyline, their long necks waving like thin, graceful stems to the rhythm of their slow, undulating walk. Hundreds of zebra and antelope of all kinds mingled with the ostriches and grazed side by side with the Maasai cattle. These hundreds of miles of Africa belonged to them, and they lived there in undisturbed tranquillity.

On my arrival I went once again to the District Commissioner's office, this time with some trepidation. He received me with suspicious surprise. However there was nothing he could say when I handed him the letter, with its imposing heading: "The President's Office."

I set out at once for the interior region of the Maasai reserve. My first objective was to visit the *olaiboni* of the Maasai of that area, their great "prophet" whom they feared, respected and obeyed. Without his co-operation I knew I could not achieve anything. To have his permission, I had to explain in detail the reason for my presence, and to get him on my side. I arrived near his hut after three hours of dusty driving. The *manyatta* was about 20 kilometres from the road. I left the road and set off across a plain where there was no track and no landmark and on which the grass in places grew higher than my Land Rover. I drove slowly, for I could only see a few feet ahead of me, and had to ask my driver to walk in front of the car to point out the holes and hidden tree trunks which lay in our path.

Suddenly, we caught sight of a man coming towards us, a small speck of bright orange in that sea of golden grass. It was he. He came on, his long orange blanket falling down to his feet and a little woollen bonnet of the same colour on his head. I greeted him in Maasai. He held out his hand to me, but his grave, unsmiling expression did not change; he looked me straight in the eyes, but he did not utter a word. He let me explain the purpose of my visit and ask his permission to take photographs. I stopped speaking. Silence fell. I was worried for I had no idea what effect my words had had on him. Then he spat on the ground, looked at me again, but still his expression remained unchanged. Then he spoke, and in a deep and grave voice he told me that he was very pleased to receive me, that what I had said was entirely acceptable and that he would willingly allow me to accompany him back to his hut. I sighed with relief, smiled and held out my hand to thank him, and then as a sign of gratitude I put round his shoulders a blanket of almost the same tone of orange as the one he was wearing that I had bought in Narok, and placed two bottles of beer in his hands.

He led me back to his *manyatta*, and called all his family together to meet me. About twenty women, some young, some old, approached me, accompanied by about fifty children of varying ages. They were his wives, daughters, aunts, his old mother, his children and his grandchildren. One by one they stepped forward to shake my hand. The children bowed their heads for me to touch as is the Maasai custom. Hundreds of flies covered my face and hands. Then the old man asked me whether I preferred to stay with him or whether I would rather go on to the warriors' *manyatta* where the rite was to take place. I answered that I would prefer to go straight to the place of the ceremony so he told his son to accompany me, and present me to the warriors. I thanked him warmly and once more crossed the sea of grass. The sun was setting we had to hurry to arrive before nightfall for we still had to pitch out tents.

17

The *manyatta* was seething with warriors who wandered around half-dressed and covered from head to foot with red earth, which glowed in the last of the sun's rays. Accompanied by the *olaiboni*'s son, I approached them at once, so that he could present me to them. Meanwhile my two men started unloading the Land Rover and pitching the tents. When they saw me in the middle of the *manyatta* the *murran* came towards me singing and dancing. The *olaiboni*'s son spoke to them for a considerable time explaining why I had come. They listened attentively, staring at me. I greeted them, and they shook my hand; they were very good-humoured and laughed a lot. They asked if I was a girl or boy and touched my hair and clothes so that soon I too was covered with red ochre. I explained that I had to pitch my tents before nightfall and left them, arranging to meet them in the morning. As a token of gratitude for being granted permission to stay with them I offered them a sack of sugar that weighed 200 lbs. I knew they would use the sugar for making beer which would be drunk at the ceremony. They were delighted with the gift and thanked me in the Maasai manner by spitting on my hand. Things seemed to be going well.

The tents were finally pitched at ten o'clock by the light of paraffin lamps. I was terribly tired. I had been driving since seven in the morning.

The following morning two warriors came to my tent, telling me that their chief had sent them to inform me that I must pay a certain sum of money in order to photograph the interior of the *manyatta*. I pointed out that I had already given them a sack of sugar, but they insisted that I owed them money as well. As I know that the Maasai were very shrewd and that they would do their utmost to get money from us, I paid up. I had no choice. Both spoke in English, to show me that they too had been to school. The one who did most of the talking told me his name was Noah. He was a Christian, having been baptised by the Protestant missionaries at Narok. After I had given them the money, they went off happily telling me that they had been appointed my guides and assistants and would arrange everything for me. This meant that I could work without further hindrance. I was surprised to see how easily they accepted me and how soon we all became friends. I let the warriors look through my lenses which thrilled them and I explained the elements of photography to them. They asked me to pose for them, so that they could photograph me. With each passing day my clothes, hair, and cameras got redder and redder from the ochre. Like the Samburu, the *murran* were fascinated by my long hair and kept stroking it. They told me that it was like the mane of a lion, which was the greatest compliment they could pay me. During these days I succeeded in taking pictures of the most revealing aspects of the life of the Maasai, who are known for their camera shyness.

I went to the *manyatta* every morning and spent the whole day there. Soon its inhabitants stopped paying any attention to me and my work, as they were wholly occupied with preparations for the ceremony. The huts were repaired and covered with fresh cow dung, shields were repainted, and they started to put ostrich feathers and lions' manes on their heads. Their hair was rolled up and covered with red ochre every day. Each morning they painted their faces in a different style. Throughout the day warriors from other, often far off *manyattas* came to join them. Soon their numbers had swelled to two or three hundred. Then the *olaiboni* arrived, accompanied by several of his wives and a few old men of his household. He came straight to my tent to greet me and to enquire how I was getting on. I

offered him a bottle of beer which he drank with alacrity as he settled down on one of my camp chairs. The entire *manyatta* came to my tent to greet him and pay homage to him. They formed a long queue, dancing as they filed past him. First came the old men, who held his hand, then the women who leaned forward to kiss his cheek, then the young girls and children who bowed their heads before him. He touched them lightly. Last of all came the warriors wonderfully naked, their bodies glowing with red grease. This scene of deep-rooted respect for their leader was moving and solemn.

One day I met a very strange man, a European, whose clothes were also covered in the red ochre of the warriors. He told me he was fascinated by the Maasai and had come to live among them. He was also filming and seemed very interested in what I was doing, and asked many questions. I stupidly told him a lot about my work.

Not long afterwards Noah and his friend came to my tent and announced that the ceremony had been postponed until the following new moon and that the *olaiboni* had returned home. Rather disappointed I wondered what I could do meantime, as I had taken more or less all the photos I had planned to take before the ceremony.

A few days later Noah and his friend came again and informed me that I could not stay with them any longer; that I must leave the area at once. I was dumbfounded and asked them the reason for their decision. At first, they were unwilling to explain and merely said that the warriors had come to this decision. Later they told me that I had insulted them; I had photographed them naked in order to show white people that they were savages. I listened in stunned silence until Noah stopped speaking.

At first I imagined that he was trying to get more money out of me. I asked to speak with the others to see if they were unanimous in their decision. Everyone was summoned, and we sat in a circle on the ground. To my astonishment they confirmed what Noah had told me. I didn't go over the whole matter again but said "O.K. If you don't want me around, I'll leave. But before I do so, I want you to know that I have never insulted you in any way, and you know it and that your nakedness is of no particular interest to me. I am not here to concoct pornography, nor to make fun of you nor to ridicule you before other people."

I got up and walked away, leaving them rather puzzled by my attitude. Ten minutes later they came to my tent and told me that they had changed their minds and I could stay. "Thank you", I said. "O.K. I'll stay."

The following morning Noah came to see me, accompanied by two men, saying that I could not take any more photographs but that I must stay on because if I left the *olaiboni* would think that they had thrown me out and would be very angry with them. So it seemed I should have to stay without taking any pictures until the new moon, which was not for another two weeks. I couldn't understand this sudden reversal. What ought I to do? I asked advice of Kimuyu. He urged me to pack and leave immediately. But what about the ceremony? If I left without the *olaiboni*'s consent, they would never let me return.

I stayed on, virtually a prisoner. I stopped going to the *manyatta*, and nobody came to see me. There were no more visits round the evening fire, friendship had come to an end, so had their trust in me. I found myself surrounded by hostility. On the fourth day a Land Rover drew up outside my tent, and an official from the administration got out. He was

dressed in European clothes, and accompanied by two policemen who carried guns. My driver told me later that Noah and his two friends had spent the previous evening talking with the strange European, and he could not help wondering whether the European had turned the *murran* against me.

The official greeted me in an unfriendly manner and told me that he had received complaints about me. Those who complained said that I had photographed them naked, and without their consent. I tried to explain things calmly. The official listened in silence, and he said that it would be better for me to go back to Narok and clear things up with the D.C. He told me to pack. We set off in haste. I was wretched at having to miss the ceremony. "They'll never let me go back again," I thought. How could I explain what had happened? Why should they believe what I told them? Now they would obviously take away my permit. I saw everything that I had so carefully built up on the verge of crashing.

One of the policemen was to accompany me to Narok to make quite certain that I did not try to escape. The official wrote a letter to the D.C. and put it into the policeman's hand. As we went past the *manyatta* I caught sight of Noah with about twenty of his friends. He came up to the car, and signalled me to stop. "Don't come here again," he said in English. "If you do, you will be killed." Furious and terrified I put my foot on the accelerator and drove away, in a cloud of dust. The dark thoughts whirling in my head grew blacker every minute. I might be kicked out of Kenya which for me would be like a death sentence. We drove on in silence, flanked by two sullen policemen.

A car approached us and made signs that we should stop. A policeman, beautifully dressed in well starched khaki, got out, greeted me and with a smile asked to see my permit. He showed me his identification and I noted that he was the superintendent. I handed him my permit and he nodded to me indicating that everything was in order! Only a simple "road check", he said as he waved me on, but just before I let out the clutch the policeman in my car jumped out and handed him the letter. I read it over his shoulder. The words "has been arrested for taking pictures of naked men without their consent" jumped to my eyes and for a moment I thought that my heart had stopped beating. The smile on the superintendent's face disappeared. "Hand over your camera," he said. "You have committed an extremely serious offence."

I tried to explain that I had done nothing of the sort, but I knew that my words were falling on deaf ears. I gave him the bag with all the cameras and also the packet of film. "Take her to the police station," he ordered. "Confiscate all the equipment and wait for an official clarification." Then saluting he got into his car and drove off in the opposite direction. The clouds of dust rising from the two cars formed a curtain between us.

By the time I arrived at the police station it was already seven o'clock at night. A policeman was speaking through the radio transmitter. He motioned me to wait. He and his friend at the other end chatted gaily and told each other funny stories and laughed. At last he switched off the transmitter and turned to me. Catching sight of all the cameras lying on the bench he looked at the policeman who accompanied me. The letter was handed over, and he read it slowly, his expression changing as he reached the damning accusation. "You really mean to say that you took pictures of naked men without asking their permission?" he said. "This is a very serious offence." I explained that it wasn't true. "But that's

what the letter says." I knew that there was no point in arguing. He told me that I would have to wait for the man who had the key to the safe. He had gone out. No, he had no idea when he would return. It could be in a few moments, or it could be in an hour. I asked him to call the chief of police. "He's off duty." "Where does he live," I asked. "I'll go to see him." A subordinate policeman accompanied me to the Police Chief's house. I was shown into the living room. The chief of police saw me come in with one of his men and looked at me hazily. He asked me what I wanted. I collected my wits and said that I wished to put my cameras into the safe at the police station as they had been confiscated. He handed over the keys to the safe to the policeman who had accompanied me.

I went out into the night to the police station. There they made a detailed inventory of all my equipment. Finally, they wrote the words "has been arrested for taking pictures of naked men without their consent, all the above equipment has been confiscated." The policeman held out the paper for me to sign. I refused, saying, "It's completely false, and I refuse to put my signature to it." "Very well, here's your copy", he said. Kimuyu and Chengo were anxiously waiting for me. They had prepared hot soup and tea. I told them what had happened at the police station, and we talked for a long time about the events of this miserable day.

I spent the night in a small hut, and set off at dawn. I didn't want to face the local authorities without having asked advice. So I left at dawn before things started moving in the offices. I must see my friend at the Ministry and tell him what had happened before he heard the story through official channels. I drove like mad. Even though I knew I was innocent, I was haunted by the idea that nobody would believe me and that my book would be stopped. The relief I felt when I saw my home and parents was indescribable. They did their best to calm me, and gradually I regained my courage.

The following day I set off for Nairobi where I went to the Ministry. I was shown immediately into my friend's imposing office. I did my utmost to keep calm, as I told him my story, briefly and concisely. He listened without a word, but I thought his expression trusting and pleasant. "That's all," I ended. "I'm sorry to have to tell you all this, and more sorry than I can say that I shall miss the ceremony." He answered, smiling, "I know. I have all the details." So he had already been informed, and had said nothing to me because he wished to hear my version and see if it agreed with what he had been told! "Don't worry," he continued. "You'll get to the ceremony. But just remember one thing. You are working with men, and this won't be the last time that you'll have trouble." I couldn't believe my ears. He had believed me, he still supported me. He rang for his secretary and said to him, "Please call the D.C. at Narok." Then he rose and asked me to go back the following day to collect my cameras. As I left his office after thanking him for the tenth time, I said to myself that there were still a few decent intelligent people left in the world and suddenly I felt that from now on, there would be no more insurmountable obstacles and that I would get through to the end somehow. As I drove home, my car seemed to skim over the road as if it had wings. The next step was to face the *manyatta*, the enraged young warriors, the people who had warned me never to return. That would be a different story, for even if the official side of the matter was settled, I still had to deal with the human one. I would ask advice of some of my friends who knew the Maasai and had lived with them for a long time.

I told them my story and the outcome of my interview with the Minister. All, without exception, advised me not to return. It would be, they said, *most unwise*. The peoples of the open country did not give a damn for the officials in Nairobi, and a permit to return would mean nothing to them. If they were hostile it would be better not to provoke them, as they were capable of anything, particularly at the time of the ceremony when external discipline and authority were thrown to the winds. "Don't push your luck too far," my friends begged.

I was torn between deciding to give up the whole venture, which seemed cowardice, and continuing. That evening I decided to give it up. The story was not that important that I had to risk my life for it. For two nights I couldn't sleep. Then I began watching the sky. The new moon was just rising. I had only a few days left, after that it would be too late.

I went to see Francesco, a close friend for twenty years, who owned a large farm next to ours. I told him my problem. I had enormous confidence in him. He grasped the situation, saw my despair, and realised how important the whole matter was to me. It had become a challenge, almost an obsession. We talked about it for hours on end and eventually he said, "You'll go, and I'll come with you. Don't worry. If there is a way out I'll find it for you." The next morning we set off.

For the third time I took the road to Narok, but now I wasn't at the wheel. I never liked the man's role which had been forced on me over the past few months; taking decisions, resolving problems, driving the car, in short all those things which men are so much better at than women. This time my visit to the D.C.'s office was brief, and we left for the *manyatta*. About 2 or 3 kilometres from our "battle ground" I got out of the car. We had decided that Francesco would turn up first without me to see what the atmosphere was like. It was the only precaution I took. I stayed by the side of the road with my two Africans. The car disappeared in a cloud of dust. There was nothing for me to do but wait. It was one o'clock in the afternoon, very hot, but pleasantly dry. I sat down under a tree and undid the pile of French newspapers and magazines which I had brought with me. I read every one from beginning to end. I looked at the sun. It must have been about four o'clock. Francesco had been gone about three hours. I tried to picture his arrival at the *manyatta* and the *murran*'s reactions.

The two Africans who had stayed with me slept peacefully under a tree not far away. I watched the clouds floating in the sky, and then the sunset. Flies buzzed round. I liked the country, the landscape, the silence, the heat and the solitude. Here time and distance had no meaning. Days pass without anything happening. The weather is always fine and the few periods of rain hardly break the monotony. They just change the colour of the grass. This is what eternity must be like.

A few miles from where I waited, I imagined the preparations for the great ceremony getting under way with a wonderful show of youthful energy, noise and bustle. Soon that too would disappear and give way to the immense emptiness of Africa. There would be few visible remains because the Maasai abandon the ceremonial site for ever once the ritual is over. The place of the ceremony is chosen by the *olaiboni* and when it is over the *manyatta* is burned and no traces are left. The heap of grey ash is blown away on the wind, and the grass grows again. I kept watch in the direction the car had taken. There was no cloud of

dust, and no sound of an engine. I began to worry. The sun had set, and I started imagining terrible things; angry faces, black looks, the insults which had pursued me as I left, came back to me one by one. How was Francesco going to calm them and persuade them to be friends again? I had confidence in him, but as night fell I grew more and more afraid. The first stars appeared, and suddenly it was very cold. Still no sign of him. I walked backwards and forwards. I wondered whether his long absence was a good or bad sign. I lit a fire to keep warm, and then from far away I heard the faint hum of an engine. I got up in order to hear better and to try to catch sight of the headlights. The sound of the engine grew louder and there he was. I ran up to the car which had stopped by the fire. It was eight o'clock. Francesco got out, threw me a haggard look and covered his face with his hands. "Well?" "I think it's O.K.," he mumbled, "I've been talking to them for the last six hours."

"Tell me what happened." "I'm dead drunk," he said. "They got me tight on their beer." I begged him to tell me more. "Let Loigunyoki tell you." Loigunyoki was a Maasai shepherd from my farm who had gone with him. I asked him to come and sit by the fire with me. "It was tough, very tough, but I think we've won," he said, then he told how they had arrived and been received with hostility. The *murran* had refused to talk to Francesco, or to hear what he had to say. With his characteristically calm determination, he let them go on insulting me. After they had finished he spoke with quiet firmness, agreeing with them up to a point, but later persuading them that the whole misunderstanding was due to a cooked-up story in which there was not a grain of truth. Moreover, as proof of what he said, he told them that I had in fact brought the pictures to show them. (I had developed the photos which the police had returned to me). Francesco took Noah, the leader of this little band, aside and spoke to him at length.

Then he asked to see the *olaiboni* who had returned and was much angered when he found out what had become of me for the *murran* told him that I'd simply left. When he heard Francesco's version he was also indignant that I had felt obliged to stay alone by the roadside in the dark, because I was afraid of appearing before them. "Go and fetch her at once," he told Francesco. "Nothing will happen to her." The *olaiboni* walked to the centre of the *manyatta*. The warriors were dancing. He stopped them with a wave of his hand. He spoke to them in a severe voice, saying that he would not accept the fact that one of his children was sleeping outside in the cold while the others were warm in the *manyatta*. Nobody uttered a word. They bowed their heads and looked at him in respectful silence. He told them that I had come back to continue my work, and that if anyone tried to interfere they would be punished. This must have made a deep impression for no voice or head was raised. Francesco thanked the *olaiboni* warmly and begged leave to go and fetch me before nightfall.

However, before he could set off he was invited to drink with the witch doctor. He was obliged to stay in the *olaiboni's* hut for more than an hour swilling down huge bowls of wine made of fermented honey, leaves from the special trees and water. The result was a highly alcoholic brew. Poor Francesco had drunk deep lest he offend his host, and came back victorious, but too drunk to stand on his feet. I was wild with joy, but it was now too late to go back. We decided to spend the night in a shepherd's camp a few kilometres from where we were.

The following morning Francesco insisted on going by himself again to the *manyatta* to make certain that nothing had changed during the night. I waited for another two hours. He returned with the news that all was well, and that they were all agreed on my return.

The *manyatta* was as I had left it, except that now bands of multi-coloured material waved like flags on each hut. There was a holiday air about the place. Hundreds of warriors, painted red from head to foot, wandered around or stood and talked in small groups. A few were dancing. As they saw the car drive up, they came to surround us. "Where is she?" they cried. "We want to see her." I stayed in the car. Noah came forward, and opened the door. I got out. He took me by the hand and they asked a stream of questions. "How are you?" "Have you brought the photos, and when are you going to show them to us?" There followed a stream of compliments about Francesco.

I had been rather nervous when they all converged on us, but their smiling faces re-assured me. Everyone came up to shake my hand. There was no trace of their past anger. They had forgotten everything. We were friends again. They came with me to the *olaiboni's* hut, and just as we arrived he walked towards me. He placed his hand on my head, which I had bowed in proper Maasai fashion as women do in greeting respected elders. Then he held my hand and told me how pleased he was to see me again and how I should always be welcome among them. He also said that I had nothing more to fear and that I need anticipate no interference in my work. We were shown the camp site which they had chosen for us. It was close to a little stream, huge trees gave shade, and the closely cropped grass formed a carpet upon which we pitched our tents.

Surrounded by about fifty warriors we unloaded the car and set up our camp. There was a generally friendly air about the proceedings, but nobody offered to help us. Leaning on their long spears, which they had stuck into the ground, the young men watched us work, touching everything and marvelling at the quantity of things which Europeans considered necessary to life. When they had satisfied their curiosity they wandered off.

In the evening they came back to visit us, and seated round the fire we talked for a long time. They confirmed that the ceremony was due to start the following day and that the warriors of the surrounding country had already arrived, though more joined them that night. For many this meant several day's walk and some had come from as far afield as Tanzania in order to take part in this ceremony which was held only once in seven years. As the *manyatta* had become completely full several new arrivals settled to sleep on the ground near our tent, around our camp fire. They covered themselves with the red blankets which they wore as clothing during the day and fell asleep.

The following day we were woken up at seven o'clock by cries and chanting. I got up and from my tent saw warriors dancing around the whole area of the *manyatta*. This was the beginning of the extraordinary ceremony which I describe in detail in the Introduction to the photographic section later in the book.

When the ceremony had ended, we broke camp and hit the road, the wild cries still ringing in our ears, the fantastic vision of a dying way of life dancing in our eyes.

THE INDIAN OCEAN CHAPTER III

After spending some time at home, I decided to visit the Giriama tribe on the coast. A *Giriama and Orma*
friend lent me a very beautiful house on a lagoon near Malindi about fifty miles from
Mombasa. I took my children with me to let them enjoy the tropical sea. We set off, one
morning, in the direction of the Indian Ocean 350 miles away. It took us ten hours to
reach the blue lagoon and it was seven o'clock when I finally switched off the ignition and
the headlights. James, the caretaker, came forward to greet us with a huge smile. The
children were dead tired. We unloaded the car and went to bed. A gigantic moon cast a
cold light on the coconut palms around the house. Their feathery heads sixty feet above us
swayed and whispered in the wind. Beyond them, the sea crashed against the reef. Enormous
waves burst on the rocks, and exploded into a fan of white spray which hung for a moment
in the air, before falling back into the black water. Inside the lagoon the sea hardly stirred,
gently caressing the immense white beach which shone like snow in the moonlight.

It was stifling inside the house. I opened all the windows and lay down on my bed.
A wonderful feeling of well-being came over me and I fell into a deep sleep. I woke up
with a start, hearing a noise near my bed. I opened my eyes without moving and in the
moonlight saw the silhouette of a man. I asked in Swahili, "Who is it?" supposing that
it was my new house servant looking for matches to light the fire, and that it must be near
day-break. As there was no answer I raised my head. Suddenly, panic-striken, I realised it
was a stranger. I yelled at him to get out and asked what he was doing there. He stared at
me in silence and did not move. I yelled again, and after a moment, which seemed inter-
minable, he moved from the side of my bed. Terrified because he did not run away, I
jumped up on the bed, stark naked. Instinct made me grab the pillow and I hit him on the
head with it. I had nothing else at hand. He slapped my face, and told me in English to
"shut up". By now absolutely petrified, I went on hitting him and swore at him, telling
him to leave my room at once. He took one more look at me, moved slowly towards the
window, through which he had come, bent down to pick up something and jumped out
in a leisurely manner.

I saw him walking off slowly, along the little path of white sand, which led down to the
beach. In the bright moonlight I could see that he had my transistor radio in his hand. I
shouted at him to return and give it back to me. He disappeared into the night. My house
servants, wakened by my cries, appeared outside my windows, with sticks in their hands.
I was shaking as I told them what had happened. We ran after the man but he had dis-
appeared and the beach was empty.

James begged me to go and call the police at Malindi. At first I hesitated, thinking it
was useless. Malindi was 12 miles off, and by the time the police arrived the man and my
radio would be far away, hidden in the scrub. I finally gave way to James' pleading, and
we went to wake the chief of the nearest African village. Together we phoned from the
little hotel and asked the police to come at once. They turned up two hours later, an
inspector and two corporals. I looked at my watch; it was half past three in the morning.

25

They sat down and listened attentively to my story. When I had finished they asked me to start all over again, but more slowly, so that they could write down my statement. The inspector took out a large piece of paper, and began writing in a simple hand, working with such concentration that he reminded me of my daughter doing her dictation. When he had filled up two sheets of paper he handed them to me for correction and verification and asked me to add anything that he might have left out. The most minute details seemed to be of the utmost importance; even the date and place of my birth and my profession, and a heap of other things totally irrelevant to the theft. The police left me two hours later.

Before he got into the car, the inspector came up to me and asked if I would take a photo of him. I promised to do so, but told him that first he must start looking for the thief. I lay down again, after making certain that all the windows in the house were closed. I tried to calm down.

Two hours later I was woken by the sound of a car engine. Then I heard someone tapping at the window. Completely dazed I got up and pulled back the curtains. The police were there again. "Come," they said, "we have someone here. Perhaps you can identify him." I walked to the back of the blue-grey Land Rover and saw a man inside. He was handcuffed and his trousers were slipping down. He stared at me with hatred like a wild animal. I recognised him immediately. The police had picked him up at the bus stop, searched him and found two gold watches, and 1000 shillings in his pockets, and in his socks coins with the head of Queen Wilhelmina and John Kennedy. He had been waiting for the bus, with my radio in his hand, when the police car drove past and the inspector noticed him. He had visited four houses that night.

The following day my house servant handed me a letter from the chief of the village. Here it is:

Dear Madam Watamu 19–10–67
Plot 10 Watamu

I writing this letter with the utmost integrity towards everything in general, I fully sympathies with you for the unfortunate night you had your radio stollen and the rough time the intrudder gave you, I relize what a shock it had been to you asspecially a lonely lady in an issolated area like the one house your are occupying. I fully sympathies with you beyond any reasonably doubt.

I have a feeling I must share with you. The first time I met you I fell hard in love with you and realizing very well the fact you are married, I have invainly fought this feeling back to control my emmotions but fell back on the point that I must let you know that I am deeply in love with you. You might be aware there moments ware a man could not be able to controll himself against them.

Please do not be hard on me in case you are not pleased in the manner I have pressent my self to you as far it is, I have played square and there are cards for you take your turn.

Excuse all the stuff if you do not fit in the picture and let me know of the proceedings.

Yours affictionuley,
Sub Chief
WATAMU

Torrential rain fell during the following five days and nights, only letting up now and again for a few hours. The road was under two feet of water, and water streamed down over everything. The sea seemed part of the stormy grey sky. We stayed inside the house, getting more and more on each other's nerves, going out occasionally, when the rain stopped for a few hours, to walk along the sopping beach. Then the sun shone, hot and bright, and the sea and sky became blue again. Not a cloud remained to remind us of the sad, rainy days. Everything dried and shone once more. We rushed to the sea and stayed there all day enjoying the warm, soft water, and lay on the beach roasting in the sun. We went for walks on the coral reefs, when the tide was out, and picked up shells. The children were wild with joy and splashed around in the water to their hearts' content.

It was on the reef that I saw Shaibu for the first time. I caught sight of him far off, walking with a friend. At first they were only two black specks flat on the horizon. I kept my eyes on them as they came towards us, growing bigger all the time. When they were a few feet from us they stopped. I greeted them, and they squatted on their heels to speak to me. I was lying down in the water. Even under his straw hat, faded and misshapen, drawn down well over his forehead, I noticed Shaibu's extraordinary eyes. They were black and elongated, and his nose straight and thin, with delicately curving nostrils. His mouth was finely drawn and hardly at all negroid. He had very long legs, and enormous feet. In his large hands, with their long thin fingers, he held a sack full of all kinds of shells. I started a conversation, simply in order to be able to look at him. He stared at me through eyes half closed against the blinding reflection of the water, and told me that he was a Bajun, a tribe which I didn't know, and which apparently came from an island 190 miles away. He was a fisherman and made a living by selling the fish and lobsters he caught and the shells he collected every morning. He lived from one day to the next. We spoke for a moment and then he got up, his long black body towering above me. He bade me farewell and left us. As I watched him go I made up my mind to go and visit his distant island. If his beauty was anything to go by, his tribe would certainly be worth seeing.

That evening I went to the little African village in order to find out more about these people. Shaibu was there, chatting with the other fishermen. He wore a striped orange sarong, knotted round his waist, which fell to his feet. He seemed even taller. His torso was bare and his head, now without the straw hat, was small and a perfect oval. He came over to me smiling – he took me to his family, and presented me to his mother, a big, fat woman, his three sisters, and his fourteen year old wife, who were all dressed in *bouie-bouis*, the enveloping black Mohammedan Mother Hubbard, with veils hiding the lower half of their faces. They greeted me with grace and simplicity, and begged me to sit down. They offered me scented tea and little cakes, made of coconut, while Shaibu told them about our meeting that morning. He seemed as proud to present me to them as them to me. I stayed with them for a considerable time and talked about my work, my safaris, my children and my family. They were curious about me.

I met all Shaibu's friends when he accompanied me back through the village nestling among the palm trees. The little square huts, with their roofs of coconut fronds were lit from within by paraffin lamps. Men walked around between the trees and went in and out of their huts. Because I was accompanied by one of them, everybody greeted me as I

passed. I stopped to talk with them, they told me about the day's work, about the number of fish they had caught, and the price it had fetched. The veiled women stayed inside the huts, looking at us through the tiny windows.

One day, Shaibu and two of his brothers invited me to go fishing with them. They came to fetch me at 6.30 in the morning, and we embarked on their small *ingalao*, a boat fashioned from the hollowed out trunk of a tree. They pushed it off the beach with a long pole, and then raised the sail, which was made of coarse cloth. The wind soon filled it and we sailed over the transparent water. The boat was very narrow, so we had to sit at the bottom, one behind the other in order to prevent it from capsizing. They spat into their masks to clean them, plunged them into the salt water to rinse them, fixed them on their heads and loaded their guns. When they reached the coral reef, they lowered the sail and fastened it firmly with a rope. They jumped into the water and I followed them sinking down among the fishes, the many-coloured coral and the enormous fronds of seaweed which grew on the sea bed. The three Africans swam around me, graceful as dolphins, enveloped in thousands of tiny shining air bubbles, which sparkled in the sun. Every few minutes they came up to take a breath of air or to throw a fish they had caught into the bottom of the boat. They caught them with incredible facility as though they were catching butterflies. I hardly ever saw them miss one. From time to time they came across a lobster or a squid. Then they came up for air and to collect the net, to glide again to the bottom. In one movement they scooped up the lobster into the net and surfaced again. When they caught a squid, they let it wind itself round their arms, and once in the boat they struggled with it to untwine it and turn its head inside out. The fight never lasted more than two minutes. We set off at low tide and returned at high tide with the sack full of fish and lobsters. These they sold to the hotel catering for the Europeans, who lived on the shores of the lagoon.

Although I was able to take some photographs of Giriama girls dancing I was rather disappointed by the rest of the tribe and became increasingly more interested in finding out about Shaibu's people. I decided to make my way to the Bajun island. Shaibu suggested that I should sail there with his brother Leli in his small dhow. The Islands were a three days' journey away. By land we would have had to go through the town of Lamu, the famous old Arab city, but the road leading there was still under water. We loaded the entire contents of my camp onto the deck of Leli's dhow, which was primitive but served its purpose well. Ali and two other friends formed the crew. I bought all six of us striped yellow and orange sarongs and white T-shirts and felt very much like a noble lady of long ago, setting out on a voyage with her crew dressed in livery.

A great storm was brewing on the horizon, the wind blew, and the sea was covered with white crested waves which hurled themselves against the side of the boat. Then it started to rain. We covered the cargo with a large piece of canvas, and waited for nightfall. At this point I decided not to go by boat as I get terribly sea-sick when the sea is rough, so my sailors set off at midnight without me. We arranged to meet at Lamu. The wind had dropped, and a full moon lit their course. I waded to the boat with them, and watched them raise the huge sail, pull the ropes and tie them skilfully. Then they vanished into the night.

Next morning I took the small six-seater plane for Lamu. I climbed on board together

with four veiled Bajun women. The plane seemed to float in the air like a feather, caught by each gust of wind. I sat near the English pilot with my cameras at my feet. It was noon. My dhow had been at sea for twelve hours. We followed the coast line the little huts hidden among the coconut palms looked like toy villages. Huge white crested waves broke on the shore below, which stretched away for miles. A flock of goats with their goatherd stood out against the blistering white sand and was the only sign of life on the beautiful tropical beach below us. We had been airborne for half an hour when I caught sight of a tiny white sail in the distance. I asked the pilot if we could fly low over the boat. He nodded and we swooped down. The boat grew larger and I recognised my sailors. The sea was hurling itself against the craft, making it dance around like an empty shell on the waves. I was glad to be in the air. The sail swelled in the wind; they were making good progress. I waved frantically to the crew through the window, and they waved back. We arrived at Lamu an hour after taking off; the plane landed smoothly on the grassy runway, where a small group of Africans was waiting for us. They placed the luggage on their heads, and together we walked for about twenty minutes along a track towards the boat which would take us to the Island of Lamu.

When we landed, I went to an Arab house, with a letter of introduction from a mutual friend. A charming man of about sixty, clothed in a long *kanzu*, the white shirt that falls to the ground, received me with typical Arab courtesy. He read the letter carefully, gave me a delightful smile and said that his house was at my disposal. He led me up a white painted staircase, and showed me into a rather shabby room. Several of the small window panes were cracked and broken, and the walls were whitewashed. Three little beds, made up with well-worn sheets, were lined against the walls. We sat on the edge of the terrace that overlooked the harbour and I told him about my work and the purpose of my journey.

Some ten Arab dhows were moored in the port below, I kept a watch on the harbour bar, for the storm was blowing again, and it was pouring with rain. Boats came in, one by one, their sails billowing in the wind, but mine was not among them. Night fell and I waited until ten o'clock then I went to bed. In the morning I ran onto the terrace as soon as I woke up, to see if they had arrived during the night. They were still not there. I started to worry.

I went to the D.C.'s office to introduce myself. He told me that he was about to set out to visit the Orma, a tribe who lived about fifty miles away and he invited me to go with him. I accepted gratefully; it was a welcome distraction. I discovered a people of whose existence I did not know. The men, very tall and distinguished looking, were dressed in bright green, orange and violet cloths; long white veils knotted like turbans round their heads fell to their waists. The women had fine features, with long, thin, pretty faces; they were clothed in black material which clung to their slim, supple bodies. On their arms and legs they wore dozens of silver bracelets. Their village, built on the banks of a lovely lake, covered with gigantic white water lilies, was quite different from any I had seen up to now. The domed houses, made of long grass, looked like giant bee hives. I used my camera a lot.

When I returned in the evening I found Shaibu waiting for me on the bridge. Our mutual relief at seeing each other expressed itself in excited talk and screams of laughter over our apprehensions. They had had a ghastly trip. Thank God I took the plane.

CHAPTER IV ISLAND OF THE VEILS

Bajun Shaibu led me to the boat where I found the crew. We waited for the tide so that we could set off in the morning. All my camping material which had been completely soaked during the trip from Watamu was dried off in the sun and once it had been stowed away again we set sail for Faza. The wind was fair, as we slid out of the port, gliding gently between the mangroves which stretched for miles along the water's edge.

It was two o'clock in the afternoon, and the sun was very hot. The water was miraculously calm, like a mirror. We were all suddenly very hungry. We got out some eggs and bread and cooked them on a wood fire in an empty kerosene tin. At six o'clock the wind dropped. The boat slowly came to a full stop. We were about half a mile from Faza. We waited. Night fell. There was not a breath of wind. The moon rose; a huge orange ball on the horizon, casting its reflection on the water. I lay on the rough little bridge and watched its swift ascent in the sky. The sailors, crouching along the side of the boat, stood out like black crows silhouetted against the moonlit water. They chatted quietly to each other and smoked cigarettes. An almost unreal atmosphere enveloped us. After a long while they gave up their watch and announced nonchalantly that we would sleep on board and continue in the morning. The sail was lowered, they wrapped themselves in their *kikois* and after finding a suitable corner, curled up and went to sleep. Shaibu got out my mattress, made my bed on the aft deck, covering it with a *kikoi*, then knotting two others at the corners he improvised a little roof over my head. I lay down and covered myself with a fourth *kikoi*.

I stayed awake for some time, looking at the stars and following the moon. The boat hardly moved. In the silence of the night I was possessed of a feeling of great peace. I felt wonderfully protected and unafraid among these Africans who looked after me with the simplicity and dignity found only among those uncontaminated by modern civilisation. I fell asleep very late.

I was woken at five o'clock by the sound of the sailors who were talking to each other as they hoisted the sail. The morning light shed its greyness over the world around us, the sea and sky reflected each other. Only the coconut palms, still black as night, stood out darkly along the water's edge. Very slowly we slid towards the little village of Faza, which was still asleep. Small, square huts, thatched with coconut fronds stood along the shore, reflected in the still grey sea. Around them gigantic palms rose heavy with yellow coconuts.

In spite of the early hour the air was heavy and it was already stifling when we landed. I tried to tidy myself a little, after having spent the night on deck. I knotted a *kikoi*, the women's sarong, round my waist and got out a clean T-shirt from my suitcase. I looked like the rest of the crew. No more mini skirts or bikinis. I was about to visit people who still possessed the deep Moslem sense of decency. My legs had to be hidden at all costs. Here the men and women were covered from head to foot, and the sight of a naked torso or bare legs, or women without veils was unthinkable. We could have been in Sicily.

With Shaibu I made a swift tour of the village and returned to the boat rather dis-

appointed, haunted by the doubt that after all the trouble and expense of the journey, I was not going to find what I was looking for. The women were short and very ugly, and the men totally uninteresting. I looked at Shaibu and asked him if he had been telling me stories. He assured me that this was not so, and said that his village was much prettier, and had a much better climate as it faced the open sea, whereas Faza was on a creek, which made the air heavy and hot.

We raised the sail again and set our course in the direction of Kisingitini, further round the island. It took us about an hour and a half to get there. I noticed the difference at once. Dozens of small craft moved in and out of the tiny natural harbour. The village, like Faza, was built at the water's edge, beneath the coconut palms, but on one side an enormous beach stretched for miles. We jumped out of the boat, which we had anchored about 100 yards from the shore, as the water was very shallow. I knotted my *kikoi* round my waist, tucked the ends into it and followed the sailors into the water which came well above my knees. We found the chief of the village, a gentle looking African, waiting for us. He was wearing a white *kanzu* which fell to his feet, and had a little red cap on his head. A large black umbrella hung from his arm. He was seated on an old up-turned canoe, surrounded by about six of his men. I hastily let down my *kikoi* and walked towards him. He rose and offered me his hand, as with a smile he welcomed me to his island and asked me to take a seat beside him. Almost immediately we were surrounded by hordes of children and women draped in black whose faces were completely covered except for their eyes. I was obliged to shake everyone by the hand, and repeat the same thing over and over again. I had to explain who I was, what I had come to do, how I had travelled, and so on. Every-one was fascinated and listened intensely to what I was saying. I was relieved to notice that a few of the people were goodlooking, but Shaibu was still by far the most outstanding. I decided to stay a week, hoping that I might discover something interesting to photograph.

The chief was called Shakue. At last he got up and offered to show me a site for my camp. Several of the inhabitants invited me to their houses, but I explained that I preferred my tent as it was cooler. The heat was unbearable, and my *kikoi* clung to my damp body. Sweat poured down my back. Blast decency, I thought. The men went back to the boat. In spite of the ghastly heat, they started unloading my camp and carried it on their heads piece by piece, from the dhow to the site we had chosen. They arrived bathed in sweat, threw themselves on the ground for a moment's rest then went back for the next bundle. They were followed by a long line of children who had offered to carry something, and who returned, each carrying some little thing – a chair, a kettle, a water can.

Shaibu opened a camp chair for me and I sat watching everyone else do the work. I couldn't move. The chief sat on a chair beside me. The village children milled around in their tiny shirts which were torn and worn, little *kikois* tied round their waist. My arrival had caused a great stir. Later they told me that it was very rare for a European to come to their island, and that the fact that a white woman had chosen to set up her camp amongst them was considered a great honour. Everyone came to see me to show approval, and, of course, to satisfy their curiosity. The pitching of the tent was a source of endless fascination and when, from time to time, someone was asked to hold a rope or bang a nail, he did it as though it were a great privilege.

At nightfall, the women, who until then had stayed in their houses, came in small groups to visit me. They approached my tent very timidly and silently, appearing out of the dark night. When they were close they whispered their greetings from beneath their veils. I could see only their eyes, which shone brightly from out of all the yards of black material. They stayed for about ten minutes, devouring me with their eyes, and only speaking when I addressed them. Then they bade me farewell, and left swallowed up by the darkness. Five minutes later another group would arrive. This went on during my entire stay. "We have come to look at you" they told me. The less timid among them, after a few visits, ventured to sit on the camp chairs. A few even came inside the tent, and sat on the bed to talk to me, but this was very rare, and only happened towards the end of my visit when they had got used to me. I let them come, it was my only chance of seeing them, and since I had come to photograph them I had to begin somewhere.

Our conversations, which at the beginning were rather stilted, became easier as we indulged in feminine chat. They told me about their problems concerning their homes, husbands, children, and lovers. They laughed a great deal when they heard that our problems were the same as theirs. I knew them all by their names, some of which were very beautiful, such as Halima, Hardigua and Amina. They went wild with joy when I told them that my daughter's name was Amina. When I walked about in the village, they came out of their houses as they saw me go by, calling to me and inviting me in. Wherever I went, I heard the word *karibu, karibu*, which is the Swahili word for "welcome". I often went into their houses to chat for a moment. On these occasions they offered me very strong sweet tea, flavoured with ginger, which they served in rather dirty cups, together with strange cake fried in coconut oil, and cooked papaya. This food did not taste very good, and I used to tell the women that I was not hungry, lest I offend them. On their visits to me they brought me small gifts; hard boiled eggs, papaya, milk or wood for my fire. In this way I was able to get the pictures I wanted, for these women had never allowed themselves to be photographed before.

One day a very tall thin man came to my tent, dressed in the typical white *kanzu*, carrying a black umberalla as a sun shade. Hordes of children followed him. He looked like the Pied Piper. He stopped in front of me and asked the children to go away. Then he introduced himself as the religious teacher. He was called Harris. I asked him to sit down, he seemed worn out and kept patting his face with a coloured handkerchief. He was very different from the others, his complexion was light, his hands fine, he wore a small beard around his chin and looked like an Arab. He was gentle, and smiled a lot, spoke very slowly in a deep voice, and in every way seemed completely suited to his calling. It soon became clear to me that he more than anyone else was qualified to tell me about this strange tribe so mysteriously wrapped up in its modesty and religious taboos. He explained that he had spent two years in Cairo, where he had been sent by the government to perfect his Arabic, and to learn the art of teaching the Koran and instructing his tribe in its religious laws.

In the introduction to the photographic section on the Bajun I describe their origin, their way of life and their customs, so I shall not go into these details here.

I wanted to take some photos of the men fishing. We set off one morning at dawn in

several *ingalaos*. When we were already far out at sea, a storm which had been brewing on the horizon burst. The rain fell with terrifying force. In a second we were enveloped in a thick curtain of water and could only see a few yards around us. The small fishing boats, caught in this grey cloud of rain looked like delicate Japanese paintings. The huge drops of rain made the water jump nervously. We were soon completely soaked and leapt into the sea. I put on my mask and flippers, tore off my long *kikoi*, which until now I had taken off only for sleeping, and followed my friends into the water which was much warmer than sitting in the boat. Shaibu glided to the bottom and soon shot several fish, his friends caught lobsters in their nets, and I followed them everywhere, intrigued and amazed at their agility. Suddenly I observed some strange shapes lying on the sea bed. I dived down to the bottom, and there underneath an enormous rock were about ten elephant tusks. I surfaced again and called Shaibu. Together we went down and tried to bring them up. They were completely encrusted with shells and green and yellow coral. At the end of one of the tusks a large piece of coral had grown in the shape of a flower. We raised some with great difficulty for they were very heavy, and placed them on top of the rock which stuck out of the water, and then dived again for more. We managed to get three out of the water. They were beautifully preserved, and the thick encrustation showed clearly that they must have been there for a long time. My exclamations of joy and excitement attracted the attention of the others. When they saw the tusks they said that I could not possibly keep them, that it was extremely dangerous to take them out of the water, because ivory belongs to the state, and that if the police found out we would all land in jail. They added, "It's all right for you. You are white, but we would have endless trouble." We argued for more than an hour. I felt I couldn't possibly part with this fabulous find. Finally they persuaded me to throw the tusks back into the water. So I took some photos of them, before they disappeared with a loud splash back to the sea bed, from which we had dragged them with so much effort. All the way back I kept thinking about the tusks. I wanted to find a means of keeping at least one of them. I decided to ask permission of the authorities to take one legally. The fishermen explained that they were probably part of a shipment of contraband cargo on its way to Somaliland. They knew that a ship had foundered not far away, about ten years ago, and that three men had been drowned. Probably these tusks were all that had survived the wreck.

That evening the chief of the village, who was also the government representative, came to see me. During our conversation I said a few words about the ivory tusks. I saw Shaibu's face fall. The chief looked at me with an air of great attention. He seemed to know nothing about the tusks and was very interested in what I had to tell him. I asked him how I could get hold of one without getting into trouble with the authorities. He assured me that this was quite out of the question, but that he would go and have a look at them himself. The following morning he took a boat and went to the rock accompanied by my friends. He came back at about two o'clock and walked straight to my tent. There he sat down on a chair and told me that the tusks were nowhere to be seen. "What are you saying?" I remarked in surprise, "they were there yesterday." "Well, they aren't there any more, they have disappeared," he assured me, adding that it was a very serious matter and that I should tell him exactly where we had left them. He seemed to be accusing me of

33

having taken them or at least of refusing to disclose their whereabouts. His attitude was no longer friendly. He told me he would have to send a report to the police at Faza, and that I would not be able to leave until the matter had been cleared up. I said that it was ridiculous that I should be supposed to have any knowledge of the present whereabouts of the tusks, that if they were no longer where I left them this was none of my business.

In the evening the police arrived by boat. About ten of them jumped out, with guns in their hands. Some went straight to my tent, others wandered round the village. Suddenly I had the feeling that the whole island was crawling with policemen. I told them my story, and assured them that I knew nothing about the disappearance of the elephant tusks. All my friends were taken by boat to the Police Station at Faza. I felt certain that nothing would happen to them, but I was annoyed at not being allowed to leave. I had already been ten days on the island and there were no more photos I wished to take.

I was discussing the problem with Shaibu when an old man came up to us and sat down on the ground at our feet. It was Hashim's father. In a small, trembling voice, he asked why I had denounced his son to the police, and said that I had brought much trouble on the family and on the whole island. He prophesied that they would all end in prison, and that I had no idea how brutal the police could be. I was upset, for he looked so worried and frightened. He also told me that the women of the village were in his house, all in tears accusing me of having taken the tusks and got their sons in trouble. I tried to calm him, and explained that I had not given a single name to the police. On the contrary, I had been very careful not to do so, when I saw how the whole matter was being blown up. The police could not find anybody guilty of anything without proof, I told him. He listened attentively, and a look of hope spread over his wrinkled face. In time he grew quieter, got up, walked towards his house and repeated my words to the women, hoping to calm them.

My four friends came back, as I had surmised, late at night. They had been freed after having made a statement at the police station. The following morning two policemen came to my tent and ordered Shaibu to go to Faza with them. I explained that Shaibu had nothing to do with the tusks and that if he had to go, I should go with him. "Fine, come along," they said. So we set out on foot to Faza, Shaibu and I, with an armed policeman on each side. We crossed the village looking like criminals; the people threw black looks after us. Our friends accompanied us to the outskirts of the village begging me to try and get them exonerated. I told them not to be afraid. It took us two hours to reach the police station. There I asked to speak to the chief of police whom I had already met. Briefly I explained the whole story. Luckily he was intelligent and understood at once that I knew nothing about the matter. He gave me a letter for the chief, telling him to set me free. Next morning we left the island, content to let the Bajun unravel the mystery. At Malindi I later heard a rumour that the chief had removed the tusks. If so, when I had breathed the word in his ear, he had acted with great speed and cunning to hide the booty, before the whole affair blew up. I wished that I had been as clever.

The stormy weather of the past few days now gave way to sunshine, and the sea became calm. I decided to return to Malindi by boat. We stopped for a few hours at Lamu, to buy food, and then set sail again in the direction of some rocks where the fishermen wanted

to catch lobsters before returning. We arrived at low tide. The band of coral which surrounded the rocks was covered with only a few inches of water. We got out my mattress, a few tins and paraffin lamps from the boat. At night the white sand shone in the pale light of the new moon and on the beach there was a little triangular roof, made of coconut fronds, built by some fishermen catching shark. We spent the night in the little hut. My faithful crew went off at dawn. As I did not want to go with them I stayed behind and went for a walk on the rocks and bathed in the crystal clear water while I waited for them to come back.

When at three the sailors returned with their catch we sat on the sand and ate grilled lobsters, on which we poured fresh olive oil and lemon juice. At five in the afternoon we set out for Malindi. We still had two day's sailing before us. The wind was behind us and followed us all the way. The boat tilting heavily to one side, raced ahead leaving a gilded wake that was swallowed up by dark water.

That evening at eight o'clock we stopped to fish by the light of the paraffin lamps near some other rocks. The lobsters come out at night to feed on the seaweed growing on the coral. Attracted, or blinded by the light, they become motionless, and this is the moment to catch them. Eventually all were transferred into a straw cage floating in the water, which kept them alive. We fished until two in the morning and returned to our little hut with about 250 lobsters. Next day the cages were hoisted aboard and covered with pieces of old sail which had been soaked in water to keep the lobsters alive. We sailed on all through the night. I enjoyed the silence of the night, the water lapping against the boat, the melancholy song of the sailor at the helm who sang to keep himself awake. The songs told of the greatness of God. God, the source of happiness and sorrow, of hunger and of death, God guides the destiny of men just as he guides the way of the sea, the winds, the seasons. Dawn broke. The journey seemed endless. After two days and one night on the boat the first sight of the coastline seemed miraculous. It appeared like a faint grey shadow which very gradually grew darker.

We arrived at Watamu in the evening. The sun was setting behind the coconut palms; a huge red ball of fire that bathed the whole world around us in its light. My sailors made my bed and a fire to cook my dinner, ever considerate of my welfare. We sold the lobsters to the little hotel at Watamu. The sailors got a good price and went off with a fist full of money, after a farewell drink at the hotel bar.

The following morning we transferred my luggage, which was in a terrible state, dirty, wet and rusty, from the boat to my car, and I set off for Nairobi which I had left exactly two months earlier. The return journey was catastrophic. The engine stopped twice, and smoked, and I had to tear all the wiring out to prevent the whole thing going up in flames. I had three burst tyres at intervals of less than 100 miles and I had to spend the night by the roadside, devoured by mosquitoes, waiting for new tyres. When I arrived in Nairobi the car stopped for good and I had to call a taxi to get home.

CHAPTER V LAKE RUDOLPH

Turkana The rains lasted two months. I waited on the farm for them to stop, then left for Lake Rudolph to visit the Turkana. My first stop was Kitale where I spent the night with Kimuyu and Shaibu at the local pub. It was a long trip – six hours – the car heavily laden. There would be no further possibility of getting fresh provisions or petrol after here. Good water was scarce, and I had to carry enough with me to keep us going for a month.

The Kitale Hotel was almost deserted, a few odd couples sitting around in the great hall. It is old and a bit shabby and very big. It is typical of the colonial type hotel; long corridors with big double rooms and bathrooms – deep comfortable English armchairs in the corners that form a bed-sitting-room. The bathrooms are clean and well kept, the water very hot! – the last chance of comfort before we set out for the wilds again. It was too late for dinner so we ordered eggs and bacon and a chicken, with boiled eggs and bananas for the next day's lunch on the road. Then we retired to our rooms to catch up on rest and sleep before starting out on the long drive to Fergusson's Gulf about 250 miles away – nine or ten hours of rough going lay ahead of us.

At 6 a.m. the night watchman woke me with tea. It was still dark outside. We had to start early, for I knew that by ten o'clock the heat would be on us. We had to get as many miles behind us as possible – not that it would make much difference since we would be travelling all day. This thought got me out of bed in a hurry.

By seven we were off – the petrol tank and all the jerry cans having been filled with petrol and water. An Indian shop was open, so I stopped and bought a bottle of Beaujolais for the trip. A crazy idea. A heavy mist hung over the country. The sun was rising, filtering through it; everything was still quiet and half asleep. We drove into the morning – the road was good. Spirits were high – we were all glad to get back to the bush. Shaibu and Kimuyu chattered gaily and cracked jokes; the car went well. At two o'clock we stopped for lunch in a dry river bed. We felt groggy and hot, our throats were dry and our eyes stung with the dust and the intense light. The shade of the tree and the cool sand were a relief; it's incredible how the earth remains cool when the sun is not on it. We lunched off the picnic prepared by the hotel. My bottle of Beaujolais was almost hot but tasted good – I knew it was a crazy idea to drink red wine in such heat.

An old man appeared along the road. He saw us and stopped to have a look. I greeted him and invited him to sit with us. I asked him if he would like some water; he looked thirsty and parched. He was almost naked except for a cloth wrapped round his waist. In one hand he carried a spear and a long stick, in the other a little wooden stool. On one of his wrists he wore the knife-bracelet, a typical Turkana weapon. It is a circle of very thin metal about one and a half inches wide, the outer edge razor sharp and covered for protection with a leather sheath. They wear it like a bracelet and use it to fight and to cut up meat or food. No Turkana ever travels without one.

The old man swallowed the tepid water I gave him, and handed the mug back for more. He drank seven glasses without saying a word; then he remarked "It is enough," squatted

down on his little stool, bent his knees in front of him, and sighed with fatigue and aching bones. He spat on the ground in front of him – dark brown spittle from the tobacco tucked away between his bottom lip and back teeth. The Turkana always chew tobacco; it stains their teeth a dark colour but it helps them fight thirst and fatigue. He spoke Swahili, so I asked him where he was going. "To a *manyatta* over there," he told me, pointing out into the bush, "to see my camels." "How far are they," I asked him. "Oh, far away still." "How long does it take you to get there," "I'll walk today and all tomorrow and perhaps I shall reach there before the night falls," he replied. "How long have you been walking?" "Since yesterday morning." "What do you do when the night falls?" "I sleep under a tree." "What do you eat?" "Nothing, I have some tobacco." "What about water?" "I drink if I find water, otherwise I chew my tobacco. Can you give me some cents to buy tobacco?" I gave him three shillings, which he tied in his knotted cloth. "This water is very good," he added as if he were speaking of some sort of wine. "It is rain water from Kitale," I told him. "Yes, I know, it is very white." He did not move and watched us in silence. I gave him some chicken and some bread. He munched at it. He didn't seem very hungry. We gathered our things up and packed ourselves back into the car. As there was no room for him, we left him sitting there under the tree and drove off, covering him in dust. Poor old man.

An hour later I started to feel the effects of my bottle of Beaujolais. It was 3.30 in the afternoon and very hot. Shaibu and Kimuyu were asleep. My head began to feel heavy; my eyes were closing. I made terrible efforts to drive – I didn't feel too good and the road had got bad – very bumpy and sandy – and the car was so heavy. I pushed on for another hour, then I couldn't go any further. I felt sick. I told Shaibu to drive. I felt worse and tried to relax but couldn't. When it became unbearable I told Shaibu to stop. It was now five o'clock. I got out and collapsed on the ground under a tree. The world was spinning round me – I was drunk, completely drunk. Kimuyu and Shaibu laughed like mad. I lay in the grass for a long time trying to get control of myself, but failed. Finally I told them to unpack the car; we'd spend the night here since I couldn't go on. They said I was crazy and refused. There were only another forty miles to Lodwar, our first stop for the night. Forty miles seemed like 400 and I insisted I couldn't go on. They still refused and told me to rest a while longer; I was too sick to argue. They sat waiting for me to recover. The sun began to sink and I felt a bit better; the heat had subsided slightly. Shaibu pulled me up from the grass and pushed me into the car, saying we must go on before night fell. He was right, so I obeyed. He took the wheel and we pushed on. Soon I recovered. A great herd of camels crossed the road with a beautiful naked youth behind them. I took my first picture of the safari, and the click of my camera brought me back to my senses.

We reached Lodwar at 8.30 and found our way to the D.C.'s house. I half fell out of the car and hesitantly entered the house. The D.C., to whom I had a letter of introduction, was having a party – seven or eight Africans were sitting around in wooden arm chairs, bottles of beer in their hands. As I stood at the door, they all looked at me in surprise; I felt and looked dirty, bedraggled and embarrassed. I asked for the D.C. He got up and I handed him the letter. After reading it he offered me a bottle of beer. I felt I shouldn't drink it – I was still trying to digest my Beaujolais – but I had to be polite and was very thirsty.

We spent that night at the D.C.'s house, a lovely long white-stone building. It was built in the old colonial days, a typical outpost of the Northern Frontier District. A long arched verandah ran along the whole front of the building; bougainvillaea hung everywhere. The D.C. showed me to a room with a bed and a wash-basin in it, but it was very hot and stuffy inside so all three of us put up our camp beds on the verandah.

Next day was a holiday to celebrate Madaraka Day – (Independence Day). More people arrived for the party, about thirty in all. They joined the earlier guests on the open terrace and drank beer. Among the guests were several visiting Members of Parliament, and local dignitaries – police chief, store owners, cattle traders. Beneath us I could see parts of the little town of Lodwar, capital of Turkana district, with its police post and prison barracks. This was where the President of Kenya was confined during the Mau Mau uprising and the Emergency.

The night was hot and heavy and the sky very clear, I collapsed on my bed and tried to recover – I had to get to Fergusson's Gulf next day. The D.C. was very kind; he was rather shy, but helpful and sympathetic. This was important because it is very difficult to get co-operation from officials to photograph the Turkana.

After another hot and dusty drive, we reached Fergusson's Gulf next day at noon. We were now in almost desert country, the vegetation was sparse and the land covered in sand and lava rock. Lake Rudolph is an extraordinary phenomenon in this landscape. The great stretch of water – miles wide and miles long – lies there like a mighty sea surrounded by sand. An oasis of doum palms grew in a small area around the gulf, strange tough palms that rise sturdily out of the sand with spiky leaves like giant fingers sprouting straight from the trunk. The Turkana village we had to work in was spread out beneath the palms, 200 or 300 little huts looking like bee hives and made from palm leaves, stuck into the sand and tied together with sticks. Each man has several wives, and each wife has her hut where she lives with her children.

When the villagers saw us arrive they crowded around – hundreds of fat naked children swarming about the car. My arrival was obviously an event. We drove round looking for a convenient place to pitch our camp. We needed some shade, and to keep our distance, not so much from the village as from all those children who would have invaded us day and night. The palm trees grew in clumps and gave little shade in spite of their wide spiky leaves. It was very hot. The heat and fatigue of the trip were starting to tell on us. We were on edge and pitching camp was tough going. The camp site wasn't very good but the best we could find, and the knowledge that we had reached our destination and could relax helped us recover our safari mood. Next day we'd start to work. As far as I could see, the prospects seemed good. I knew, however, that I would first have to make friends with the villagers – always the most difficult part. I hired Elemelem as my local assistant. He had come to the camp to chat. He spoke good Swahili and had a pleasant face. He lived in Kalokol and knew the people well and he wanted to work for us.

Next morning was devoted to scouting round and showing myself and my camera to the Turkana who would be the subjects of my photos. There was great activity, crowds of people were bringing fish ashore from the lake. Boats were being unloaded, the catch was being cleaned on the muddy soil. Women carried great bundles of dried fish on their

heads; children and girls with pink and shining fish perched on their heads were walking from the boats towards the village. I began to take pictures but they shouted at me and ran away. Some came up and swore like troopers; nobody wanted to be photographed. They looked fierce and forbidding.

Elemelem was at my side arguing and explaining who I was and what I was doing. Gradually, some walked away in proud contempt, muttering horrible guttural sounds at me, but soon most of the angry faces and loud voices changed into smiles and laughter. Soon I was joking with them, and little by little felt their hostility melting; they were getting used to me.

Next day I was able to work in peace and was surprised at the co-operation, or disregard they showed for my cameras. The photographic material was magnificent. I was very excited and forgot the initial anxiety that I always feel when I break into a new area.

My working day started soon after sunrise since I couldn't work later than ten to eleven o'clock, by which time the light was intense and the sun too high casting deep black shadows. The heat bore down like a heavy weight and life itself seemed to come to a halt to start up again around five o'clock in the evening as the sun began to set. Here activity is conditioned by the sun, and I soon fell in with this pattern. When I couldn't work I would go out on the lake in one of the fishing boats and watch the birds.

One day I found two lovely young girls who were hovering round my camp. I watched them for a while until I could not resist reaching for my camera. I took them by the hand and led them to the sand at the water's edge and they followed without hesitation or questioning. I told the girls to stand with their feet in the water and stepped back and watched them relax.

Quite spontaneously they took up the most exquisite poses, standing with their long legs apart, their arms nonchalantly poised on their heads. Their natural grace was surprisingly beautiful, and having captured it with my camera I let them go and they dived into the water.

I took the film from my camera and having left my bag in the tent I stuffed my exposed film into the bra of my bathing suit to protect it from the sand. I soon forgot about it and went to join the girls in the water. Suddenly I remembered the film and in horror and dismay rushed from the water. It was too late. The film was soaked. As I could not open the casettes to dry them I waited until dark and then opened them under my blankets. The film was sticky and damp and when I tried to dry it on my sheets I felt the emulsion peel off. In despair I rolled the film back and stuck it into the casette, writing the pictures off as a dead loss. But I did not throw them away and when I returned to Nairobi I developed them. The results are plates 4 and 5 of this book.

On a spit of sand stretching into the lake some new huts were being put up. Wondering what they were I crossed the bay on one of the long white shiny canoes provided by the Government to encourage the fishermen. The lake was very still and we skimmed over it like water beetles. It was noon but we left the heat behind on the shore. The little outboard engine propelled our boat easily. A delicious breeze cooled our bodies. I left Kimuyu behind to look after the camp, and Shaibu came with me. When we reached the spit, we scrambled up a sandy embankment. Several little square bungalows made of pale olive-

green wood slats, with thatched roofs. The place seemed deserted. Then I heard some hammering and stopped at a door to look in. A stocky tough looking European, burned brown by the sun, was standing on a stool hitting a nail into the window frame. He was wearing an old baggy pair of khaki shorts and no shirt. I greeted him from the door and he stopped his hammering and looked round. His face, chest and back were covered with sweat. His hair was stuck to his forehead. He was obviously working under some strain – I wasn't surprised, in this heat. He had wild pale eyes, hard and piercing. As he saw me standing there, his expression changed into a surprised smile, he jumped off his stool, and still carrying the hammer in one hand, came over to me. We introduced ourselves.

Shaibu was standing outside behind me and greeted him in Swahili. The man didn't answer and seemed not to have noticed him. Shaibu repeated his greeting louder. The man threw him a mumbled offhand greeting. He told me that he was building the house himself, invited me to have a drink with him and led me off to another little round shack a few yards away. Shaibu followed behind, my camera bag slung on his shoulder. Inside the hut an enormous fridge stood in the middle of a cement floor. It was wonderfully dark and cool. All round the hut, cases of beer and sodas and Coca Cola were stacked, and on a board laid on two boxes, stood an odd collection of unmatched glasses. The man poured me out an ice-cold gin and tonic with a slice of lemon, and dropped two large cubes of ice into the glass, making it overflow onto my feet. Shaibu remained outside – he is very shy with Europeans he doesn't know.

I took a long drink and felt the freezing liquid trickle deliciously all the way down to my stomach. I turned to see where Shaibu was, he was watching the shimmering lake a few yards outside, the sun beating down on him. I asked my new acquaintance if I might give him something to drink too. The man looked at me startled and then hesitantly said yes. I told Shaibu to come in and have a drink. He came to the door. The European had a bottle of water in his hand and was about to pour it into the glass. He looked at Shaibu put the glass down, picked up a tin mug, poured the water into it and handed it to him. I watched him in stunned surprise, I felt my stomach contract. Shaibu took the mug in silence, and, without entering, swallowed the water and put the mug down. His expression was one of shocked pain. He went out again into the sun. I was speechless. When the European asked me to stay for lunch, I mumbled an excuse and said I wanted to go swimming. He didn't insist, but asked me to come again. We said goodbye and he returned to his work.

Shaibu and I slid down the sandy embankment and made our way along the lapping water's edge. The place was immense and extraordinarily beautiful, and sand, steel grey and the water shining and shimmering like glass, forced us to half close our eyes. A great expanse of long golden grass several feet high spread away from the shore. Everything was flat and seemingly unending, very far away some misty blue grey hills curved almost invisibly on the horizon. I found myself trying to remember that this was a lake not the sea. Two black figures fishing on a slim promontory of sand were silhouetted like Chinese shadows against the glare of the water.

Shaibu and I walked in silence. I didn't know how to explain what had happened in the hut. I tried, but my words sounded hypocritical and senseless. Shaibu said nothing, he

just walked along in hurt silence, so we dived into the brown water and had a swim, and our happy carefree mood returned. Shaibu began to laugh again; it was too magnificent a place to be sullen and hurt in. We walked for miles and miles, and there were endless miles ahead of us. Great flocks of pelicans three or four hundred strong were standing almost motionless looking at the water. As we approached them they waddled on, always keeping thirty or forty yards ahead of us. When we got too near they drifted effortlessly into the water and swam away, bobbing up and down like toys in a pond. Thousands of gulls and water birds filled the sky above us, swooping dizzily and screeching their indignation at the two intruders on their territory. I imagined the beginning of the world to have been like this; here, I felt, the power and existence of God was omnipresent. Never before had it been so apparent to me how small and insignificant man is, how petty and unimportant his relations – and what had happened in the hut.

A few days later I went back to the spit. I was curious to find out more about this man. At first Shaibu refused to come with me but I insisted although I knew it was unwise, since I needed him to help with my cameras. When we got there I sent Shaibu to wait for me in an empty rondavel to avoid the two men meeting again; there was a gap of two or three feet between the wall and the roof and it was cool inside. I went over to the European who was arguing with some of his workers. Seeing me he stopped shouting, and insisted I should stay to lunch. I couldn't refuse. As we walked over to the little hut with the fridge in it he saw Shaibu standing in the rondavel where I had left him. He turned to me and said in a hard voice, "Please tell that man to get out of there". He didn't like Africans in his houses. Shaibu heard him, and his steely eyes fixed the white man with hatred, but he stood his ground, and watched us approach. I didn't know what to do. I told Shaibu he had better go back to camp, whereupon he exploded. The European ducked into the hut ahead of us. I begged Shaibu to keep quiet and tried to calm him. He said he hadn't wanted to come back; if he stayed he would probably kill the white man. I could imagine the scene. Shaibu left, leaving my cameras for me to carry.

Lunch was very uncomfortable. My host, in spite of his efforts to be nice, realised I did not find him sympathetic, and the food was poor – fried lake fish and tasteless tinned vegetables. All laid out on a clean white table cloth with silver and pretty place mats and glasses. At our feet hardly a few yards away at the bottom of the embankment the magic lake sparkled like champagne. So much beauty – so much hatred.

I had finished with Fergusson's Gulf, hoping that I'd captured some of its magic. In my bag, the life and essence of the lake; – the light, the misty colour, the long sturdy fishermen on rafts, in boats with nets and baskets, the women with their arrogant faces and their urgent stride, leather skirts flapping behind them in the wind; fat shining children with silver fish on their heads, lovely skinny girls with pounds of beads round their necks, old men with hands like claws – a beautiful primitive people – and their lake.

Chapter VI NOMADS

Boran and Rendille Probably less is known about the Boran and the Rendille than any other tribe in Kenya. No-one ever goes there. They live far away and are almost inaccessible. I had a great deal of difficulty in getting their pictures.

Both tribes live in The Northern Frontier District (N.F.D.) which borders on Somalia, and there are many Somalis living in the area. When Kenya became independent many of the Somalis objected to the frontier line. They grouped themselves into bands called *shifta*, a word originally meaning 'bandit' but later extended to mean 'guerilla fighter'. They shot people and buried plastic mines in the sandy roads which stretch northwards for hundreds of miles. Vehicles exploded, drivers and passengers were killed. Troops were sent up and soon Kenya was engaged in an undeclared war with Somalia. It was not a big noisy war but a silent one, the world hardly knew, or cared much about it, but for Kenya it was a festering wound.

Motor convoys snaked cautiously into the danger area. Lots were drawn to decide which lorry should lead the convoy but this didn't ensure safety for the others. Fate would point its finger at the vehicle of its choice. On nearly every expedition one or more lorries drove over a hidden mine and exploded. There were rarely any survivors. The whole of the N.F.D. was closed except to troops and administrative officers.

The first time I asked permission to go there it was refused. But later the situation improved; it had been several months since a mine had exploded – perhaps the *shifta* were pulling out. Certainly some bandits were still operating but not any more for political ends, they were simply stealing women and cattle.

I met an Italian who flew a small four-seater plane weekly into the area – it carried provisions and mail up to the Consolata Catholic Missions scattered in the region – I asked him to take me as a passenger to enable me to make a recce and at least discover the location of the Boran and Rendille I wanted to photograph. Three hours after take off we landed at Loiangalani, on the shores of Lake Rudolph, the beginning of the great desert land which spills its lava and rock far into Sudan and Ethiopia. Only a few clumps of doum palms live thirstily around a trickle of water which spouts hot and steaming out of the sand.

At once our plane was surrounded by a group of about fifteen little boys and girls from the mission dressed in faded pink dresses and *shukas*, a cotton cloth, tied round their waists. They picked up our bags and together we walked to the small group of buildings sheltering under the palm trees. Here Father Polet, the priest in charge of the mission, greeted us. His pale blue eyes had the piercing look which often comes to people who live in strong light and intense heat. He spoke in English but was delighted when I answered in Italian. He had not been to Nairobi for a year and his only contact with Europeans had been through the news brought him by the pilot and old Italian magazines stuffed among the provisions by a kindly Indian grocer.

Here at Loiangalani there had once been a tourist lodge but it had been closed down

after a terrible *shifta* raid in which Father Stallone, the head of the mission, and a companion had been savagely murdered.

In the evening Father Polet told me the gruesome story. When news of the murders reached the H.Q. of the Mission, he was ordered to go up to Loiangalani with another priest. They found the place ransacked, empty bottles strewn around, mattresses torn, cupboards over-turned and the horribly mutilated bodies of the two Europeans lying in a pool of dried blood. The bandits had come for money and food but, finding little of either, had looted the place and killed the two inhabitants.

Father Polet stayed on to build a new mission. As soon as the school and hospital were completed two more fathers and three sisters would join him. He said that the tribesmen flocked to the mission because they knew that they would find food and medicine there. Their children knew they would be fed and so they listened to the gospels; Father Polet had no illusions about it. But their education was meagre since after a while these nomads would move on to fresh water holes and grazing grounds, taking their children with them.

Father Polet told me that about two thousand Rendille with three thousand camels were living not far off. Every two weeks or so they travelled the forty-five miles to Lake Rudolph to drink. He described the astonishing sight of the camels streaming down in an unending, twisting line over the lava, which falls steeply from the plateau to the Lake. When they got the scent of the water the camels would break into a gallop, then throw themselves into the lake and drink themselves to saturation. Their bodies, shrunken and desiccated when they arrived, filled out, their humps and their stomachs became bloated and taut. Then they turned and ambled slowly back, swaying as though drunk, making their way to their poor grazing grounds carrying twenty to thirty gallons of water inside them which would last them for the next fortnight. I longed to stay and see this sight but my Italian pilot had to move on to the next stage of his flight.

At breakfast, before we left, Father Polet told me that I had spent the night in the hut where the savage murder had taken place. I appreciated his timing. The hot silence in the hut had made it difficult for me to sleep; it was very dark. I had had no lamp, not even a candle. The dry doum plam leaves of the roof crackled and rustled in the steamy air; but I was calm and relaxed as I lay and listened. How different it would have been if he had mentioned this small detail to me the night before.

We left at dawn. Our objective was Sololo, on the Ethiopian border, three hundred miles away. Below us stretched a stark barren land like the surface of the moon. Except in very rare places, where there must have been a trace of water which had induced some thorn trees to stretch their parched heads towards the blistering sun, there was no sign of life. It was a frightening and fascinating sight. Suddenly I spotted a trail of camels slowly weaving their way to nowhere, and then I saw a tiny *manyatta* of some ten huts, enclosed by dry thorn bushes. So men and women lived here in spite of conditions which seemed to make survival impossible. These were the Rendille nomads.

When we landed at Sololo we were no longer among the Rendille but in Boran country. We were immediately surrounded by hundreds of people who had poured out of the *manyatta*. The Boran men, very tall and thin, were dressed in flowing material which billowed round them in clouds of colour. Their sharply chiselled features, their high cheek

bones, their fine aquiline noses and long narrow black eyes so typical of most of the nomadic people I had seen, gave them an air of arrogance as they stared inquisitively at us. The women's hair was parted on the top, and fell in hundreds of delicately plaited braids to their shoulders. They were the only African women I saw who let their hair grow long. A heavy necklace made of many strands of square aluminium beads starting half way up their necks hung down to form a silver bib on their chests which added to their air of haughtiness. The chief and the elders of the village came up to shake our hands and welcome us. A man and woman pushed their way through the small crowd to ask the pilot news of their ten year old son who had been flown, apparently dying of peritonitis, to hospital in Nairobi. Their hard faces betrayed a sense of anxiety which surprised me in these people who as a rule regard life and death as almost without importance. When they were told that their son was better, would live and soon be back among them, their expressions softened and they smiled touchingly.

At this moment a lorry came belting down the road; it pulled up and a stocky European, dressed in old khaki shorts and a shirt, shouted his welcome in Italian. This was Father Vittore of the Sololo mission. Five minutes later a Land Rover drew up bringing his colleague, Father Davoli. They took us to the mission building and gave us supper. It was very gay. Then they also told us incredible tales of sickness, death, floods, droughts and of encounters with elephant and buffalo. In spite of the hardship of their lives, their faces showed no traces of bitterness; filled with courage and faith and with a desperate perseverance, they seemed to have achieved an inner peace.

They had been at Sololo for three years, their material achievements consisted of a pipe line which carried water down from the mountains, a small hospital and a large room which was used as a school and a chapel. When a house had been added to these, three sisters would come to join them. This had already been started and I slept that night in one of its windowless and doorless rooms.

Next morning I attended mass, said by Father Davoli assisted by a young African who preached in the Boran language. The men, their faces cupped in their hands, squatted on the cement floor like bundles of rags, listening eagerly, the women, many of whom had babies at the breast, were not listening much, distracted by their babies.

I spent the rest of the morning making friends with the Boran. It was getting very hot and I sat on a stone under a tree watching life drift past. The women came in from the dusty bush carrying large gourds of water strapped to their back in roughly made baskets. The men hung about in small groups wandering from the shade of one tree to another, the children just stood and stared, enveloped in a vast cloud of flies.

Suddenly a convoy of twelve army lorries appeared in a cloud of dust, and soldiers, in green army uniforms and heavy black boots, jumped out, lean, tough men with remarkable faces. They poured into the little *duka* and ordered drinks. At once the sleepy village came to life, everyone talked and laughed and bustled and started loading up the lorries with chickens, goats, hides, gourds, beds. After lunch I climbed back into the aircraft, my recce accomplished.

When I told Shaibu and Kimuyu of my trip across this arid country they looked at each other hesitatingly and laughed. They asked if I was not afraid to go into such an area.

"Afraid, why afraid – what of? You do not want to come and you are scared. Are you men or women? Alright, stay, I'll go alone."

Their masculine egos piqued, they said, "Oh, we're not afraid, we'll go" and Shaibu added, "I'll follow you now, anywhere, even into your grave." (this is a literal translation of his words).

Preparations started, but I had almost lost count of the time.

We did not return to Loiangalani or Sololo but headed for Marsabit – exactly why I do not know. Maybe at that time the trip seemed slightly less difficult and hazardous. Possibly this decision was a mistake for I had great difficulty in photographing the Boran. They proved wild, shy and suspicious – it was like stalking wild game in the bush. Hardly any of them spoke Swahili. They are beautiful people; but for their colour and their crinkly hair, the girls resemble Egyptians, or Ethiopians. Their necklaces of aluminium beads, beaten into shape by the village blacksmith, make them all look like Queens of Sheba. Their shoulder-length hair is braided into dozens of small plaits which frame their faces. They are very clean and once a month their hair is washed by the village hairdresser who works ruthlessly upon it with an enormous wooden comb. While this is going on the girl lies on the ground with her head on the hairdresser's knee. The hair is pulled upwards till it is almost straight, an agonising process, the victim bites her lip and grimaces but she never utters a word, though it takes at least two hours to complete the hair-do.

I had better luck among the Rendille. This tribe originated in Somalia from where the young warriors wandered into Kenya with their camels. They got as far as the Meru Reserve, where they took wives, and the progeny of these unions are today's Rendille. They settled on the borders of the Samburu reserve and now resemble this tribe in every way, except for their language which remains almost identical to Somali. They too are nomads and follow their camels from pasture to pasture. They condition themselves to their often desperate circumstances, which involve having to walk twenty or thirty miles a day for water. During the dry season, which can last up to nine months, water holes are few and far apart. The water for the *manyatta* is carried in large skin gourds which are strapped to the camels' backs. Because of its scarcity water is only used for drinking, never for washing except when a woman gives birth. The Rendille keep themselves "relatively clean" by rubbing camel fat on their skins. Their diet also is entirely made up of milk and meat from their herds, and these are vast, often reaching two thousand or three thousand head per village.

Elections for new chiefs were being held in their territory at Laisamis. These were supervised by the District Officer. I watched the D.O. sitting under the shade of an umbrella tree, all the elders squatting motionless on their heels around him.

The D.O., who was of the Kikuyu tribe near Nairobi, did not know the language of the Rendille, so when he spoke it was in short sentences and his words were translated by an interpreter. Beside him sat the present big Chief.

Soon the D.O. rose and told the gathering that they were here to elect a Chief. His speech lasted fifteen minutes, then he sat down and one by one the *wazee* got up from their squatting positions with some difficulty. They too spoke in short sentences to give the interpreter time to translate. Ten spoke for the man they favoured; the rest were silent.

Two main contenders emerged, the obvious favourite was called Ndaragua. An ex-*duba* (Frontier Policeman) in his thirties, his speech was short, precise and convincing. He had been in the Police Force for twelve years, now he wanted to leave his post to become the chief of his people. He told them he wanted to help them make progress as other tribes had done. They were backward and ignorant, he said, but he had been around and seen many things and knew a lot about the outside world and he was prepared to give up his post, his good monthly pay, his comparatively easy life to take a lower salary and lead a harder life with few compensations, in order to help them. He knew he would now have to travel on foot where before he rode in a police vehicle, but he was ready to accept these conditions. "If you agree with what I say, I am standing here for you to choose me", he ended.

When the last man had spoken the D.O. asked the nominees to go off while the voting took place. They moved away. The old men were unanimous: "It is to be Ndarangua."

Two hours later the meeting was over. The D.O. and his staff drove off in a cloud of dust to the next tree 100 miles away where another election would take place.

Shaibu and I did not go with them for I had seen enough to know what the area offered. We sat for a while under the tree with Ndaragua and some of the elders. One of them told me that the *elmuget* ceremony was about to start. The *elmuget* was the Rendille *eunoto* or initiation ceremony. I could hardly believe my luck at being here just at the right time. I had not known of the ceremony when I set out.

Shaibu and I rushed back to the camp at Marsabit. (We rushed at snail's pace for, thanks to the sharp rocks and the deep ruts in the road, it took us a whole day to travel the forty-five miles). After we had collected some bedding and enough food for the next few days we happened to meet Ndaragua, who was also back in Marsabit. He told us that the ceremony would not take place for another two days but after we had returned over the ghastly road we found that he had misled us. We had missed the ceremony. One could still feel it hanging in the air around us.

We sat around the *manyatta* for three days hoping vainly that something was still going to happen. We slept on the luggage rack of the car, where we placed our mattresses, and listened in despair to Chief Egeres' account of the event.

This ceremony was originally a Samburu rite which the Rendille took over, adapting it to suit their own customs and dress. It takes place every ten years. For miles around they gather, breaking up their *manyattas*, strapping each dismantled hut to the backs of their camels and donkeys, moving across the barren land in slow rhythmic motion; the convoy resembled a fleet of great black sails crossing an ocean. The long black sticks used to form the skeleton of the hut stick up above the camel's back and meet at the top forming a sort of large triangle. All the Rendille's possessions are carefully tied together and the children and those too old to walk, ride on the camels, tucked in among the belongings. Then huts are built round the area where the ceremony will take place, and a whole new *manyatta* rises in the space of a day.

The *elmuget* ceremony marks the end of warriorhood, which started with circumcision. Among the Rendille, the warriors live with their families. Like many other tribes they are permitted to have sexual relations with girls but it is only after the *elmuget* rite that they

46

may marry. Until then they have little occupation except to act as police, chasing off raiders or predators with their spears.

Rather like the *eunoto* of the Maasai the ceremony begins with the slaughtering of the camels. Each of the one hundred huts in the *manyatta* belongs to a family or to some members of it. The eldest *moran* of the hut has to slaughter a camel, a cow and a goat. On the first day, ninety-five camels are brought to a clearing in the bush and their legs are tied. About three hundred *moran* are present with all the elders of the *manyatta*, the camels are thrown to the ground and one warrior holds on to the muzzle while another sticks a long sharp knife into the brain in a soft spot of the skull between the ears. The smell of blood sends the other camels wild and they try to escape, throwing the *moran* about as they cling to their humps and necks. On the last occasion several warriors had arms and legs broken. Every camel is eventually killed and carefully skinned. The ninety-five carcasses are finally cut up and divided among the warrior members of each hut. The hump, which is entirely made up of white fat, is presented to the warrior's girlfriend by his mother. The meat that is not consumed is cut up in strips and hung in the shade of a little shelter made of bushes and built specially in front of each hut. Women are not permitted to see the slaughtering. The fresh meat is carried off to a special tree under which all the warriors gather to gorge themselves day and night during the five days of the ceremony. When they have left the scene of the slaughtering, the women come in and pick up the livers and hearts and bones and skins which they carry off to their huts. Finally the vultures move in in thousands and pick the carcasses clean, and at night hyenas and dogs carry the bones away. By morning nothing but ninety-five piles of dung lie where the camels once stood. It dries in the sun and is scattered by the wind. Two days later no sign of the slaughter is visible. The skins are pegged out and dried, to be used as bedding or roofs for the huts. Then another fifty camels are slaughtered, and the cattle and goats come to the same end during the following days. The tree under which the meat is eaten by the warriors is never left unattended. Little fires are built around it and the meat is roasted or cooked in clay pots. The *moran* fill their stomachs to bursting, then they go and lie in the shade of another tree and sleep for several hours. When they awake they go back to the tree and eat some more. This rhythm is kept up for five whole days and nights.

When the moon rises the girls come out to join the *moran* and they dance and chant together long into the night.

The *moran* are not permitted to go back to their houses during these five days. On the fifth day they begin dancing at sunrise, and dance with the girls into the *manyatta* where they all sit in a group in the centre while the chief and his elders talk to them telling them the rules by which they are to live from now on, and giving them permission to take a wife.

It took me days to recover from my bitter disappointment at having missed so extraordinary a scene. I tried to be philosophical about it. Perhaps I was pressing my luck too far. I felt I had to get out. September was over . . .

Chapter VII HOME

September is over. The rains are to begin in the middle of October. I must get out before they do, but decide to stay on as long as possible, for a few last pictures. Every day the signs of the oncoming rains are more evident – mornings are shrouded in heavy mist – so thick I can often not see further than a few yards ahead of me until ten o'clock in the morning. The wind howls for hours at a time and pulls at my tent which is in constant motion, flapping and groaning – it is very cold. Very far away great claps of thunder and lightning break, but it's all still far away. I hold out stubbornly always hoping that next day will be more successful. Finally it begins to rain. It's not very heavy yet – I still have a few days – then the rain comes. It pours for hours at a time – the red soil turns into sticky clay – the firewood is soaking – we have difficulty in cooking. Everything is cold and damp. I decide to fold my camp and leave. We pack in the rain, the tent is soaking, we are drenched to the skin, but we must go or we'll never get out.

We leave Marsabit at 6 p.m., just as it is getting dark. After three miles we are skidding all over the road. The mud is almost two feet deep, thick black soil that clings like glue to the wheels. The car is under heavy strain. Driving at night makes things more difficult. The next thirty miles took us six hours to cover in dry weather when we came up. Great rocks and boulders are strewn all over it, now, they are covered in mud. We cover ten miles without stopping. Then we get stuck. It is seven o'clock. S. and K. get out and start to push as I put the car in low gear and edge the car out. Two miles later we meet the first lorry, stuck and almost completely barring the road. It is a five-ton truck heavily loaded with goods. All the passengers are digging at the mud and cutting branches to put under the wheels. We stop and exchange a few words; the road ahead, they tell me, is very bad. I have one hundred miles to do, my heart sinks. We manage to squeeze by and edge our way past them – there is a fork in the track; left or right? They look equally bad. Shaibu tells me to take the right. I take left. Why? – God knows. He probably told me too late, one hundred yards and I hit a rock and slither off the road into a hole several feet deep, the wheels spin, the car doesn't move an inch, the oil sump is sitting firmly on the rock, the back wheel is completely in the hole, the front wheels hardly touch the ground. We've had it.

We get out of the car and contemplate the scene in dismay. In spite of my considerable experience on rough roads I've never really driven in such conditions before – I send Shaibu and Kimuyu back to the lorry to ask for help.

We try jacking the car up while we wait for them. We try to wedge some rocks beneath the wheel and fill the hole. It's a hopeless task, the weight of the car pushes the jack deep into the soft mud. After an hour four men who were on the lorry come with a great big jack. It is now 8.30. At two o'clock in the morning the car is finally freed from the hole which has slowly filled as the car is lifted inch by inch.

Our friends who have given their all, bid us good luck as they return to their lorry to start all over again trying to free themselves. I want to give them some money to show my

appreciation. They refuse, they say it is only natural that they should have helped us. One day maybe we will meet again and they will need our help. That's solidarity. They disappear into the night.

We drive on, though it's madness to go on, the road is like this all the way. Three miles later we're stuck again. We get ourselves out. After a mile we come to another stop. The tracks of the lorries have cut deep ruts in the road this time, and the whole axle clogs down, the four wheels have no grip and spin uselessly. I'm exhausted – I give up. A fine rain is falling and I can't face another ordeal like the last one.

Shaibu and Kimuyu get out and start work. I let them go. I'm too weary to care. I let myself slide in the seat and somehow sleep overcomes me. I am woken by Shaibu who says "come on let's go" – We're out – I look at my watch – it's 5.30 a.m. For two hours they have toiled with grim determination, digging at the mud with spades and sticks and finally with their bare hands, when their tools got too clogged with mud to be of any use. I suggest we stop a while and rest – we can't go on like this. We prop ourselves against each other and manage to get some sleep.

At 7.30 we start again. At nine o'clock a tyre bursts – it's now become almost a joke. We must change the tyre; the rain is falling heavily. It takes us ninety minutes to change it. The jack sinks into the mud – in front of us the road is completely washed away, ruts several feet deep dug by the water stretch for a good two miles ahead of us. We cannot go on. Another ten-ton lorry going in the opposite direction is hopelessly stuck two hundred yards ahead. They have been there for forty-eight hours, without a hope of getting free. The vehicle is heavily loaded with bags of maize meal and tins of paraffin – there are fifteen people on board, four women and three children. I go with Shaibu to speak to them, we all agree that we can't move on. What to do? – We unload my car to lighten her, everything is piled in a heap on the side of the road beneath a bush and covered with a tarpaulin. Logologo, a police outpost with a radio transmitter is five miles away. I decide to go there on foot and radio for a plane to come to our rescue. I'll have to abandon the car. The insurance will pay.

I start walking when I hear the noise of an engine approaching. I go back, why, I don't know; just in case, you never know, maybe they can help. It is the military lorry that was to leave Marsabit soon after us, they have been through the same ordeal as we have. When they hear that I am going to abandon the car they say I am crazy and won't allow me to do so. – "O.K., you get the car through here," I tell them, – "I certainly can't. Even if we do get through, what do we do when we come to the lorry across the road?" – "Don't worry," the driver tells me, "I'll make a new road." – My camp material is loaded onto his trucks. He revs his engine and gets her into low gear, ploughs through the road and crashed through the thick bush to one side. He has a great iron grid which covers the whole front of his vehicle and it acts like a bulldozer that lays flat everything in its way. He disappears almost completely and we watch in stunned silence.

He drives past the stuck lorry and comes to a halt on the road the other side. He is soon trudging back to us. "Now let's try your car". – "You do it," I tell him. Incredible, – unbelievable, – he has got through. We run after him as best we can. He is standing by the car, a victorious look on his face. The engine is smoking and the bonnet is lifted to cool it.

49

It is now five o'clock in the evening. We have eaten only a few biscuits and some nuts, we've forgotten about food; there isn't anything anyway. We don't even feel tired any more or notice the mud, now dried solid, on clothes and hands. I feel as though I'm in the war, I think of the soldiers in Vietnam. "Come on, let's go," the truck driver says – his name is Benjamin. – I beg him not to leave us. We drive on in convoy; the road is slightly better – we get to Larsamis at three in the morning without lights, as something has gone wrong. Benjamin drives behind and lights the road with his headlights for us.

We spend the night in the military camp, stuffed into a tiny tent. I buy everyone bottles of beer from the canteen, and we dine on boiled dried beans. Somehow we sleep, probably from sheer exhaustion. We leave next morning for Nanyuki, another fifteen miles away. I give K. 100s. to Benjamin. How can I thank him for what he did? The road is almost dry; the rains have not yet got here, soon we leave a cloud of dust behind us. We pick up another lorry at the military camp and travel in convoy with them. At Nanyuki they leave us. Three days have gone by since we left Marsabit, one hundred miles away.

At Nanyuki we hit the tarmac road that leads to Nairobi. – We dine at the hotel owned by a friend of mine who agrees to serve us in the dining room in spite of our dishevelled appearance.

At 9 p.m. we make for Nairobi. Forty miles from Nairobi, travelling at 70 m.p.h. the left front wheel bursts, the car sways and skids off the road. Shaibu changes the tyre, the last spare wheel and a bad one. A few miles later this one bursts. Now we have none left – it is midnight. I stop a car on the road and get a lift to a nearby town. I find a service station, wake the owner and ask him for a tube. He's got one the right size, thank God. I go back to the car and change the tube. The radiator is leaking, no more water, and we are still forty miles away from Nairobi and home.

I ask the man I stopped to take me to Nairobi – I leave the car on the road with Kimuyu. Shaibu and I push on. Dawn of the fourth day is breaking as I turn the key to my brother's flat in town – I'm almost home. He is not there, no food in the fridge, the hot water is turned off – I can't wash but I get three hours sleep on the sofa, too dirty to get into bed. Next day I go to pick up the car with a breakdown van.

That's it. I don't ever want to go on safari again, at least not for the moment. I dream of staying at home and looking after my children and growing flowers in my garden – I have to end my book some day – the time has come – I'm knocked out, shot, there's plenty of material for my book. I have nothing more to say. The car is up for sale. Kimuyu and Shaibu, go home and rest, thanks for standing by me as you did.

THE PHOTOGRAPHS

THE FACE OF AFRICA

THE FACE OF AFRICA

There are still today men and women in Africa who are as much part of the land as the fauna and flora, and in many ways they have a strange likeness and communion with them; they belong to their surroundings as do the giraffe or the camel, the antelope, the acacia tree or Kilimanjaro; they belong to Africa.

1. *Orma woman covering her face with her black veil in order to avoid it being photographed.*

2. *Orma cattle herder.*

3. *Rendille woman – the fine sharp features show their Nilotic descent.*

4. *Young unmarried Turkana girls wearing beaded skirts.*

5. *Young Turkana girl about 10–12 years of age – wearing beaded leather skirts – beads are bought in the local "duka". Some are cut from ostrich eggs and carefully sewn on to the leather with very thin leather used as thread.*

6. *Orma cattle herder with initiation scars burned on forehead.*

7. *Young Orma man – strong regular white teeth are a result of their milk diet.*

8. *Old Samburu man.*

9. *Young Turkana dancer.*

10 & 11. *Turkana chiefs; Akmet and his brother.*

12. *Boran child.*

13. *Rendille girl.*

14 & 15. *Turkana girl asking for beads. Young girls laugh easily at anything.*

16. *Samburu woman.*

17. *Samburu women.*

18. *Young Somali camel herder.*

19. *Turkana fisherman.*

20 & 21. *Somali women from the northern part of Kenya. These women are swathed in yards of material which cover them from head to foot and billow like great sails in the wind.*

22 & 23. *Samburu warrior. The fringe of the hair is also used to shade their eyes from the blinding sun.*

24 & 25. *Samburu warriors. The plaited head-dress covered in red ochre grease is worn only during the period of their warriorhood. They are extremely vain and proud of their appearance during this period and great pains and many hours are taken in the decoration of their bodies with the red ochre paint.*

26 & 27. *Garbiti, a young Orma girl aged ten carrying a "Kibuyu" (water container) made from dried giant pumpkins.*

28 & 29. *Turkana elders.*
Choperre (left), Paramount Turkana chief, 95 years old, 33 wives, 60 children. He was chosen chief by the white rulers of Kenya when the country was first colonised. He is greatly revered by his people. The leaf-like ornament (centre) is made from finely beaten tin and hangs from a hole in the nose. On the right, chin ornament made from solid ivory is held in place by piercing the lower lip.

30 & 31. *Orma woman.*

32 & 33. *Ouarede – Orma youth.*
His village is situated on the edge of a large swamp which is crossed by small dug out boats punted by long poles. Crocodiles live in these swamps and the boats capsize easily if the body is not kept in the centre.

34. *Young Maasai couple.*

54

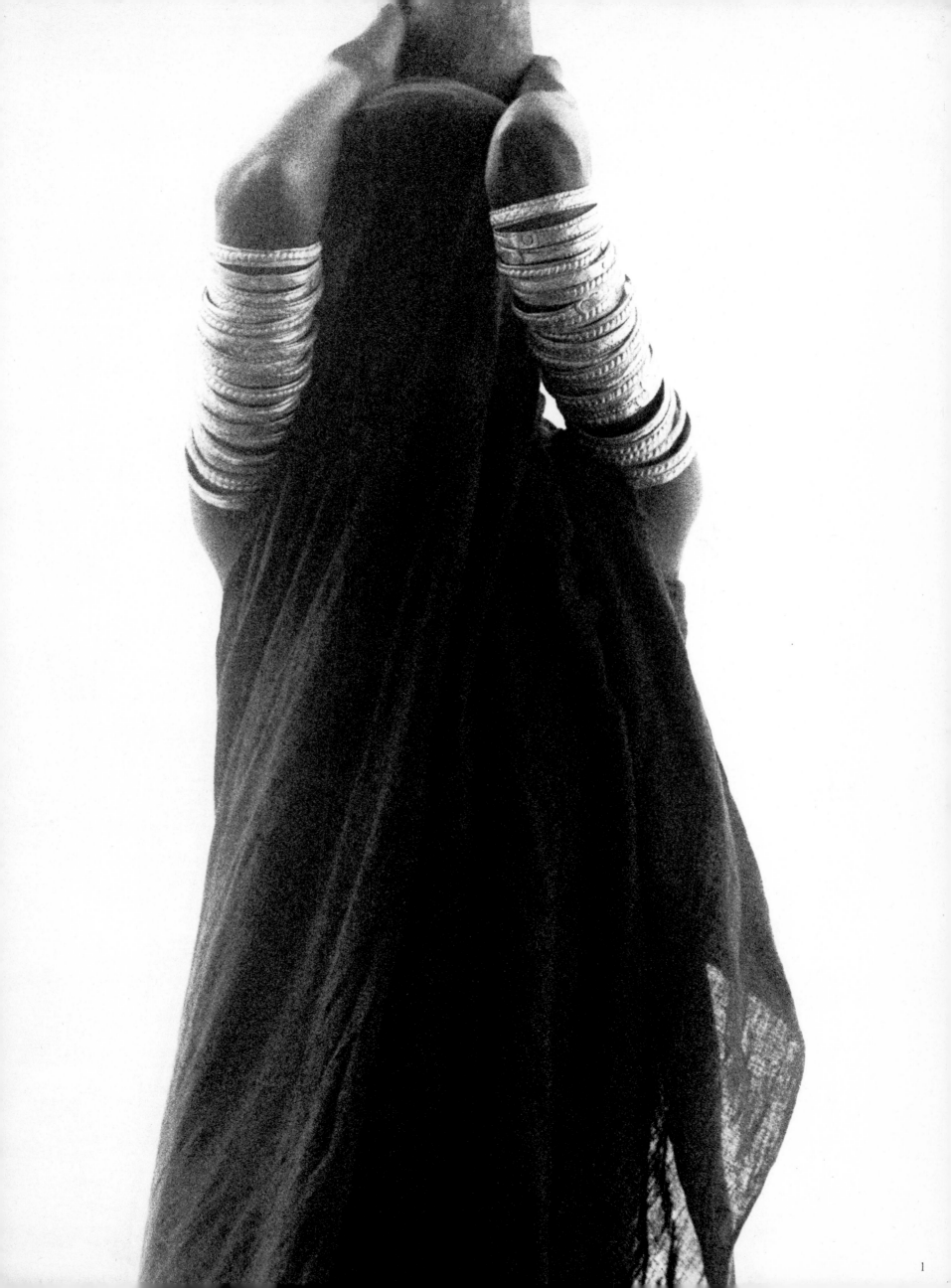

1

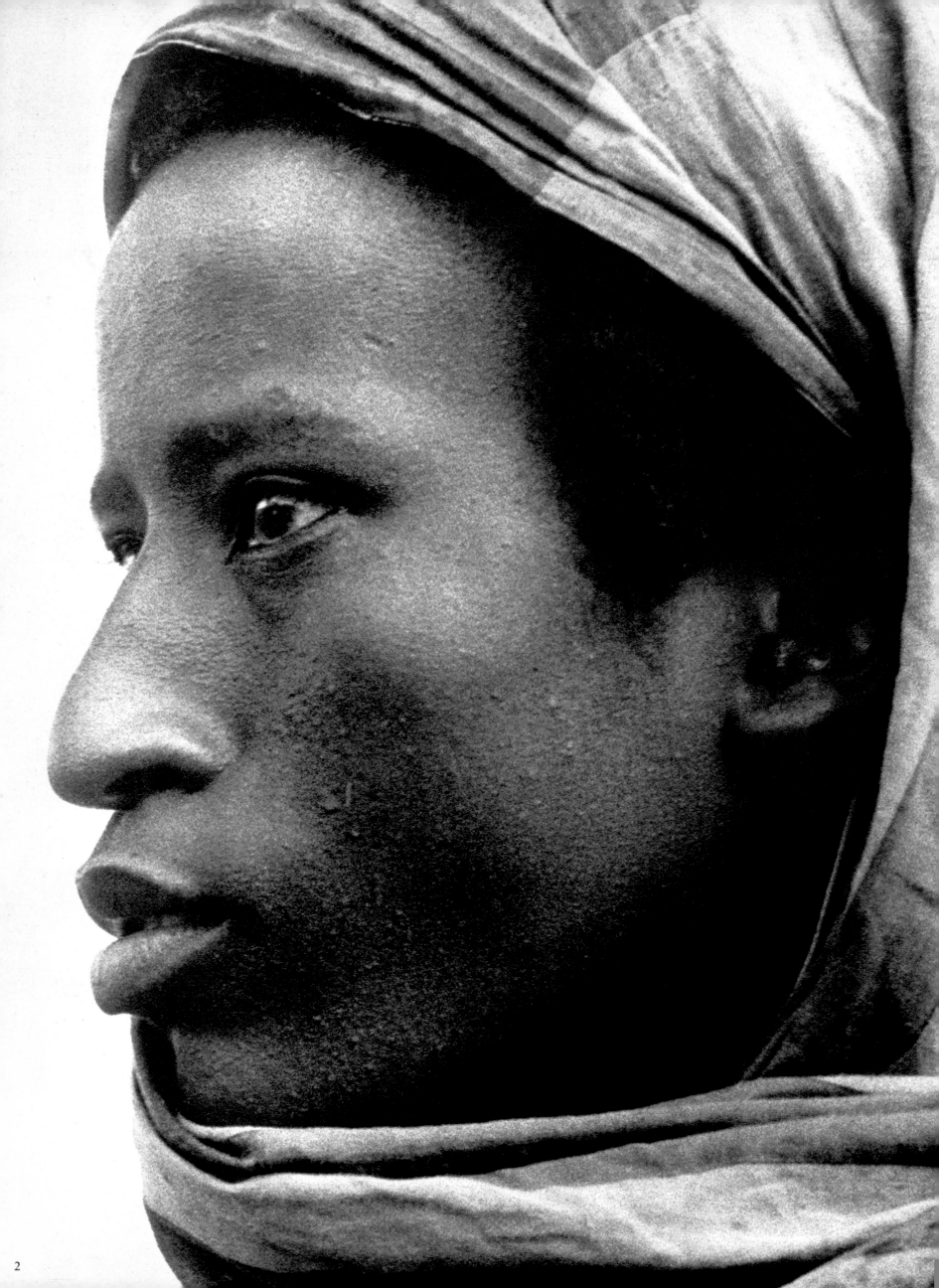

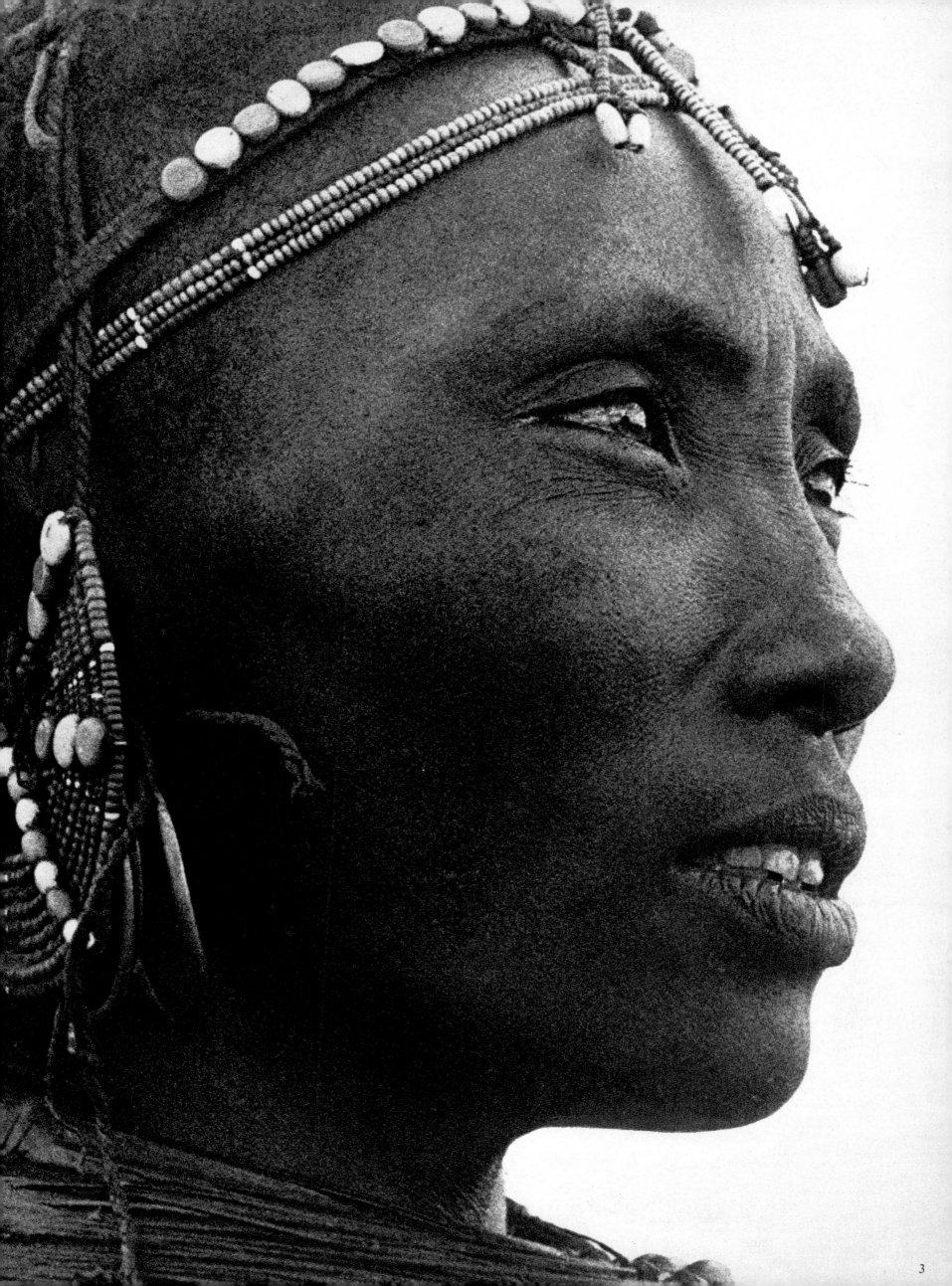

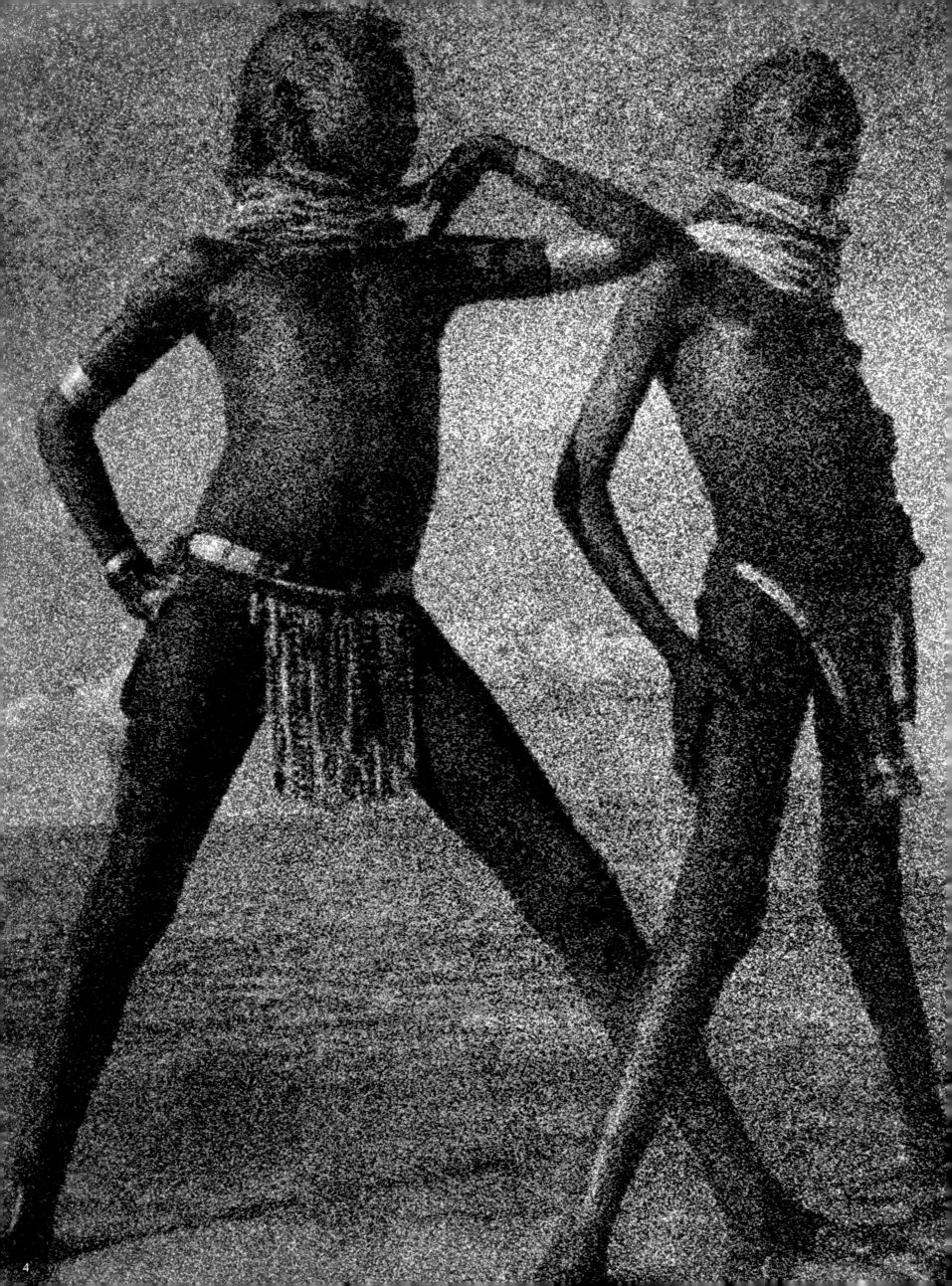

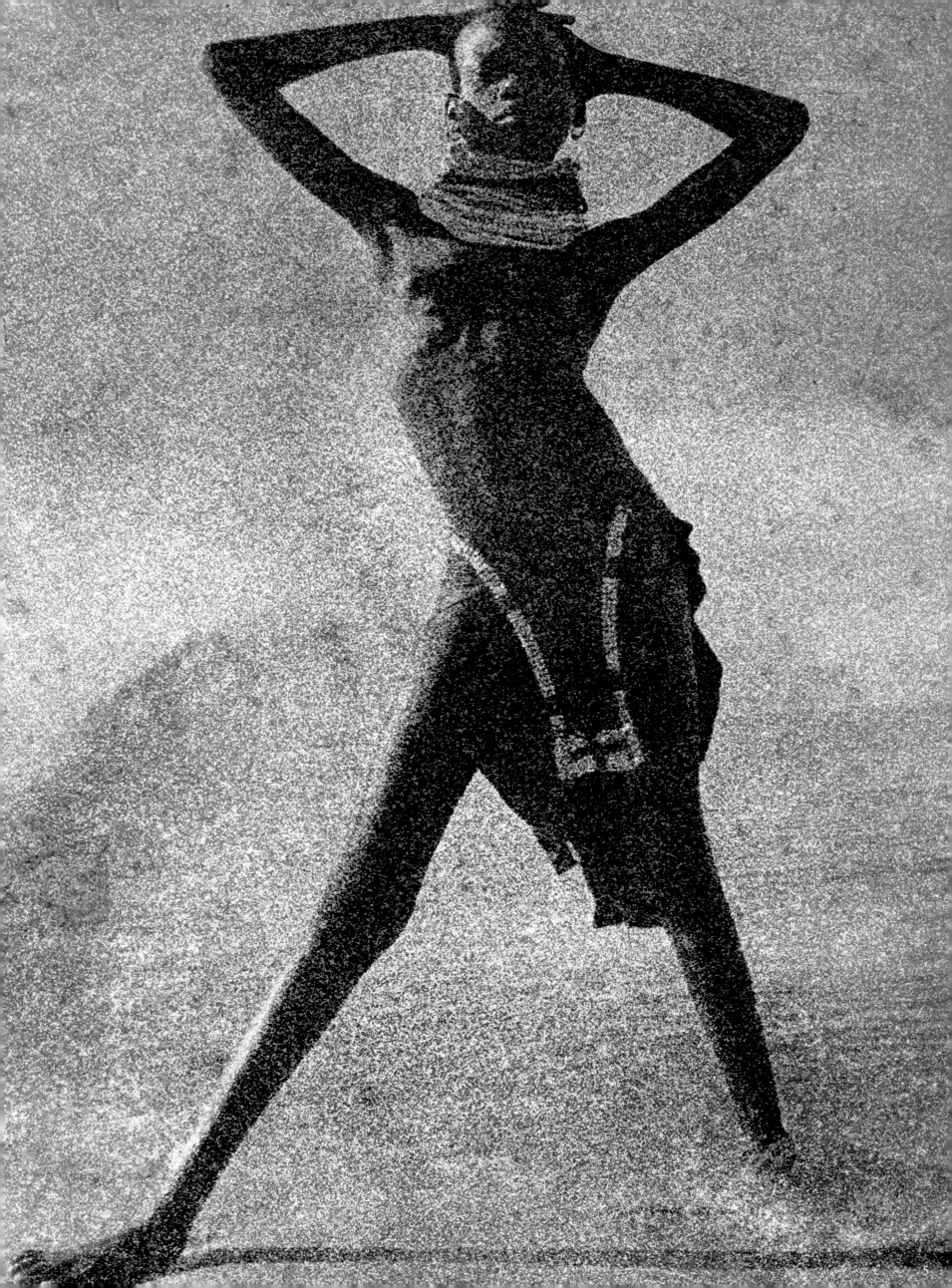

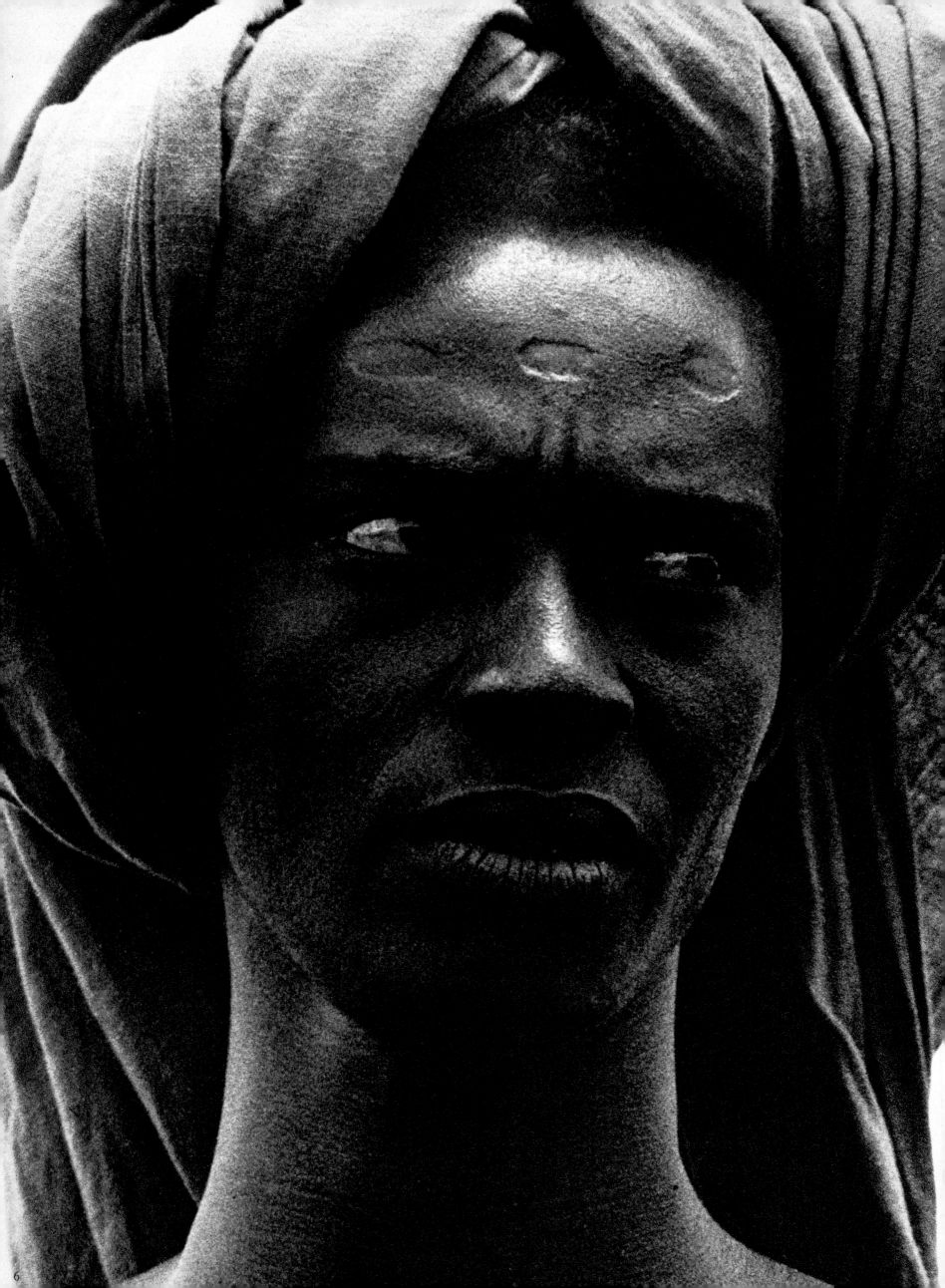

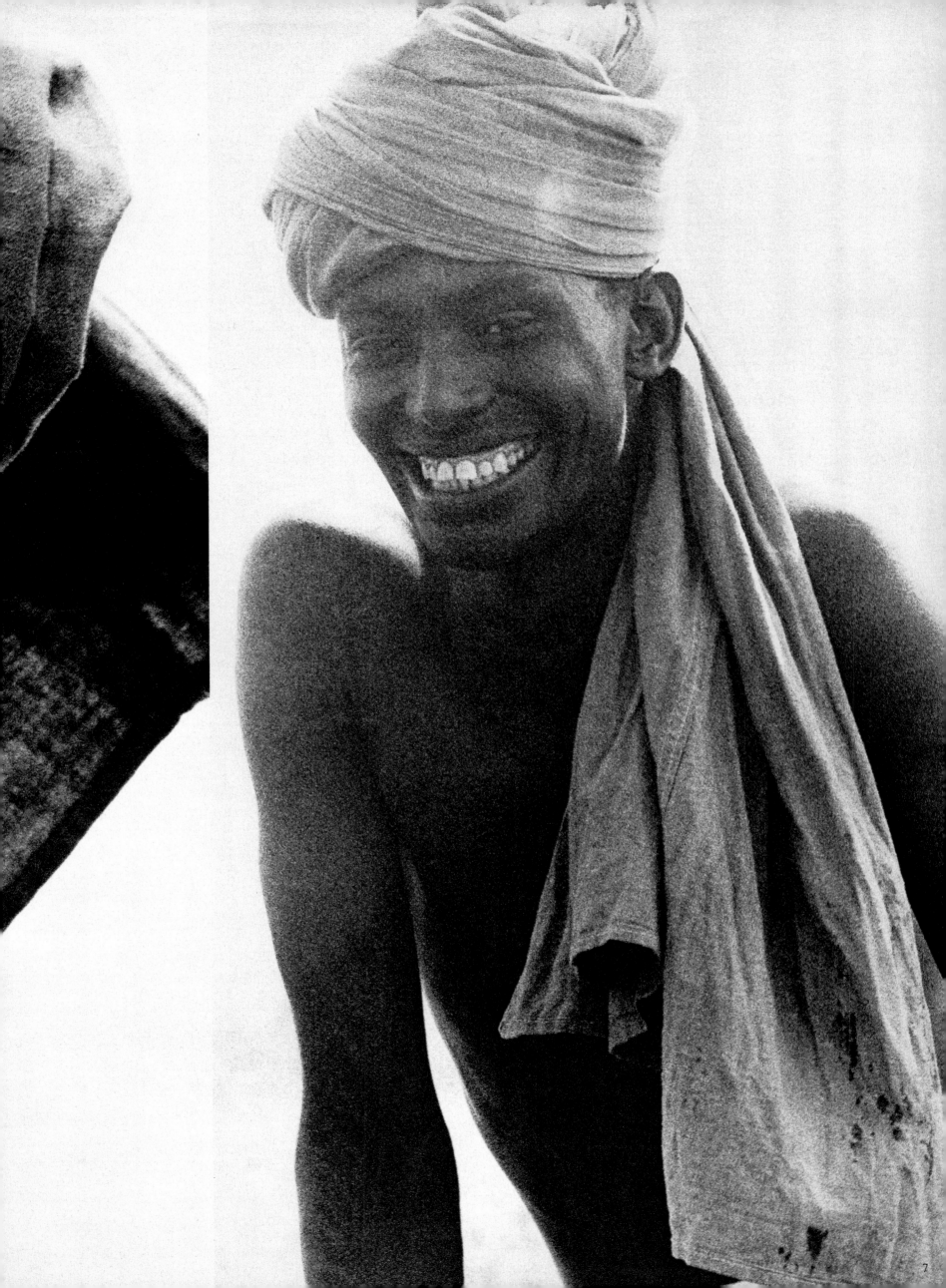

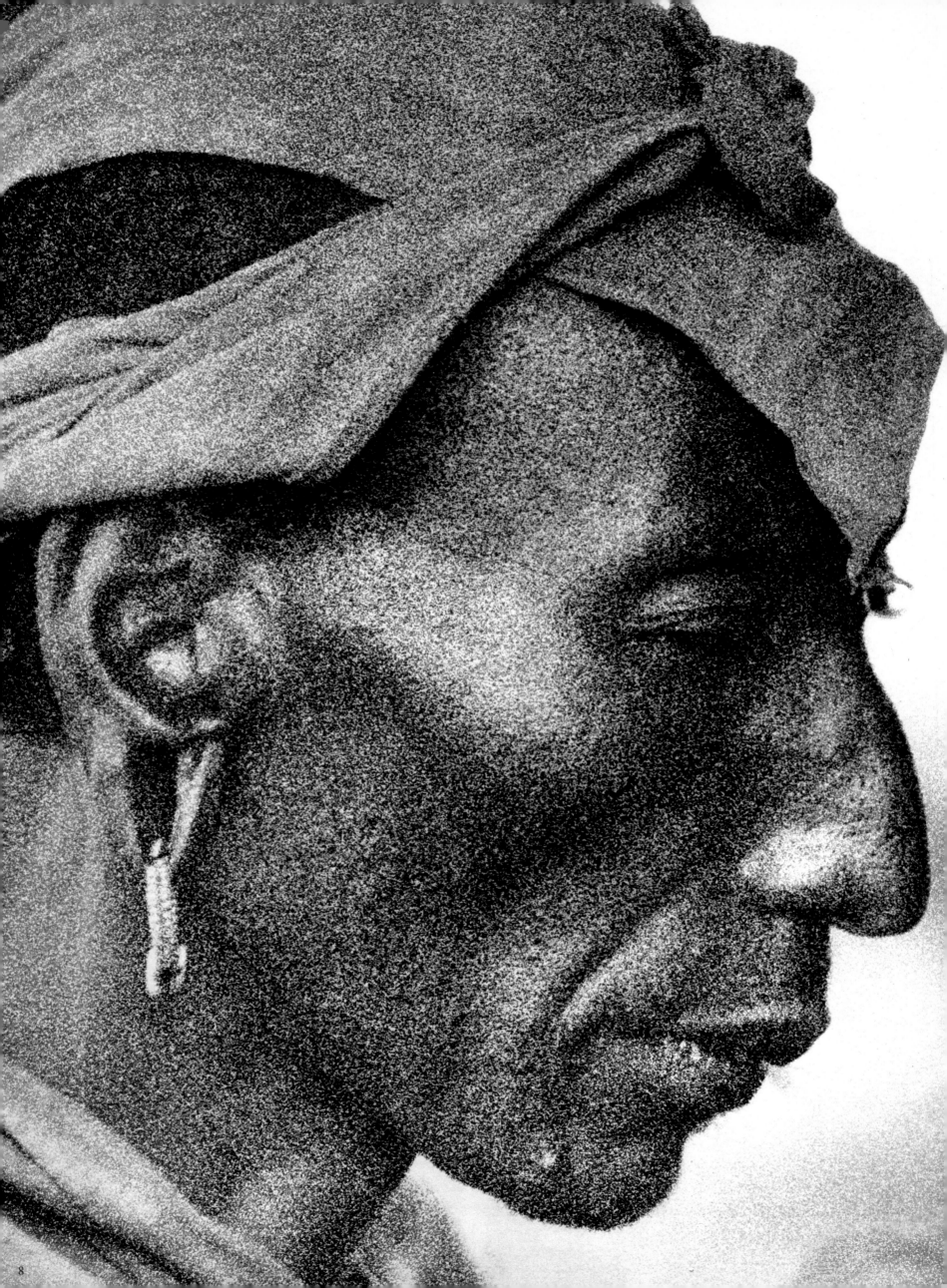

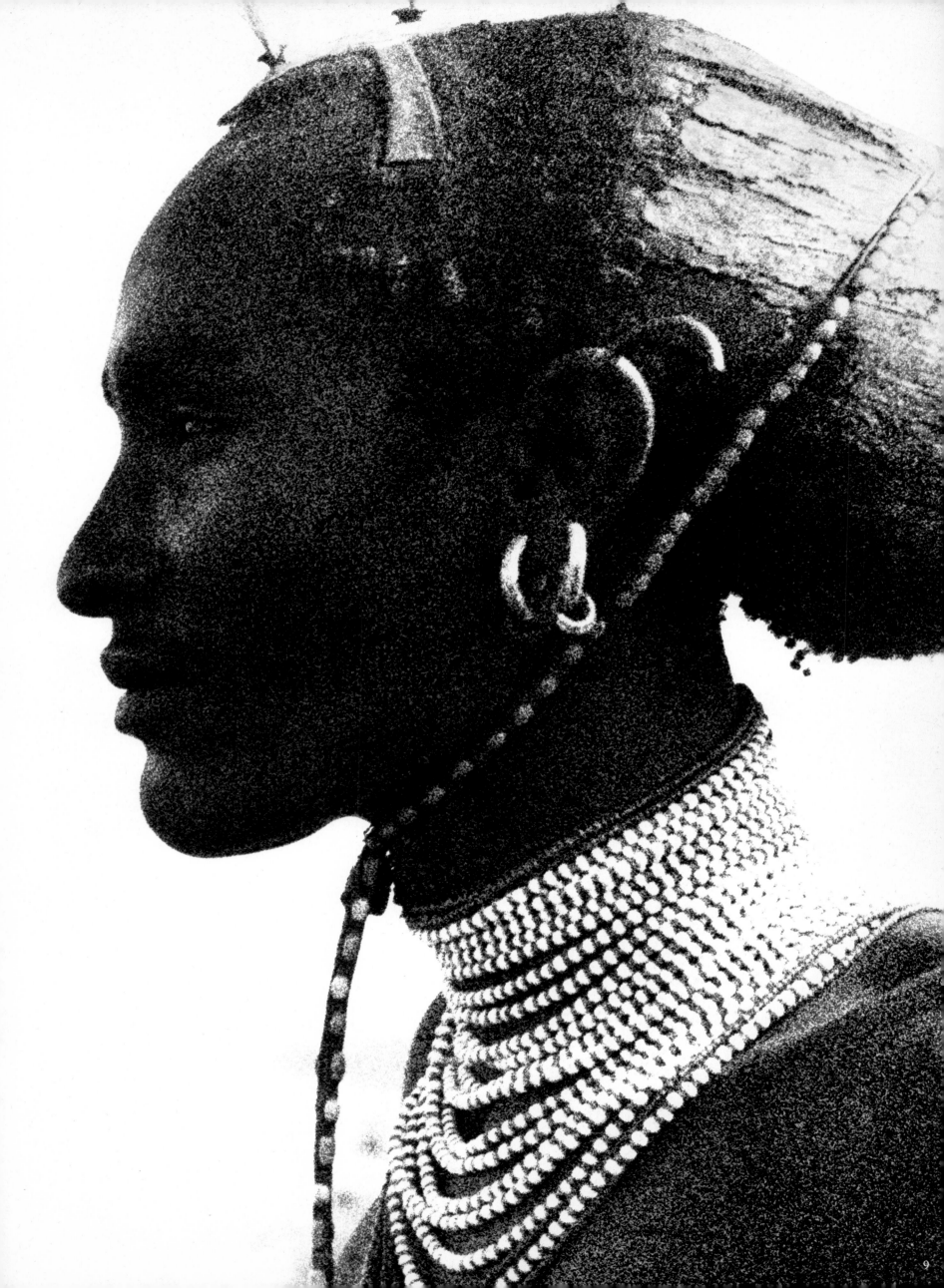

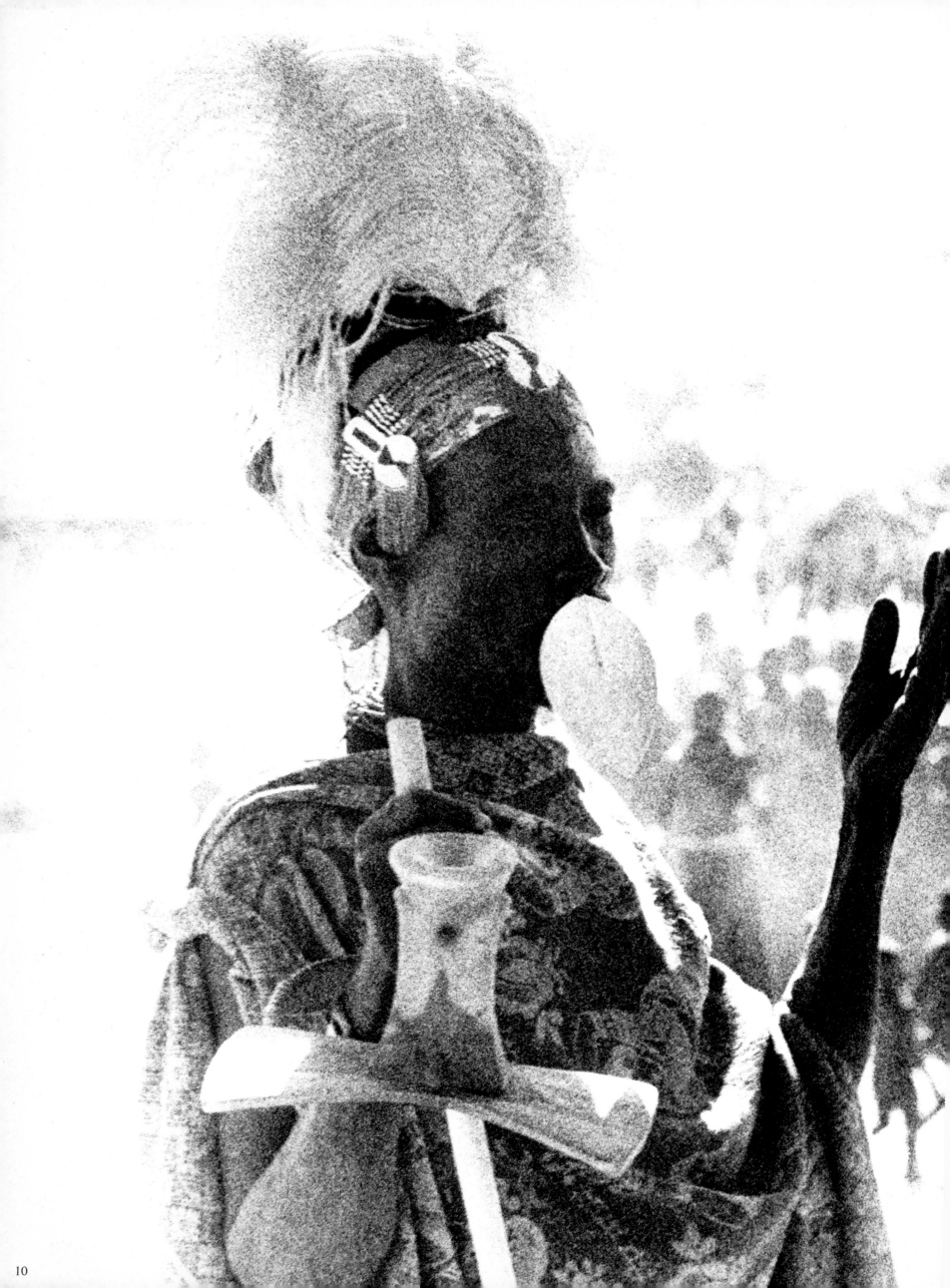

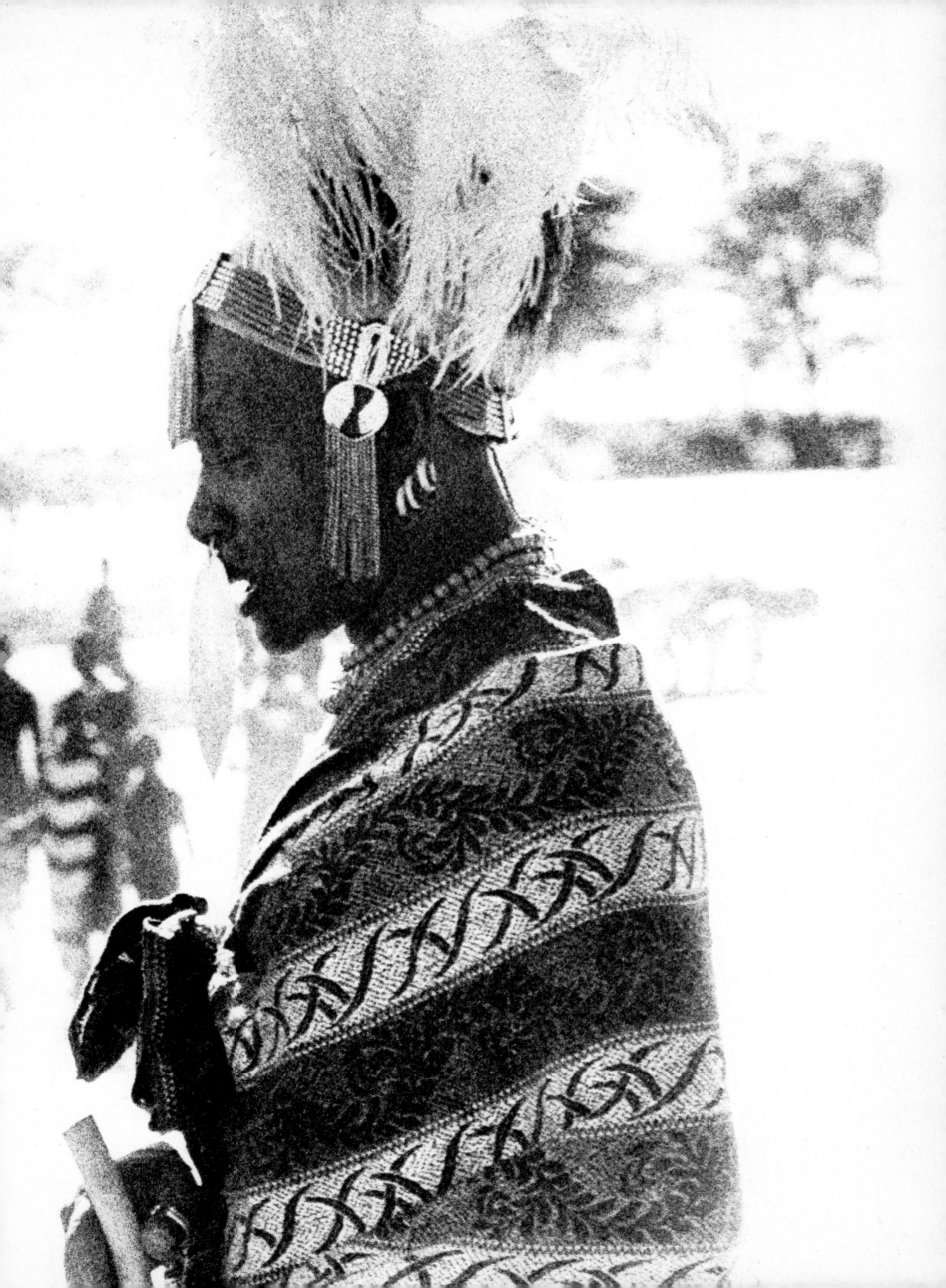

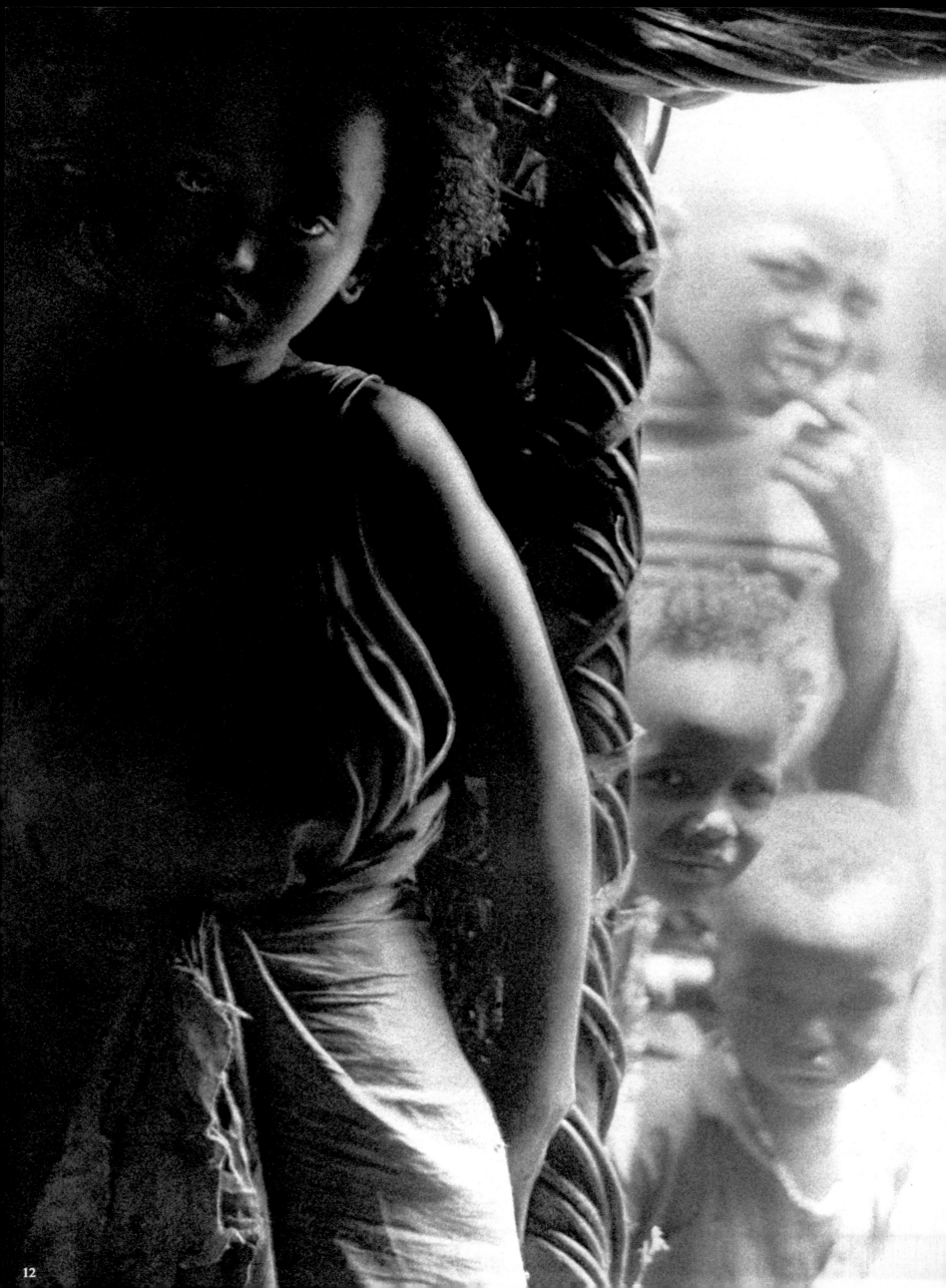

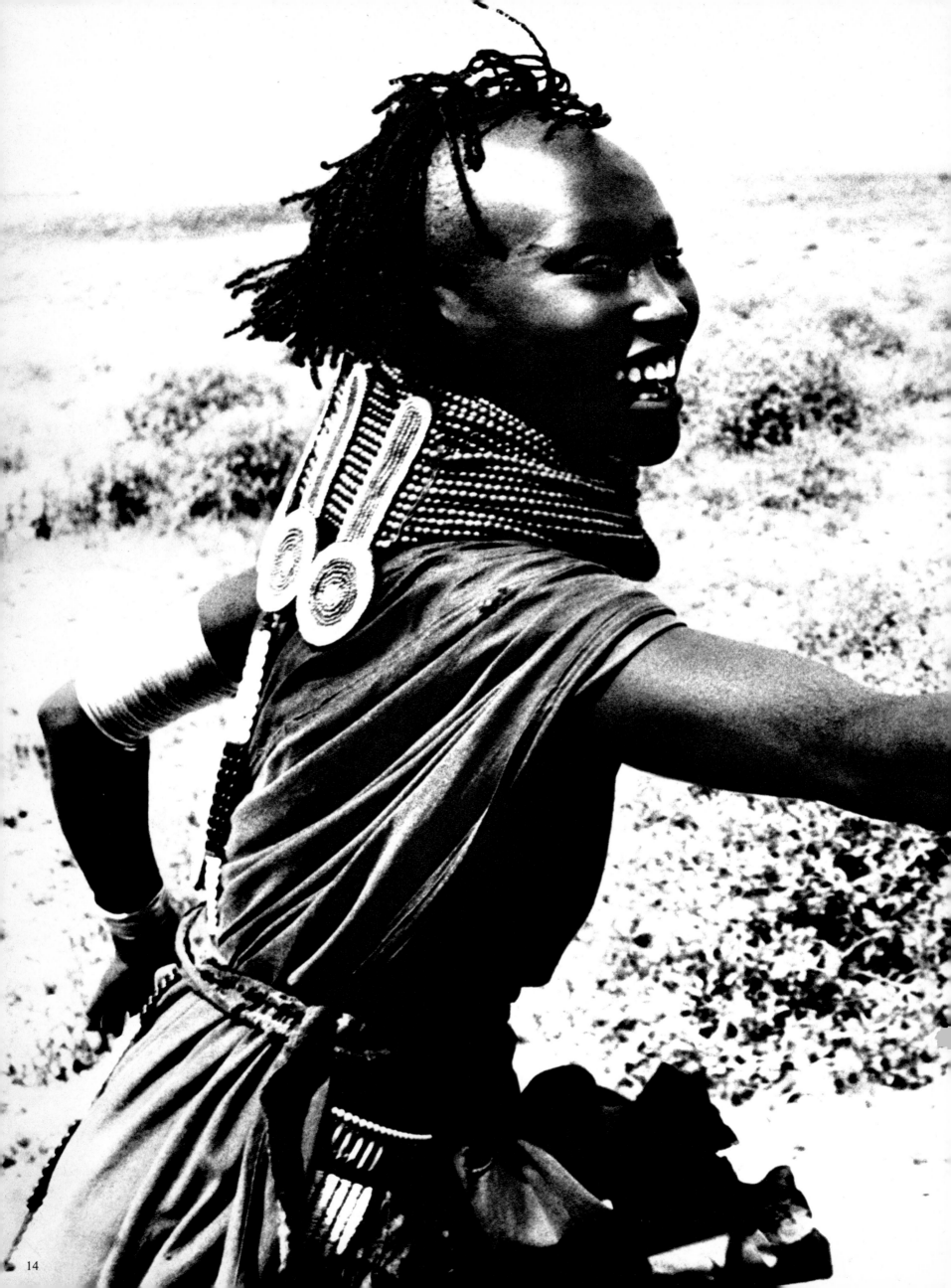

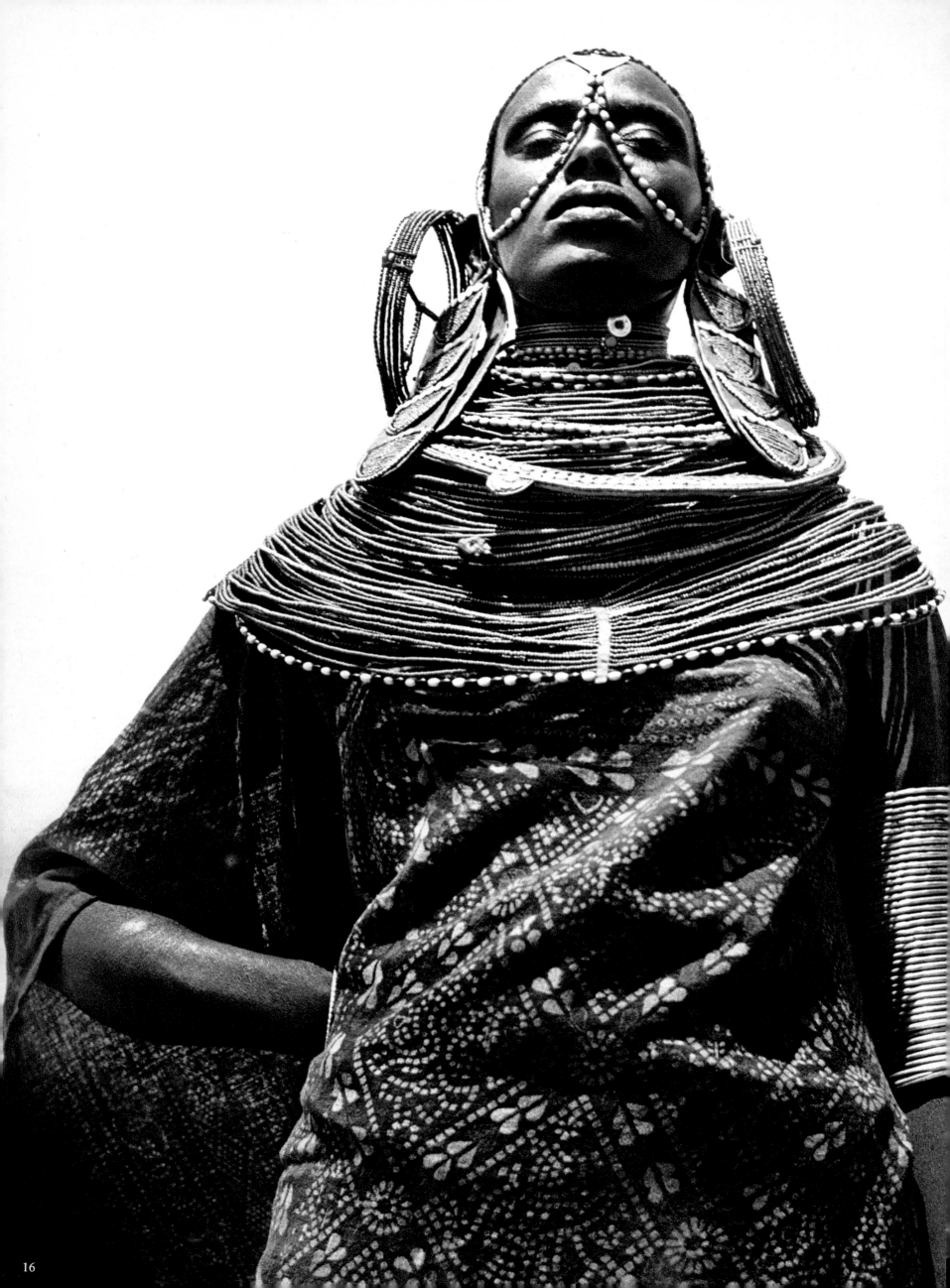

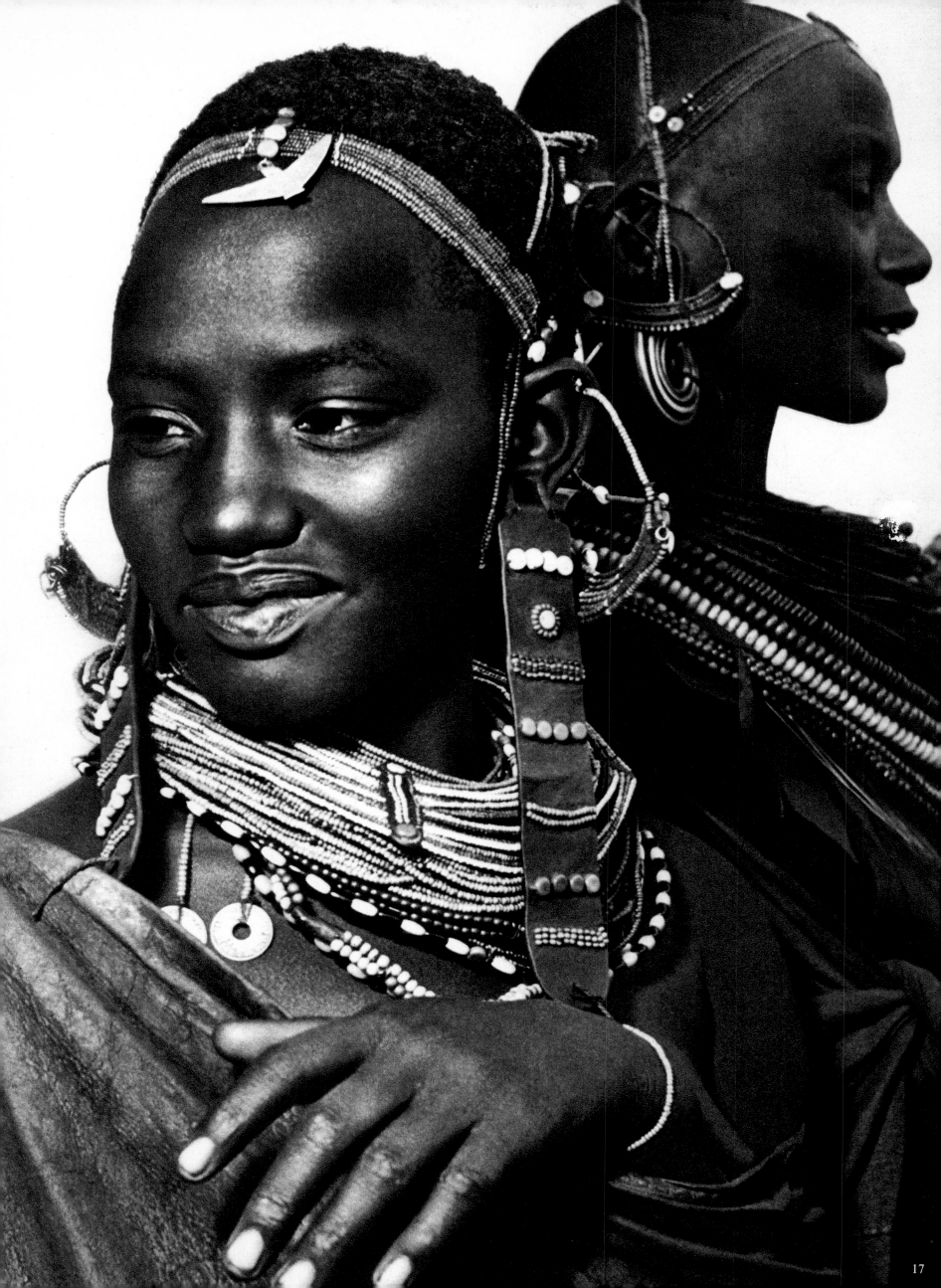

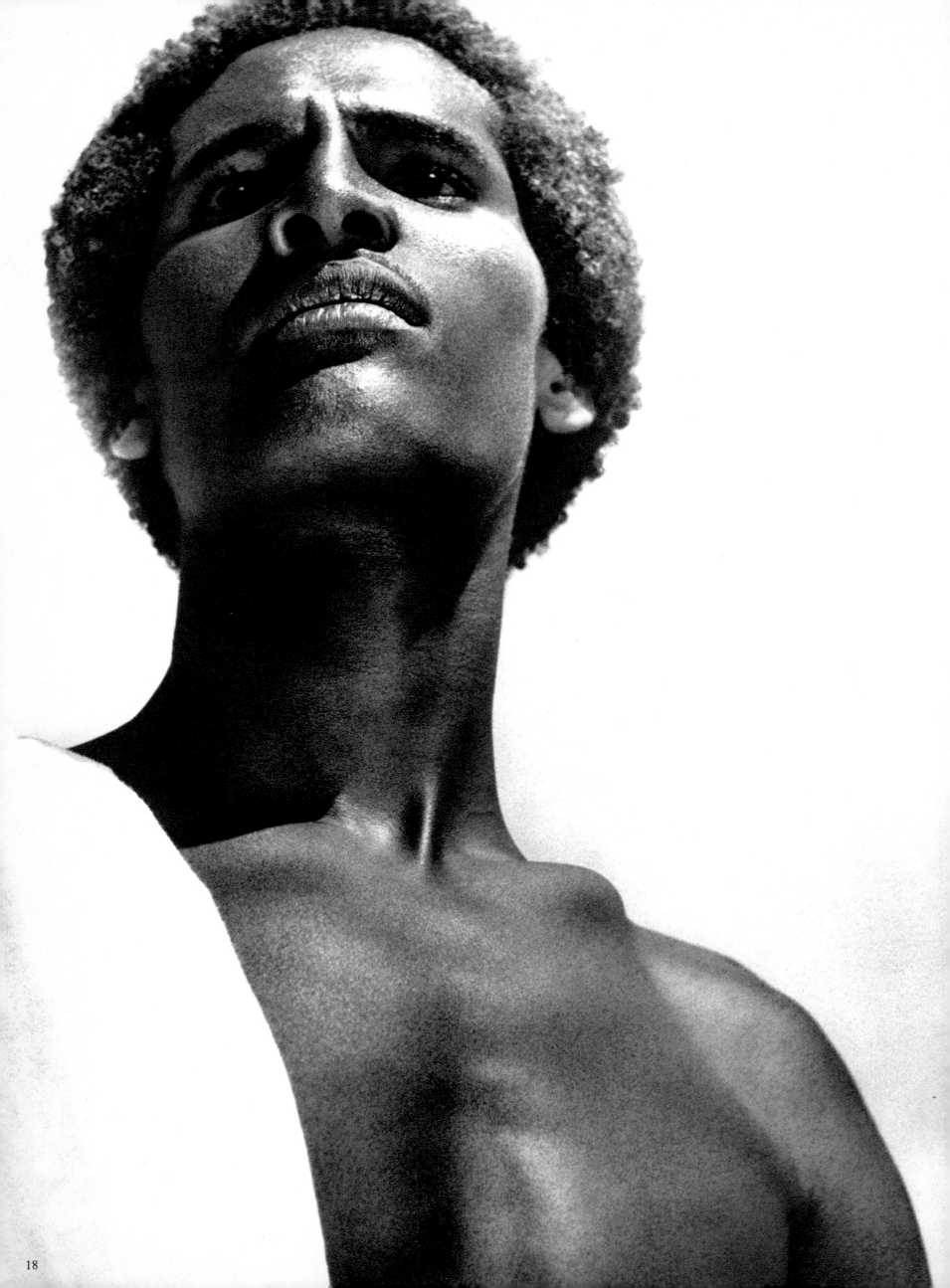

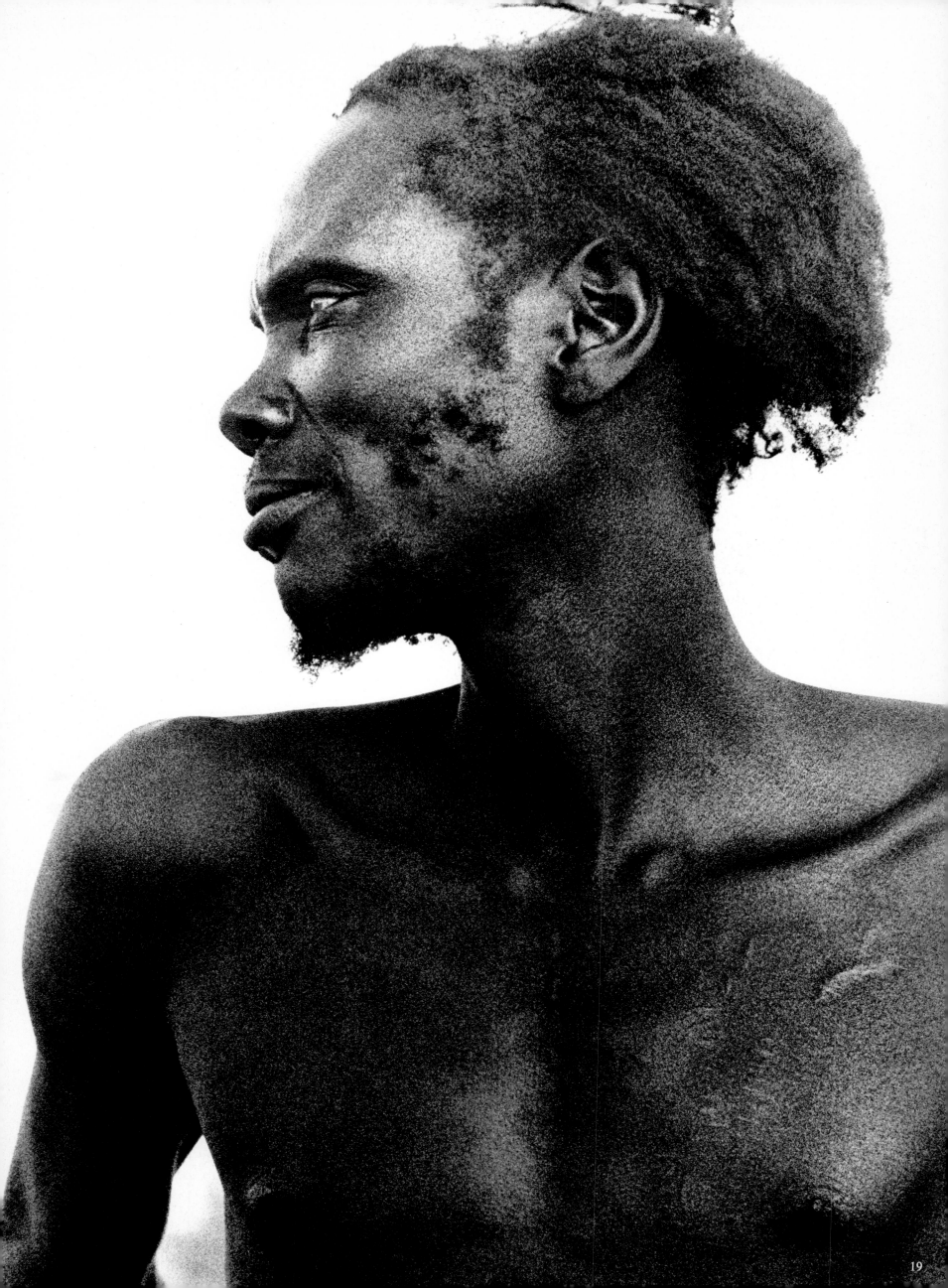

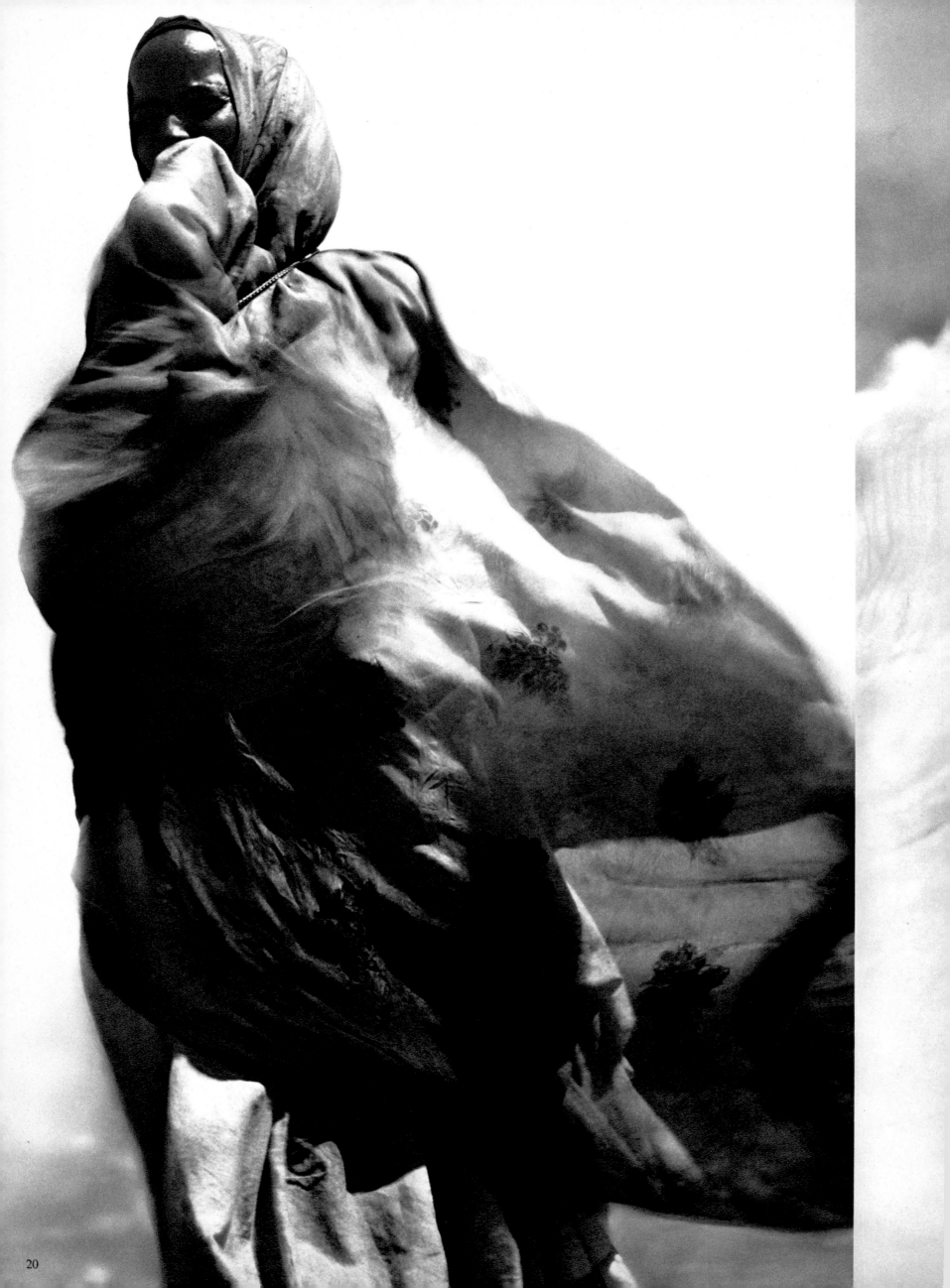

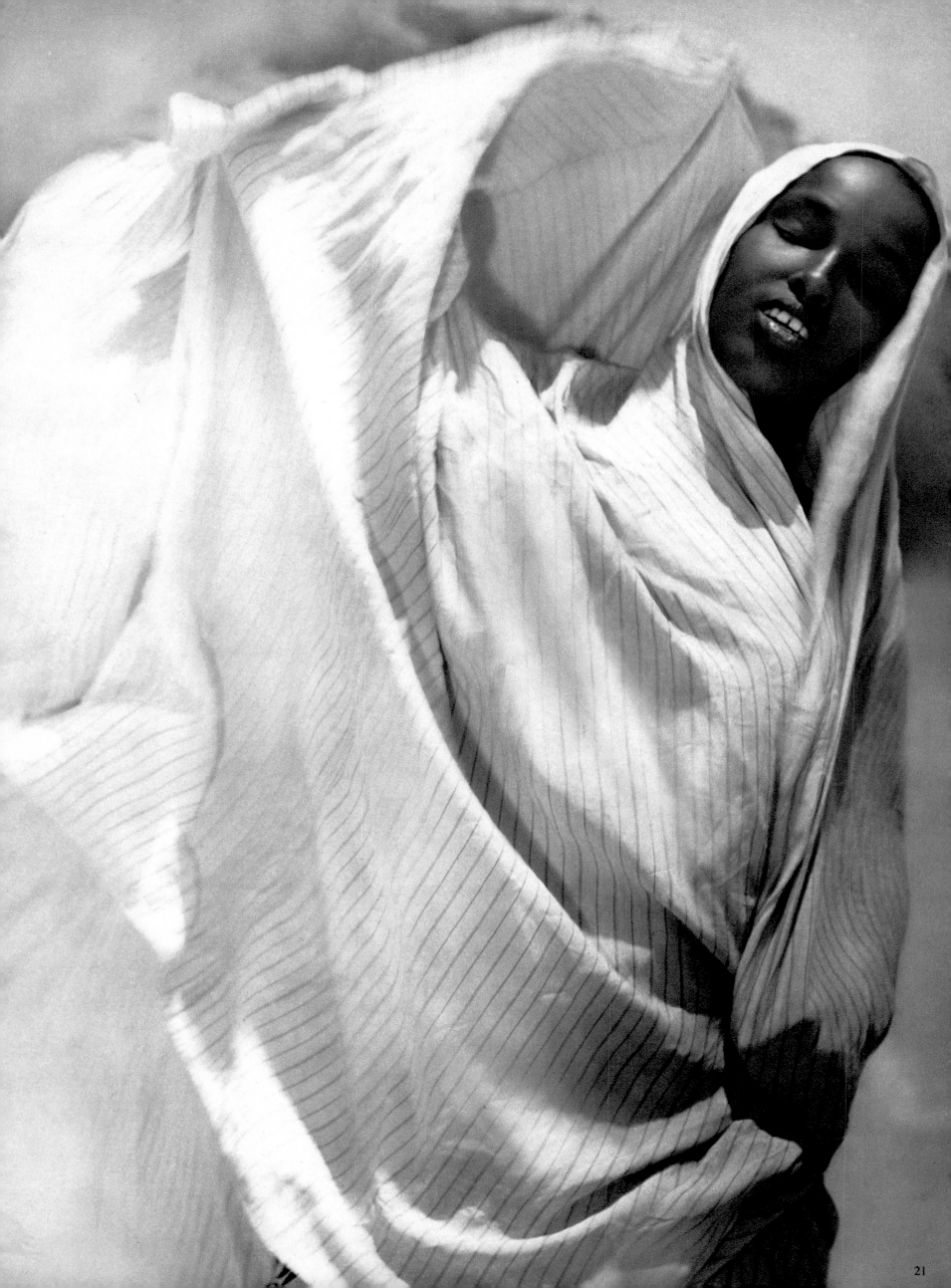

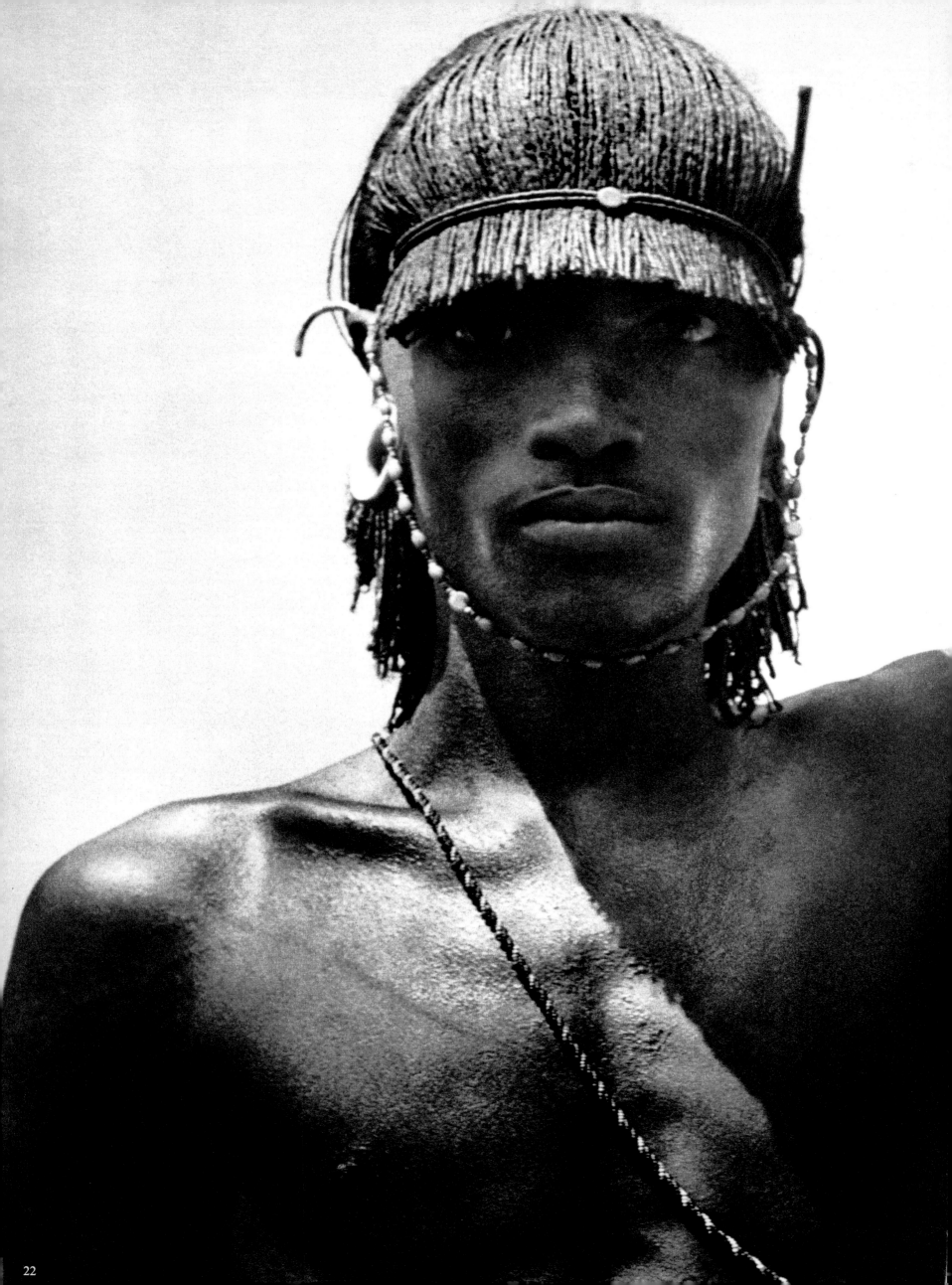

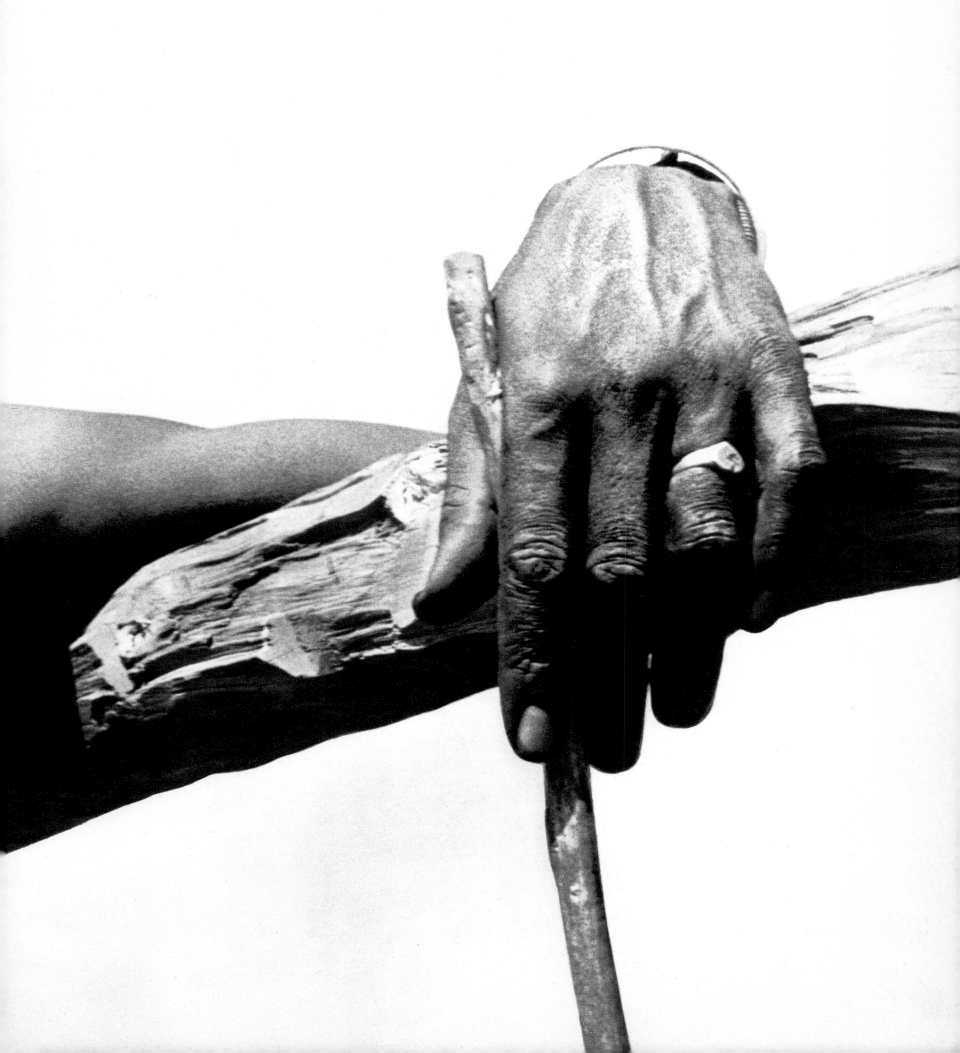

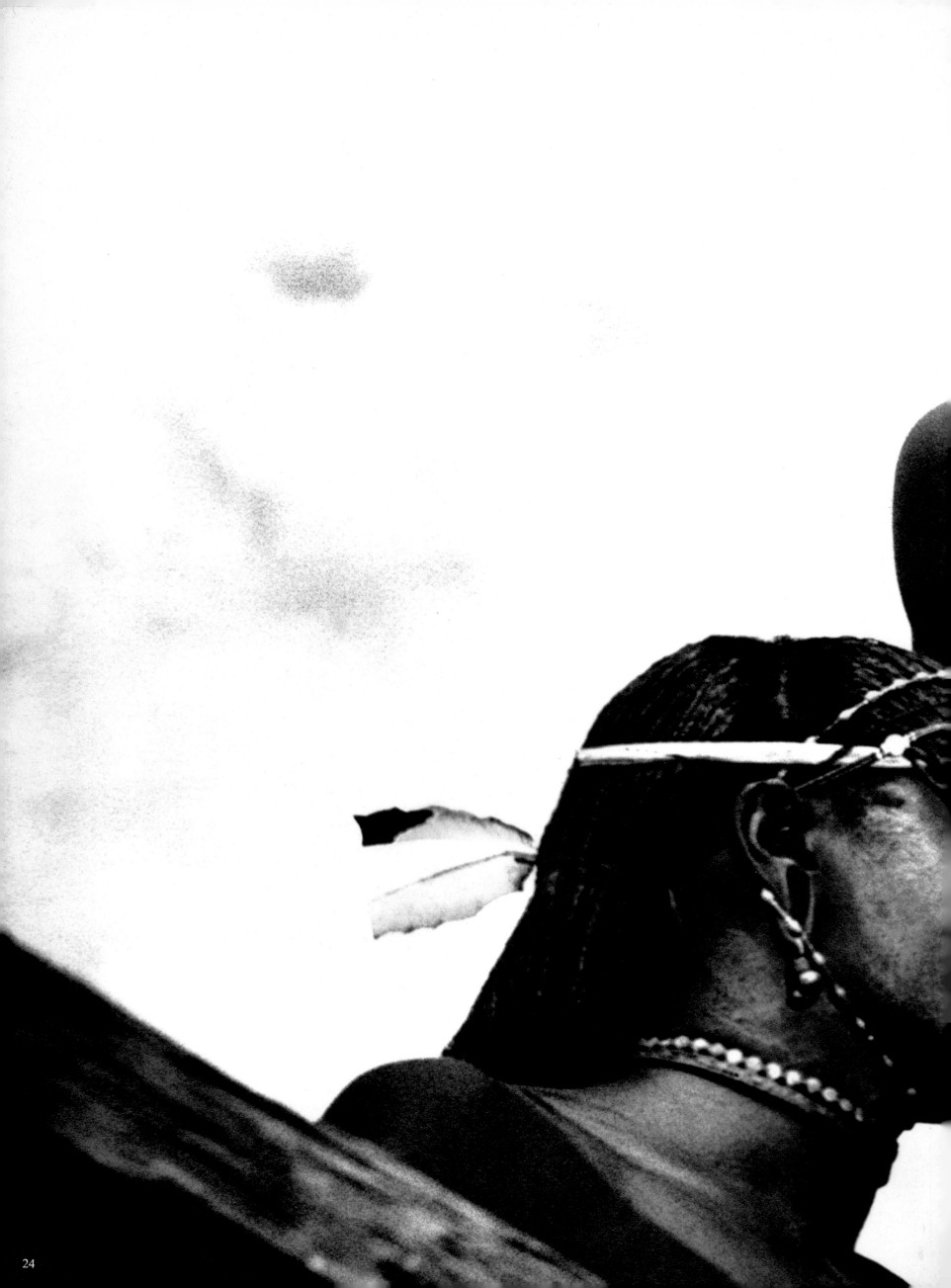

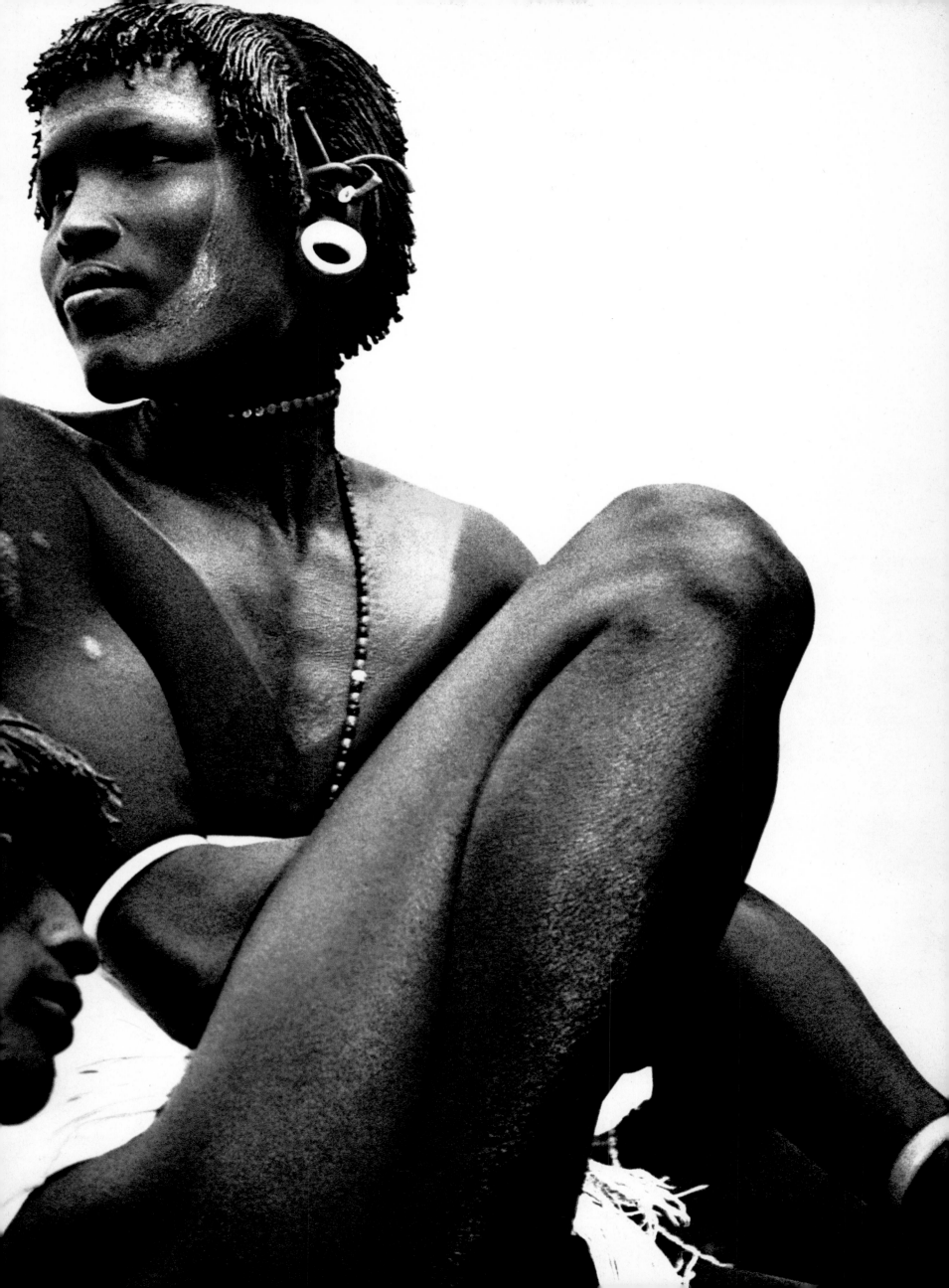

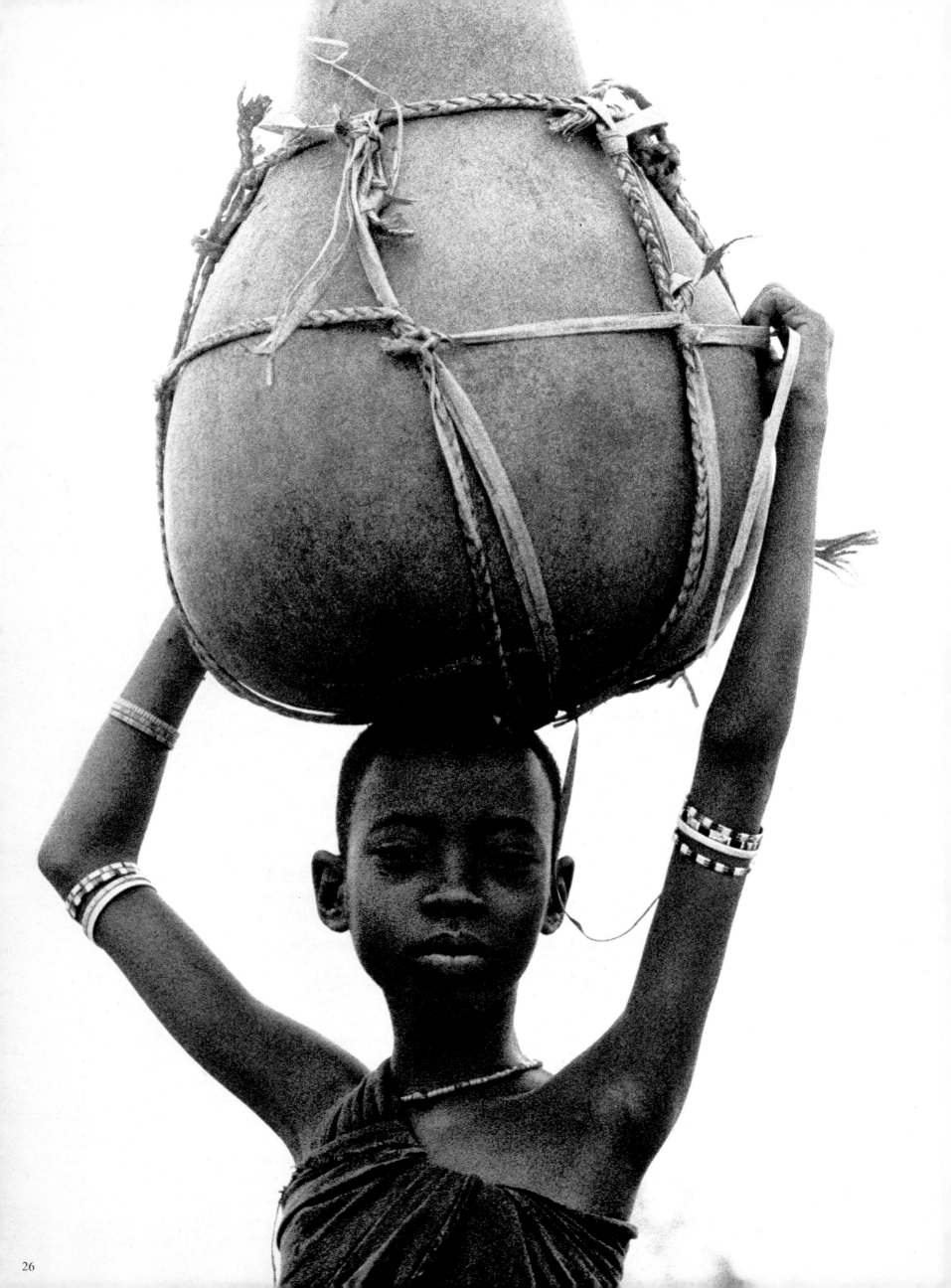

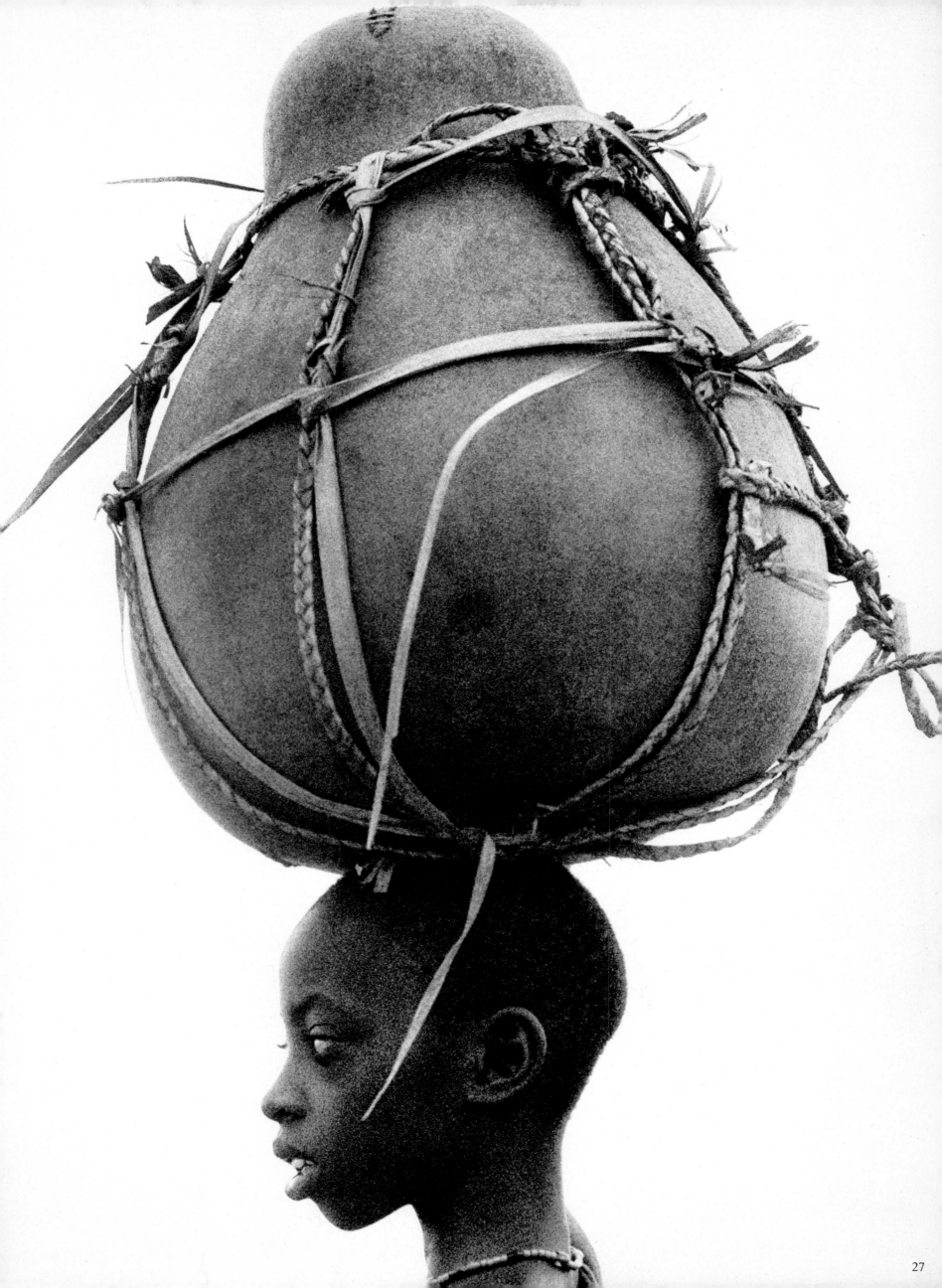

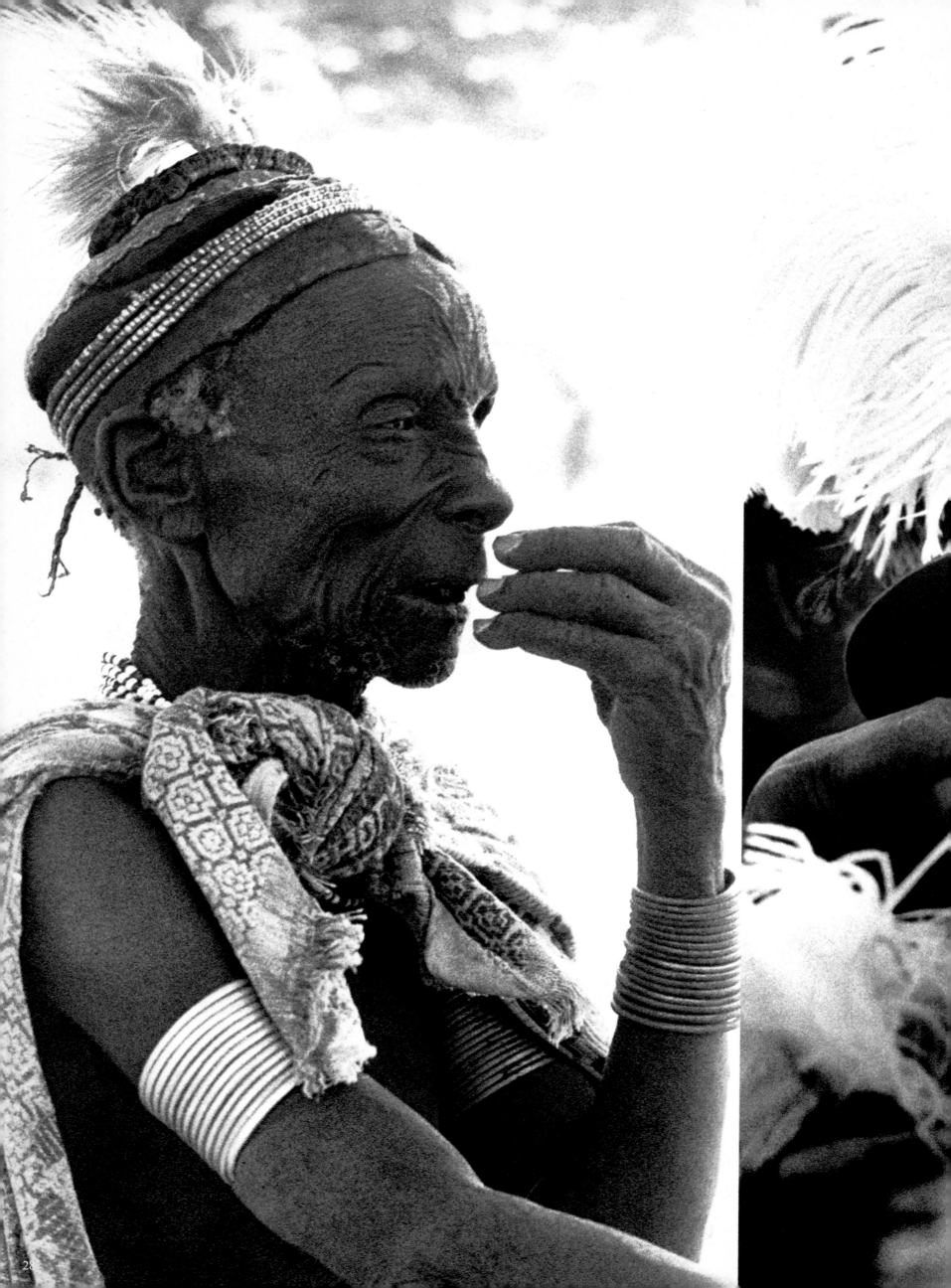

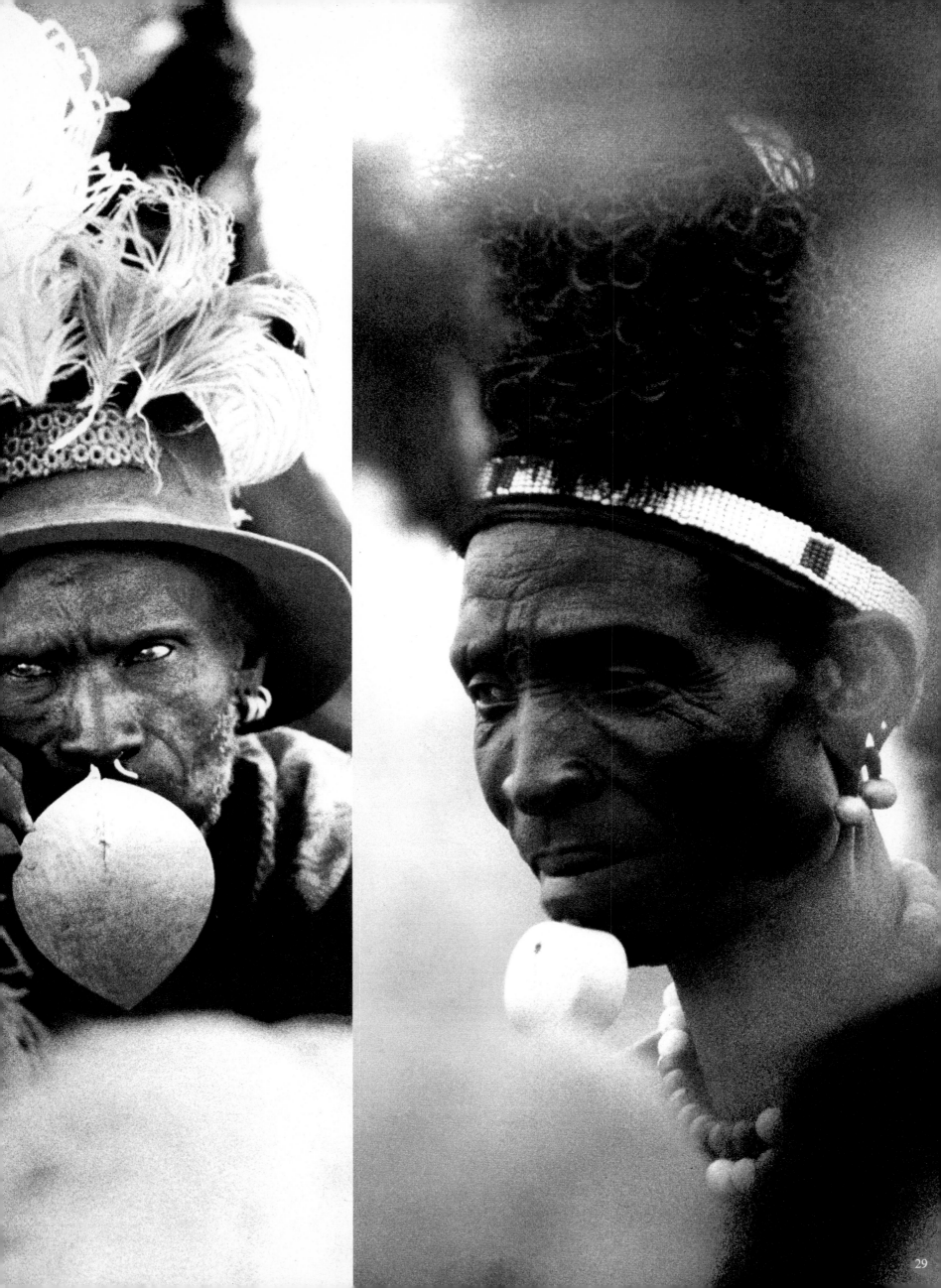

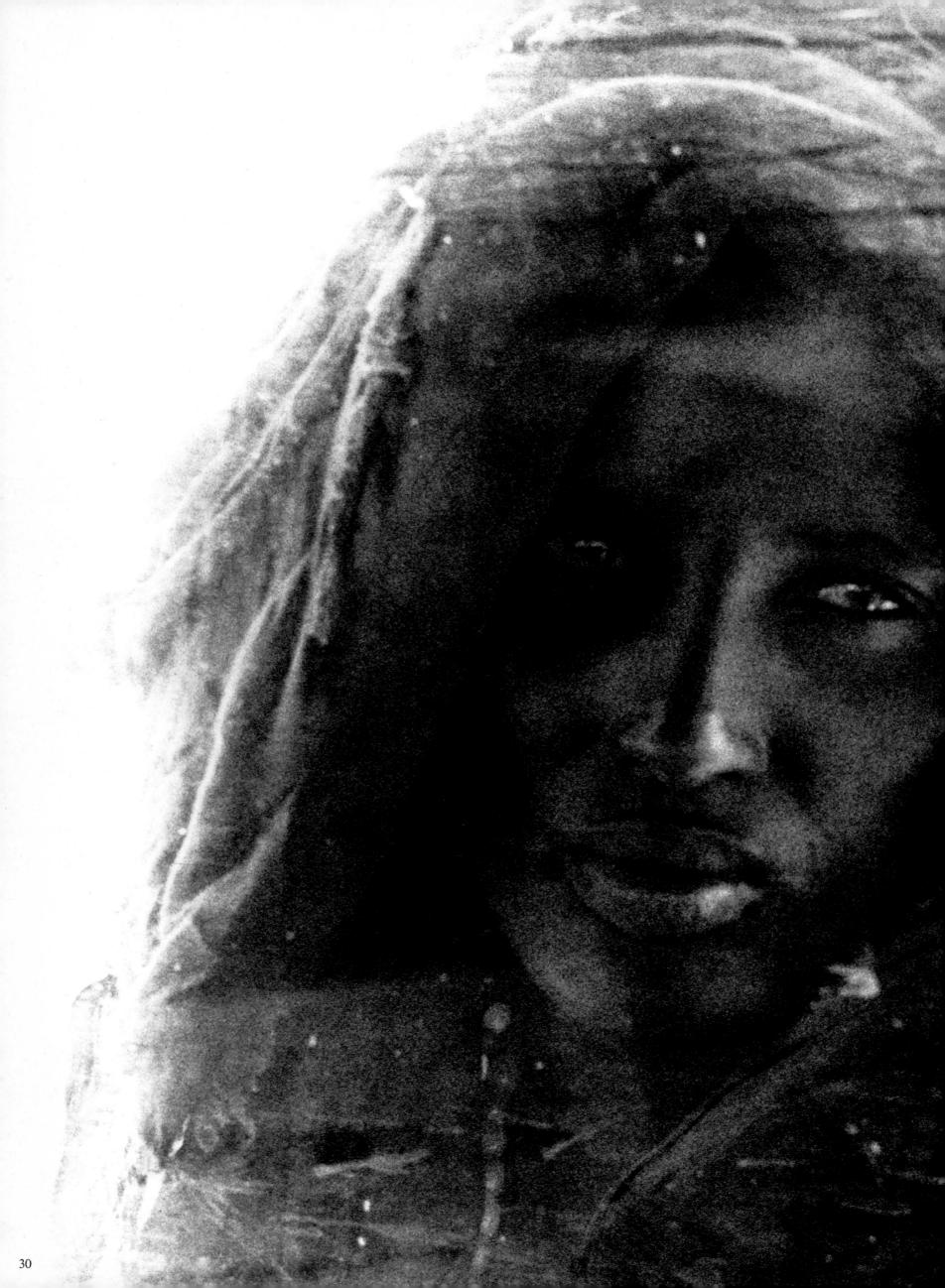

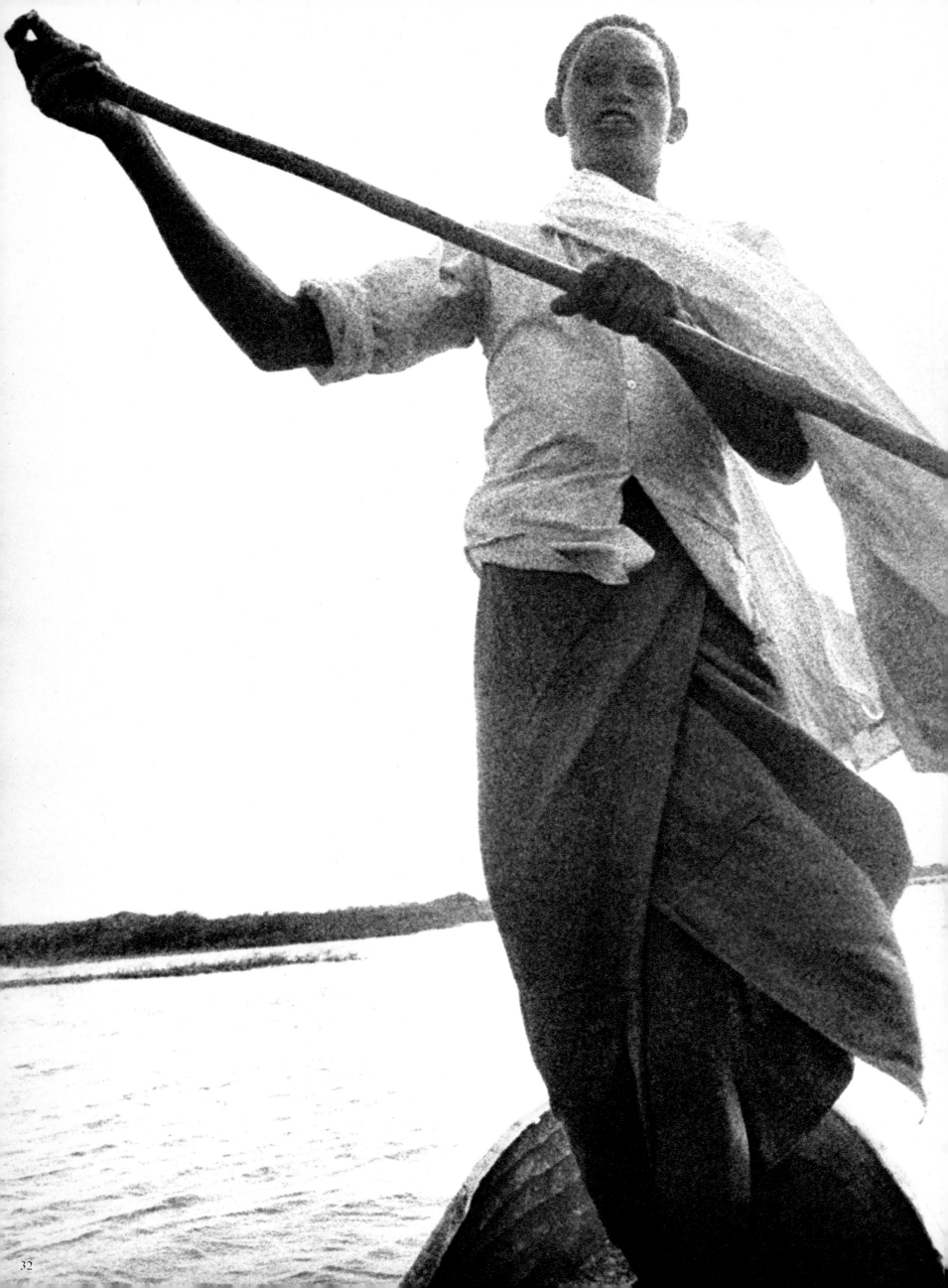

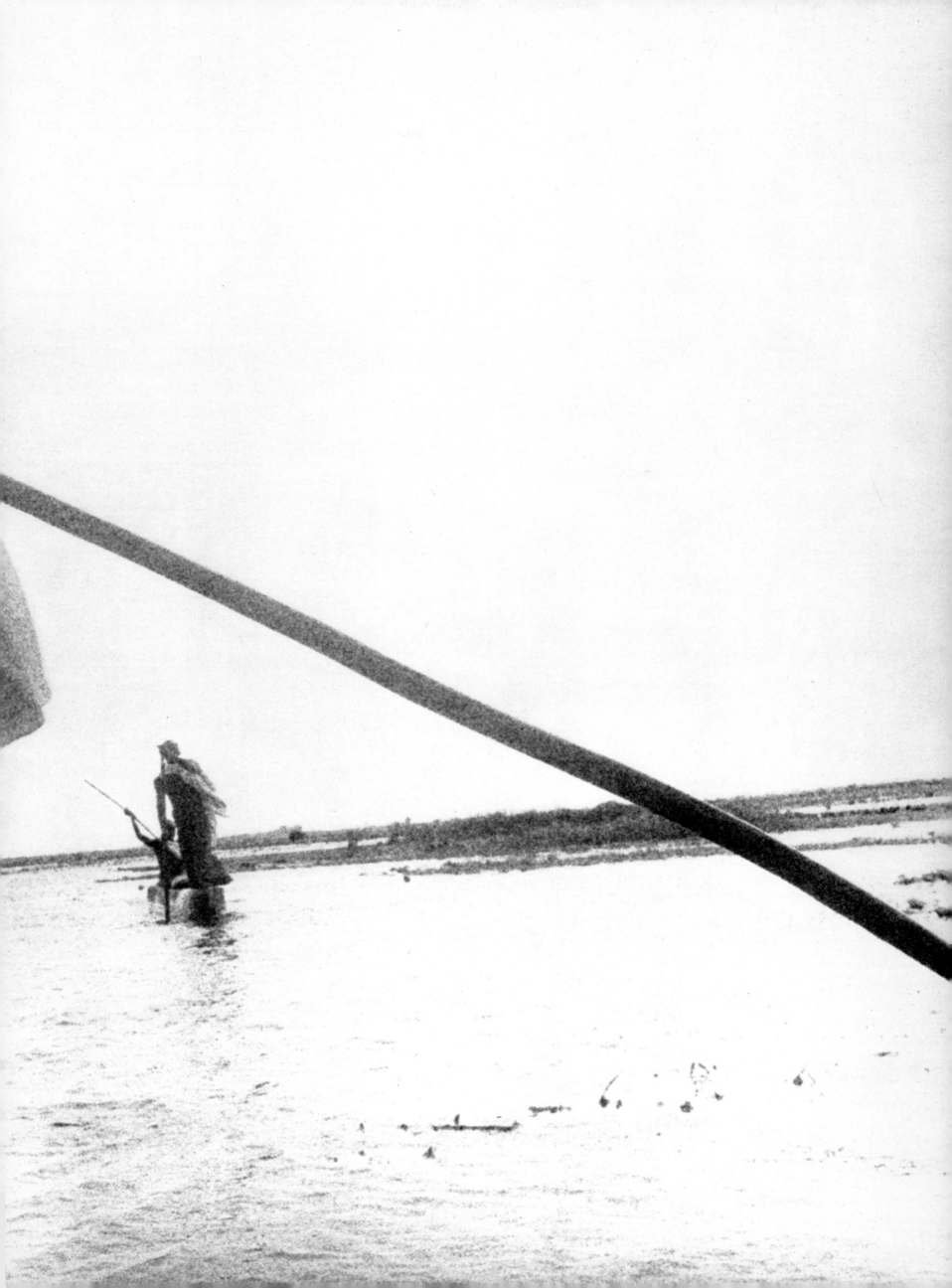

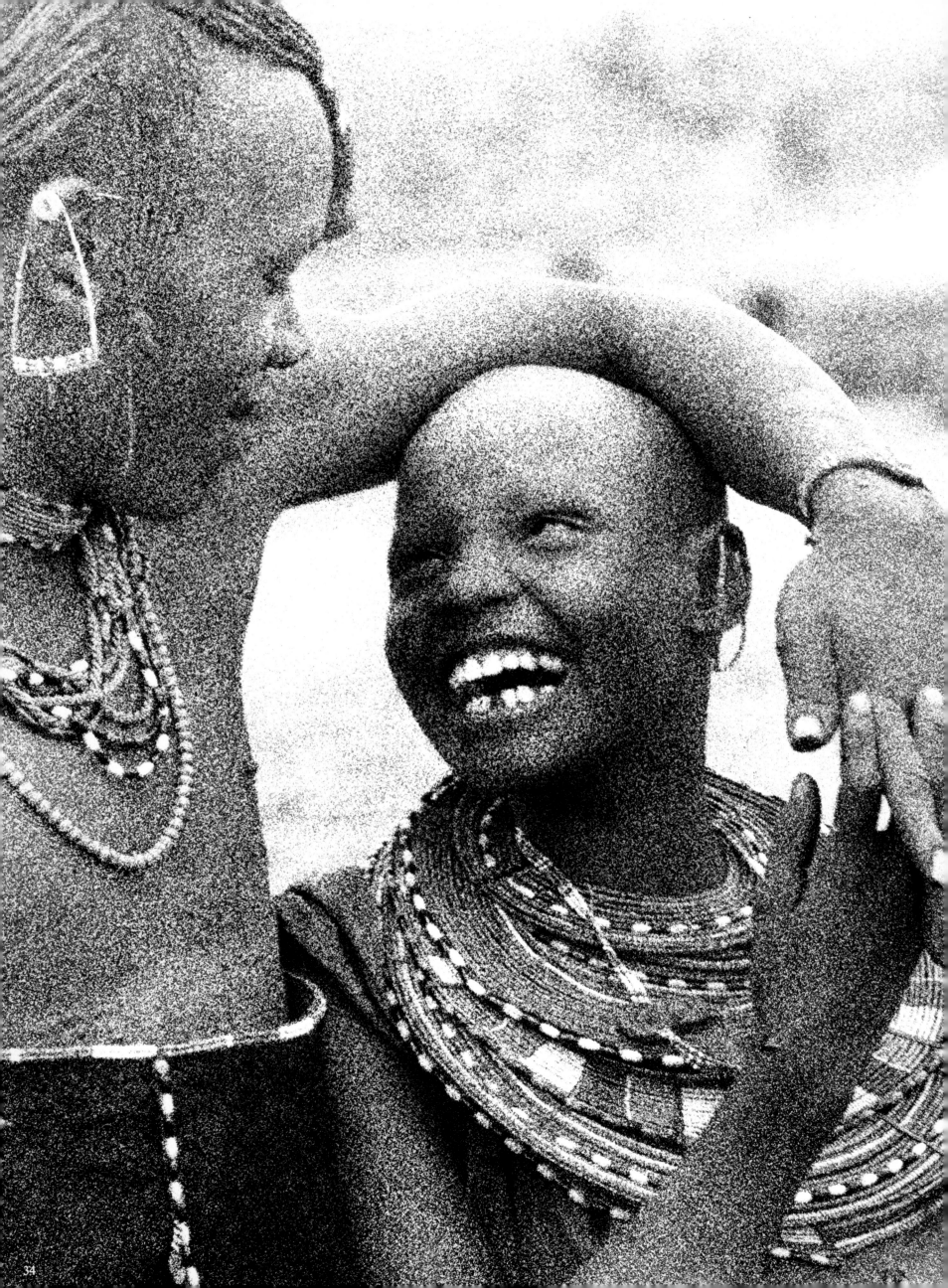

A MAASAI CEREMONY

A MAASAI CEREMONY

The Maasai are a pastoral semi-nomadic people who inhabit the open grasslands and dry forests of the Great Rift Valley of Kenya and northern Tanzania. Primarily a cattle-keeping people, they live mainly off the milk, meat and blood of their livestock. Among all the tribes of East Africa their *murran* (warriors) are the most renowned for their bravery.

Shortly after puberty, their young men undergo a tribal initiation ceremony, involving circumcision and thereafter become *murran*, for a period of ten to twelve years. At the end of this period they take part in the *eunoto* ceremony after which they cease to be regarded as warriors are allowed to marry and have children. They become full tribal elders.

On the first day of the ceremony, I was awoken at six o'clock in the morning by cries and chanting. From my tent I saw a bedlam of warriors dancing around the entire *manyatta* (village). There must have been at least five hundred of them, many wearing lion's manes and ostrich plumes on their heads. The lion's manes are worn on the most important occasions and only by those *murran* who have killed a lion in the traditional way. The long golden hair of the mane, speckled with black, fell to their shoulders, down their backs and around their faces, almost completely covering them. The head-dresses weighed at least ten pounds, but the *murran* wore them as though they weighed only a few ounces.

Those who were not lucky enough to have killed lions wore head-dresses of black ostrich feathers sewn on to a leather circle framing the face. From the top three white feathers rose in sharp contrast to the black ones.

The spectacle before me was breathtaking. The warrior's naked bodies, covered with red grease, shone in the morning sun as they danced in single file. The flags, made out of *kikoi* cloth, which had decorated their huts the day before, were now knotted over their shoulders and streamed behind them as they danced. They strode in circles which became figures of eight, while executing a series of skipping steps, chanting or crying like birds of prey, as their spears flashed in the sun.

Then suddenly, they broke step and rushed toward the forest which swallowed them up. An old man told me that they were going to decorate their faces and bodies with a special chalky limestone, which is found beside a little river in the wood. He ordered two youths to show us the way. We jumped into my car and followed about seven miles a small game track made by elephants and cattle, which led through the bushes. But soon the vegetation became so thick that we abandoned the car and for about ten minutes continued on foot.

At first we were unable to see the *murran* although we could hear them laughing and chattering. We sent Lorginyoki and the two boys on ahead to tell them we had come, because we realised that we had to act with prudence when dealing with people whose moods change so violently, and during this ceremony, which is designed to test their manhood, we felt the need to be particularly careful. We waited about fifty yards away, close to the stream, until we saw our two guides running back, pursued by hundreds of warriors shouting insults. Noah was leading the group which was chasing our boys.

"Good morning, Noah," said Francesco, holding out his hand. Noah shook his hand, "Good morning," he answered. "Are you coming to take pictures? Come on if you want to."

Through the branches I caught sight of a little clearing; a white limestone cliff about sixty feet high rose above it; at the foot a rivulet of fresh water trickled. The warriors were decorating their faces and red bodies with a mixture of chalk and water. When they had made a thick paste they dipped their fingers in it and traced patterns on each other's bodies, zig-zag on their limbs, stripes on their backs, and semi-circles on their stomachs. Their faces were painted differently; for those warriors who had killed a human enemy, there was a white semi-circle on the *right*-side of their face; for those who had killed only a lion or an elephant, the semi-circle was placed on the *left* side of the face. The opposite side in each case was painted with a semi-circle of red ochre, obtained from gently rubbing their fingers down their heavily greased hair and then applying it to the face. The effect was like an ancient Greek mask.

When they saw me they hesitated for a moment. A white woman with a camera. But they soon returned to decorating each other when they realised Noah was with us. Remembering the trouble that photographing naked men had caused me in the past I tried to take pictures only from the back. As I watched, the red men slowly became white. They looked like dancers in fantastic leotards. When they had completed the final touches they picked up their head-dresses, which they had hung on spears stuck into the ground, and placing them on their heads set off in single file through the forest back to the *manyatta*. Several of them followed me to the car and jumped inside, or climbed on to the roof. The *murran* love to ride in cars and this was a good occasion to avoid the long hot walk back to the *manyatta*. Although I realised that we were vastly overloading the car, I was happy to oblige. It was important to me to get as involved and as near to them as possible, to be taken for granted, pass unobserved, to be part of them.

I knew that I was witnessing one of the last scenes of this ritual splendour, and I was right, for shortly after a new law came into force ordering the Maasai of Tanzania to wear trousers or shorts, and forbidding their traditional *shuka* cloth and the use of red ochre. Did the authorities understand the medical function of red ochre in preventing scabies and other skin diseases among the Maasai, and that the *shuka* (a piece of seamless broadcloth knotted on the shoulder) is the healthiest garment in the arid waterless plains, where washing clothes presents a problem to a people whose sole use of water is to keep themselves and their herds alive. To use the precious liquid for washing clothes would be almost a sacrilege.

About a hundred paces from the *manyatta* I stopped the car and climbed onto the roof from which I followed the arrival of the walkers. They moved forward as if in a trance. Their faces were half hidden beneath their head-dresses. They looked more like strange birds than men. At the entrance to the *manyatta* an old man, one of the ceremonial leaders, waited for them and whispered a blessing for their future children and herds as they went by. Once in the *manyatta*, they formed a long hopping procession which wound round a special hut built in the centre of the enclosure. This hut, the *osingira*, was the focal point of the entire ceremony. Only those *murran* who had led an exemplary life and fulfilled

57

traditional expectation during their period of warriorhood would be admitted and would share in the final and most secret stages of the ritual. The elders would line up outside the entrance to the hut, and each warrior would have to pass, single file, down the line to gain admission. Those *murran* who had broken tribal customs – such as the prohibition against sleeping with unmarried women – would be denied admission, publicly rebuked, and with their family be shamed for life. All the girls of the *manyatta*, covered with pounds of beads and glistening with red grease, stood round the hut and tried with all their strength to push their young men inside. They clung to the *murran's* arms and legs, but the warrior fought fiercely to avoid being dragged in before the elders assembled. They ran round the hut, pursued by hordes of girls screaming at the tops of their voices. Several *murran* fell into an epileptic-like fit, in anticipation of the judgement that was soon to be conferred on them. They threw themselves on the ground; a noise like the grunt of a hunted animal came from their throats, and they foamed at the mouth. They trembled all over and then became as rigid as sticks. In this state they were dragged off by other *murran* who held them firmly by the shoulders until the fit had passed, which in most cases happened after about a quarter of an hour. If by then they had not recovered a girl was brought to sit on the warrior's legs. It seemed as though a current passed between them, for the man at once became relaxed and opened his eyes; he got up and, after shaking himself, went to join the others. At first I did not dare approach too near, but seeing that no one took any notice of me, I moved in closer and was able to photograph some of the most emotionally important moments in the life of these young warriors.

The dancing went on for about two hours without a pause, the girls joining in with the warriors. Then the old man who had met them at their entrance moved into the centre of the *manyatta*. The warriors, still wearing their head-dresses knelt at his feet, their heads bowed. He spoke to them for a considerable time, beating his long stick on the ground to emphasise his points. At the end of his speech he blew into a large antelope antler, which gave out an eerie sound like a foghorn. One by one the young men got up, formed themselves into a wavy line, like a snake and passed skipping, from one foot to the other, in front of an old woman who sprinkled them with milk which she took from a gourd. Finally, worn out, they came to a standstill, took off their head-dresses and placed them on the points of their spears which they stuck in front of their respective huts. The warriors then disappeared into their huts followed by the girls.

The setting sun, now a huge red ball, lit the clouds of dust that hung in the air. Peace returned. Only the old men of the village stayed around talking in hushed voices. The cattle returned from the pastures in long files, one by one, just as the warriors had done that morning. They return to the safety of the *manyatta* for the night and to give their milk to its thirsty inhabitants. Night fell, the moon rose in the sky, huge and forbidding, bathing the sleepy *manyatta* in its cold light. It is only during the four days of a full moon that such a ceremony can be held. We returned to our camp.

<p style="text-align:center">* * *</p>

The following morning everything came to life again, but four hours later than on the first day of the ceremony. It was eleven o'clock by the time the first *murran* appeared from

their huts. Drowsy, yawning, and stretching themselves, they blinked their eyes in the sunlight. The designs on their bodies had disappeared, and the dried chalk had flaked off. They went off to repaint themselves, this time nearer the *manyatta*. I followed them into the forest. After about twenty minutes they stopped and sat down in a little clearing. During the following three hours the old men of the *manyatta* took it in turn to deliver long speeches, gesticulating with their sticks to mark their points. They spoke rather angrily in a gruff voice. The young men listened in silence without moving, looking bored and restless. They stifled their yawns and stretched their arms and legs muttering to each other in low voices. Their head-dresses weighed heavily on them in the hot sun. They took them off and set them on the ground beside them, shaking their long hair out behind them. I could see them through the leaves of the bushes, the little indistinct blotches of mottled colour and light made the scene look like a strange tapestry, symbolic, beautiful but incomprehensible.

When the speeches were over they all got up and went deeper into the forest. They saw me – a few came up to me and asked me not to follow them. They were going to perform one of the most important and solemn parts of the ceremony, and no women are permitted to behold the scene, not even their own. They told me that they were going to drink the raw blood of a steer or bullock that had been specially chosen and consecrated for the ceremony by feeding it on honey-wine the evening before. This animal, selected from hundreds, had been forced to swallow about twenty litres of Maasai honey-wine, which is poured down its throat through a gourd. Its tongue is held until the correct amount has been swallowed, enough for the alcohol to penetrate the blood. Later the steer is ritually sacrificed by suffocation and pouring milk mixed with wine down its nostrils. An incision is made on the animal's dewlap, from which the skin is detached and formed into a pouch. The jugular vein is then severed and the blood flows into the pouch without touching the ground. One by one each *murran* steps forward, kneels before the sacrificial beast and drinks. The warrior beside him holds his hair back from his forehead to prevent it falling into the blood. He then gets up and the next warrior bends down to drink. When all of them have drunk, the steer is skinned in a particular ritual fashion, which results in the hide forming a single continuous thong. Small pieces of hide are cut off this thong, incised and placed on the middle finger of each *murran's* hand by one of the leaders of the ceremony. I let them go away.

At the end of the day the *murran* returned to the *manyatta*. They were very excited, intoxicated by the blood, the alcohol and with wild cries they ran like madmen through the trees. On their arrival at the *manyatta* they took up their positions for the final dance. The strange mixture they had swallowed had made them drunk. Their red throats glistened in the evening light with sweat which dropped from their foreheads around them. The old people who stood around waiting for them begged me not to stay too close for fear I be crushed. I climbed on to the roof of my car.

It was an extraordinary, beautiful, crazy ballet. The swirling dust which enveloped the dancers in a transparent cloud, pierced by the rays of the sinking sun, set their head-dresses aflame, casting incredible shadows around them. They jumped from one foot to the other, their heads jerking backwards and forwards in time to the rhythm of their song. They

formed a long line which wove in and out of the *manyatta*; it was divided into two parts; lions and ostriches. They rejoined forming circles, figures of eight, semi-circles, twisting in and out breaking apart, coming together again. They formed a huge tide of bodies which ebbed and flowed from one side to the other. All the members of the *manyatta* stood round in a great circle watching them as if in a trance.

It was hypnotising, I found it very hard to stay calm and remember what I was there for. I felt the urge to jump up and join in the dance which went on for about an hour. As suddenly as it started it stopped. Totally exhausted the dancers dispersed. In less than five minutes it was over. Quiet and empty. The dust left hanging in the air settled gently to the ground. The warriors disappeared into the huts followed by their girls.

That evening about twenty *murran* came to see us at our camp. They knew that we were leaving them the following day, perhaps for ever. They were curious to hear our impressions. By watching the ceremony we had shared with them the most important and solemn moment of their youth. Tomorrow, the final day of the ceremony, their hair would fall and they would become "old". They were all about twenty to twenty-five years of age, but today the wildness of youth, the carefree days they had known, were over. After this they were expected to display wisdom and become the respected members of their tribe. Now, they could seek a wife, have children, and grow gently old. There was a certain melancholy as they spoke. They told us how until this moment they had been permitted companionship only with immature girls who had not yet been initiated into womanhood, therefore avoiding the risk of making them pregnant and of children being born with no father to provide for them.

* * *

The following morning I got up at seven o'clock and went to the *manyatta*. Inside it small groups of *murran* squatted on low stools. They were very silent. Their mothers were shaving off their hair with razor blades, and it dropped in small heaps on a cow skin at their feet. All this hair, on which they had lavished so much love and care, and which was their great pride, fell in the space of a brief ten minutes. Some of the young girls gathered it up tenderly and rubbed it on their thighs. The warriors' eyebrows were also shaved, and their heads covered with red grease. The sun had not yet risen, and the night clouds hung like a thick blanket, over the sky. A light rain was falling. Nobody uttered a word, and it was cold and miserable. I walked among them, but no one greeted me. I might have been a complete stranger. Their faces had a melancholy expression. Squatting on their stools, submissive and silent, they trembled with emotion.

Each warrior sat anxiously waiting to see if it would be *his* mother who shaved his head; for mothers, like their warrior sons, were expected to lead an exemplary life, and any mother who was known to have slept with one of the warriors would be prevented from shaving her son's hair. And to not have shaved her son's hair at *this* occasion would have been a shame she would bear publicly for the rest of her life.

The women were not at all pleased to see me there with my damned camera. They told me to get out and started insulting me. I paid no attention and walked on to the next group. All around me were people who barely an hour before had looked like gods, now become

dull, ordinary men. Their beauty, their arrogance had gone; their shaven heads, their shining bodies swathed in dark cow skin, were suddenly old. They had taken the step.

Noah came up to me. For a moment I hardly recognised him. He offered something in his hands – it was his hair. This was, I knew, a great honour and show of friendship, for Maasai carefully burn or secretly dispose of hair or fingernail clippings, lest an enemy use them to practice sorcery against them. "Take it," he said, and I was deeply moved.

35–38. *Young Maasai warriors wear only ochre coloured pieces of material knotted at the shoulder which usually hang in front to cover their sex. The bare behind is typical of the Maasai warrior. However this is fast changing. The present government is starting to enforce the wearing of trousers in order to avoid nudity.*

39 & 40. *The olaiboni (big chief) talking to young warriors before the Eunoto ceremony starts.*

41 & 42. *Maasai warriors decorating themselves and each other with white chalk for Eunoto dance.*

43 & 44. *Maasai lion head-dress. Each warrior who has killed a lion himself is allowed to wear this head-dress during the ceremony.*

45 & 46. *One of the elders of the manyatta inspecting the dancers and shouting directions for the dance.*

47 & 48. *Elder women accompany a warrior to face the Osingira hut.*

49 & 50. *Warriors and their girls running to join dancers in the manyatta.*

51 & 52. *Warriors in full dance regalia listening to olaiboni in the forest before sacrificial blood is drunk.*

53 & 54. *Above: View of the manyatta with all the warriors gathered for final dance of the ceremony.*
Below: the dance.

55 & 56. *Maasai warrior having an epileptic fit is firmly held down by another warrior to prevent him hurting himself. Often a young girl is brought to sit on his legs – the contact of her body on his makes the fit pass immediately.*

57 & 58. *Warriors dancing round Osingira hut. The elders – their heads shaved and white chalk marks on their faces – keep them in order with long sticks and whips.*

59 & 60. *Warriors leave compound at end of dance to eat meat in forest.*

61 & 62. *Young Maasai girl measuring length of her warrior's hair before it is cut off.*

63 & 64. *Warrior having his hair shaved by his mother at end of ceremony.*

65 & 66. *Warrior with hair tied back awaits his turn to be shaved while watching his friend's hair falling.*

67 & 68. *The shaven warriors smeared in red ochre fat.*

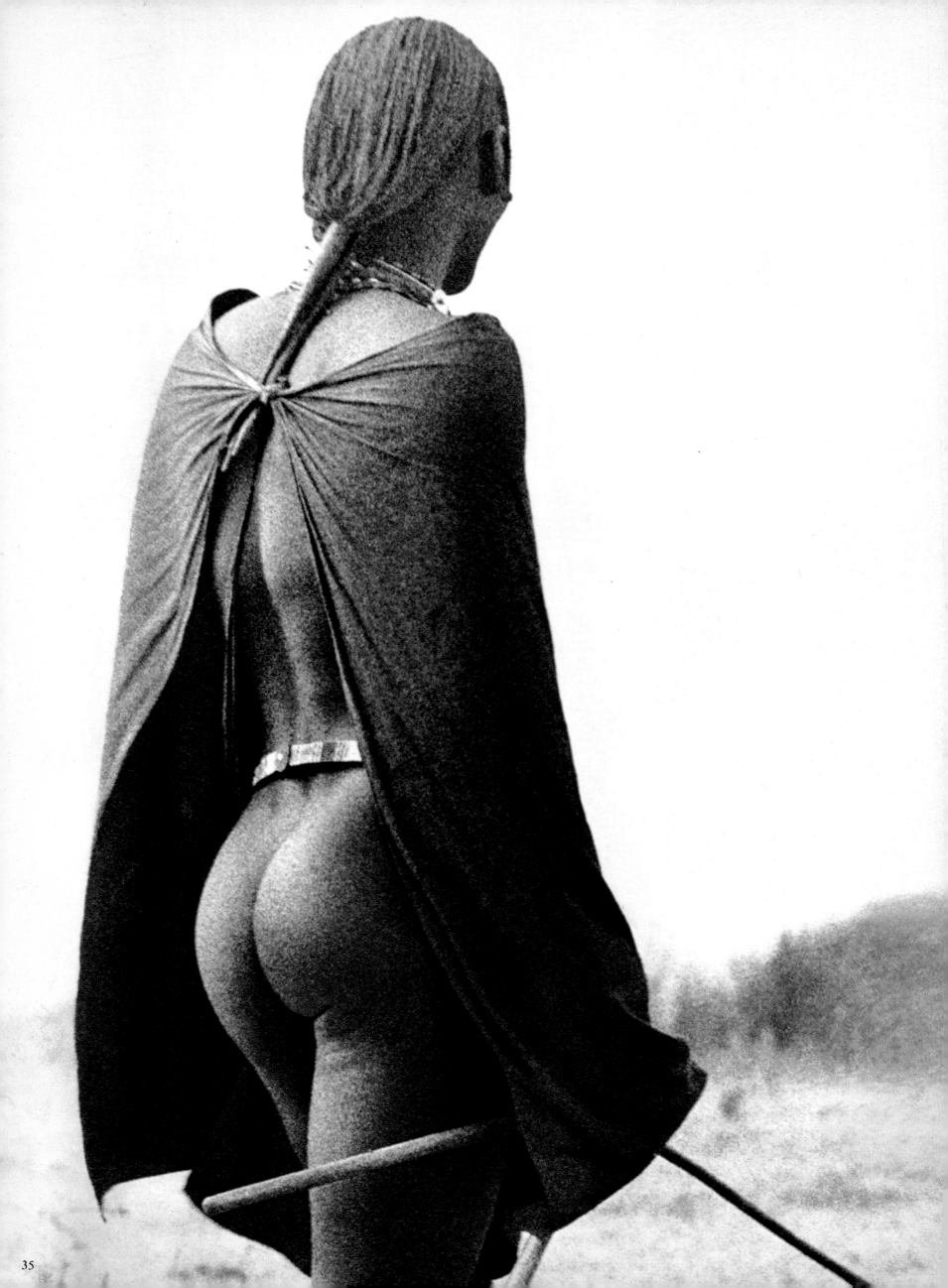

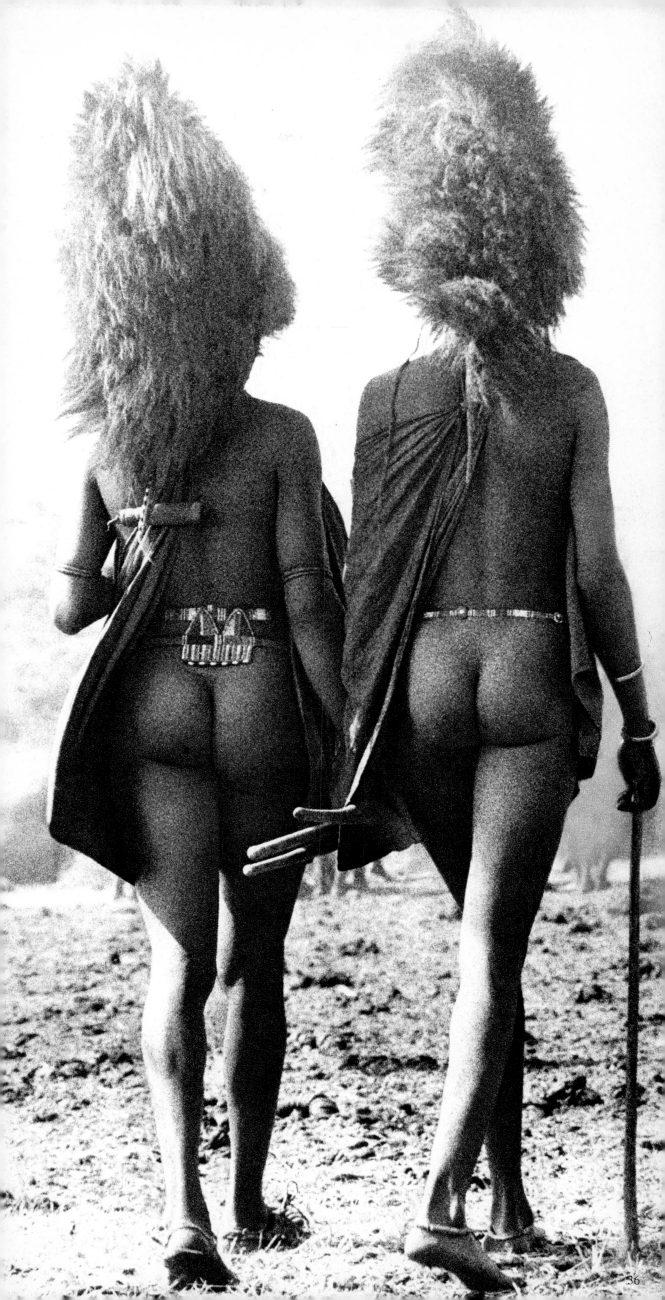

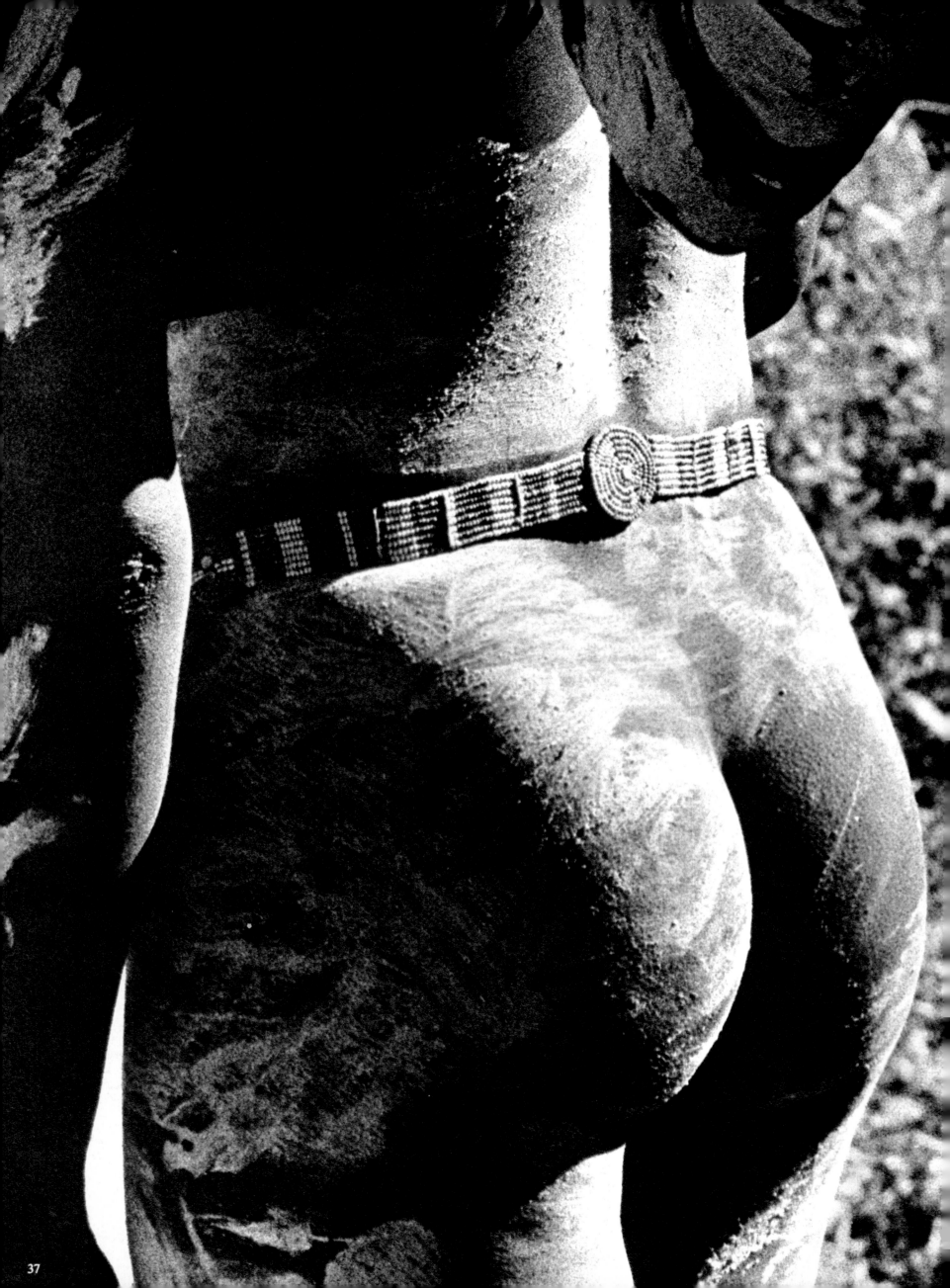

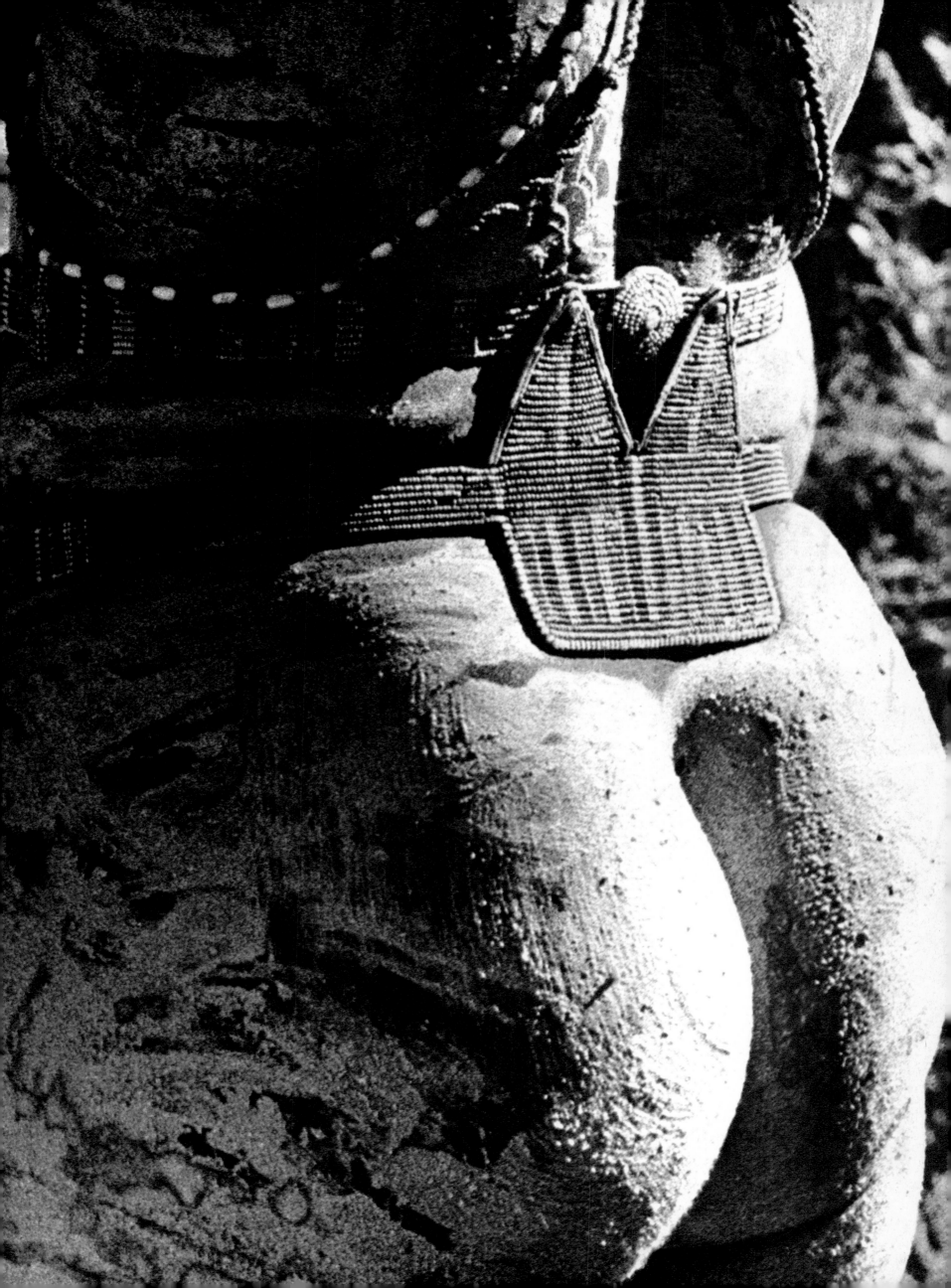

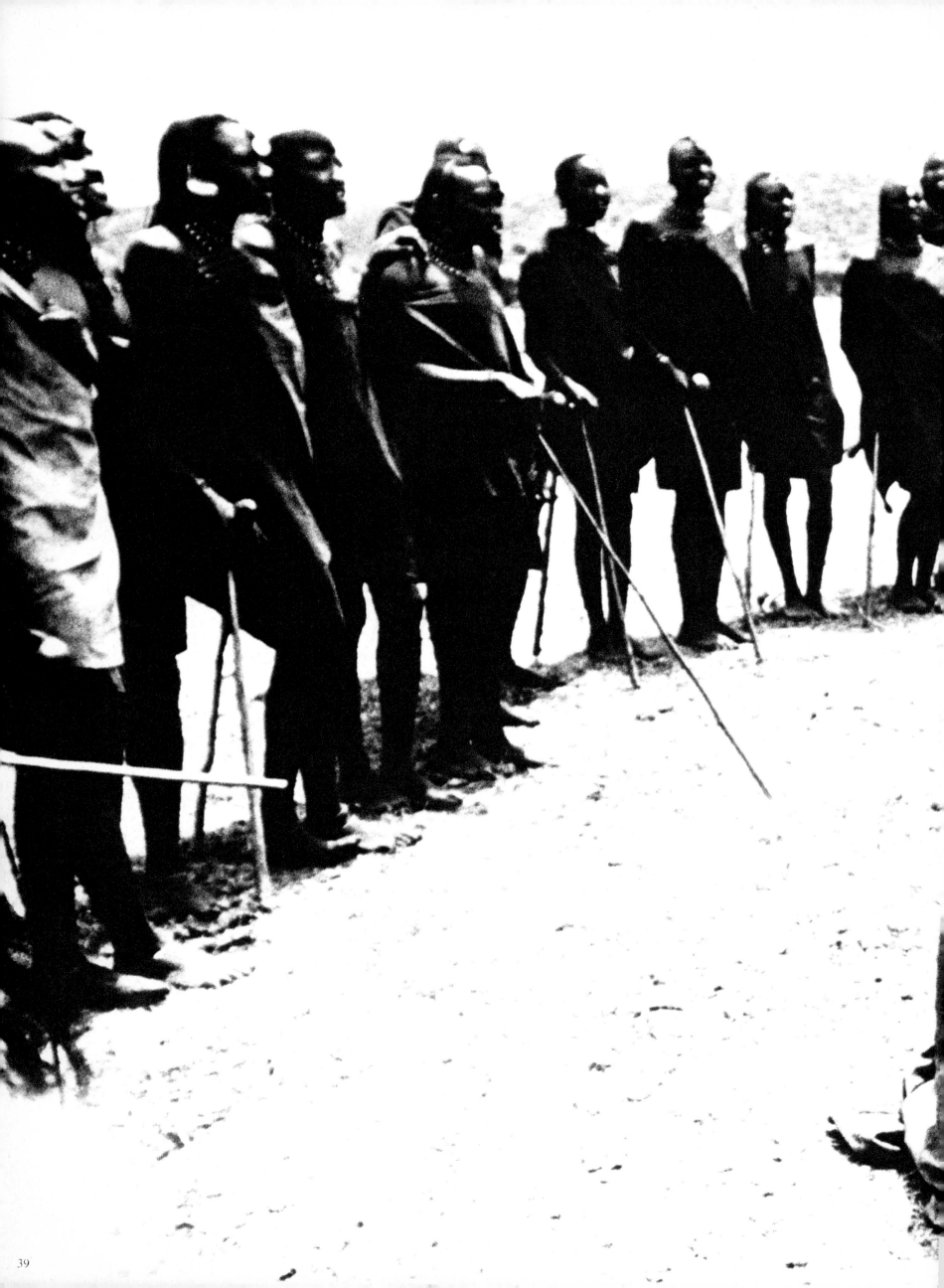

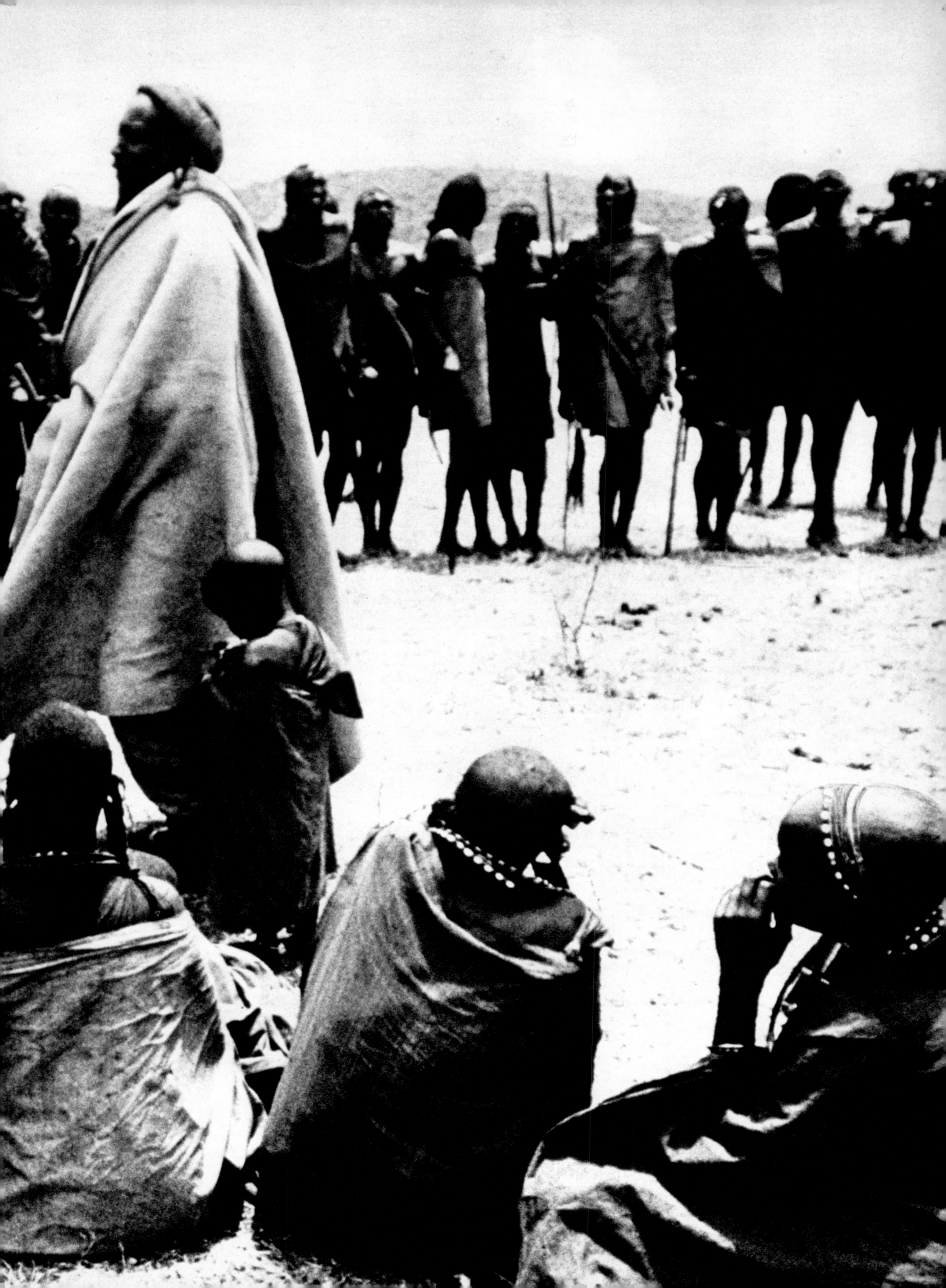

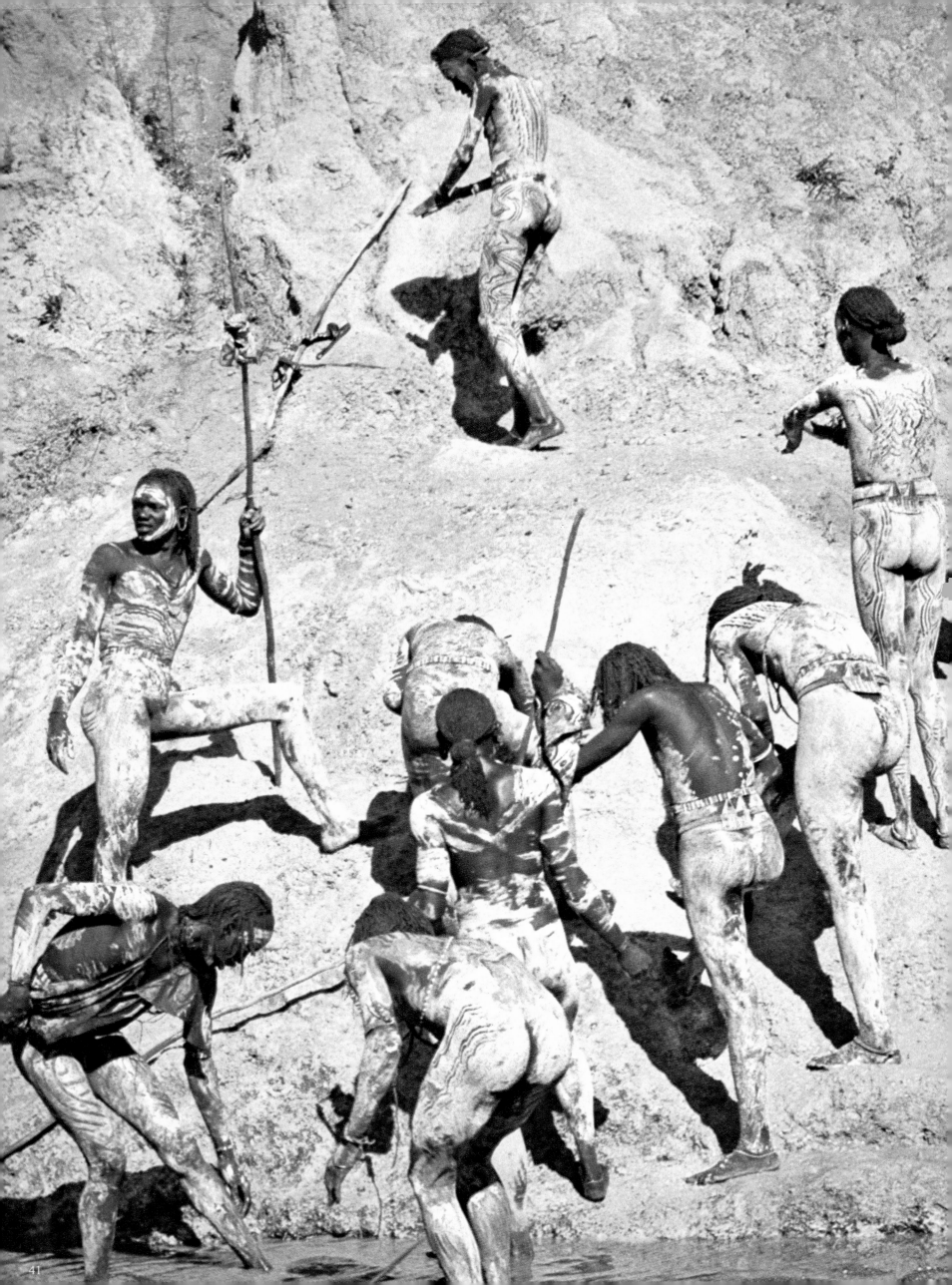

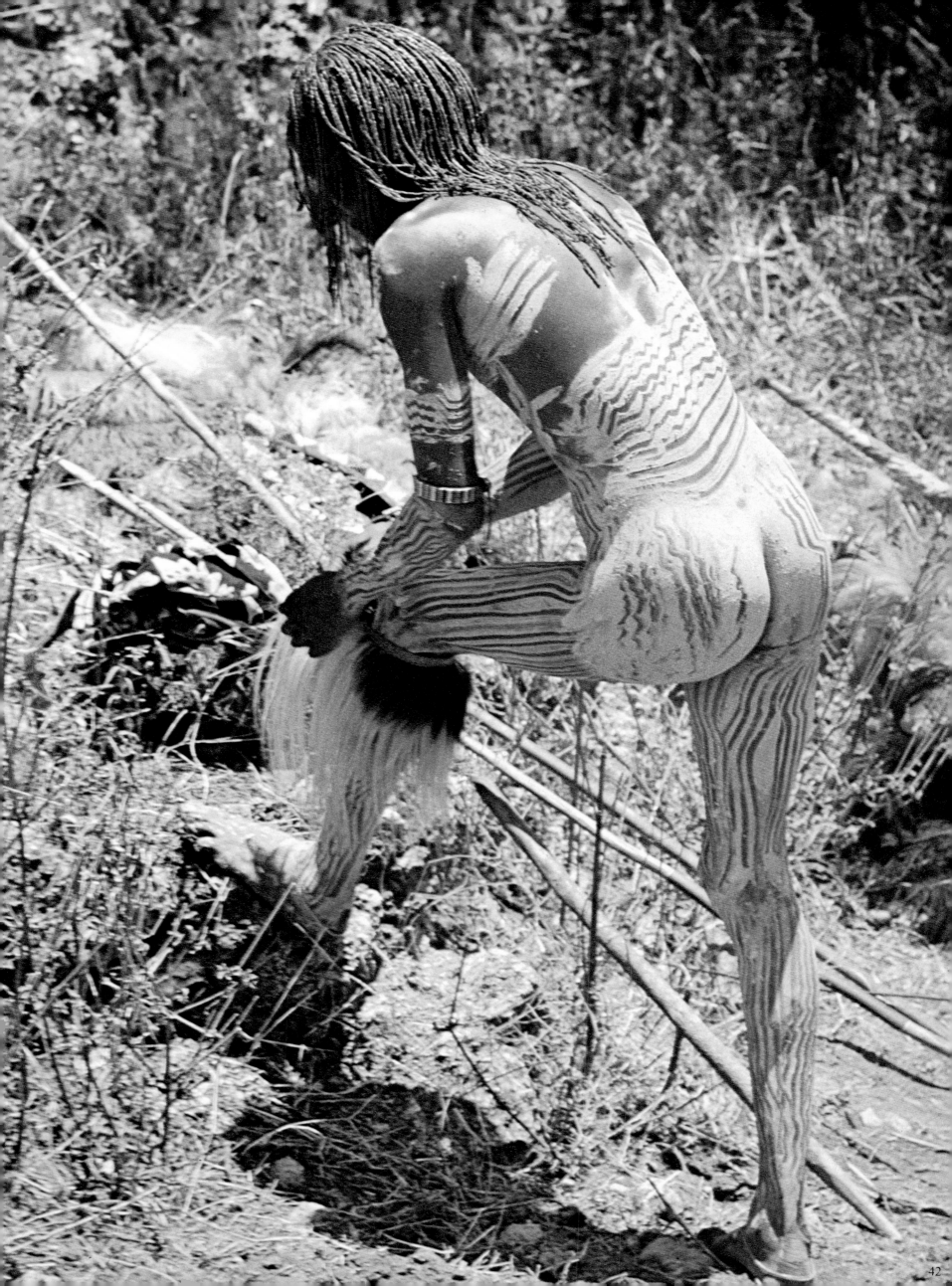

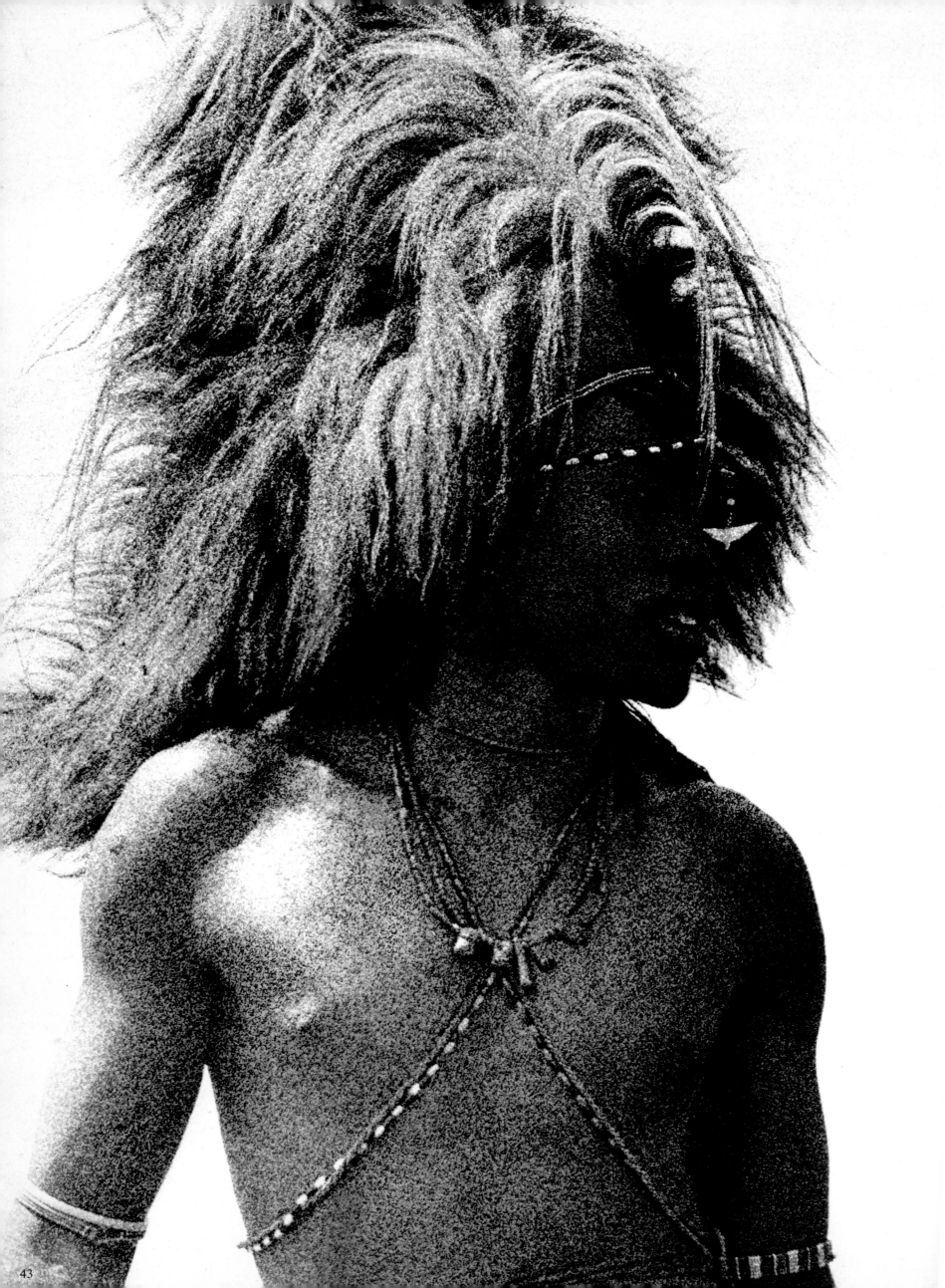

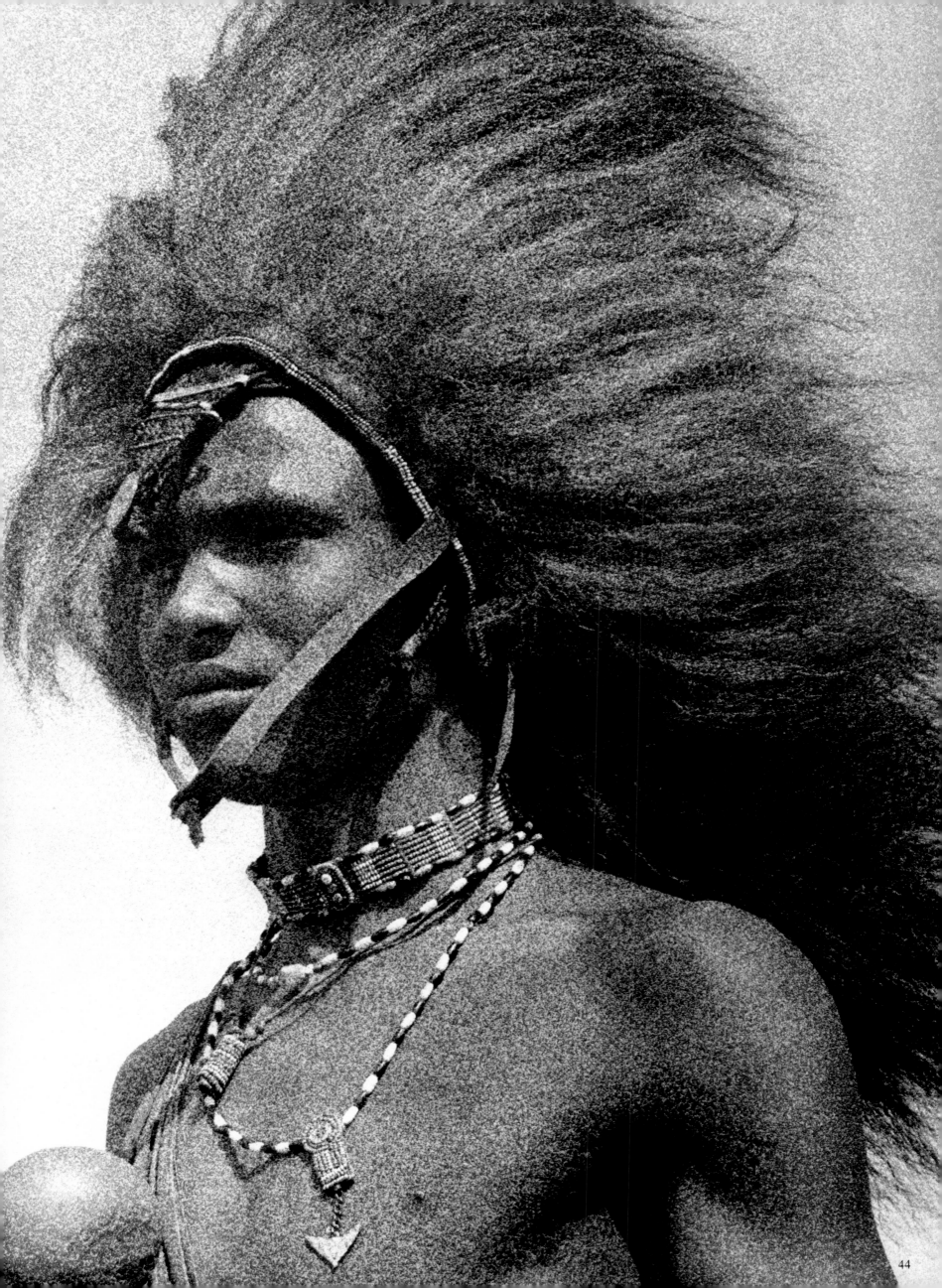

44

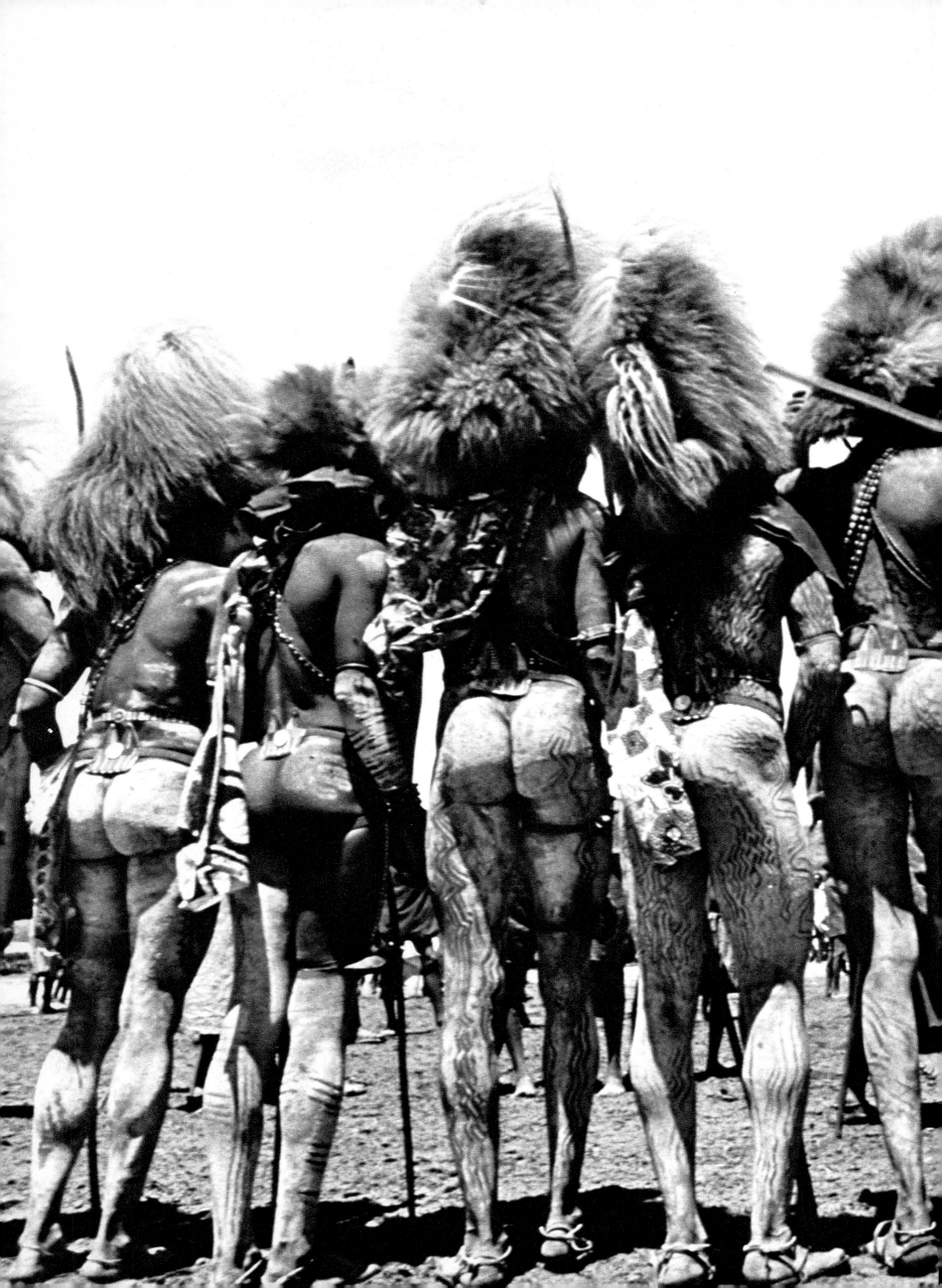

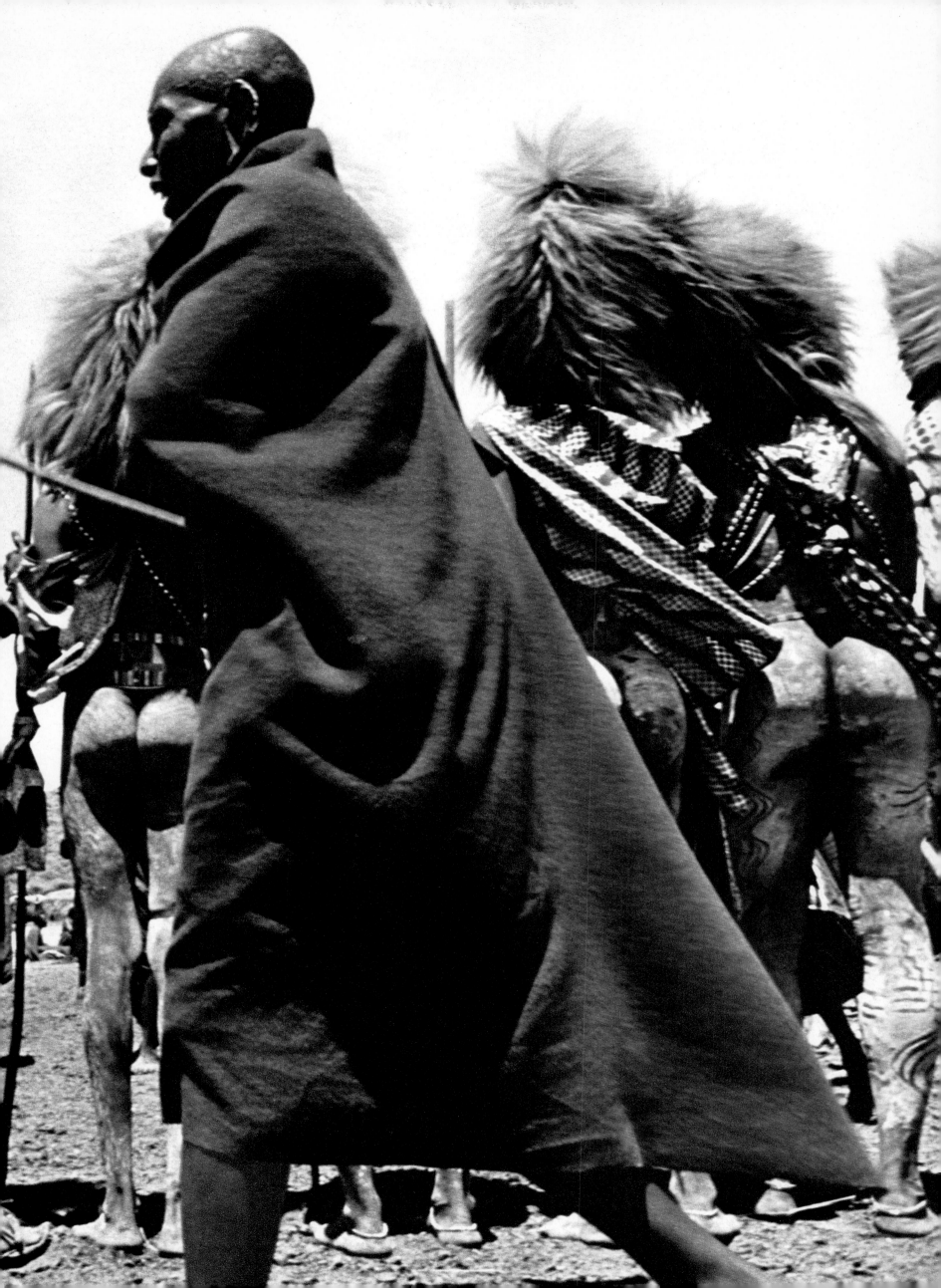

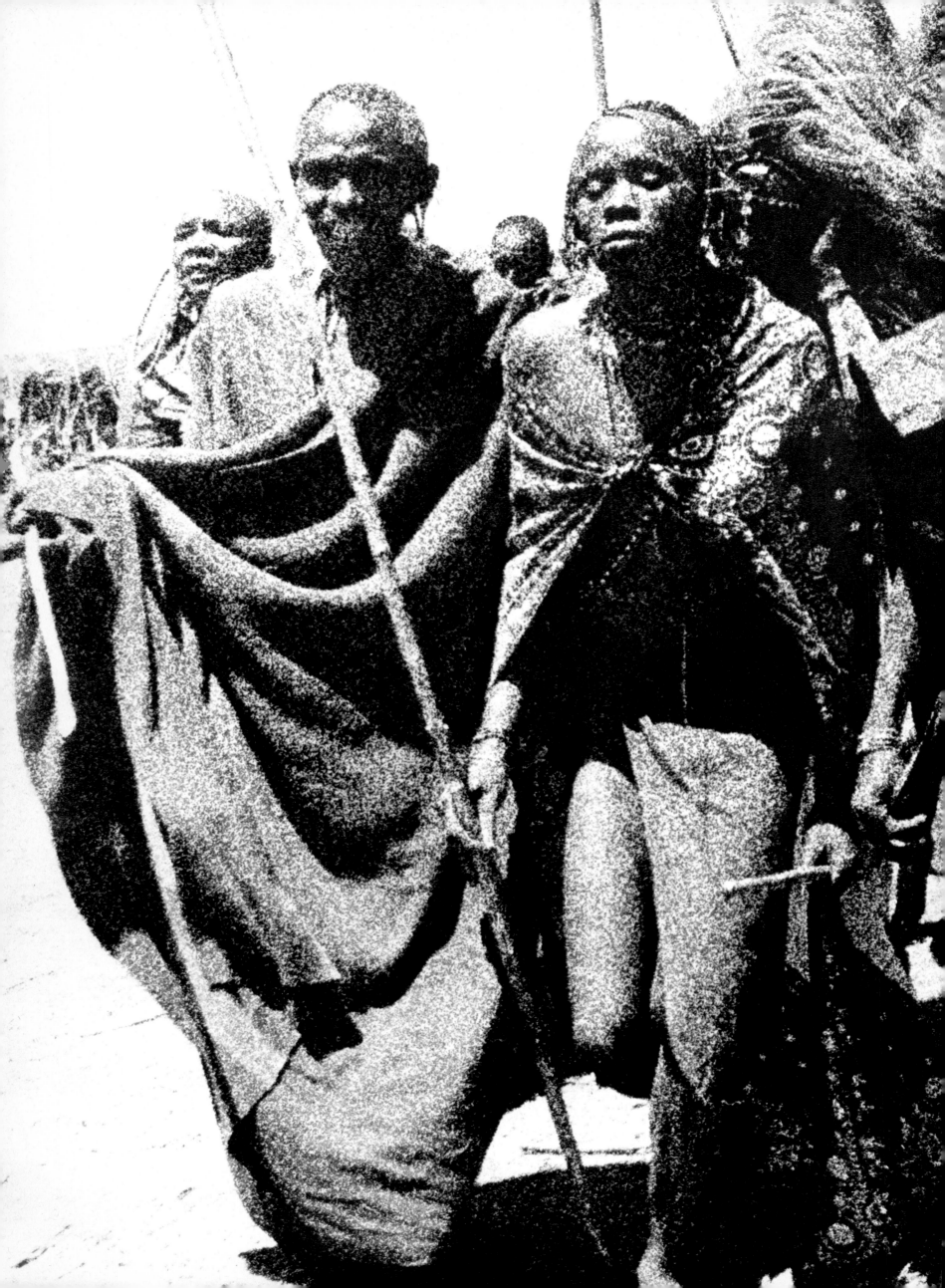

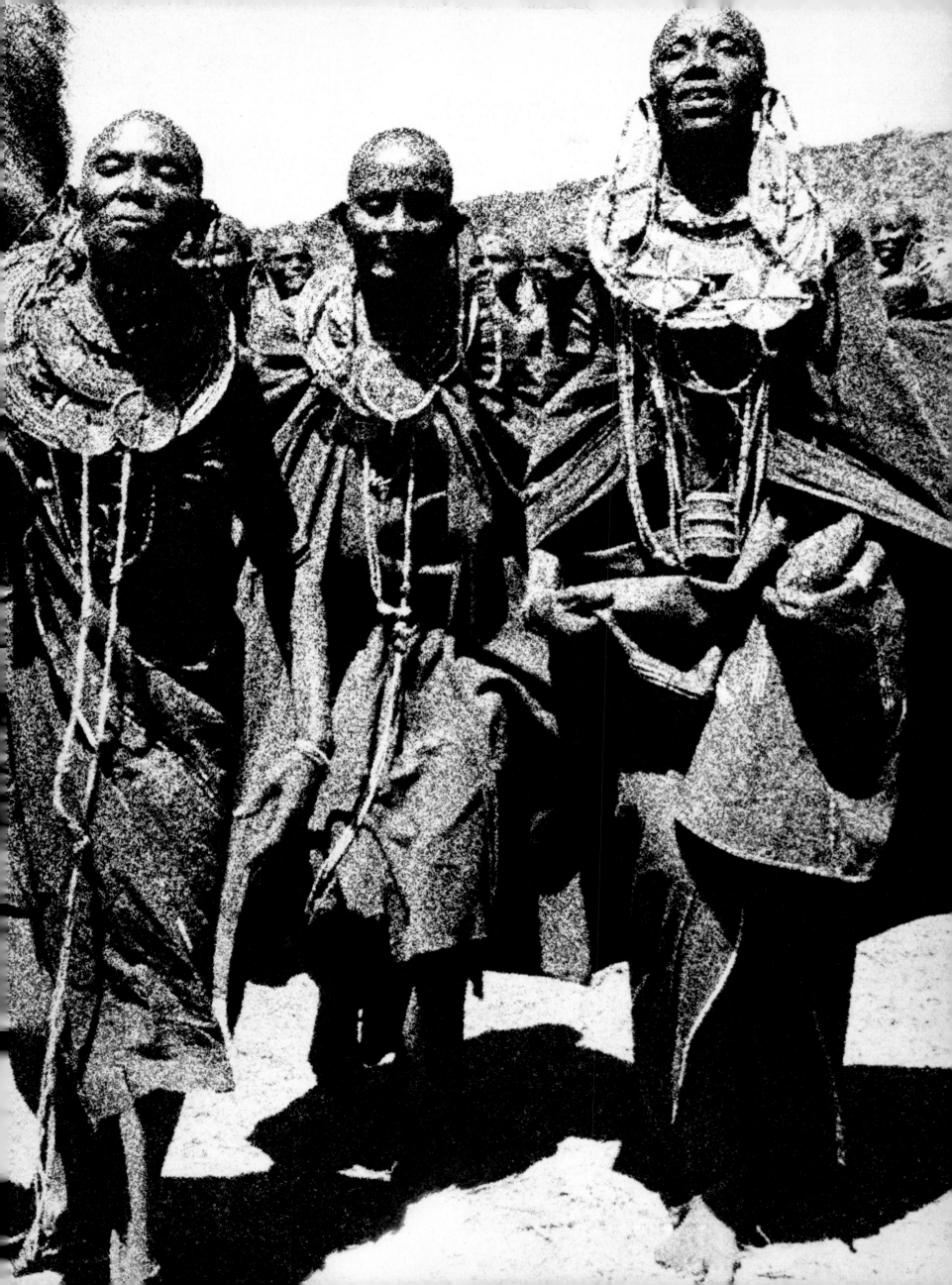

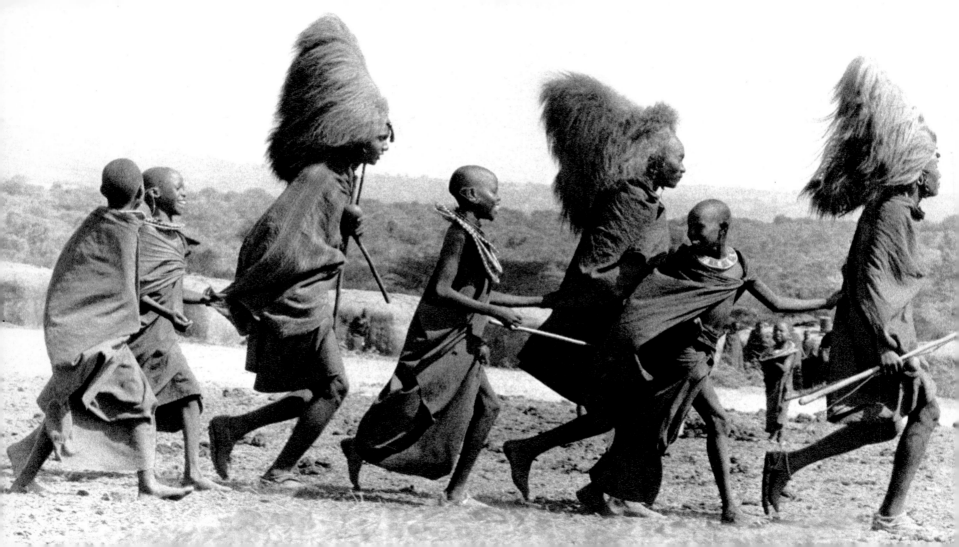

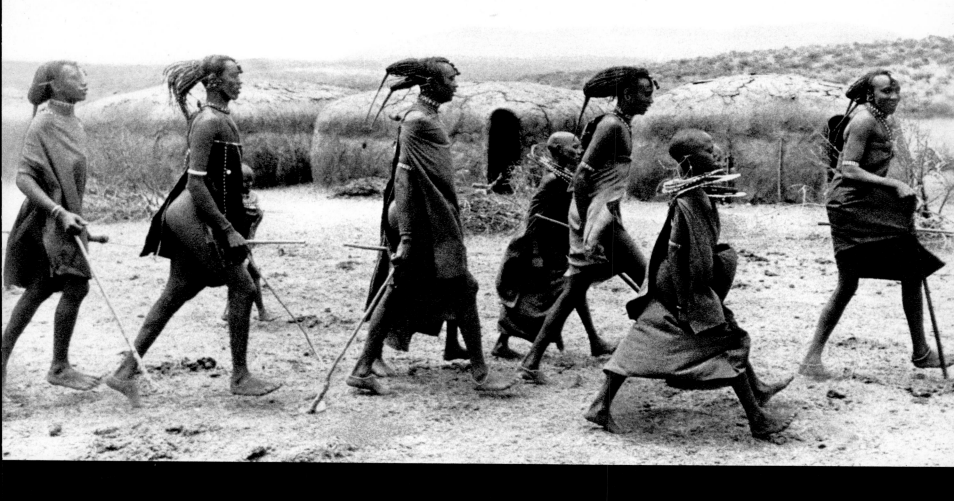

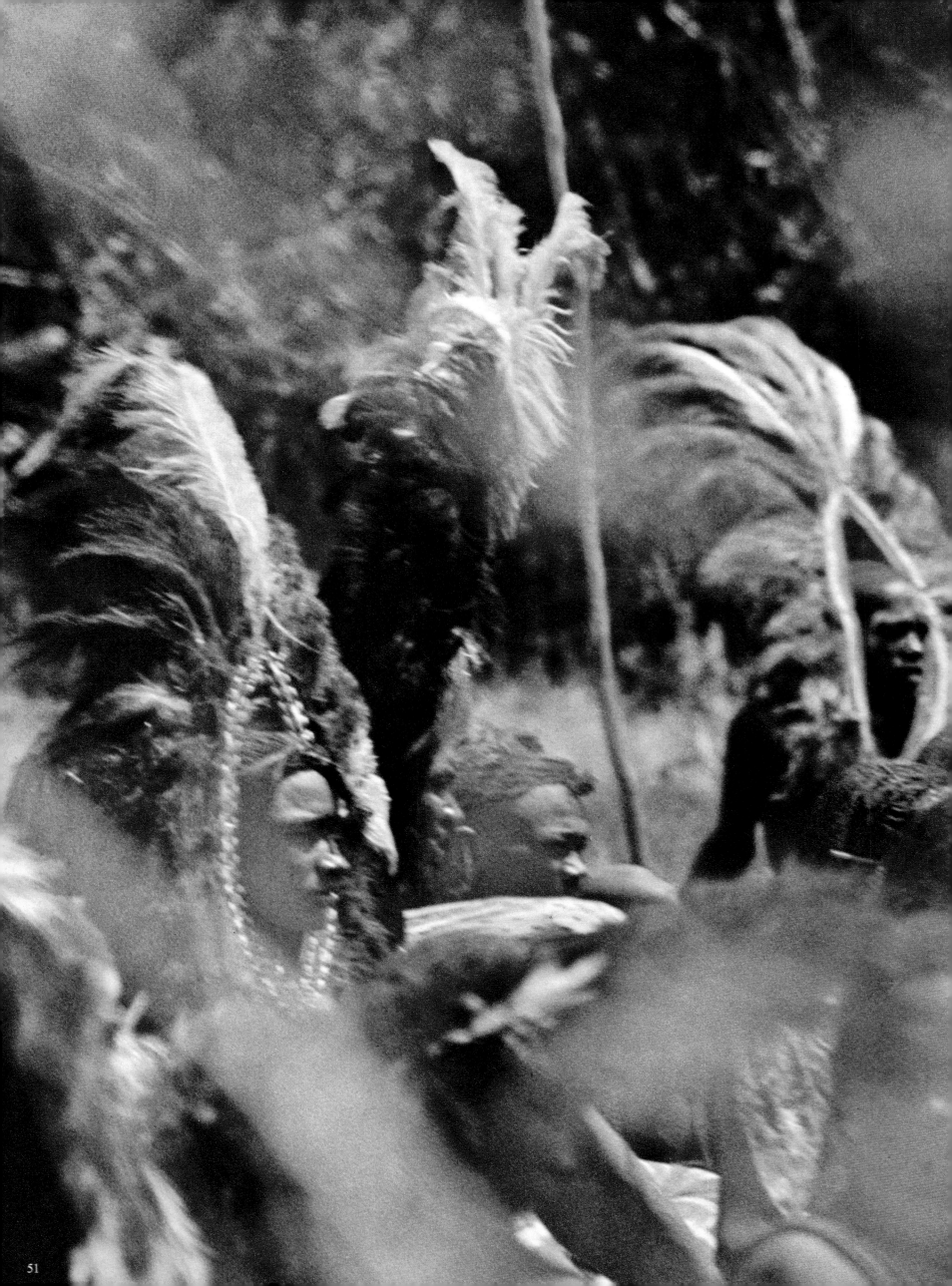

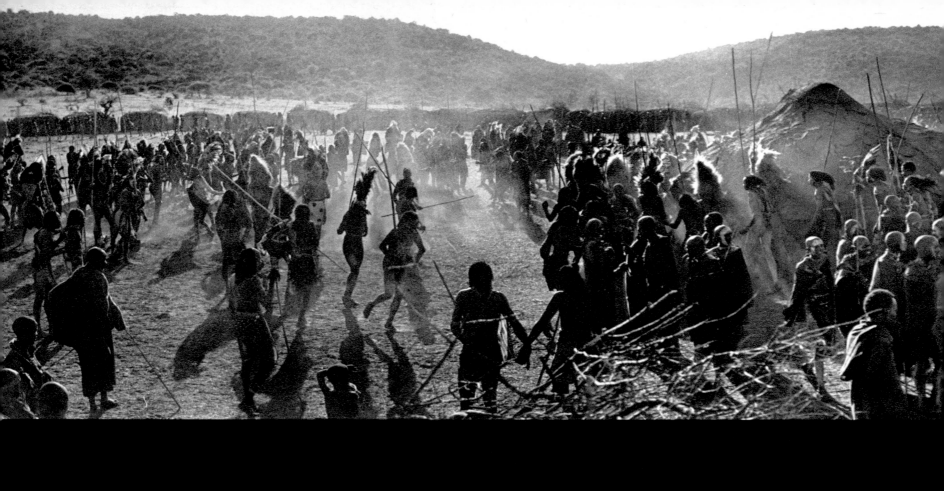

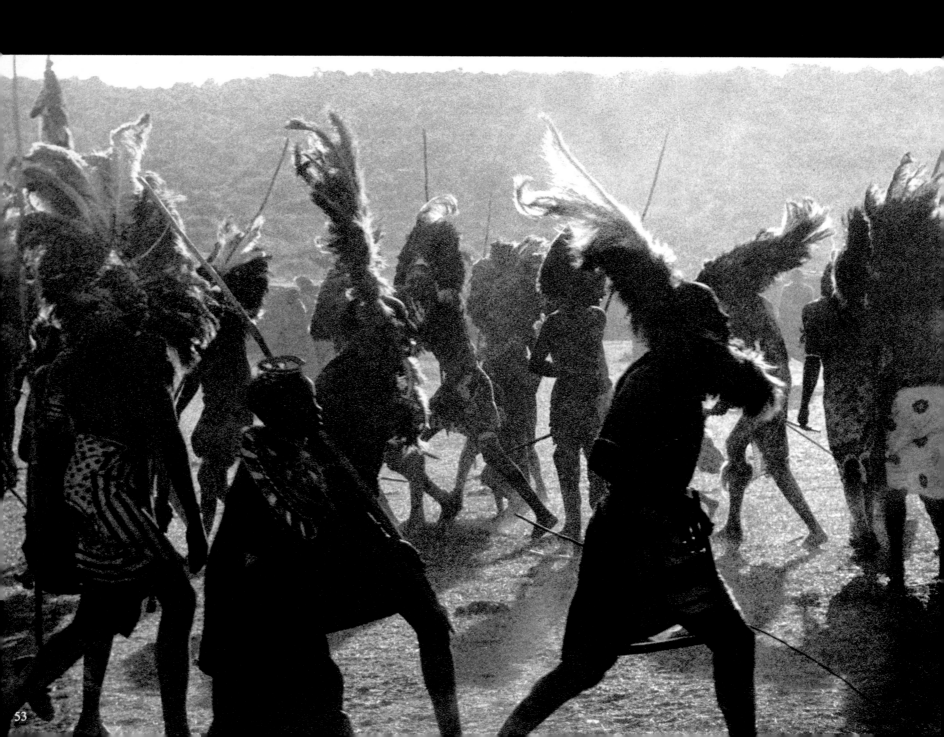

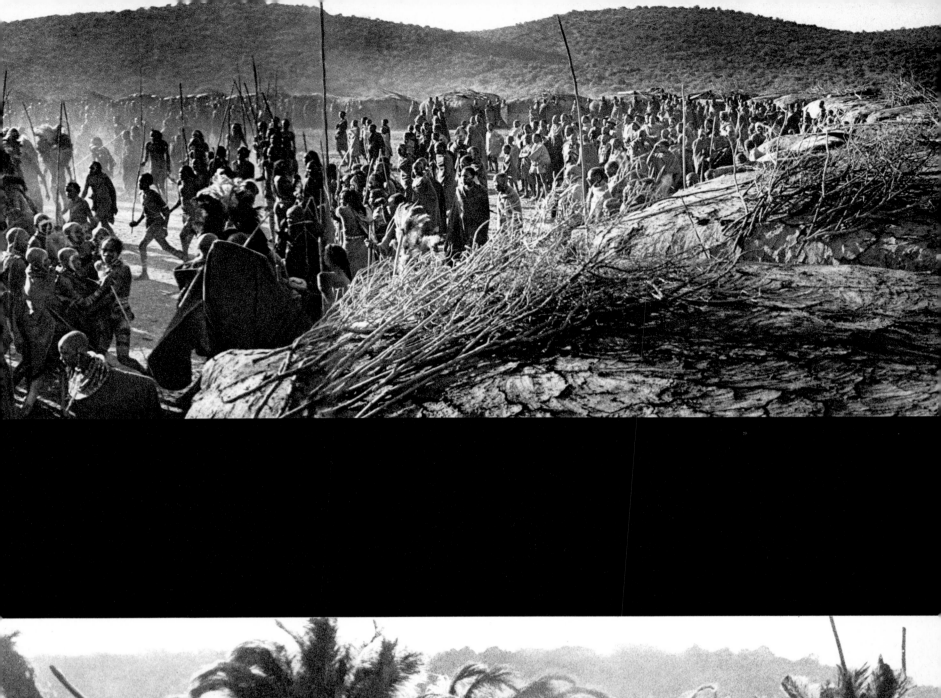

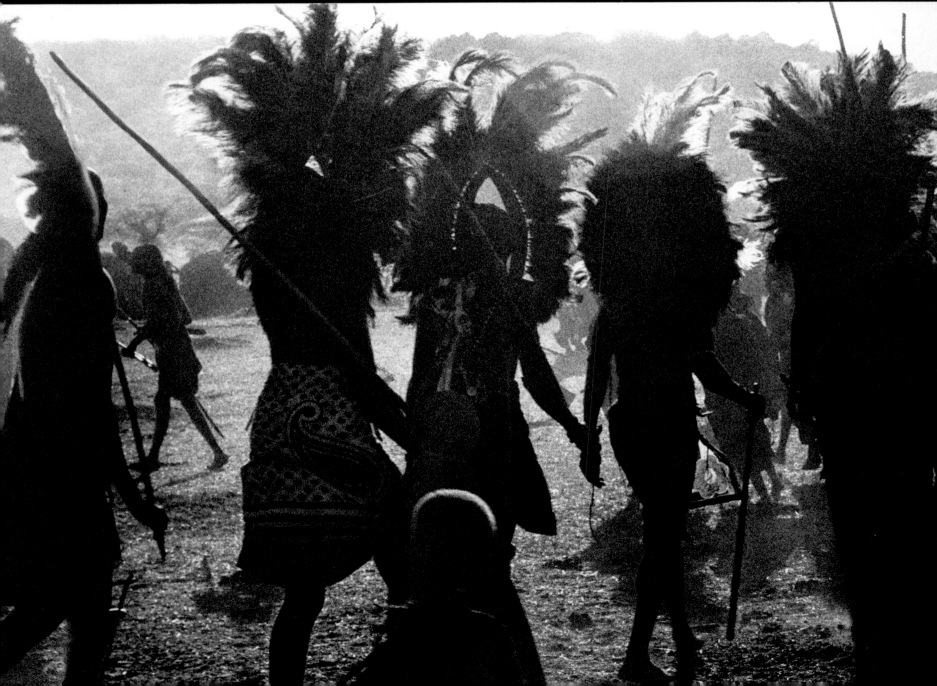

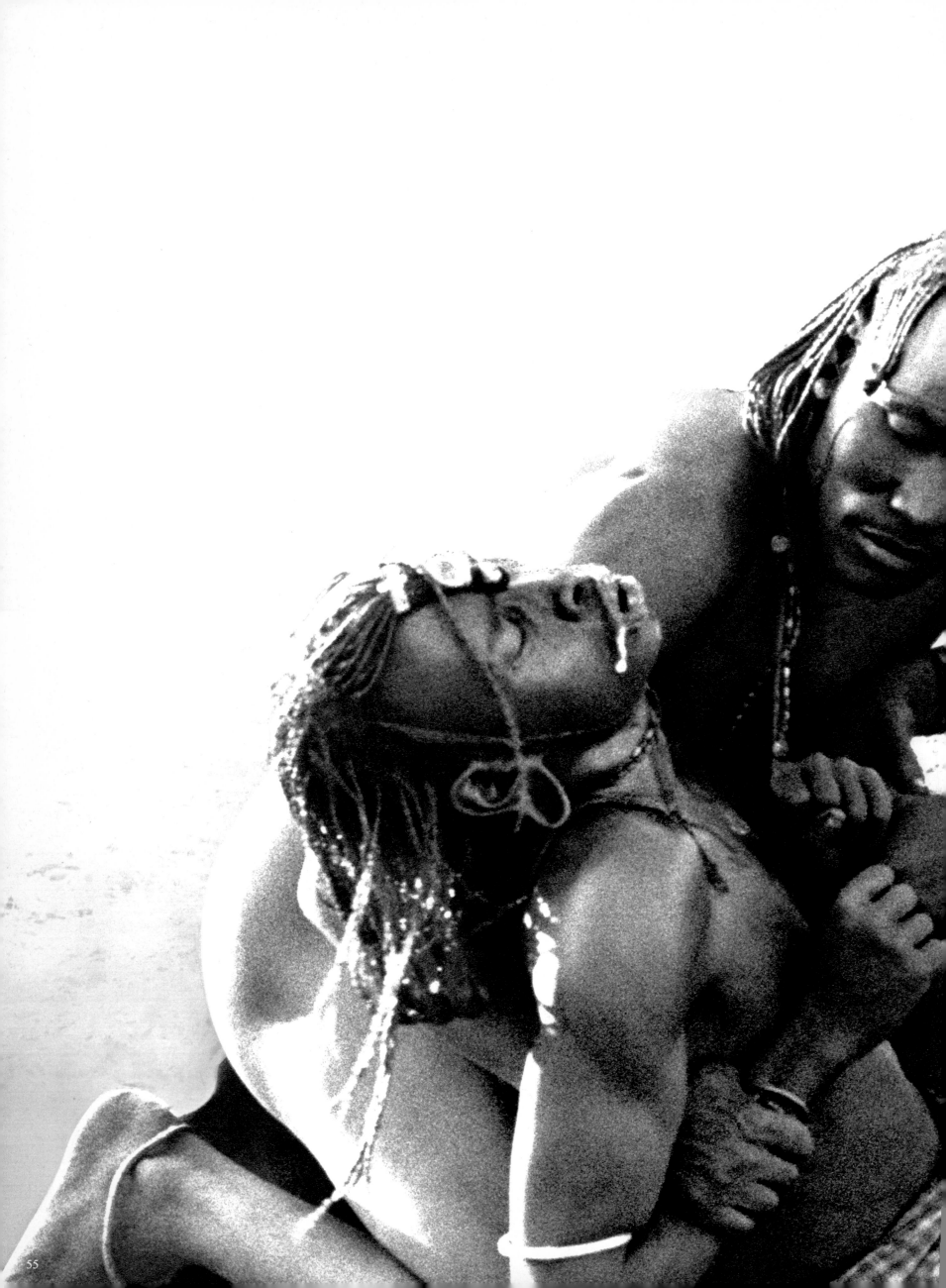

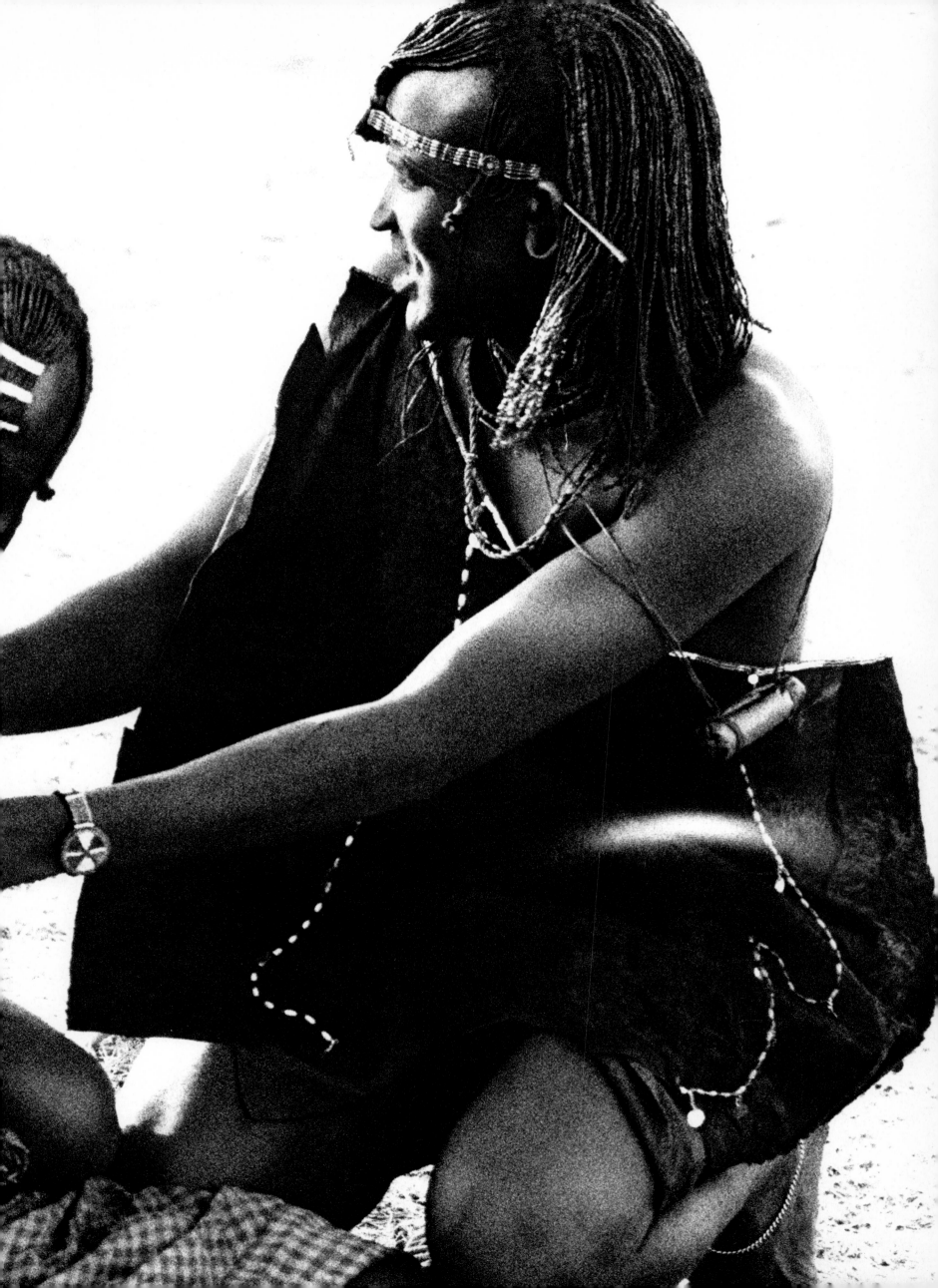

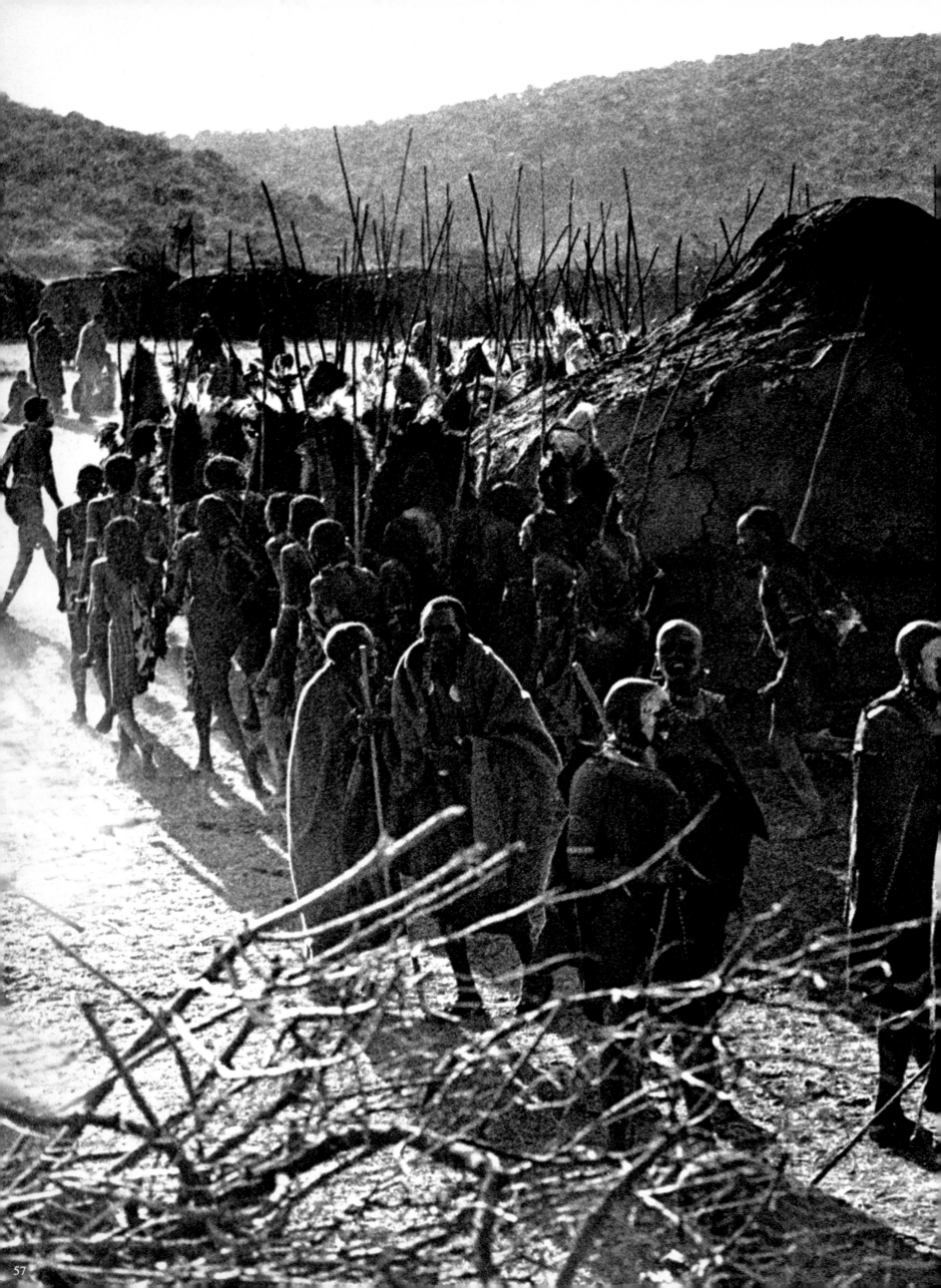

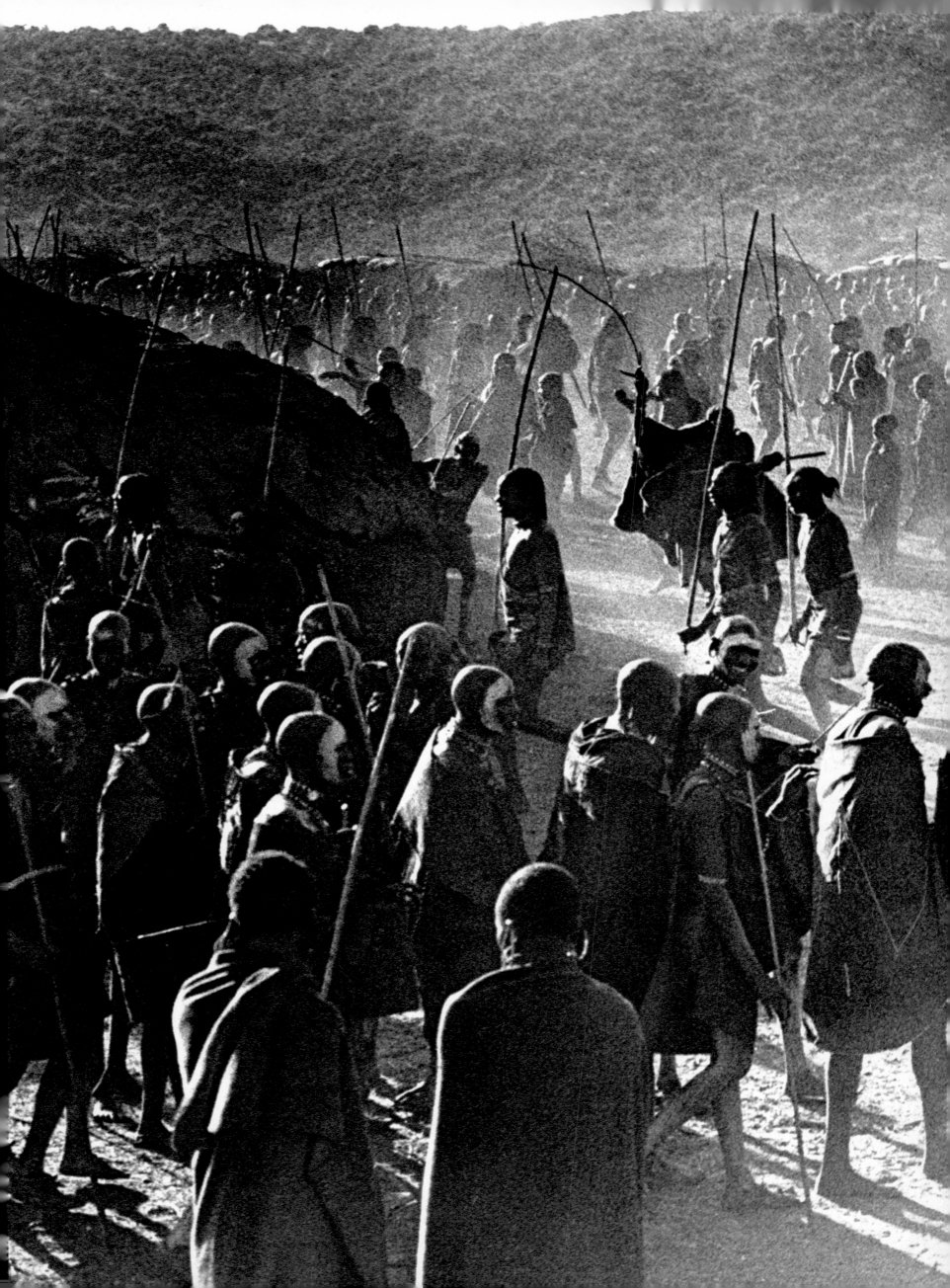

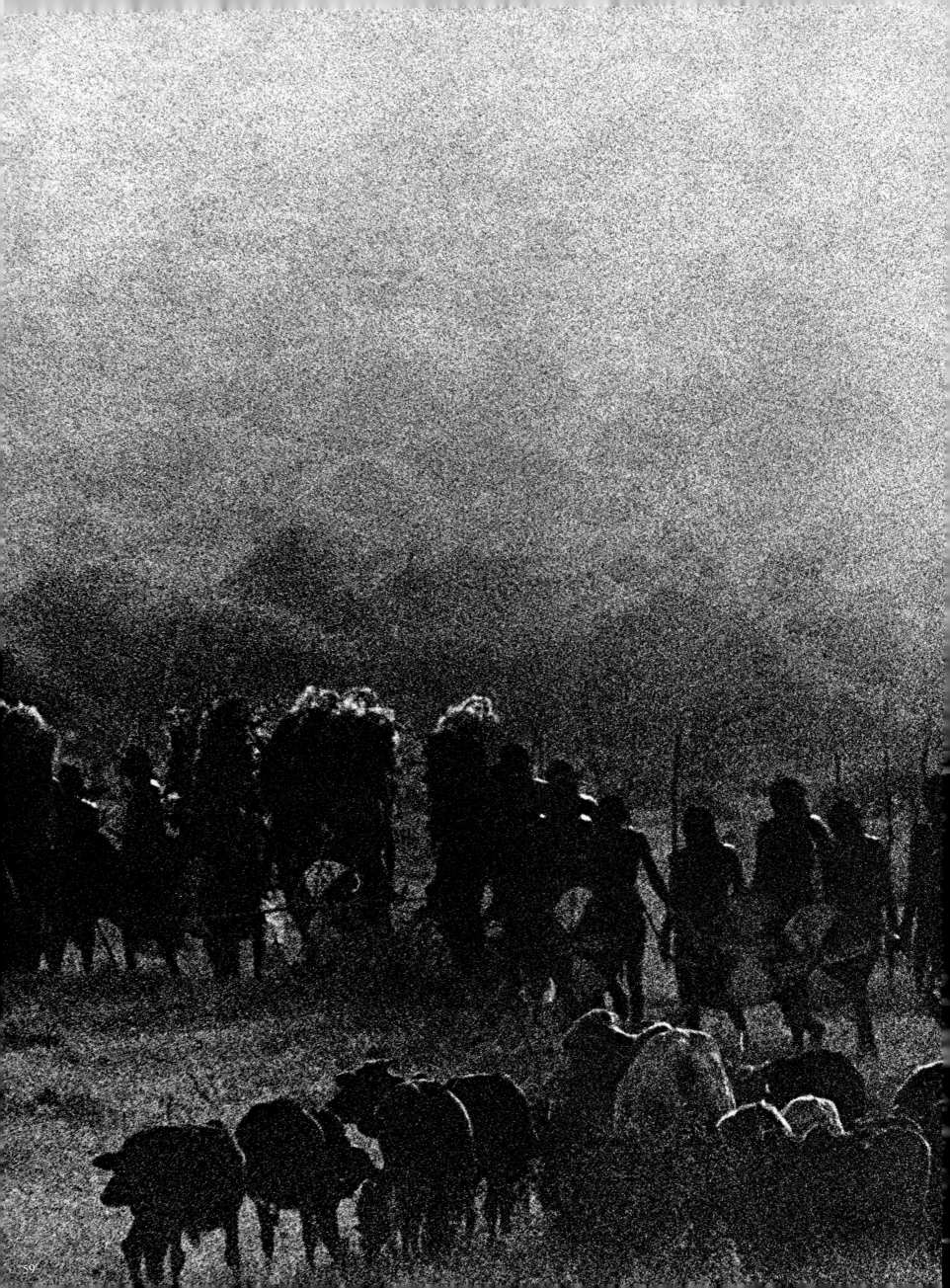

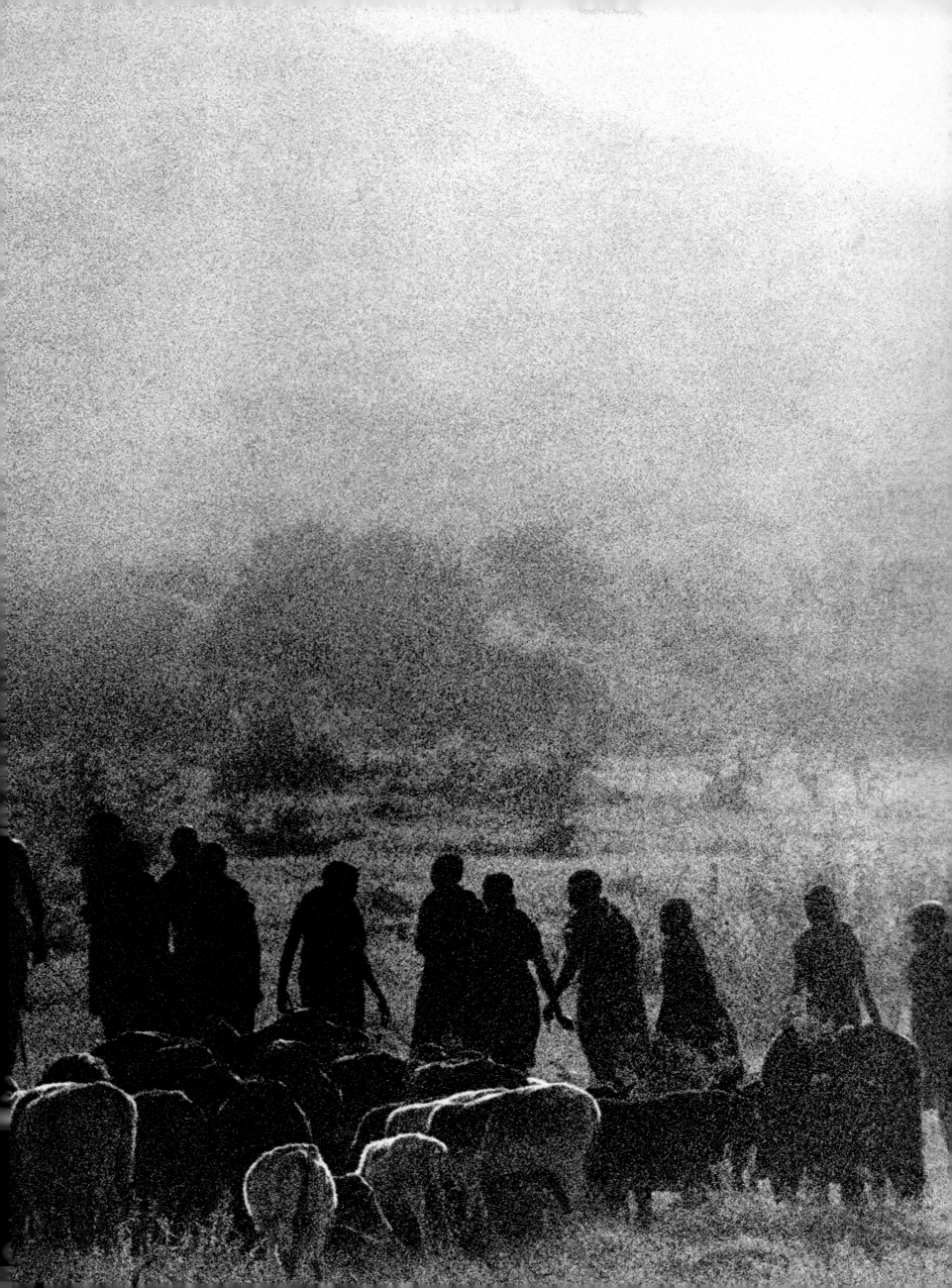

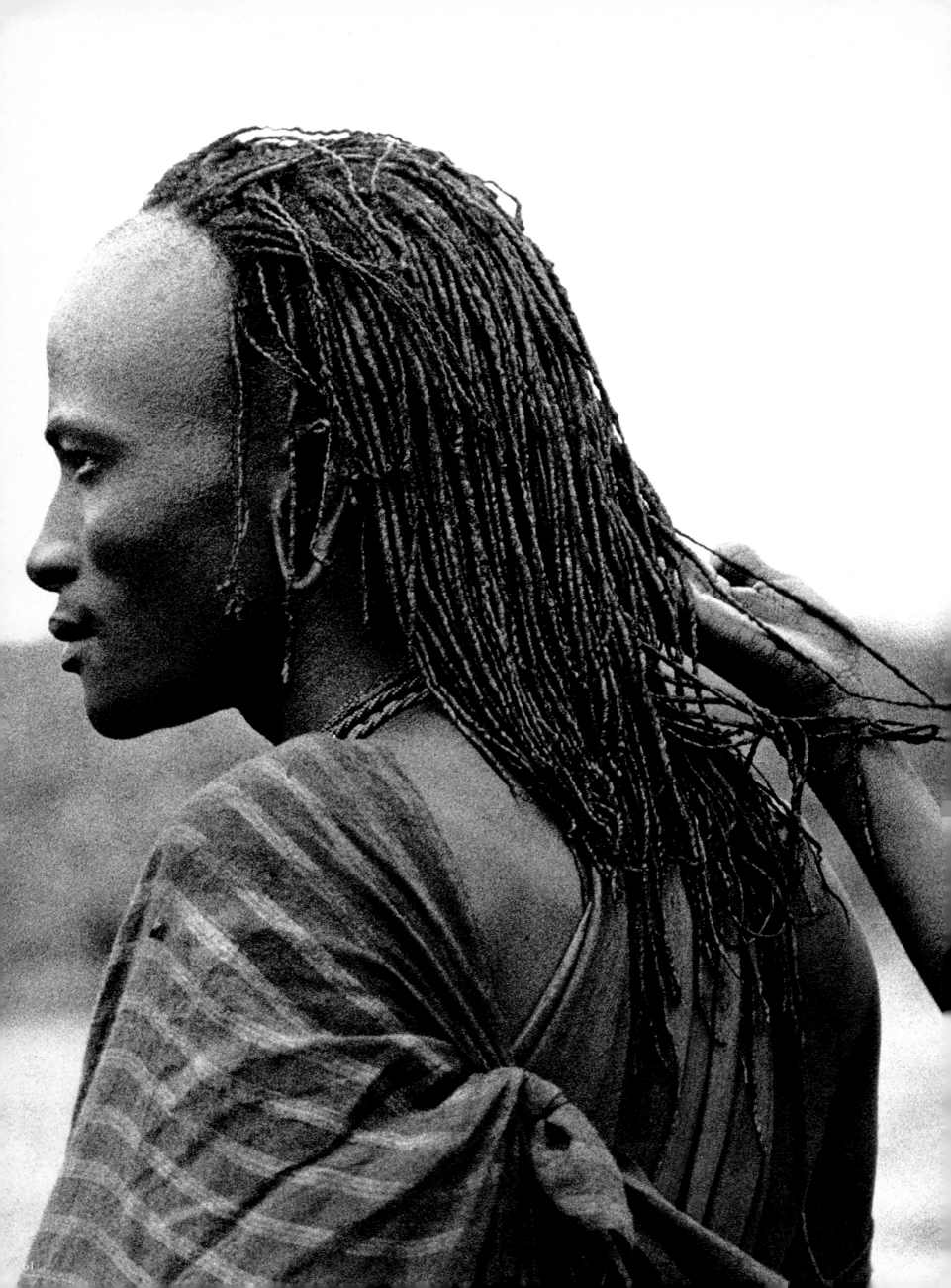

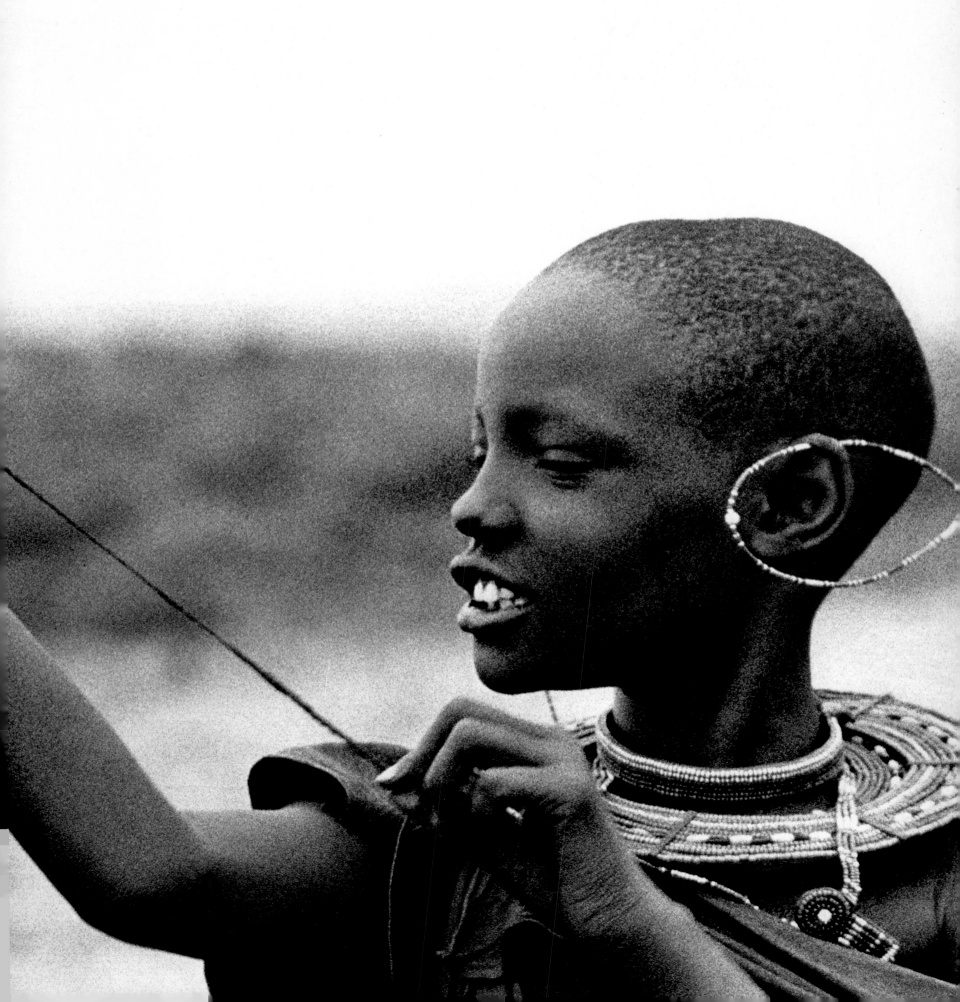

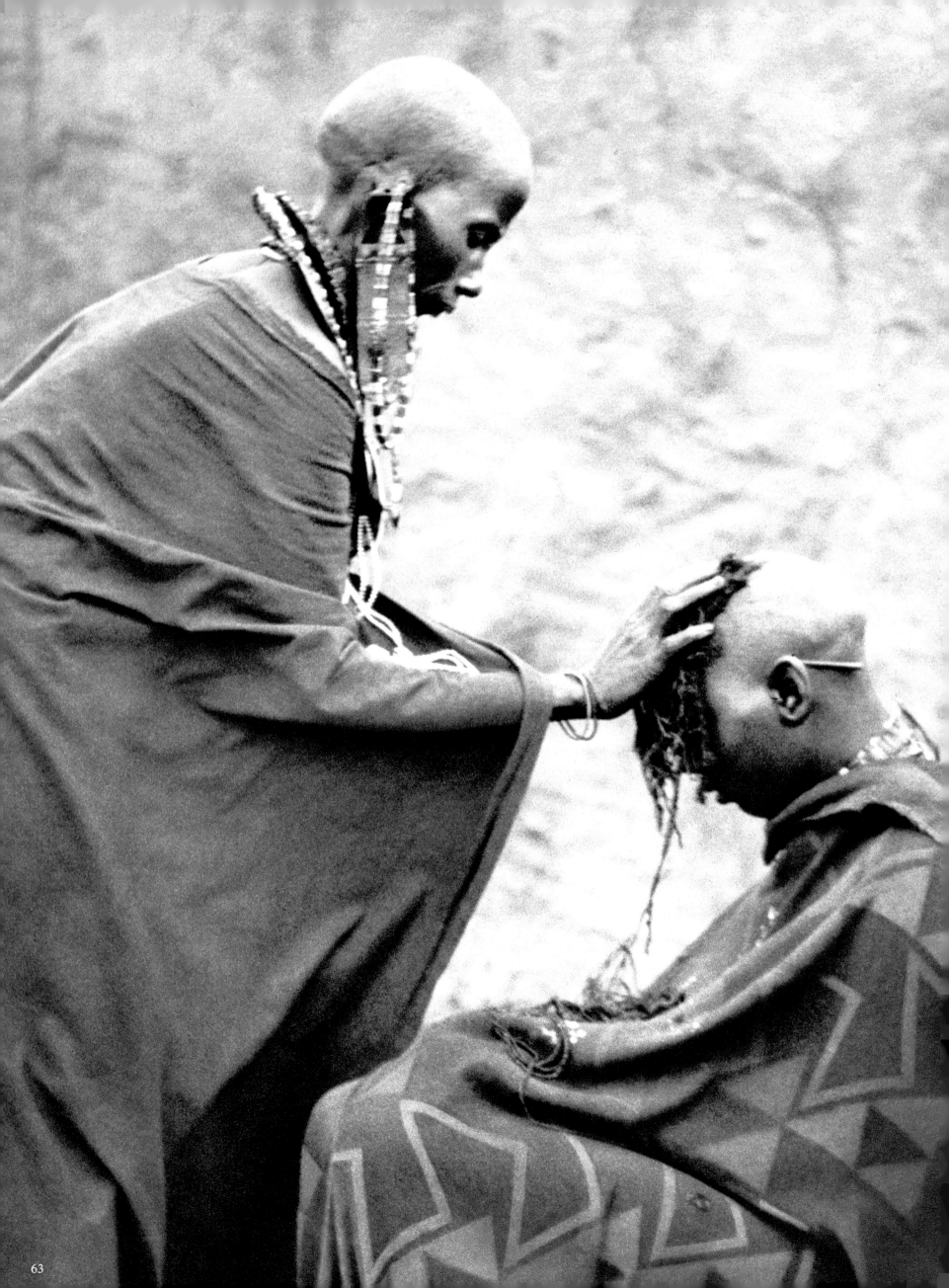

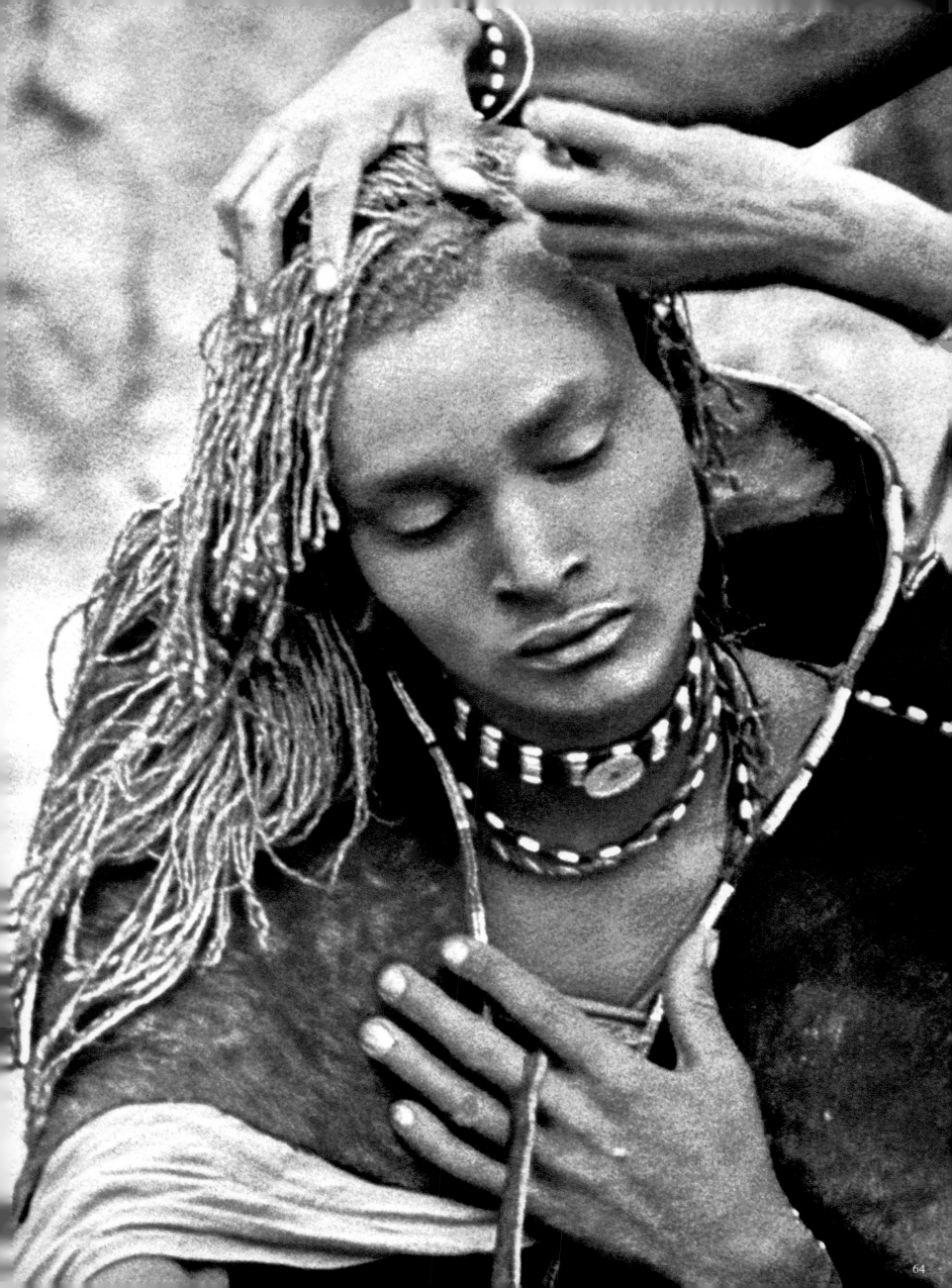

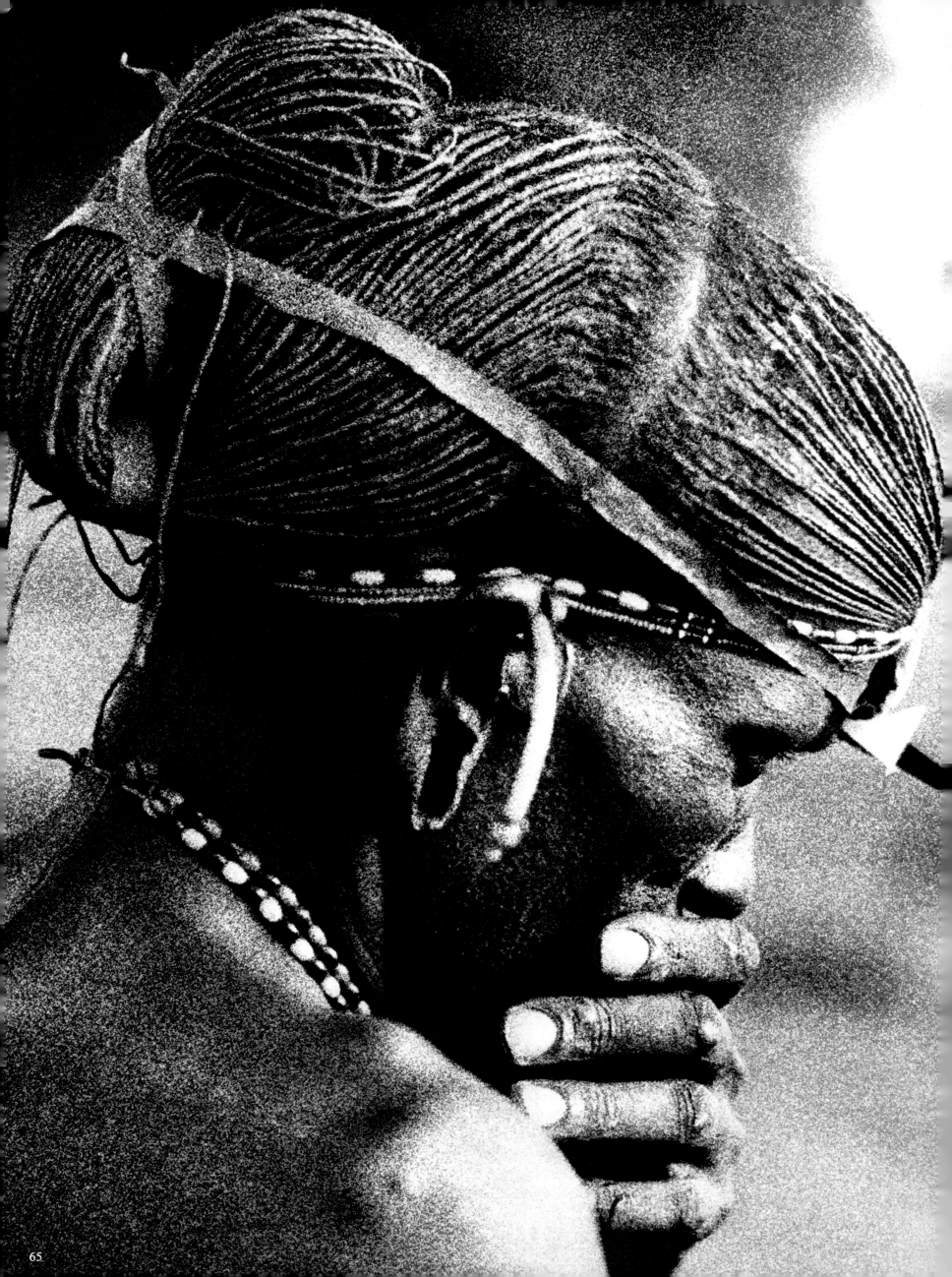

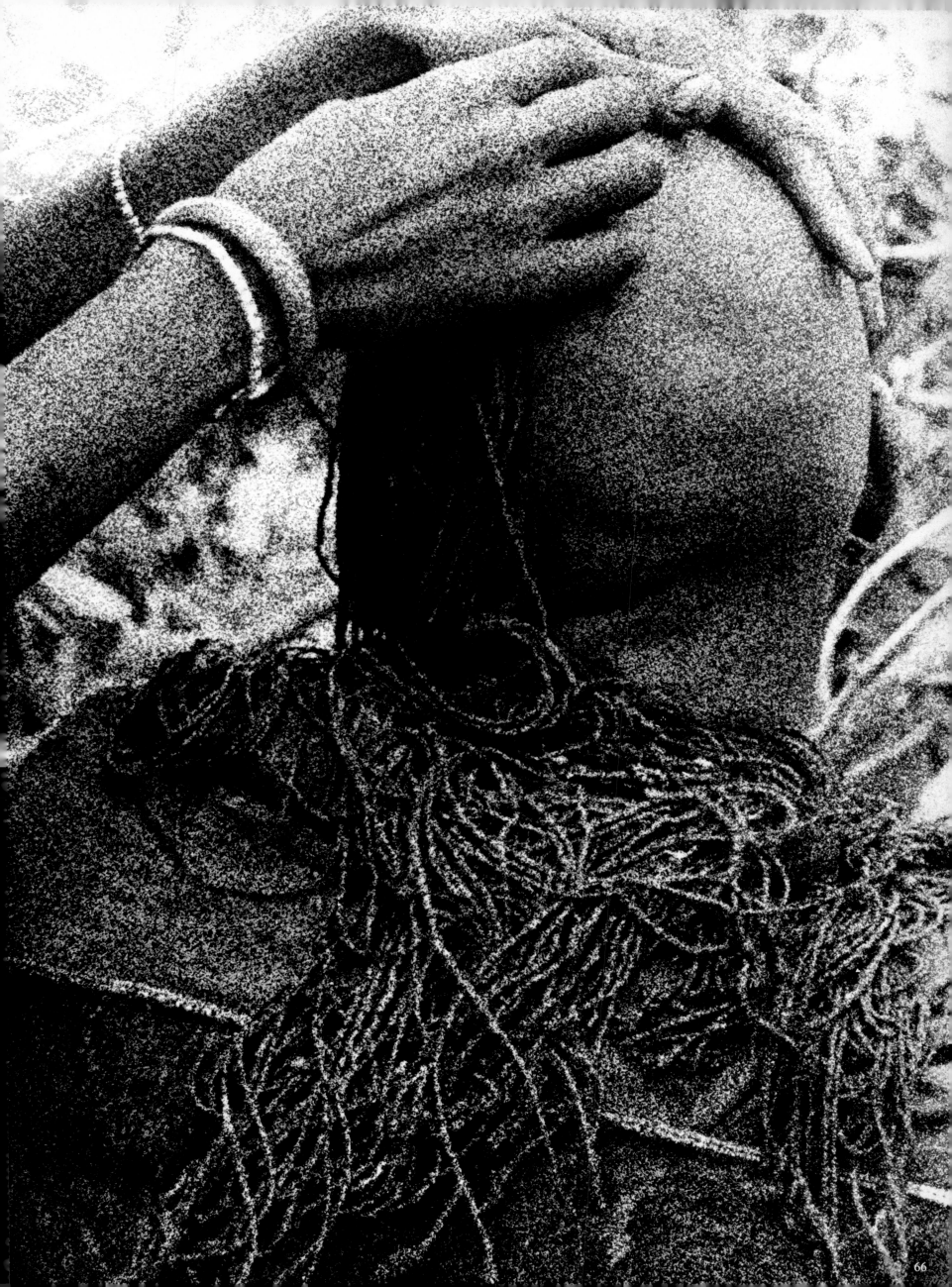

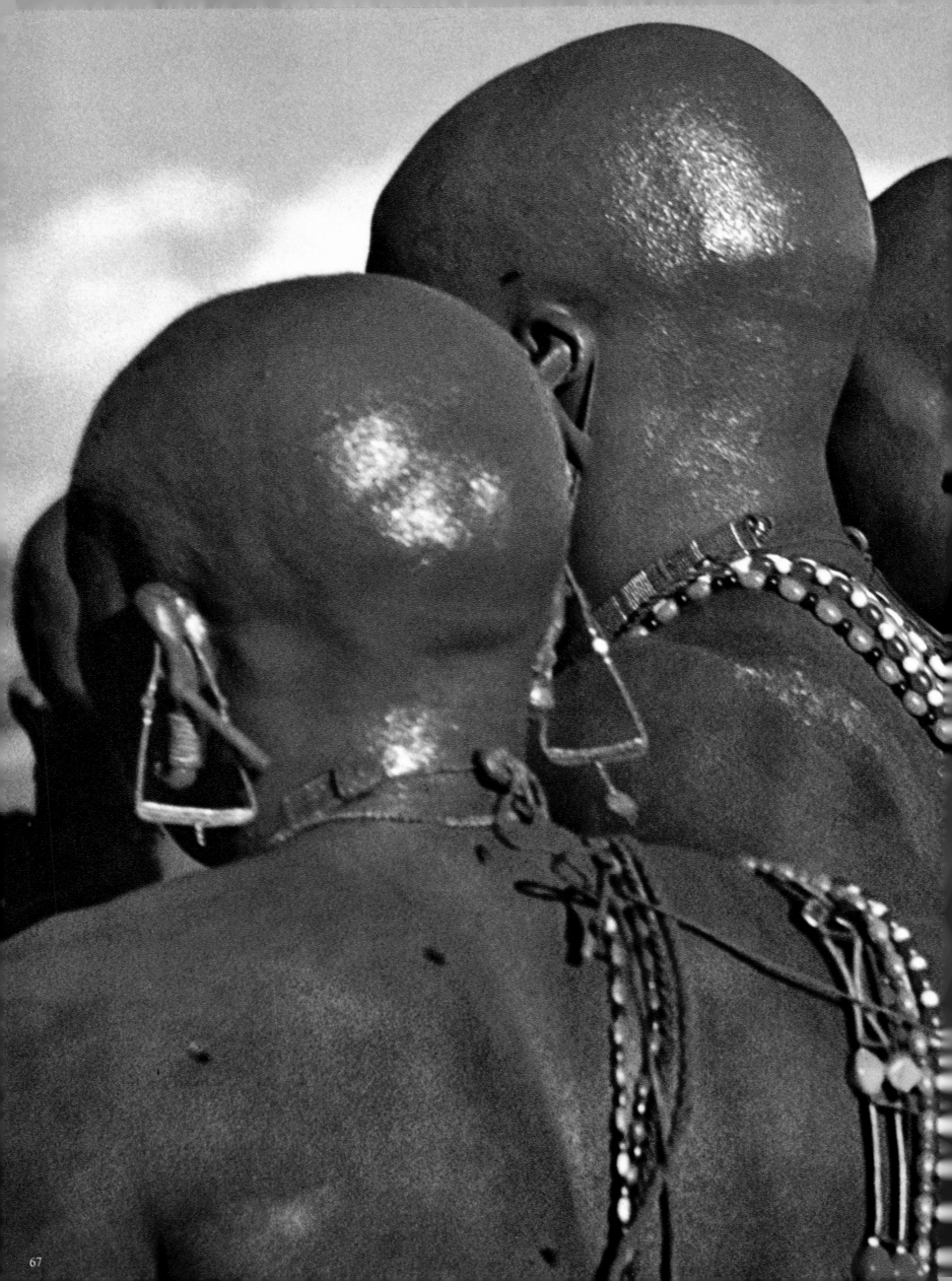

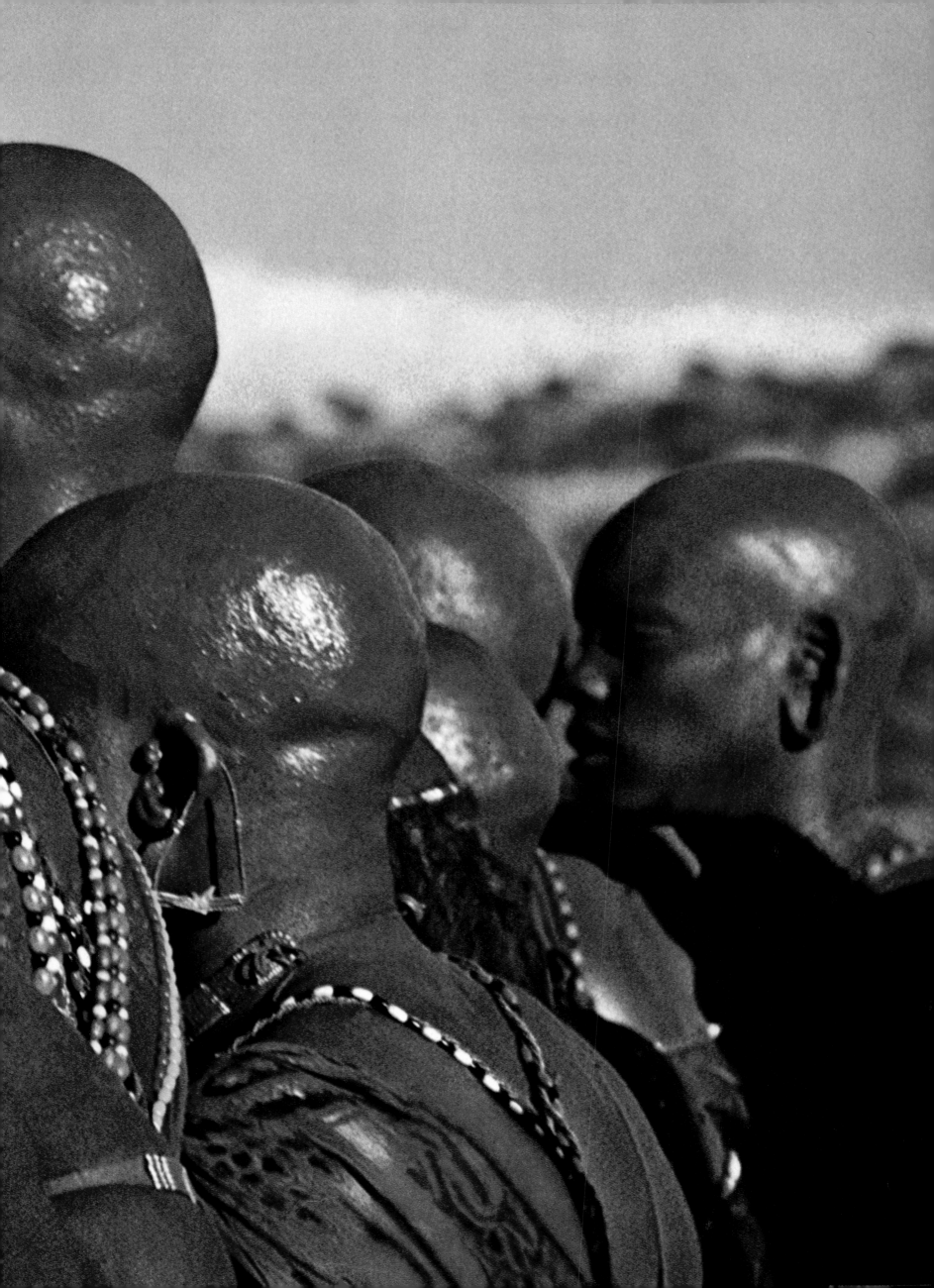

MOTHER AND CHILD

MOTHER AND CHILD

Africans regard children as the real wealth of the tribe. Daughters are more valuable than sons, since their marriage will not only bring in bridewealth or dowry, enabling the family to acquire more livestock, but also establish new "in-law" relatives to whom the family can turn in times of need. In fact, in some tribes, a man with much livestock but no children is often regarded as poor, while one with many children (especially daughters) but little livestock has high status and is often able to exercise great influence in tribal affairs.

A woman's value is closely related to her capacity to bear children. Among most African tribes it is infertility, rather than infidelity, that constitutes the main and often only reason for which a man can change his wife. Thus fertility, both of women and livestock on which the future of the tribe depends, assumes a special importance in day-to-day and ceremonial aspects of life.

Among the pastoral tribes of Kenya, whose women commonly shave their heads bald, it is only a woman with child who allows her hair to grow long as a sign of her pregnancy. During pregnancy, women are generally expected to carry on with their usual work, and in some tribes it is not uncommon for a woman to give birth while working in the fields. But usually, when her time is near, she retires to her hut where she is assisted by an older woman acting as mid-wife. There seems to be a hereditary tendency towards small hips among many African women, and delivery is often fraught with complications. Pregnant women therefore take care in choosing their food, for instance drinking only milk diluted with water, hoping to produce small babies at birth.

Traditionally, most African babies are breast-fed for long periods, even up to two or three years, during which time her husband is expected not to have intercourse with her, lest a new pregnancy sap strength from both mother and first child. Infant mortality is high, often fifty per cent in the first year, due to wide-spread pneumonia and diarrhoea. Indeed, children are frequently not given a personal name until their fifth year for fear that "death will hear of them and make a visit".

During its early years the mother carries the child on her back most of the day and there is always a close physical contact between them, such that it is rare to hear an African child cry for want of a comforting touch or warm embrace. When it is able to walk the child begins immediately to play with the other children of the village. No toys are provided but the children make their own, a piece of charcoal representing a cow and twigs stuck into the ground to make a cattle enclosure. The making of dolls and other life-like objects is frequently prohibited by mothers, as it is believed that such play smacks too much at sorcery which is feared by all.

Work comes early to African children, and it is not at all uncommon to find a Maasai or Samburu boy of five or six herding cattle with his father or older brothers up to ten or fifteen miles in a day. By the age of nine he is often put in charge of herding the calves or sheep and goats himself, or in company with a boy of his age. Girls meanwhile are learning

the women's work; carrying water, chopping and collecting wood, milking livestock or weeding gardens.

The Government is now embarked on a crash programme to ensure that all children are taught the rudiments of reading, writing, Ki-Swahili and especially English. Many children, even from the more remote area, attend Government schools or those run by the Missions. However, education of the pastoral nomads presents a special problem which is only slowly being overcome by the establishment of mobile and temporary bush schools, which move with the tribes as they wander in search of water and pasture.

Despite the growth of this type of European education family feelings and loyalties remain strong. Fathers exercise considerable control over the affairs of their children, often even after they are grown up. A nomadic herdsman, for example, rarely gains full control over any portion of his family's cattle until after his father's death. Some carry on their father's names and daughters always remain members of their father's clan, with well-defined responsibilities to it, even after marriage.

69. *Boran woman and child. Hers is the only tribe whose women's hair is so intricately plaited.*

70 & 71. *Turkana woman with her children.*

72 & 73. *Turkana woman. The quantity of beads worn by the woman varies according to the wealth of the husband.*

74 & 75. *Boran "Child of God" – this child is considered not like the others, and is a descendant of either a witch doctor or some member of the tribe who has healed sick people by special powers bestowed on him by "God". The first born child is meant to inherit these powers and sick people come to touch it with the firm belief that they will be cured. The hair is never cut and grows into a mass of tangled strands. The child is very revered from the moment of its birth, and nothing is ever done to anger or upset it.*

76 & 77. *A Turkana village.*

78 & 79. *Turkana children reaching out for sweets I threw them. This was one of our pastimes at the end of the day and proved to be a tremendous source of joy for these simple children who have so little.*

80 & 81. *Samburu children. Like all the children in the world, despite hardships and difficult living conditions, they remain gay and are always ready to laugh at anything. Their hair is kept closely cropped for cleanliness and to avoid lice.*

82 & 83. *Bajun village.*

84 & 85. *Kissing on the mouth is a very rare thing in Africa and is only done by mothers to their children.*

86 & 87. *Orma women and children. The women have very tender feelings for their children.*

88. *Somali father and child.*

89. *Turkana father and child.*

90 & 91. *Turkana youth (left) during a period when lack of rain causes grave damage to herds and crops and people die in hundreds from hunger. The Government with foreign aid, mainly from America, do what they can to alleviate the predicament but it is often like a drop in the ocean.*
Garbiti – Orma girl (centre).
Boran child (right) wearing a sack to protect himself from the cold and rain.

92. *Homeward bound.*

93. *Rendille camel herder in typical stork like pose.*

94. *The children watch the goats and smaller herds and are never without one or more sticks.*

65

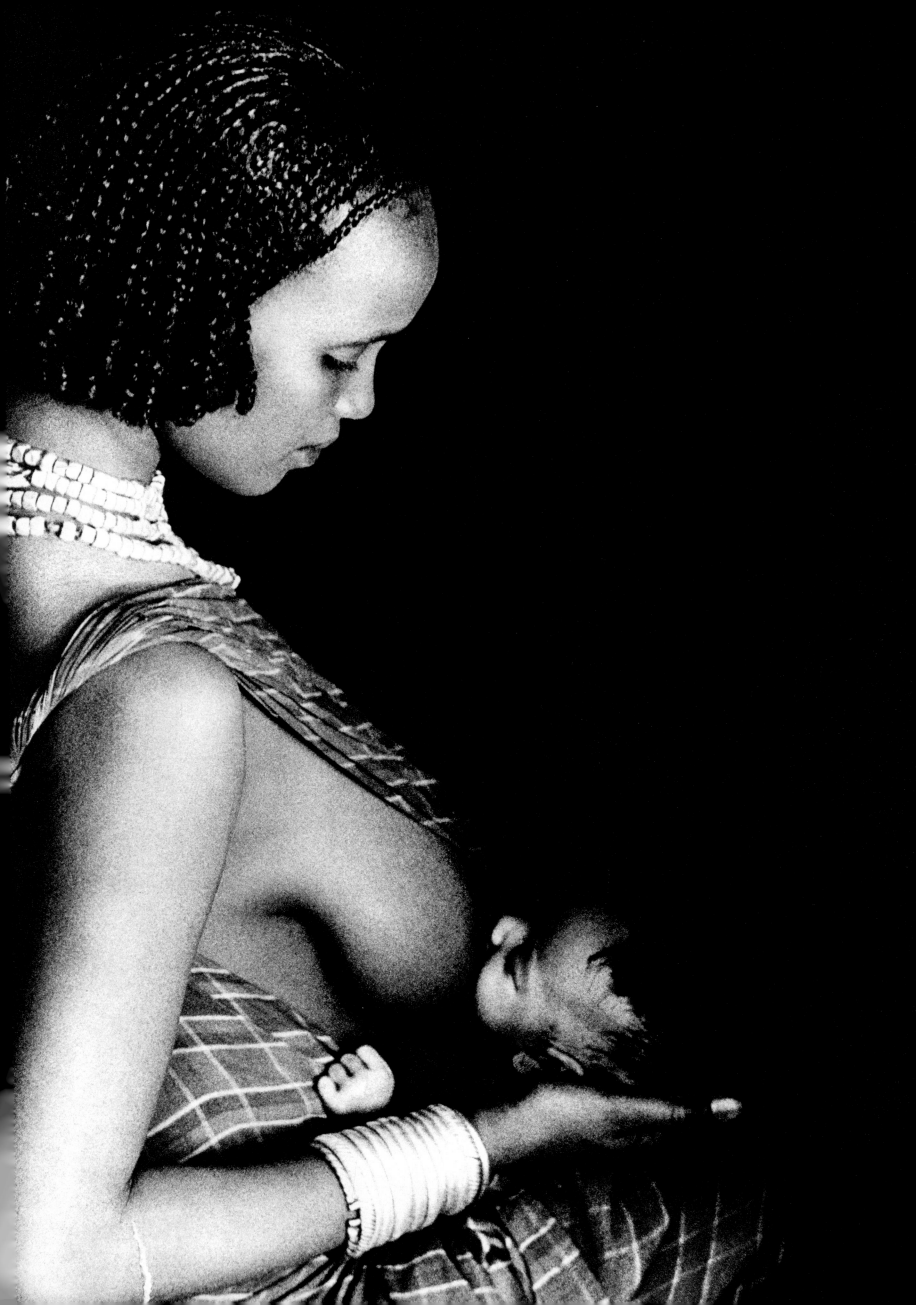

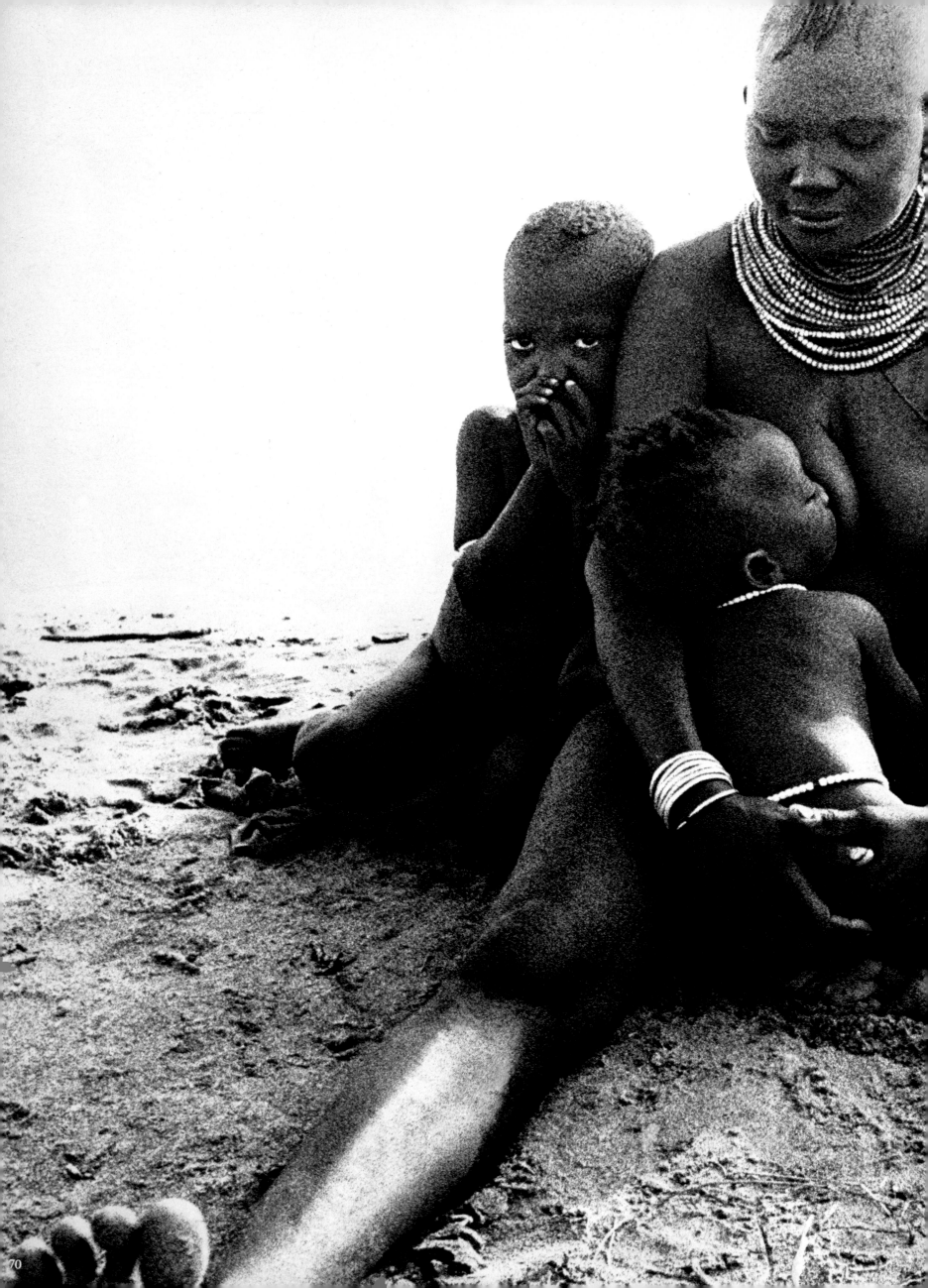

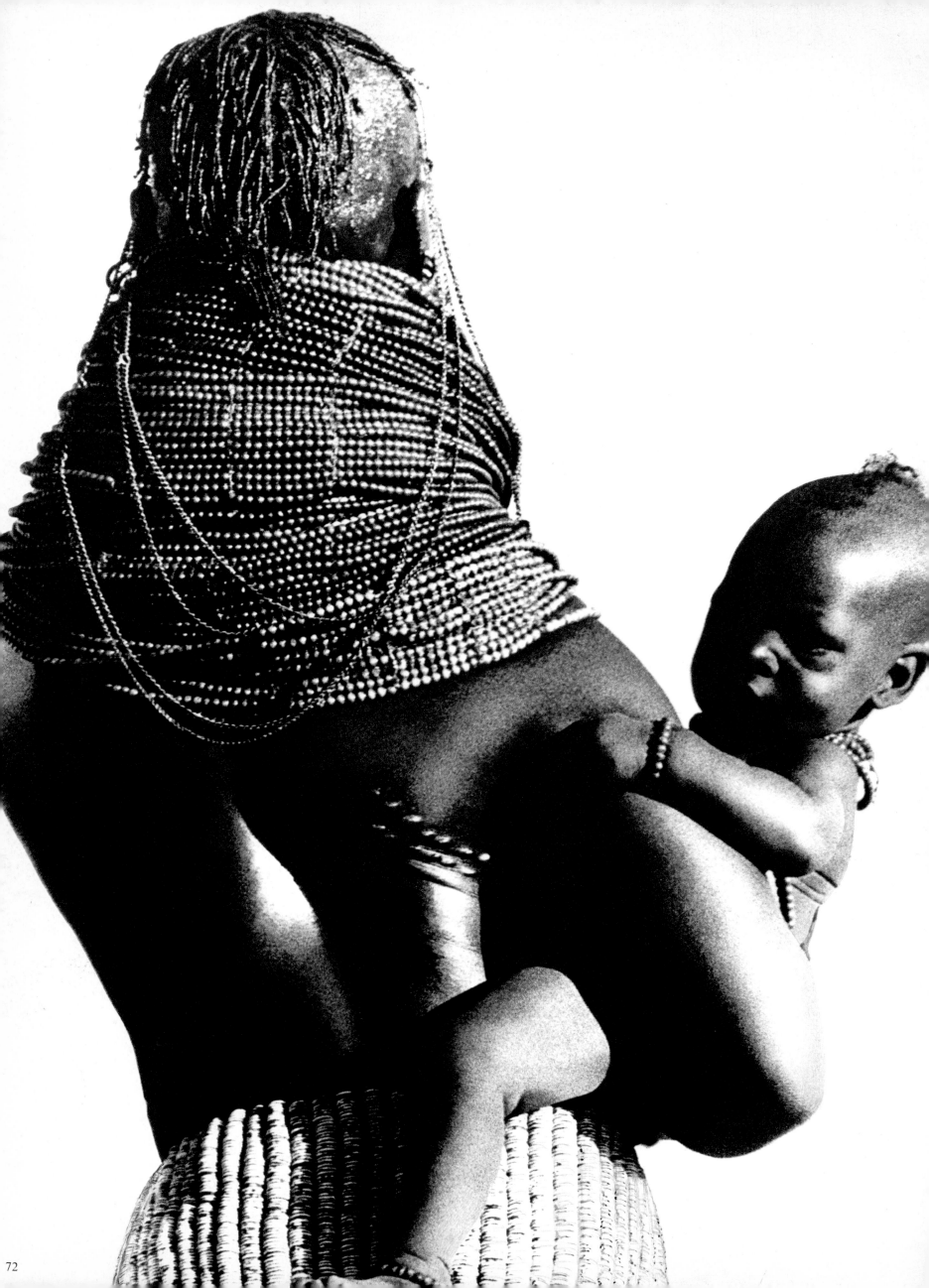

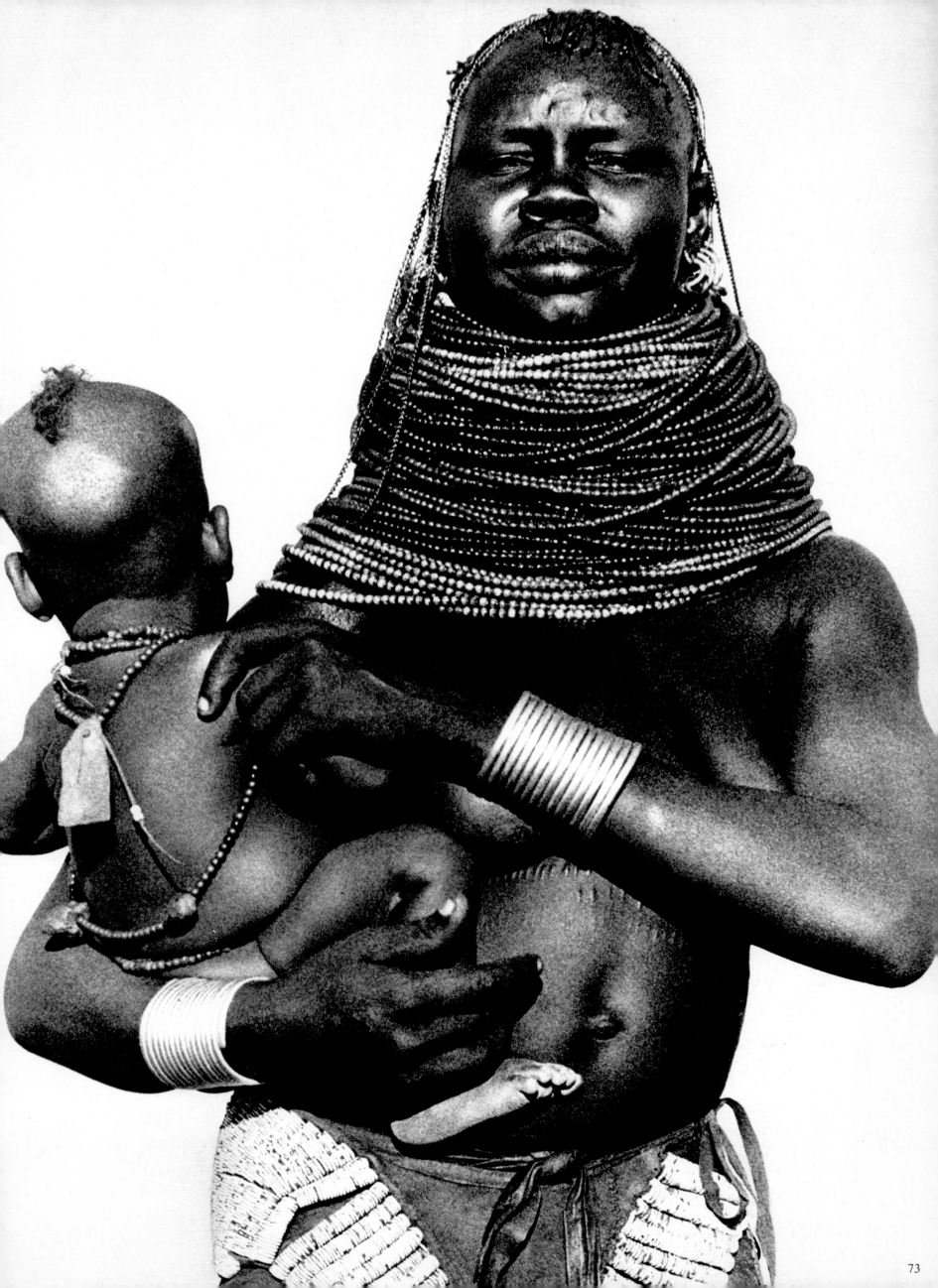

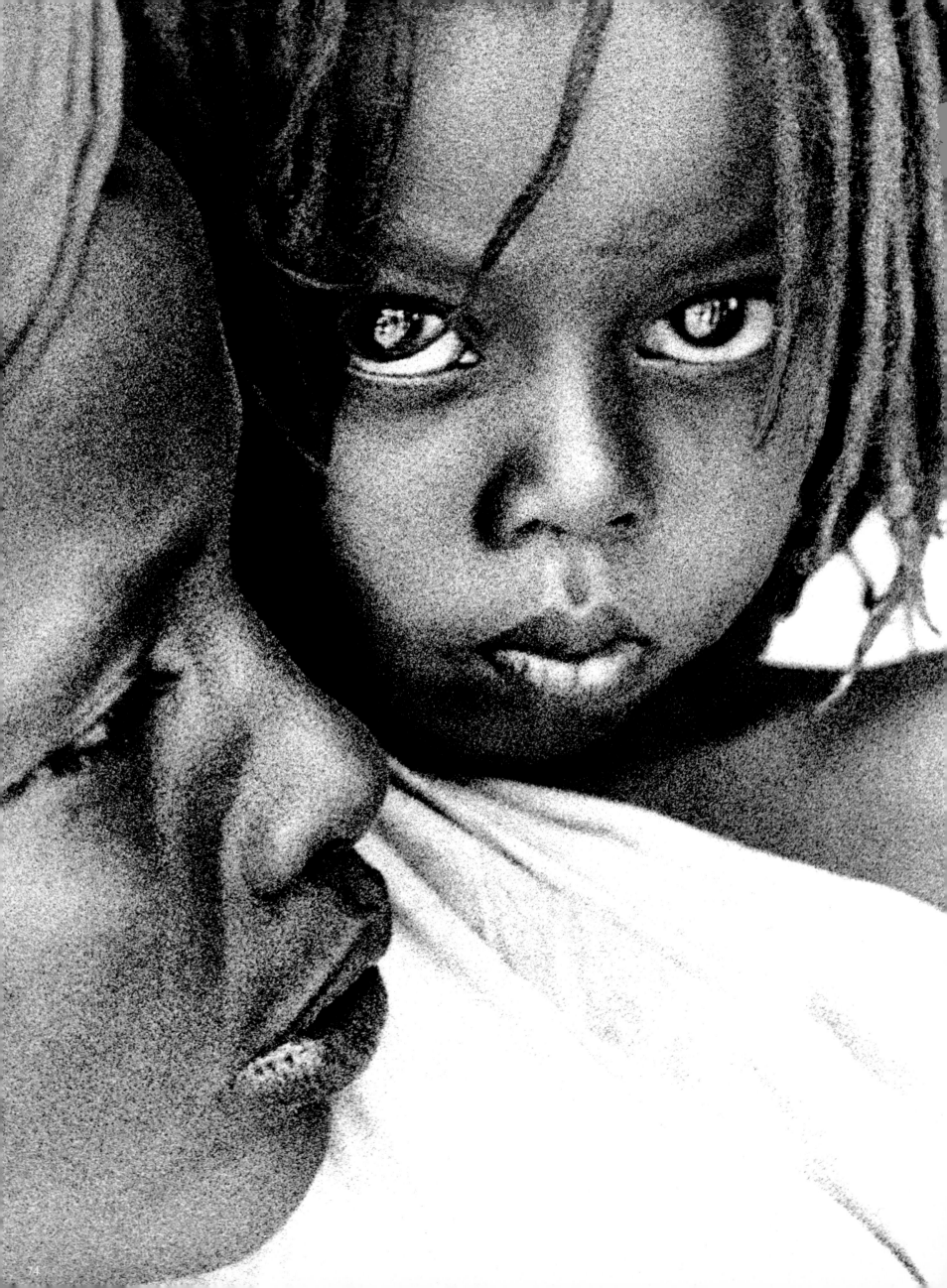

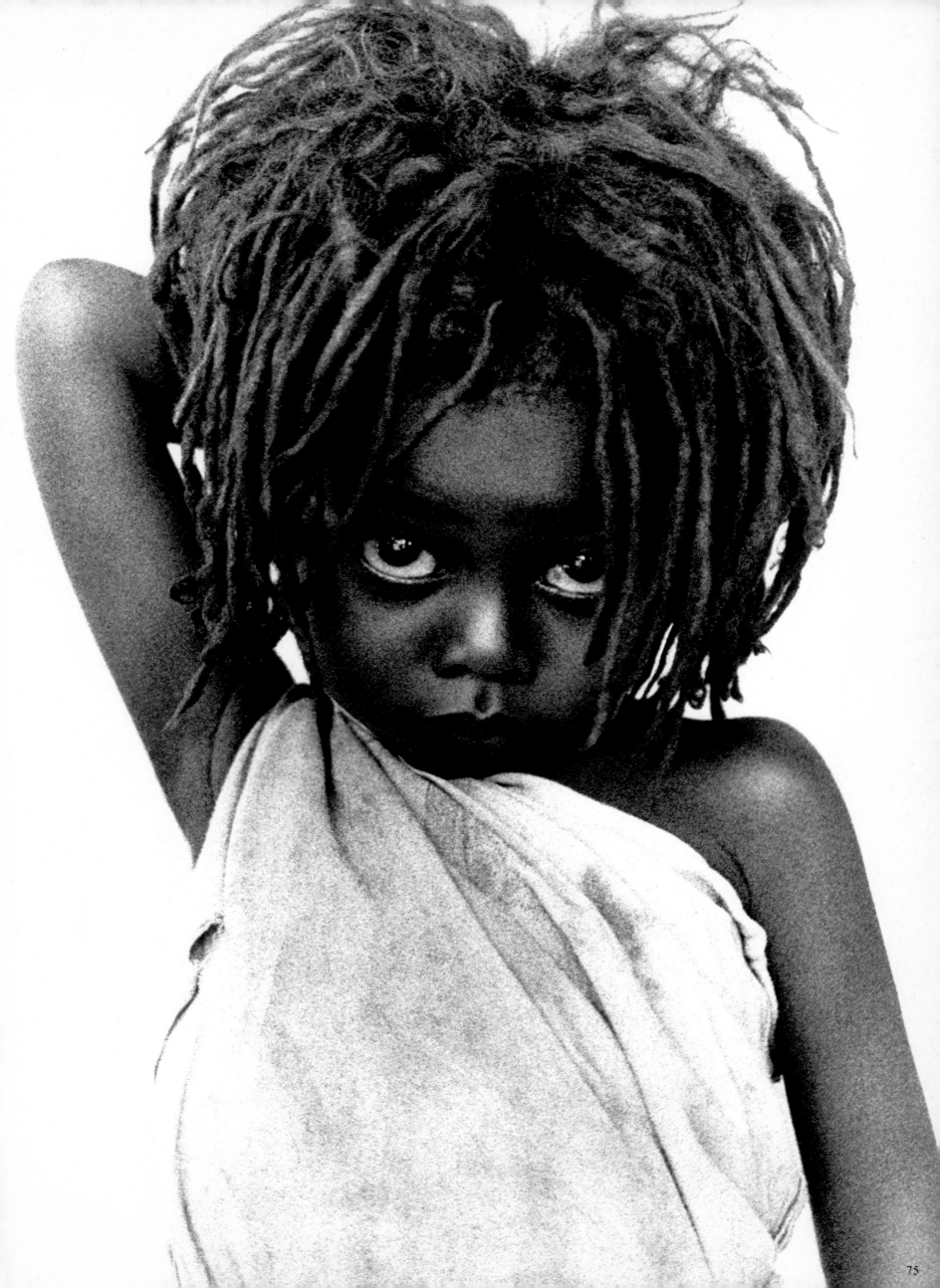

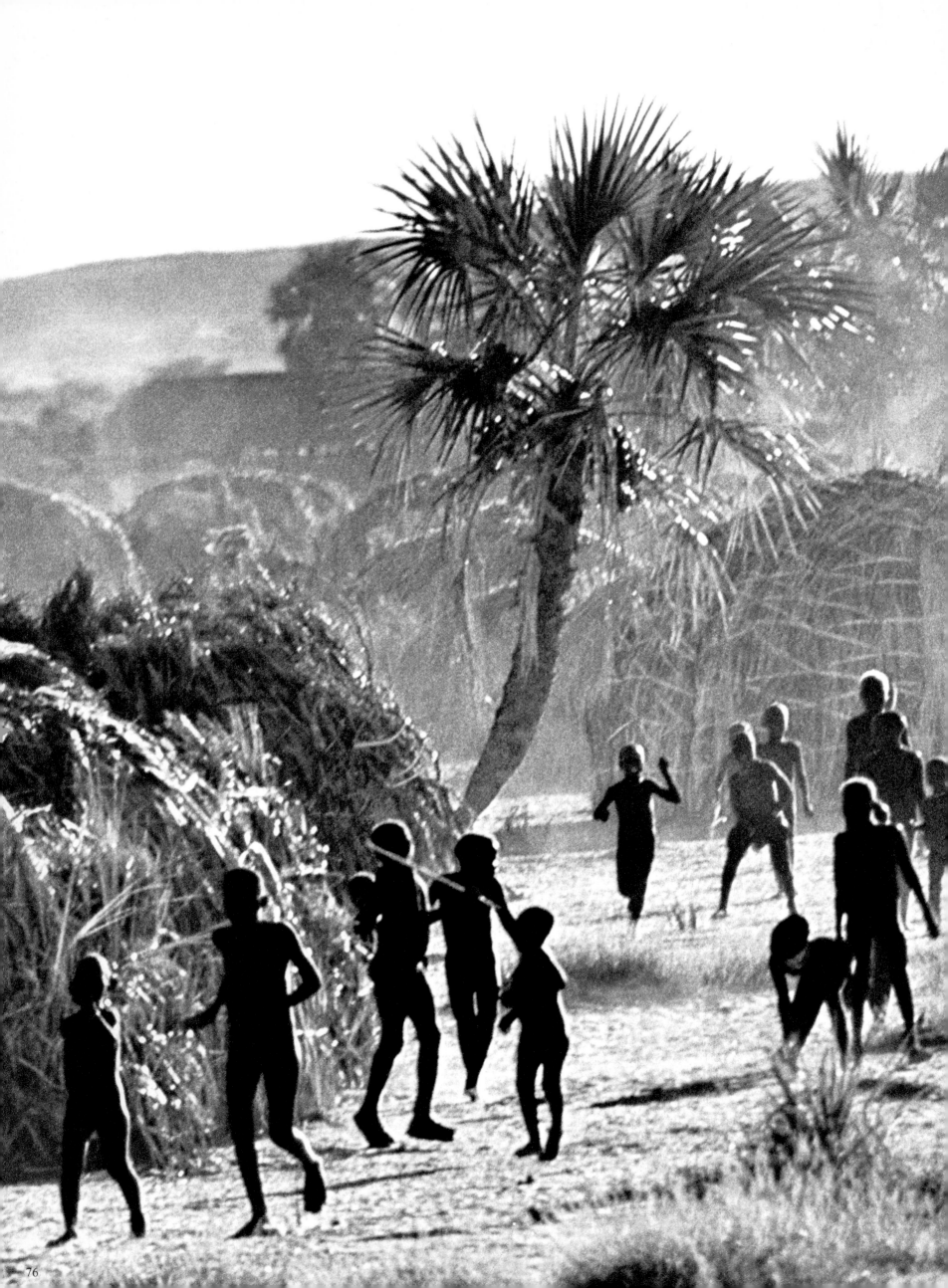

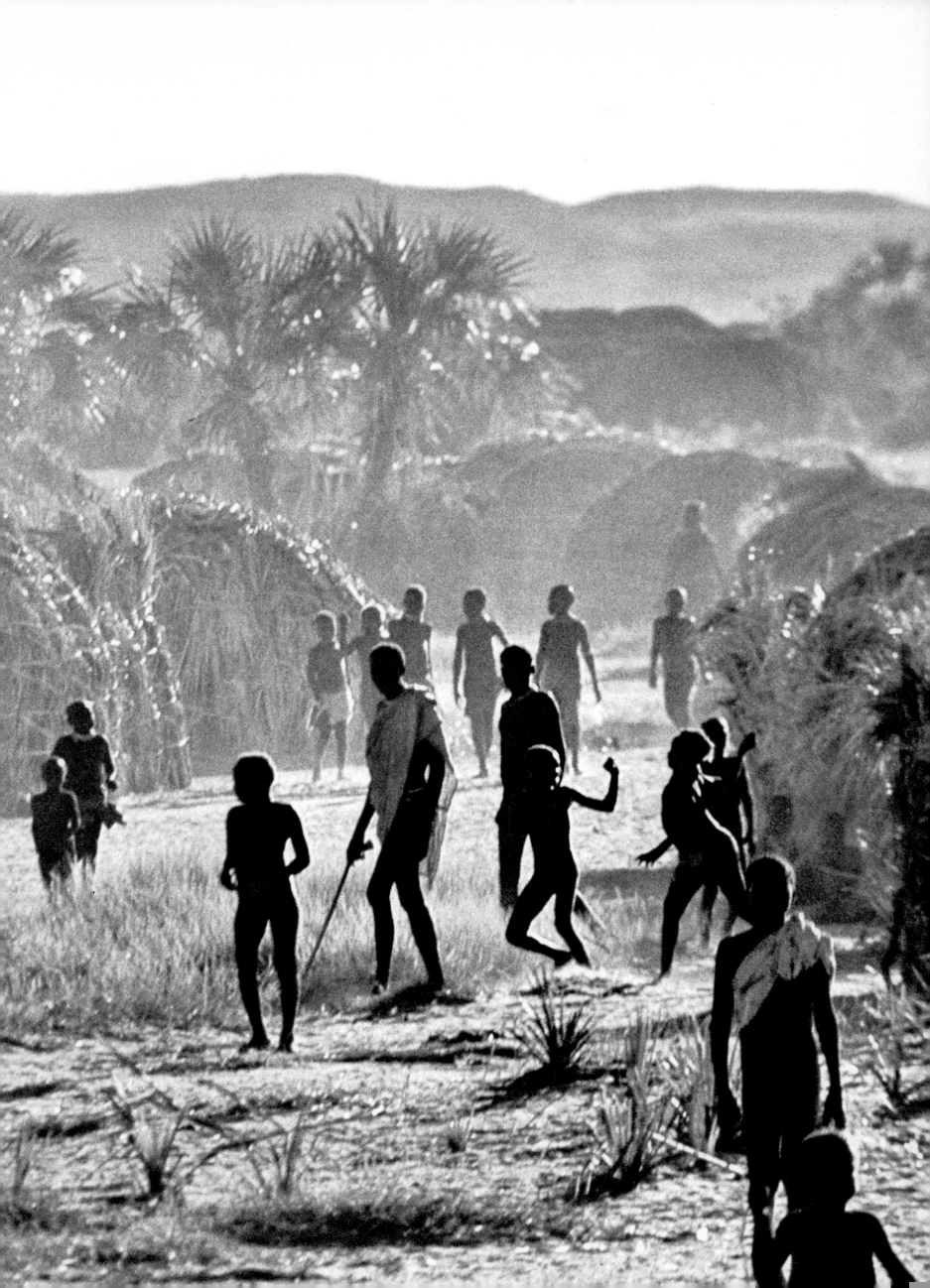

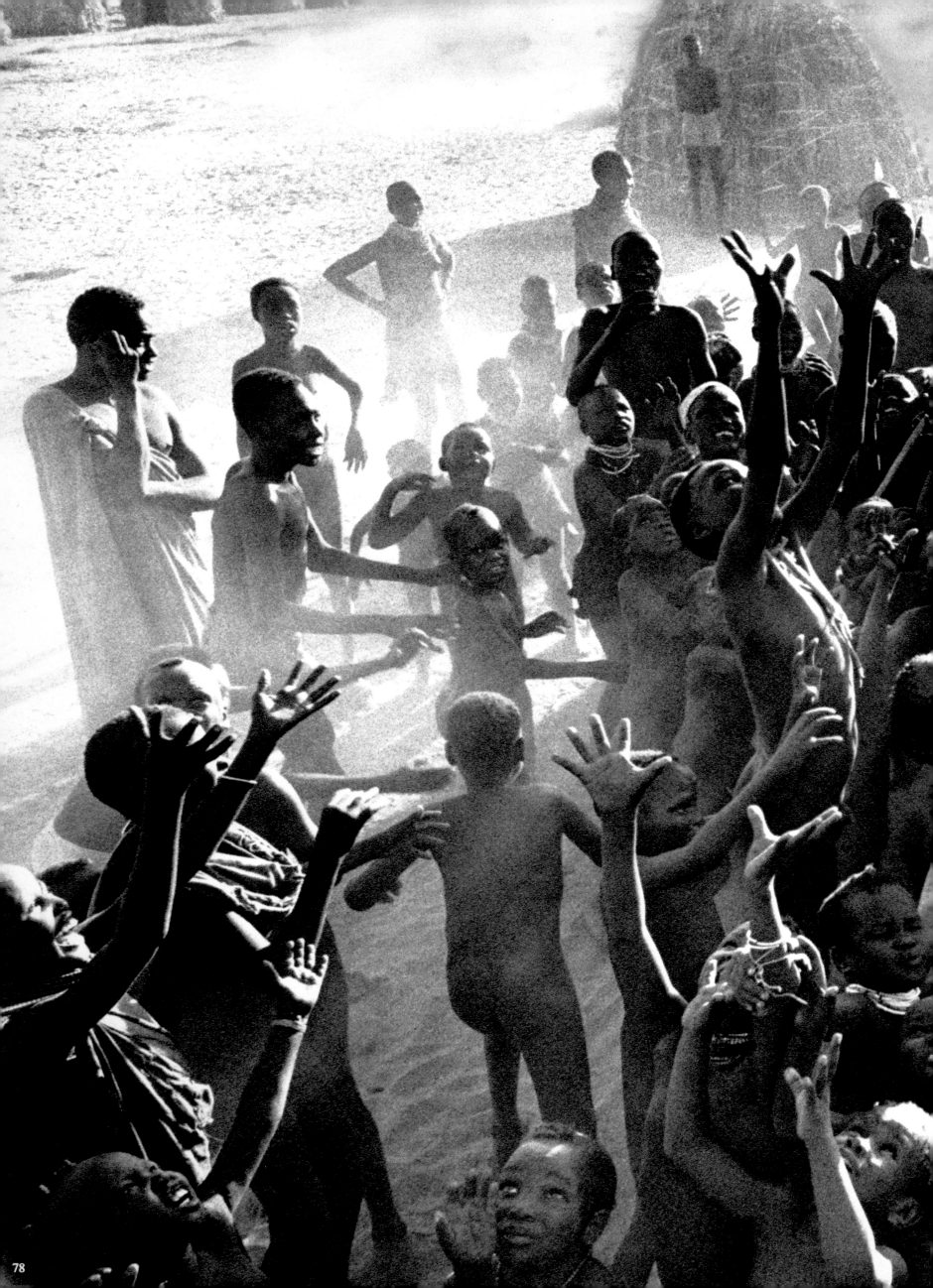

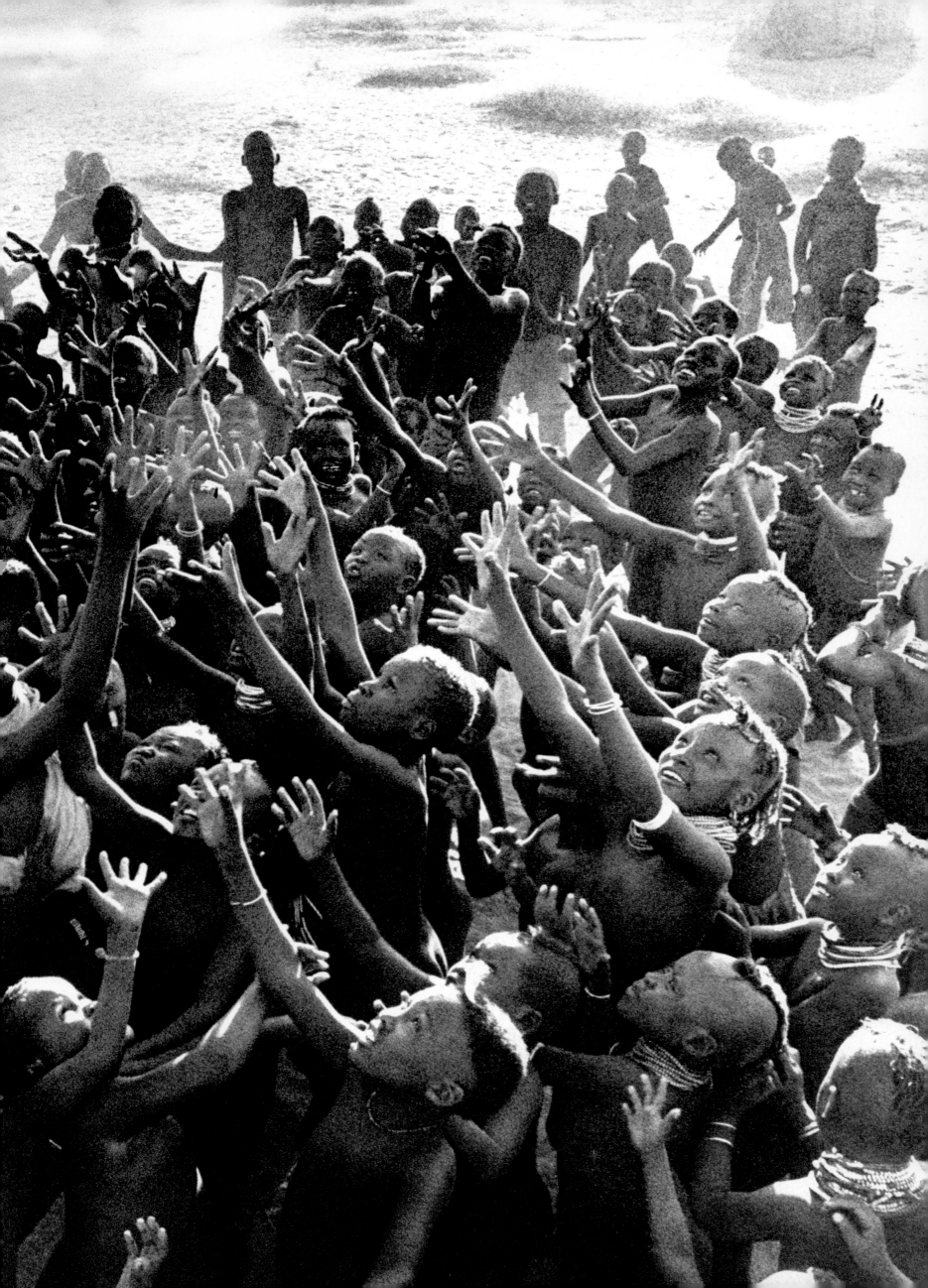

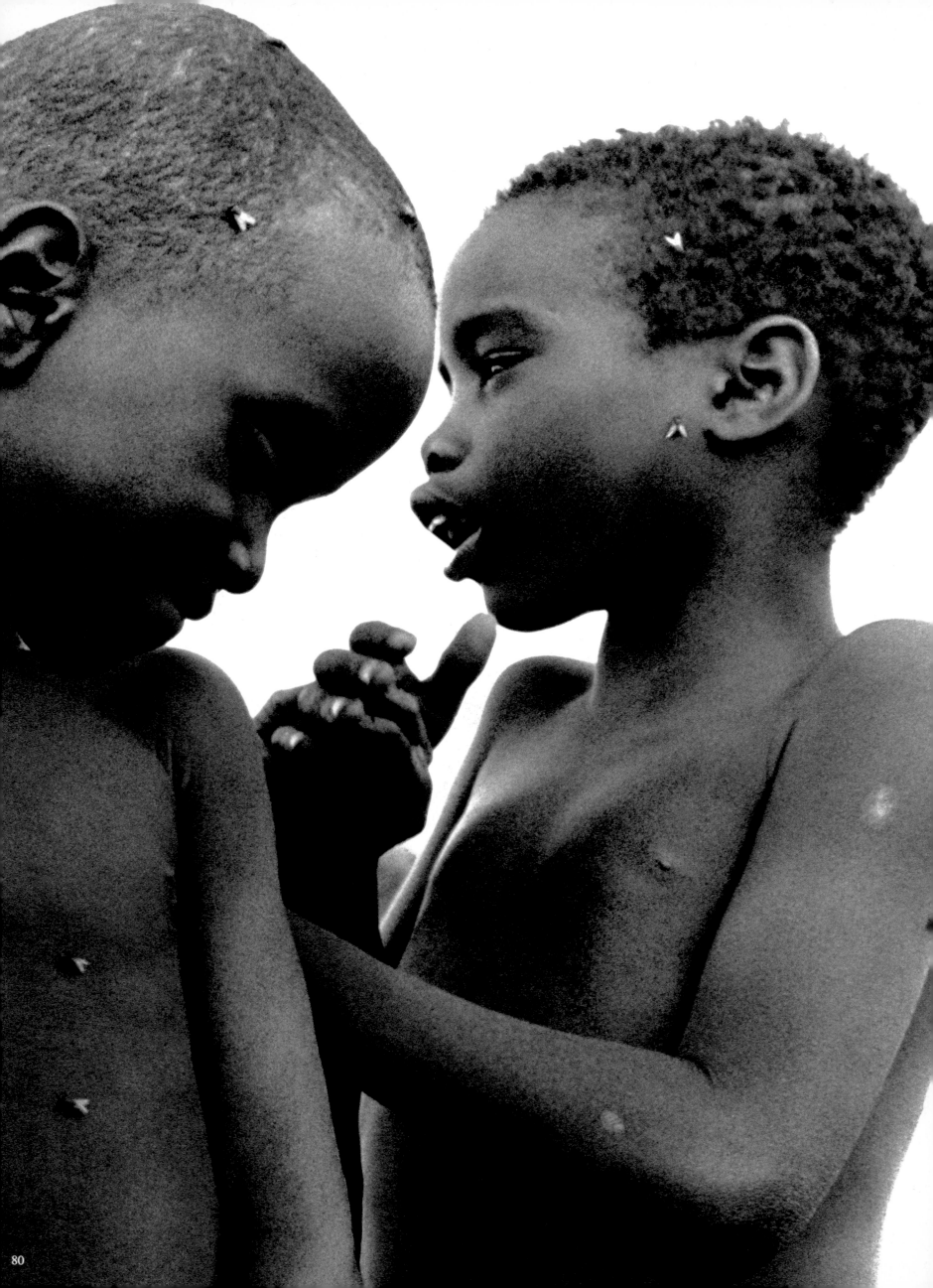

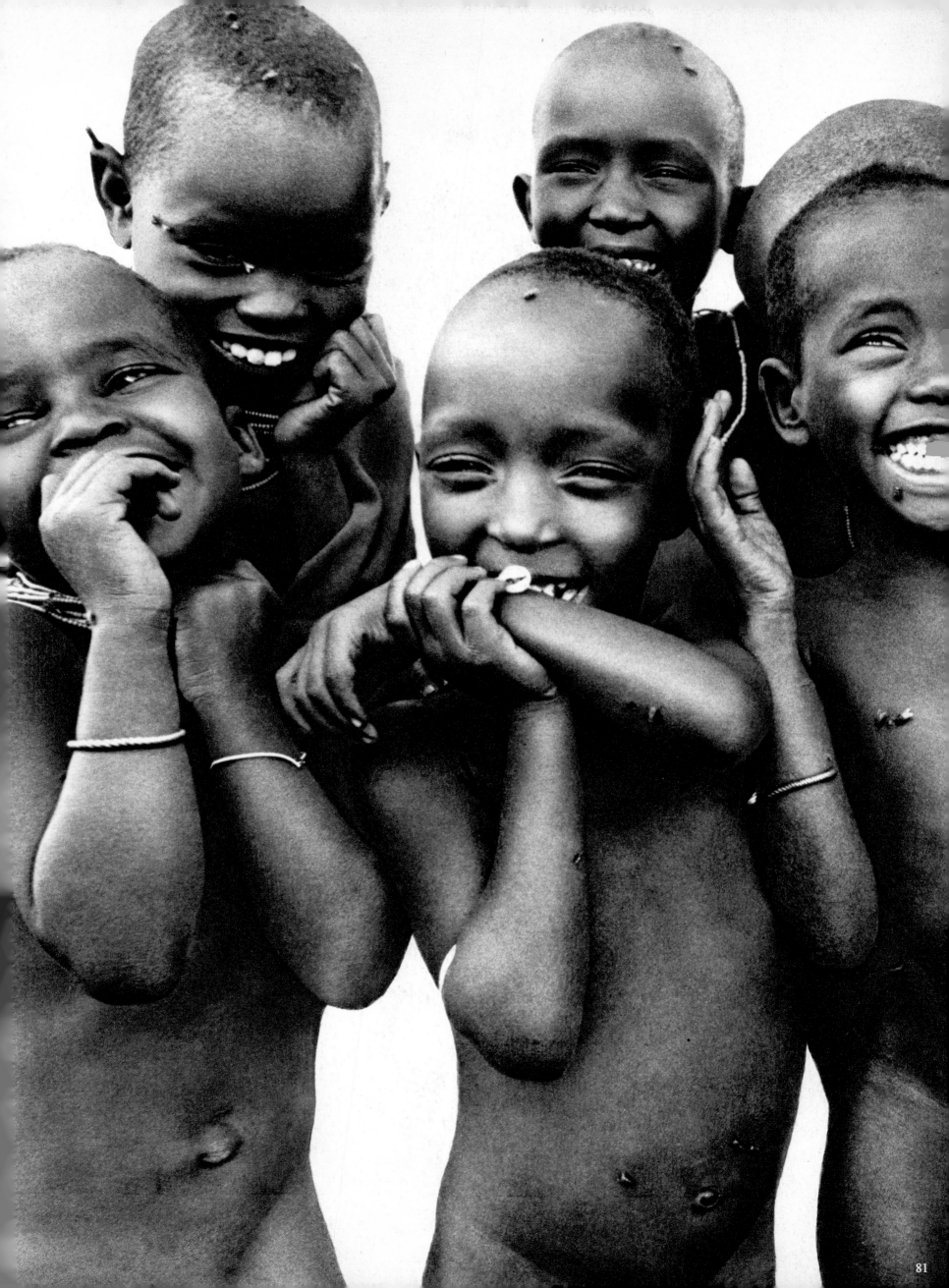

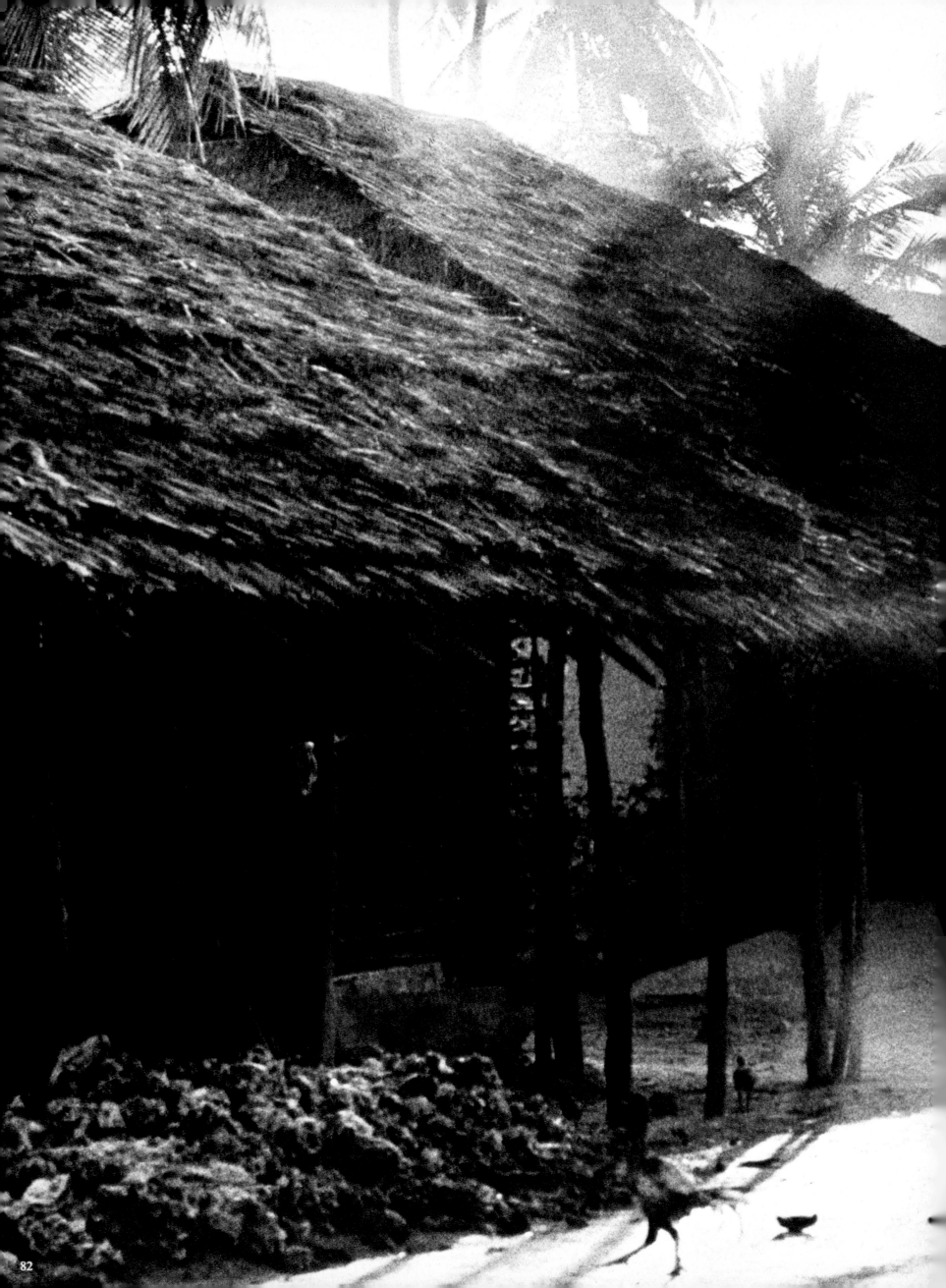

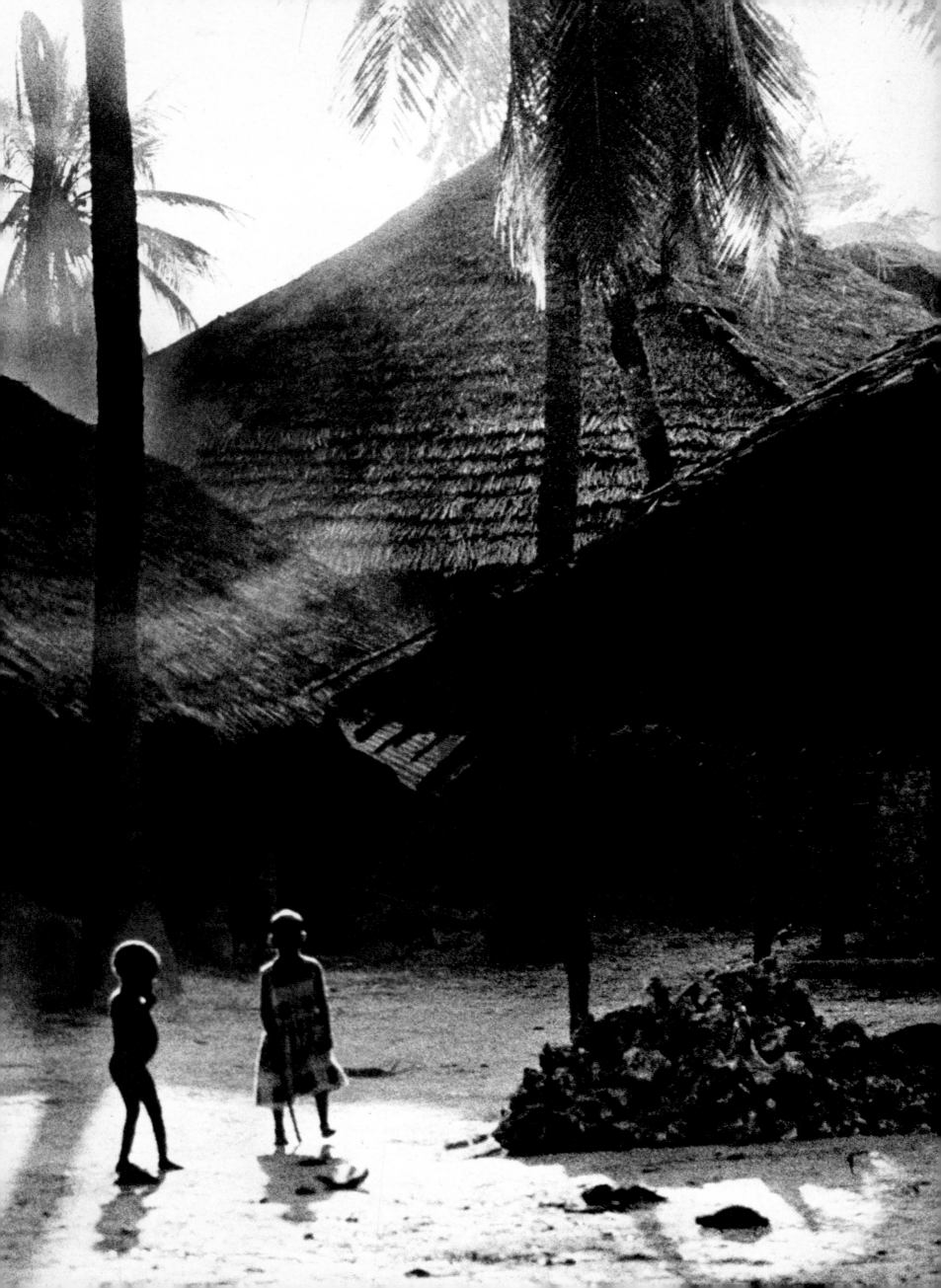

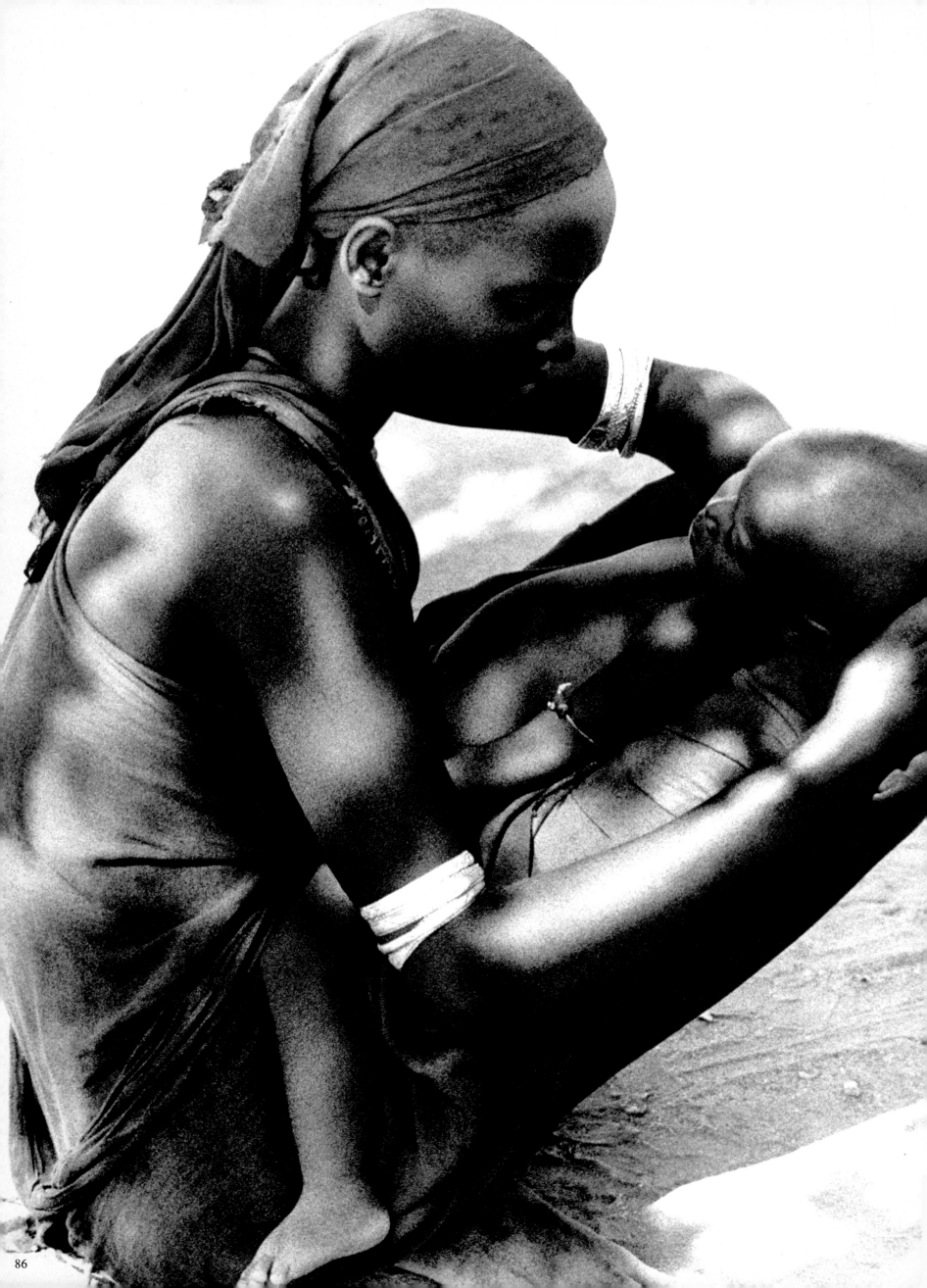

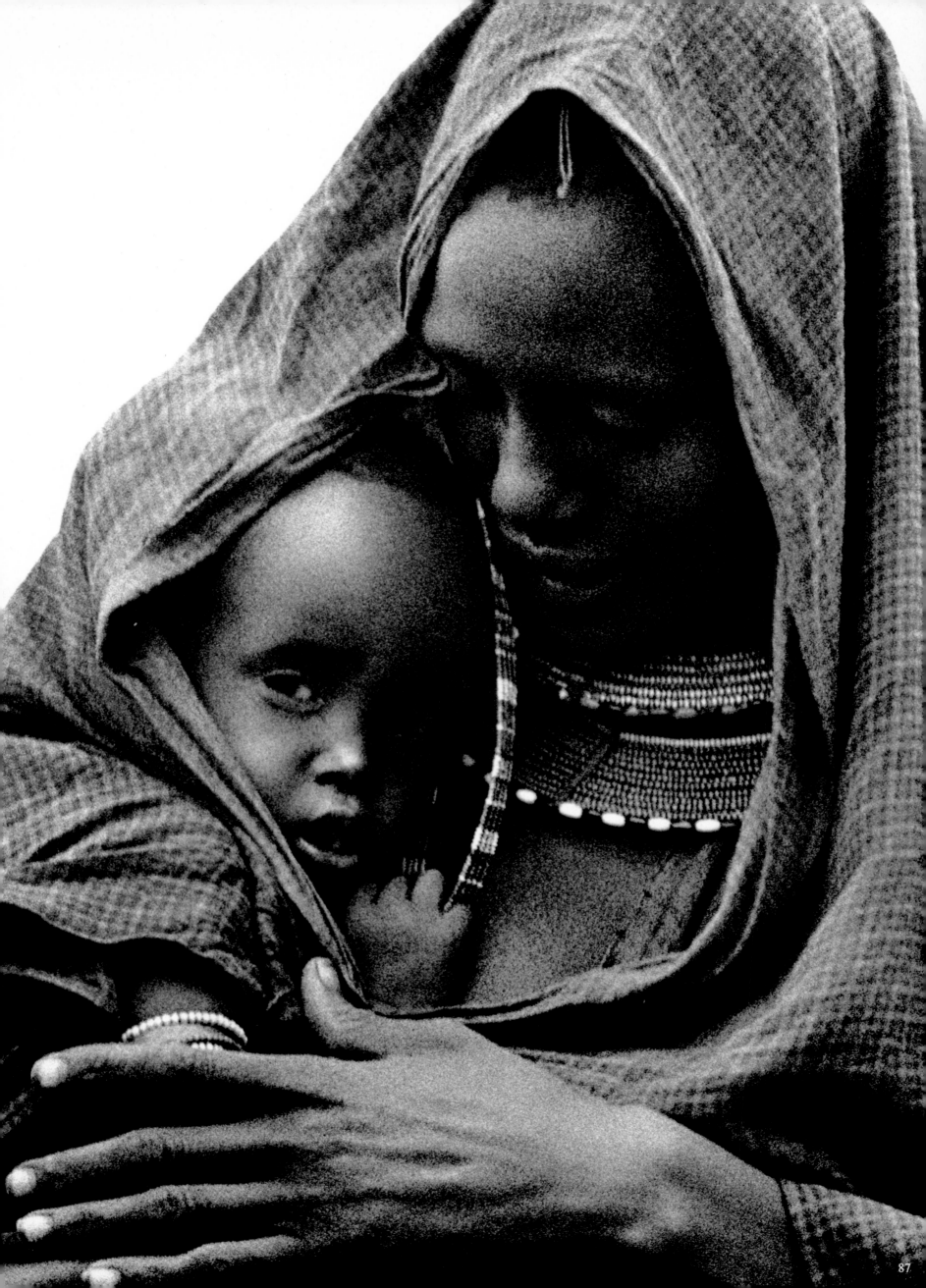

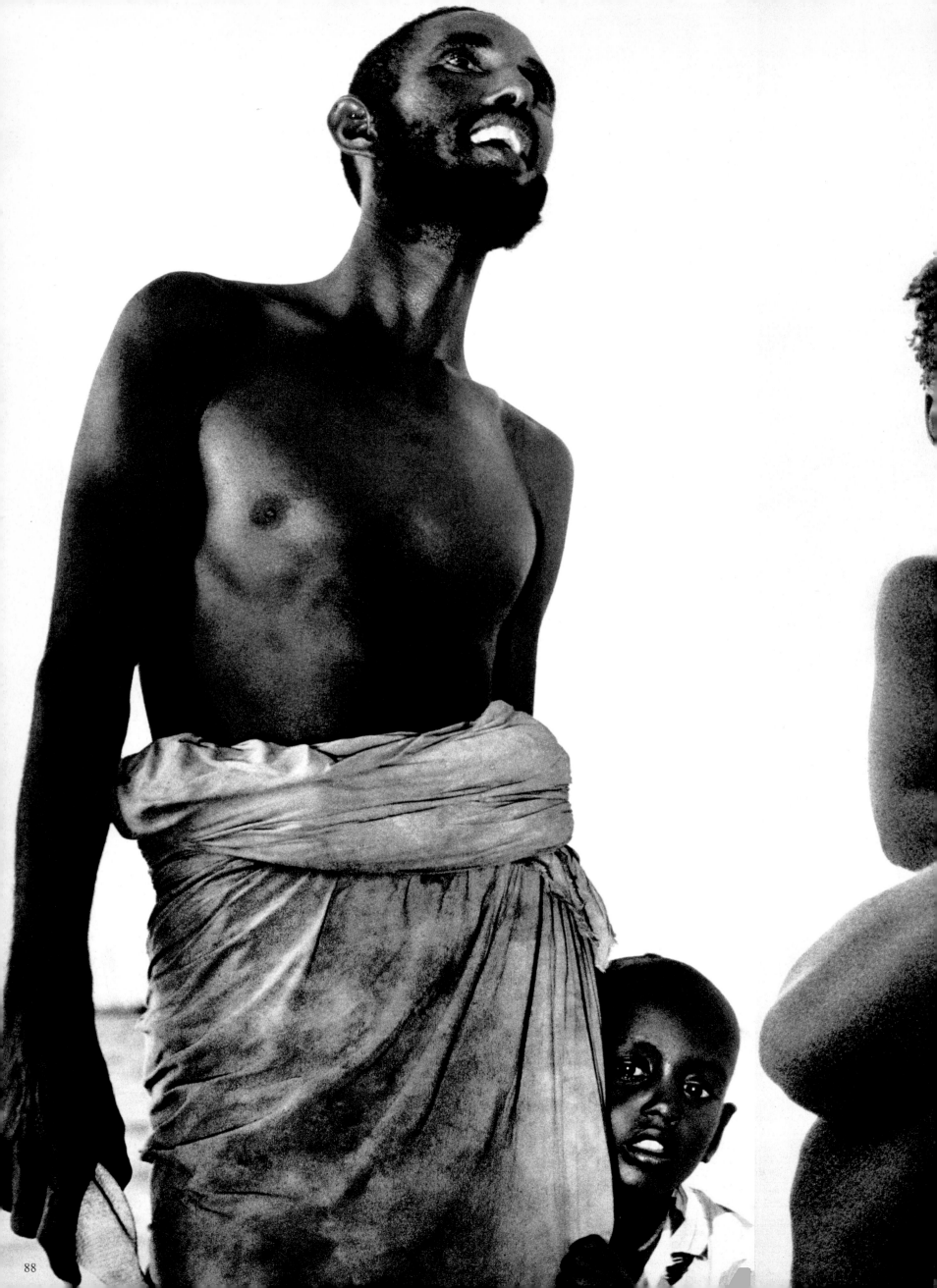

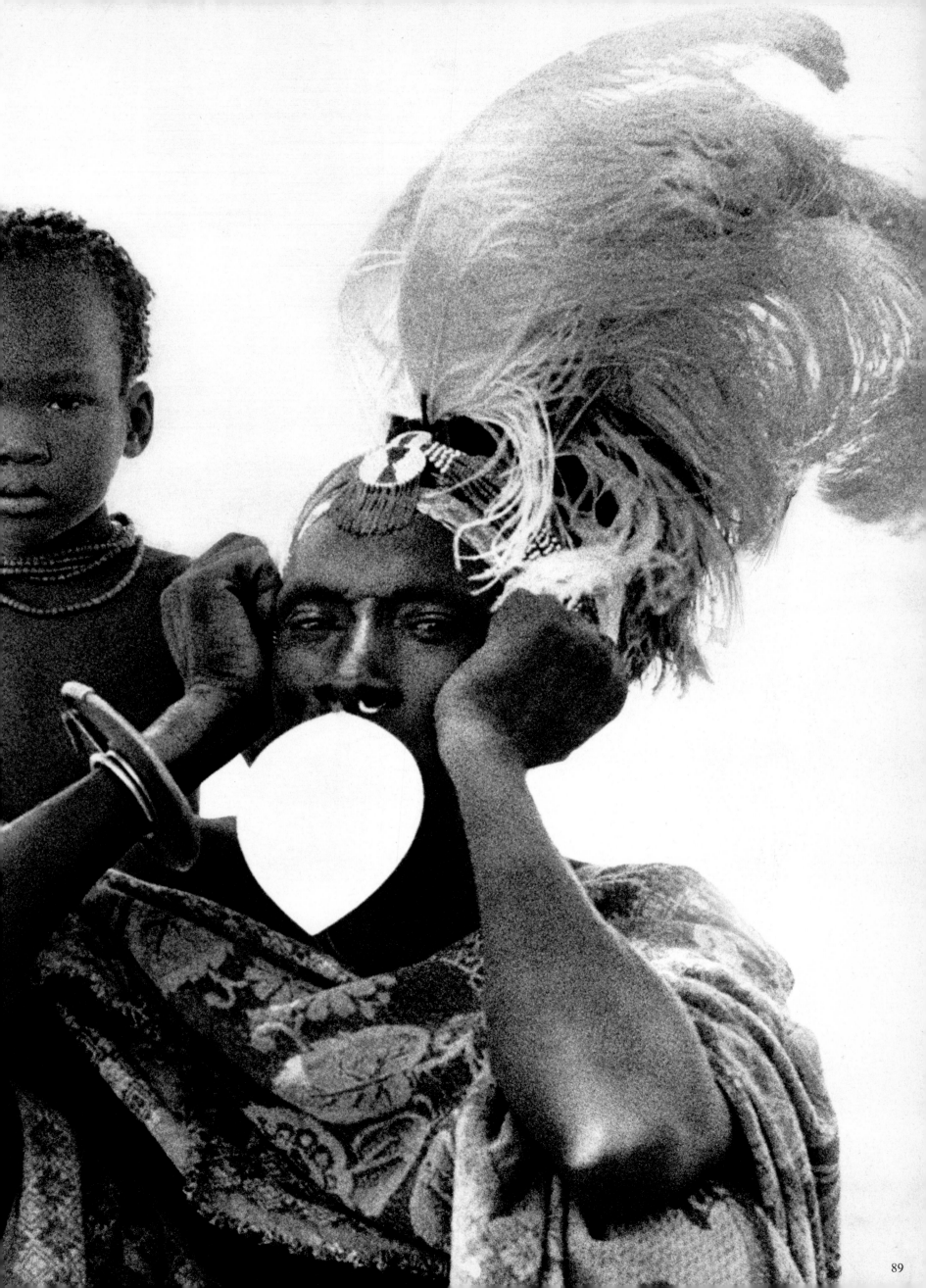

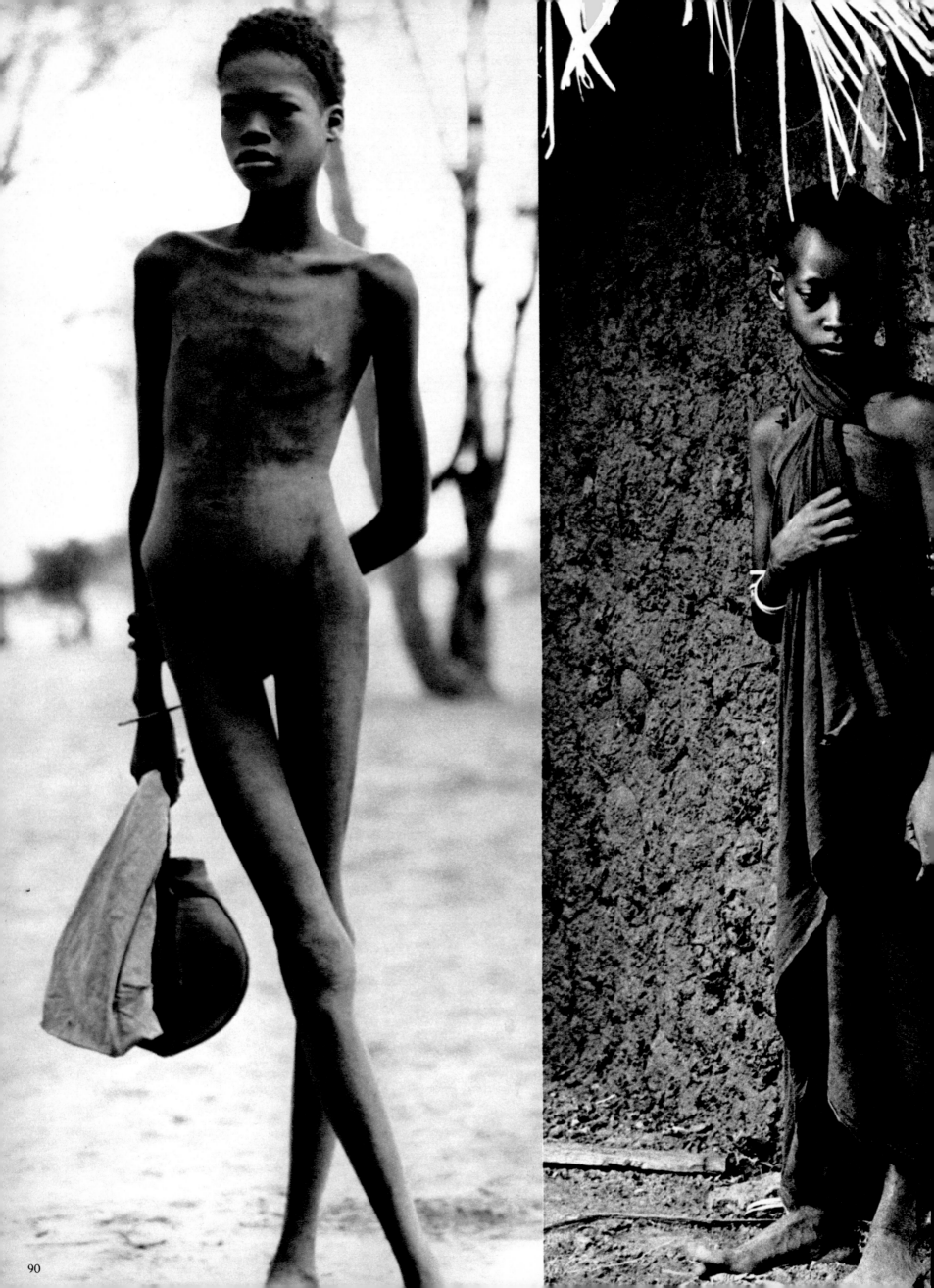

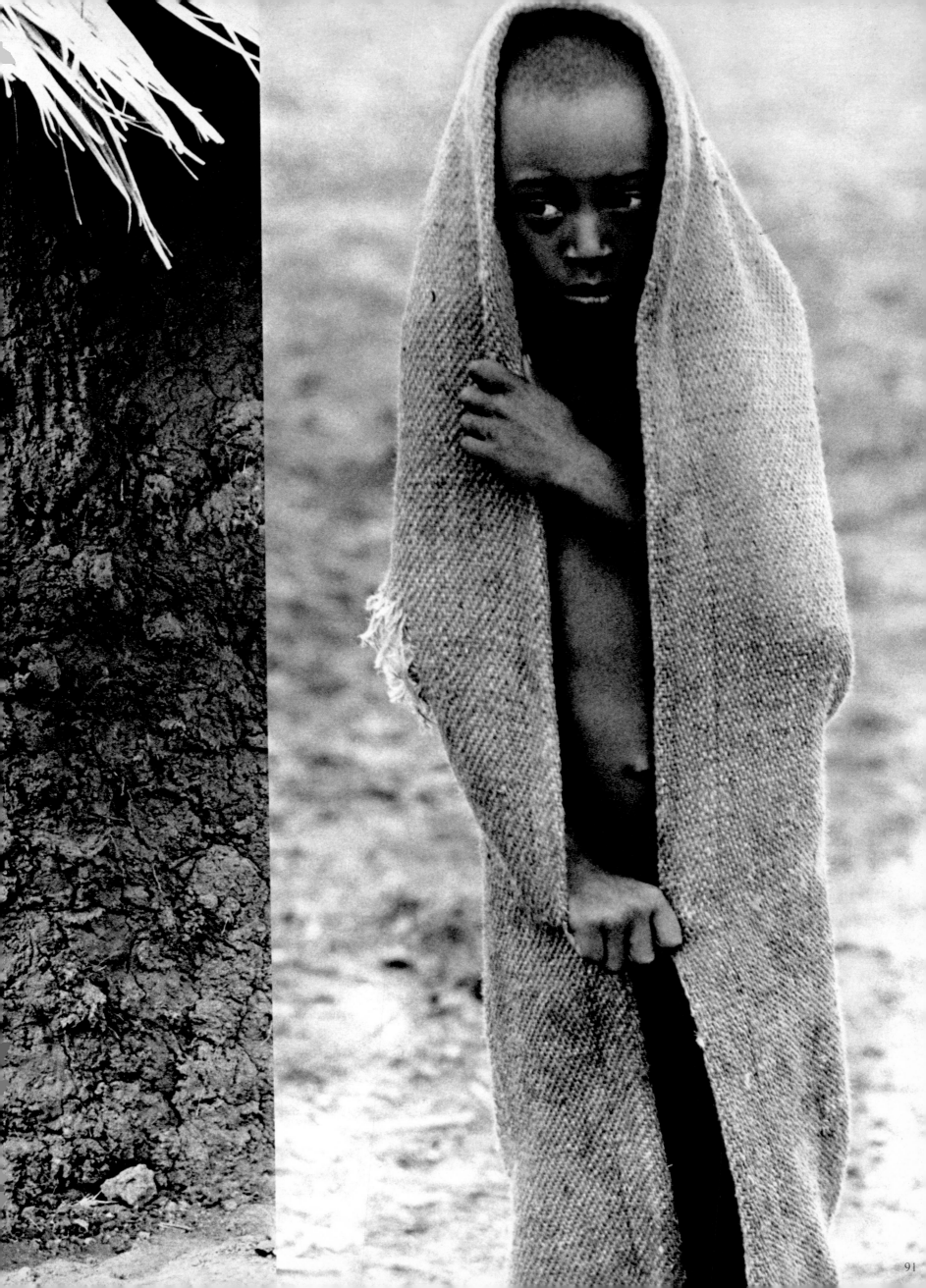

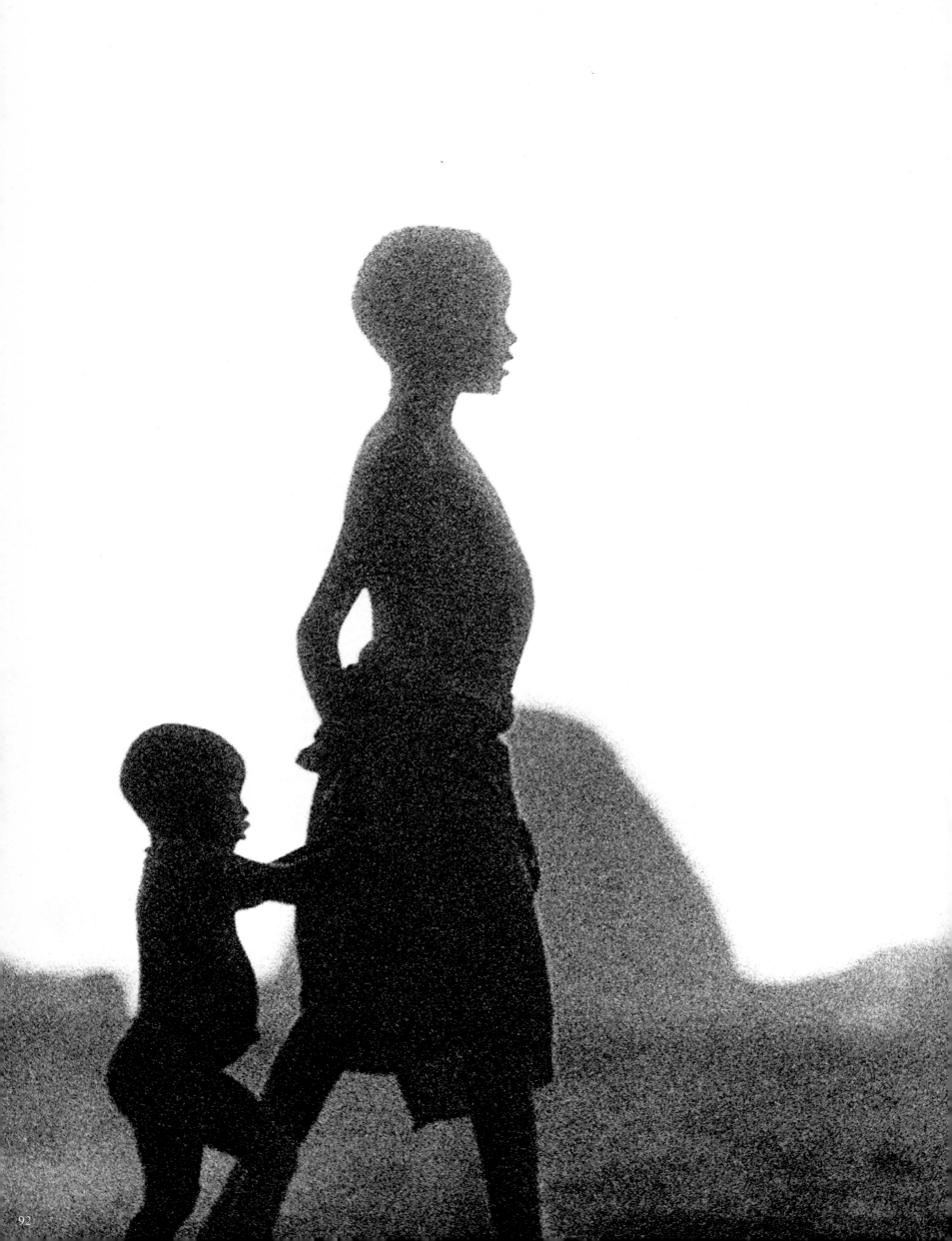

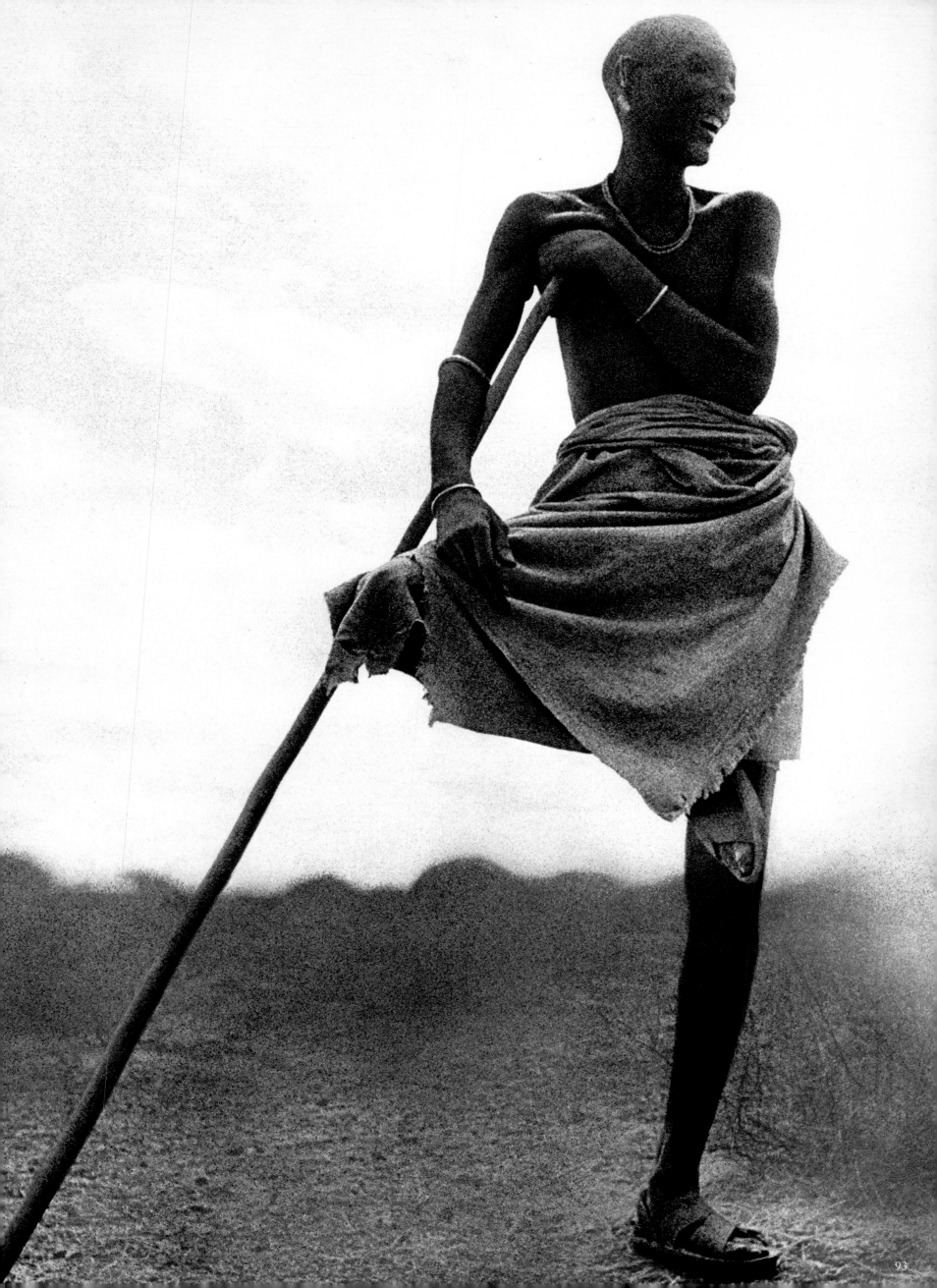

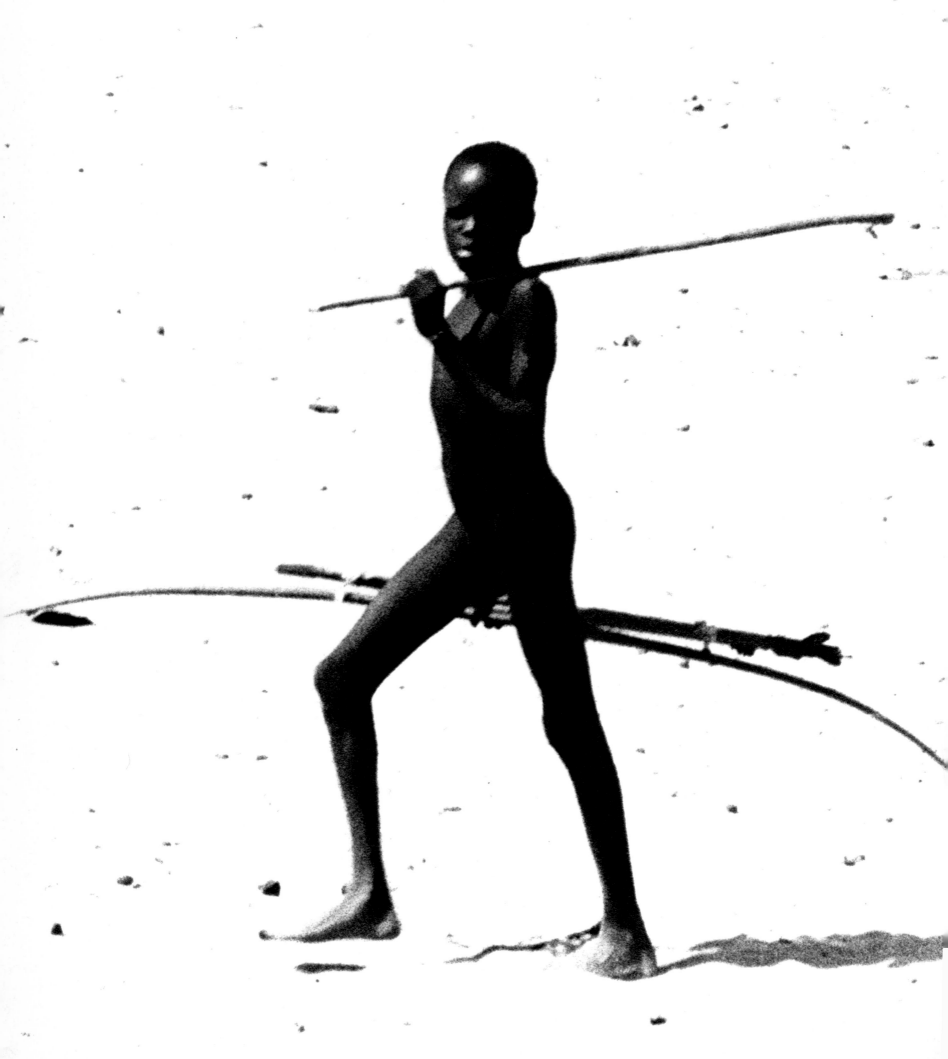

THE FISHERMEN OF
LAKE RUDOLPH

THE FISHERMEN OF LAKE RUDOLPH

The Turkana are a semi-pastoral people, who live in the arid wastelands and rocky foot-hills to the west of Lake Rudolph in Northern Kenya.

Lake Rudolph is an extraordinary phenomenon of nature – it is about 185 miles long and up to thirty-seven miles wide and lies in the middle of some of the most arid and lifeless desert in East Africa. It is fed by rainfall which is never more than twelve to fourteen inches per year and by the Omo river which flows from Ethiopia into the Northern end. On a windy day the churned-up waters, which break in great waves on the shore, are covered with thick white froth which looks like soap suds. Sudden and violent gales often sweep the lake, particularly in the South, and can prove extremely dangerous for anyone caught out in them.

The water is undrinkable because of its high chemical content which also renders its shores impossible to cultivate. All crops are immediately burned by the soda which has been deposited and lies in a thick brown layer along the water's edge. The only vegetation which seems to survive is a long spiky grass with woody blades. The Turkana dig holes as far as possible from the water's edge from which they draw the water for drinking. The earth acts as a filter for some of the soda, but it still remains murky and bitter for at least two miles inland.

This is country for a people who have learned how to survive in the face of extreme hardship, and they adapt themselves to an environment which is often virtually devoid of life. Patches of soil which can be cultivated are scattered between miles of lava outcrops, and as soon as there is a sniff of water in the air everyone gets to work on the temporary rain pans. But lack of rain and high daytime temperatures combine to prevent more than half of any crop being harvested. Ideally, this is therefore the country of the camel, but few herdsmen can afford more than a small flock of sheep and goats or a few cows. Instead, the Turkana are forced to seek subsistence in a mixed economy, involving a combination of pastoralism, hunting and gathering, and increasingly today, fishing. It is not surprising that unlike their more prosperous cousins to the south, they have no inhibitions, or prohibitions, against eating snakes, rodents, fish and fowl, or virtually anything that moves. A little imported maize is used to supplement the diet of these Lake Turkana.

Above all the Turkana here depend on the doum palm, the only tree which manages to survive in this arid lava area, and on fishing. The doum palm is put to every possible use. Fishing rafts, punting poles and paddles are made from its light, spongy wood. The stems of the leaves are used to make the frames of the baskets for catching fish and thin strips of the bark for string. The leaves are used to thatch huts and the roots are eaten as a vegetable although it has virtually no nutritive value. Indeed, without the doum palm it is difficult to see how these Turkana could survive.

The original way of fishing was for a man to stand waist-deep in the water waiting to spear any fish that came within range. They also have a slightly less haphazard way of catching the fish. A line of men enter the shallow water knee-deep carrying great inverted

cone shaped baskets about four feet wide. They form a large circle. At a given signal the baskets are plunged in and out of the water as they move slowly towards the centre. If any fish are trapped the basket is held firmly on the bottom with one hand. The fisherman thrusts his hand into an opening on the top and withdraws the fish which is strung to a piece of palm thong passed through the gills. But today, the Government is providing nets for increased production. These hang from floating poles and are weighted down with stones. Having set them, the fishermen go off, returning in an hour or so on their rafts to collect the catch. Tilapia or Giant Nile Perch of sometimes up to 170 lbs. in weight make good eating and abound. The nutritional value of these fish is very high and seems to be particularly effective on the children who are all fat and healthy, their skin taut and shining on their sturdy bodies. Crocodiles are frequently found entangled in the nets and can easily maim or kill a fisherman. Nevertheless they also are sought as food.

Part of each catch is at once boiled for soup or cooked over an open fire. But increasingly today, the rest is dried and eventually sold, mainly to the Congo, thereby providing some cash with which maize meal and other luxuries such as beads can be bought.

In recent years boats with outboard motors have been introduced to the lake by the Government as an experiment. It is hoped that with such changes the life of the Lake Turkana – which in a good year hovers barely above the starvation level and in a bad year is sustained by famine relief supplies – will improve. I couldn't help feeling, however, that this modern, more effective way of fishing was robbing the lake of much of its magic and of the primitive beauty which has existed ever since these simple people attempted to solve their natural problems with the means offered them by nature.

95. *Turkana girl shades herself from burning sun with her fish. Everything is always carried on the head so that the hands are free.*

96 & 97. *Turkana fisherman on a raft on Lake Rudolph, flamingoes overhead.*

98 & 99. *On Lake Rudolph.*

100–105. *Turkana fishermen on Lake Rudolph leave at dawn for their day's fishing.*

106–111. *In action with fishing baskets.*

112 & 113. *Early morning wait.*

114 & 115. *Dawn departure.*

116 & 117. *Returning with the catch.*

118 & 119. *Fisherman on his raft collecting fish from the net in the middle of Lake Rudolph.*

120 & 121. *A good day's catch.*

122 & 123. *Fish drying in the sun. Recently a considerable industry has grown up on the shores of Lake Rudolph. Since independence the Government is doing everything they can to develop these local industries. A large quantity of the dried fish is exported to the Congo.*

124. *Child with 50 lbs. fish on head.*

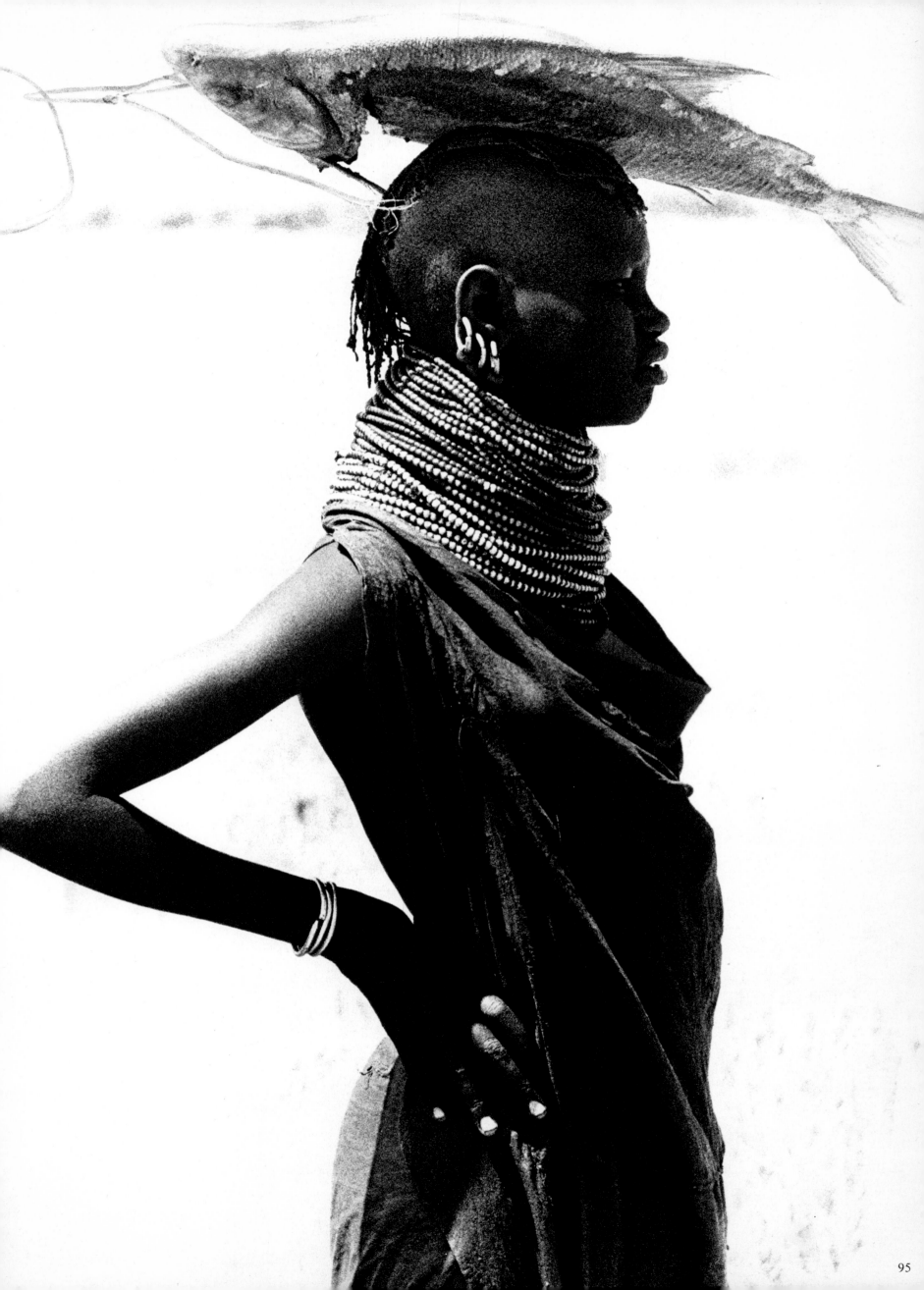

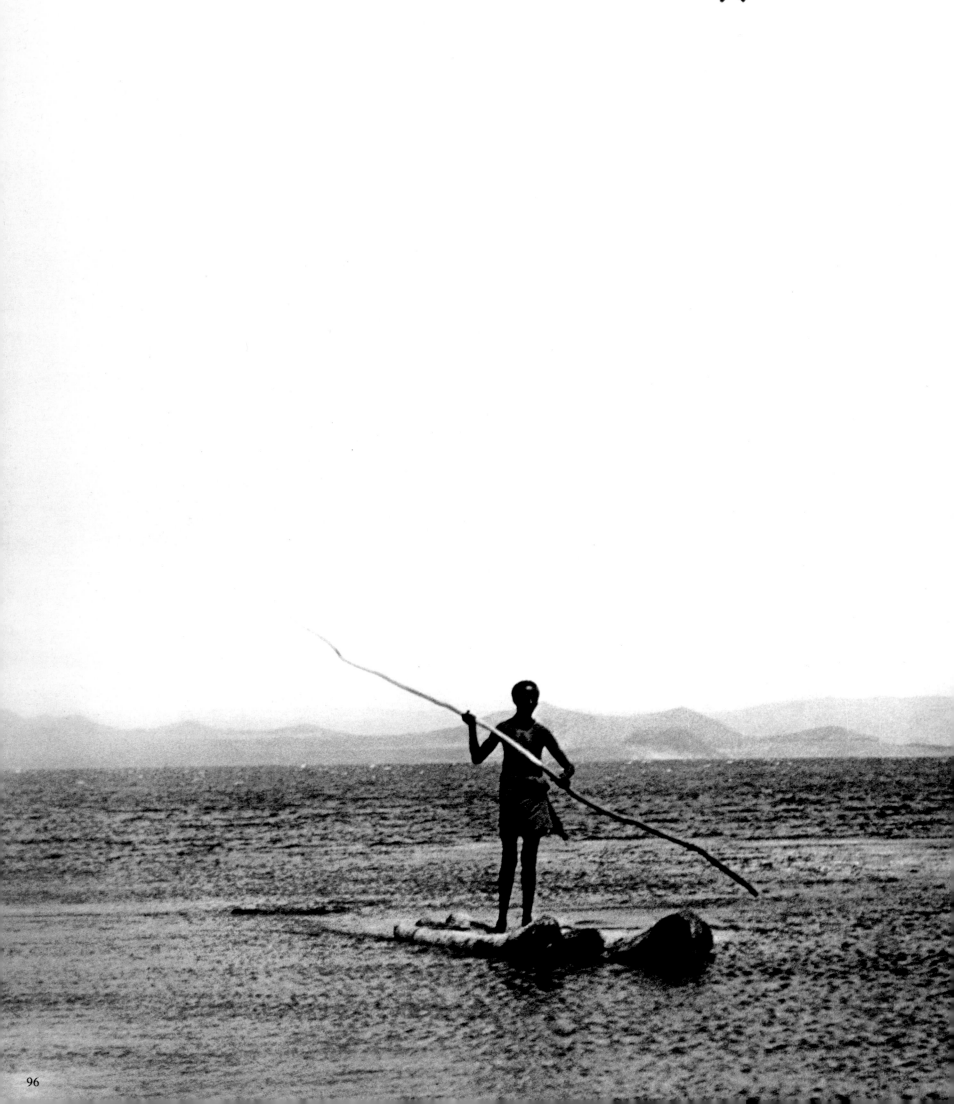

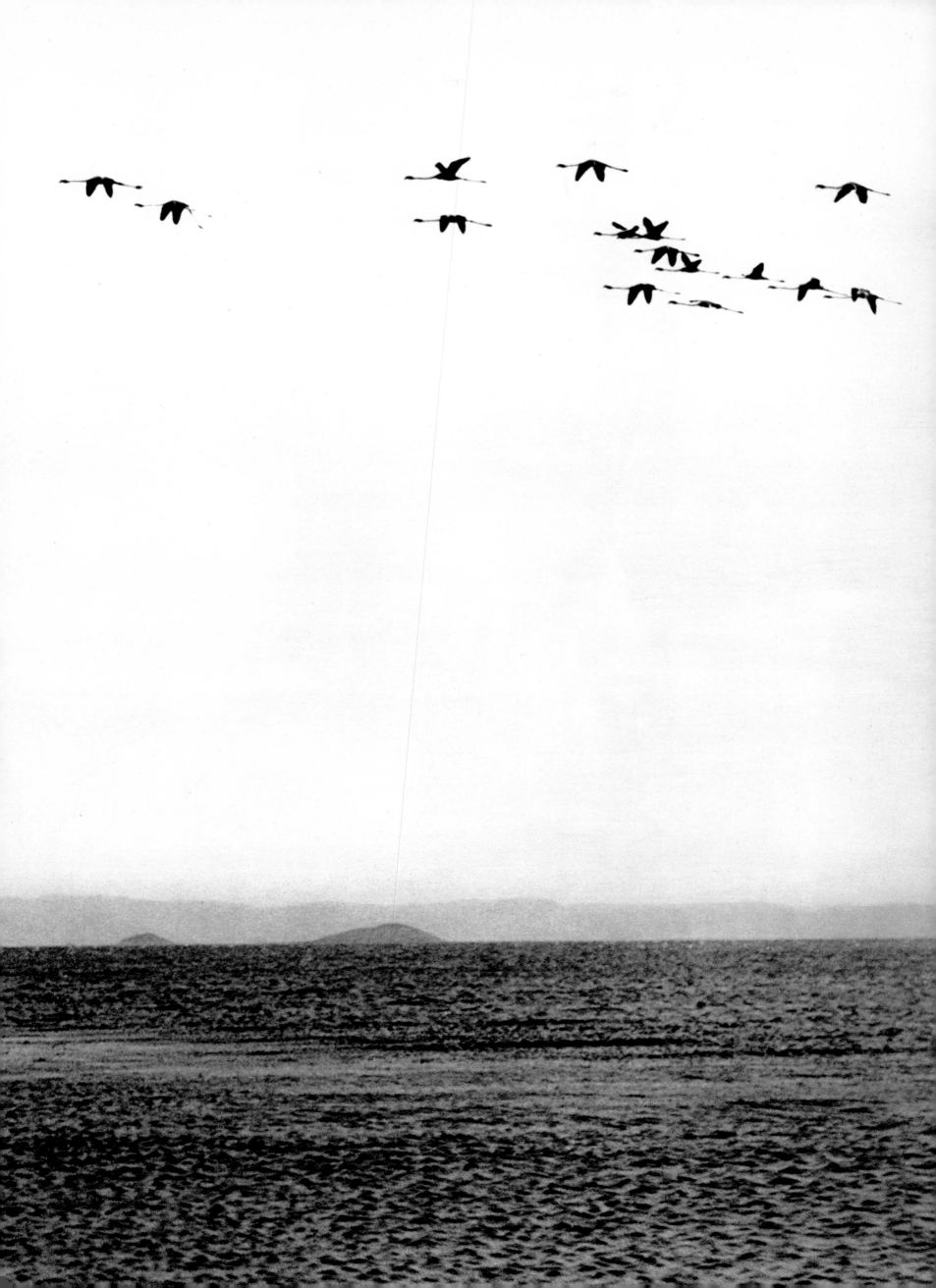

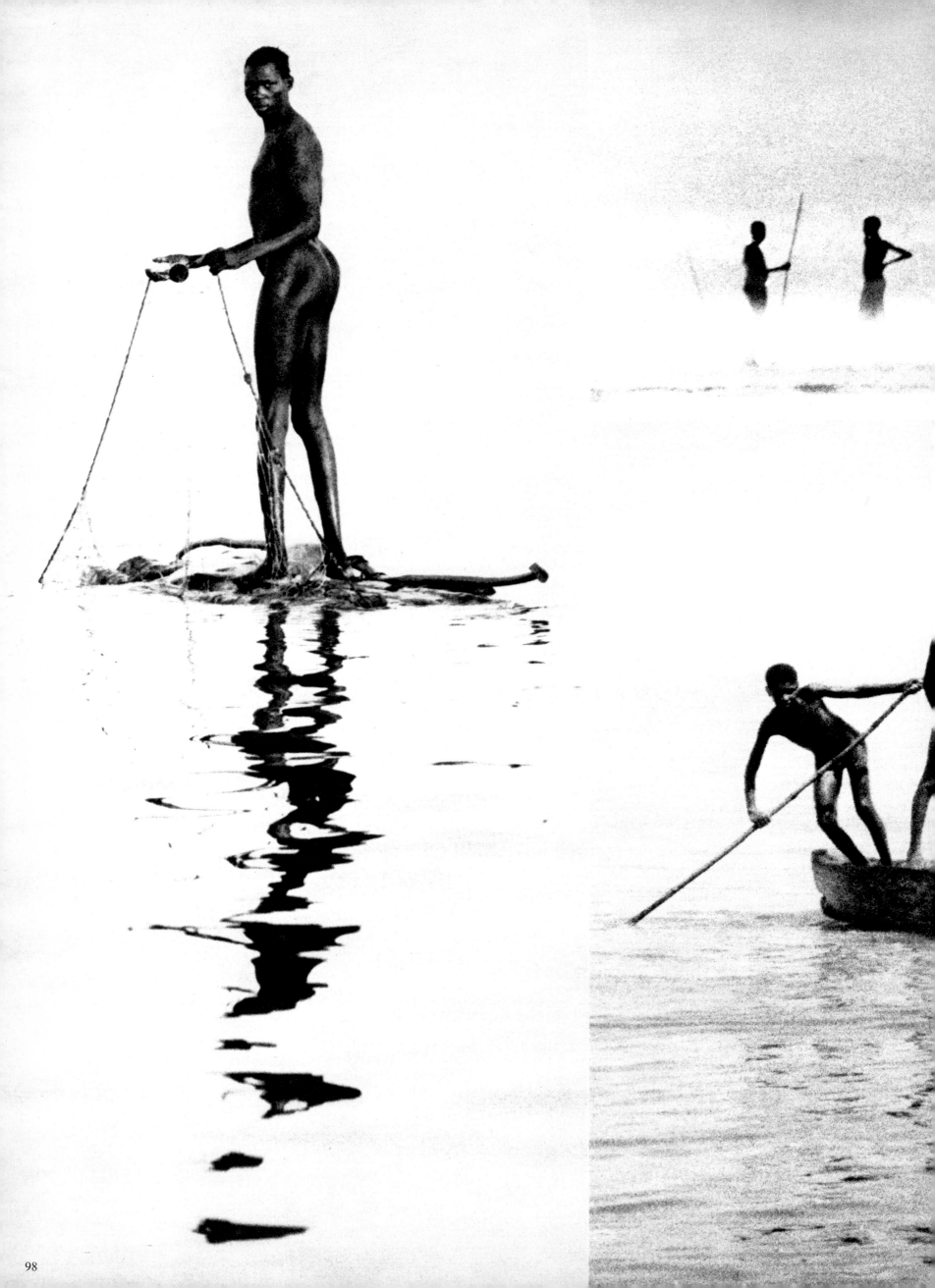

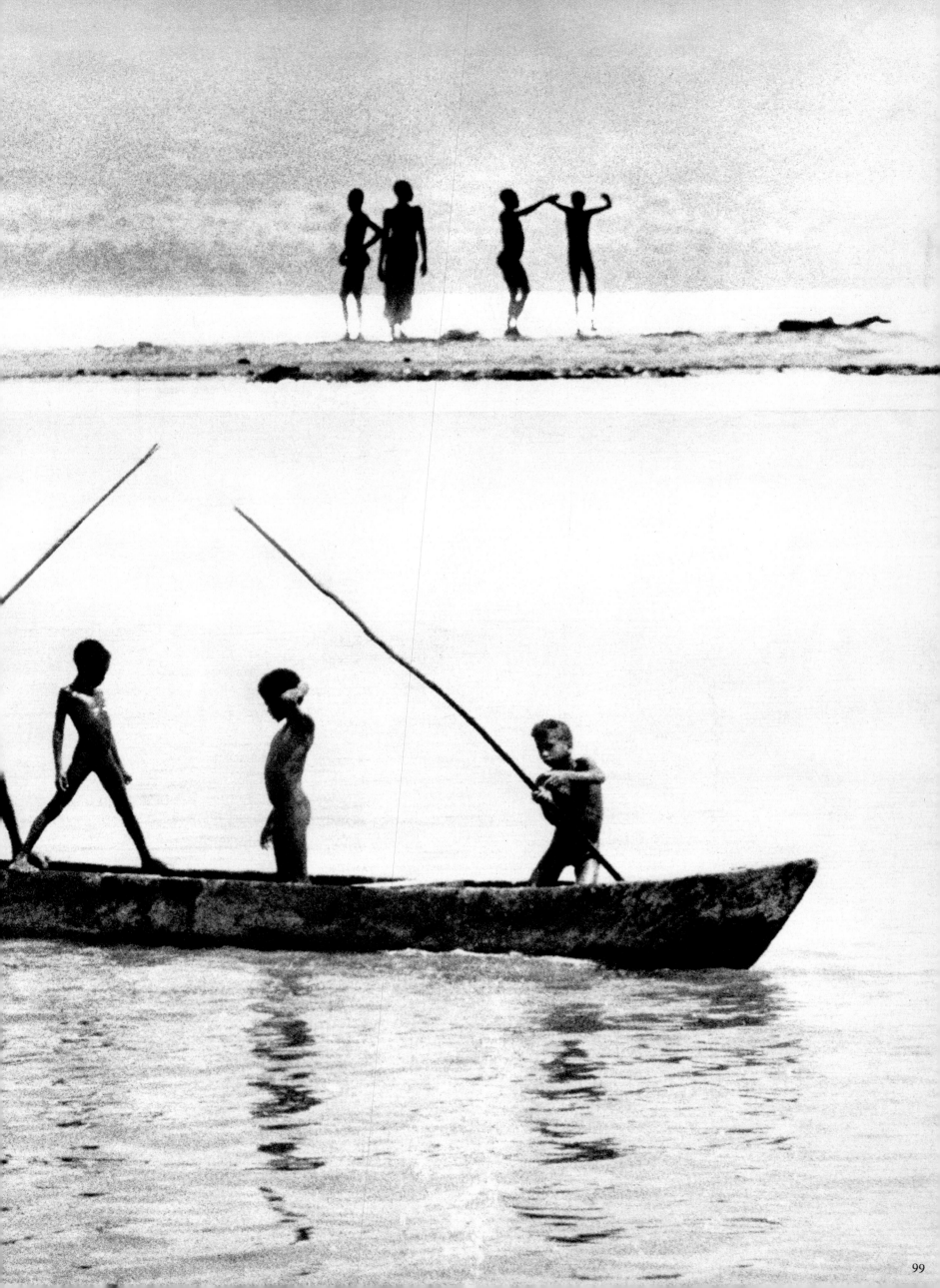

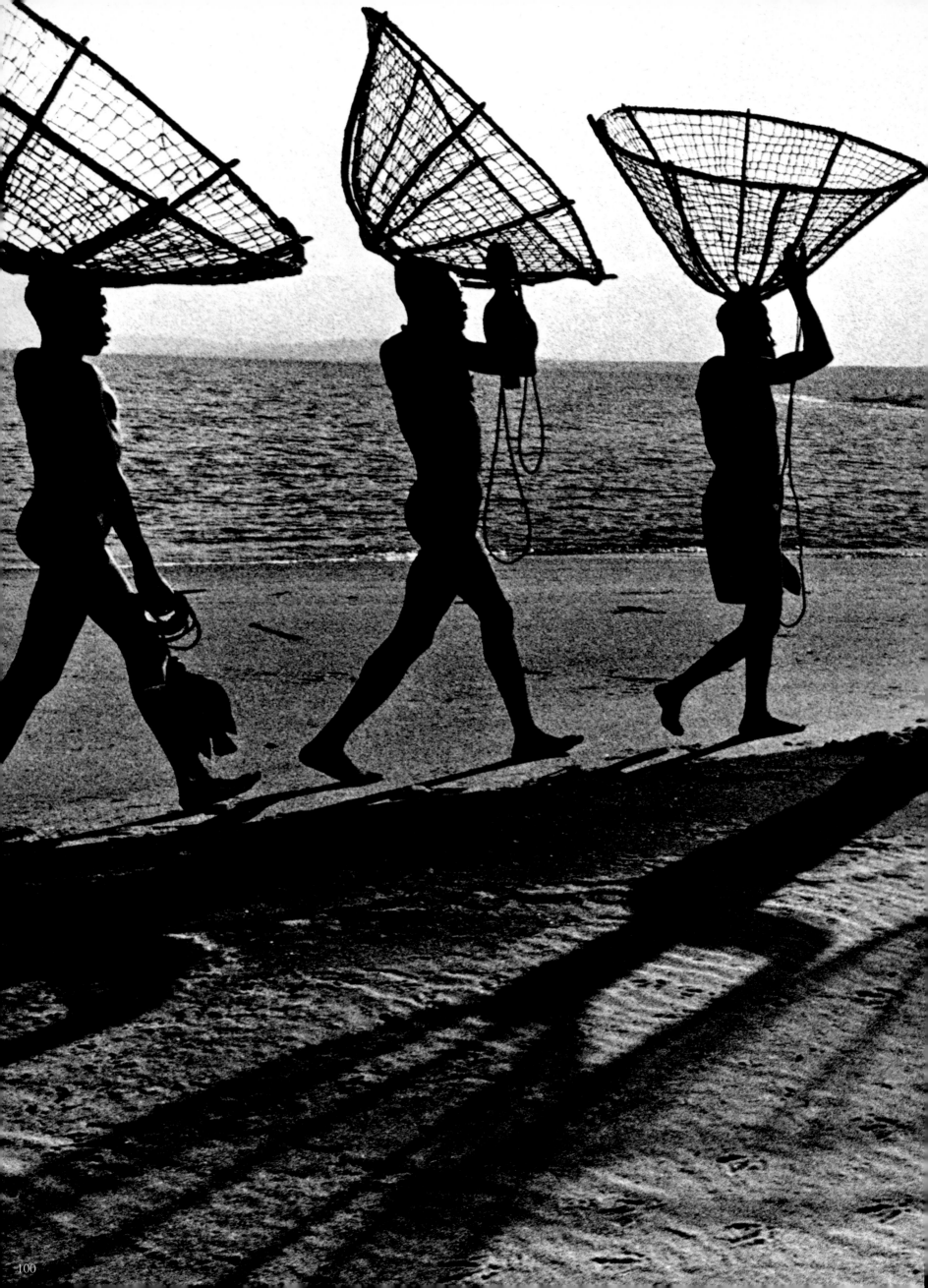

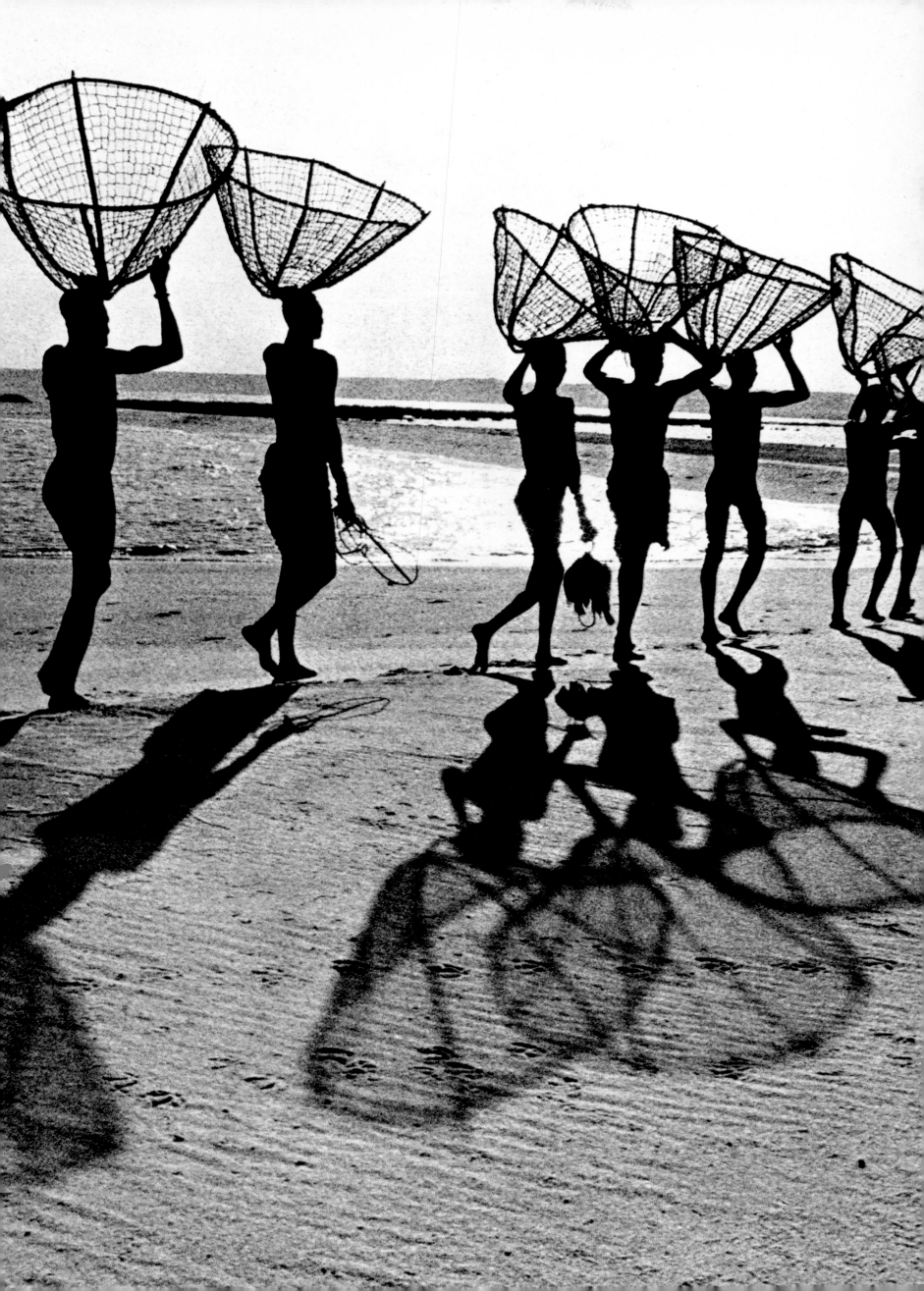

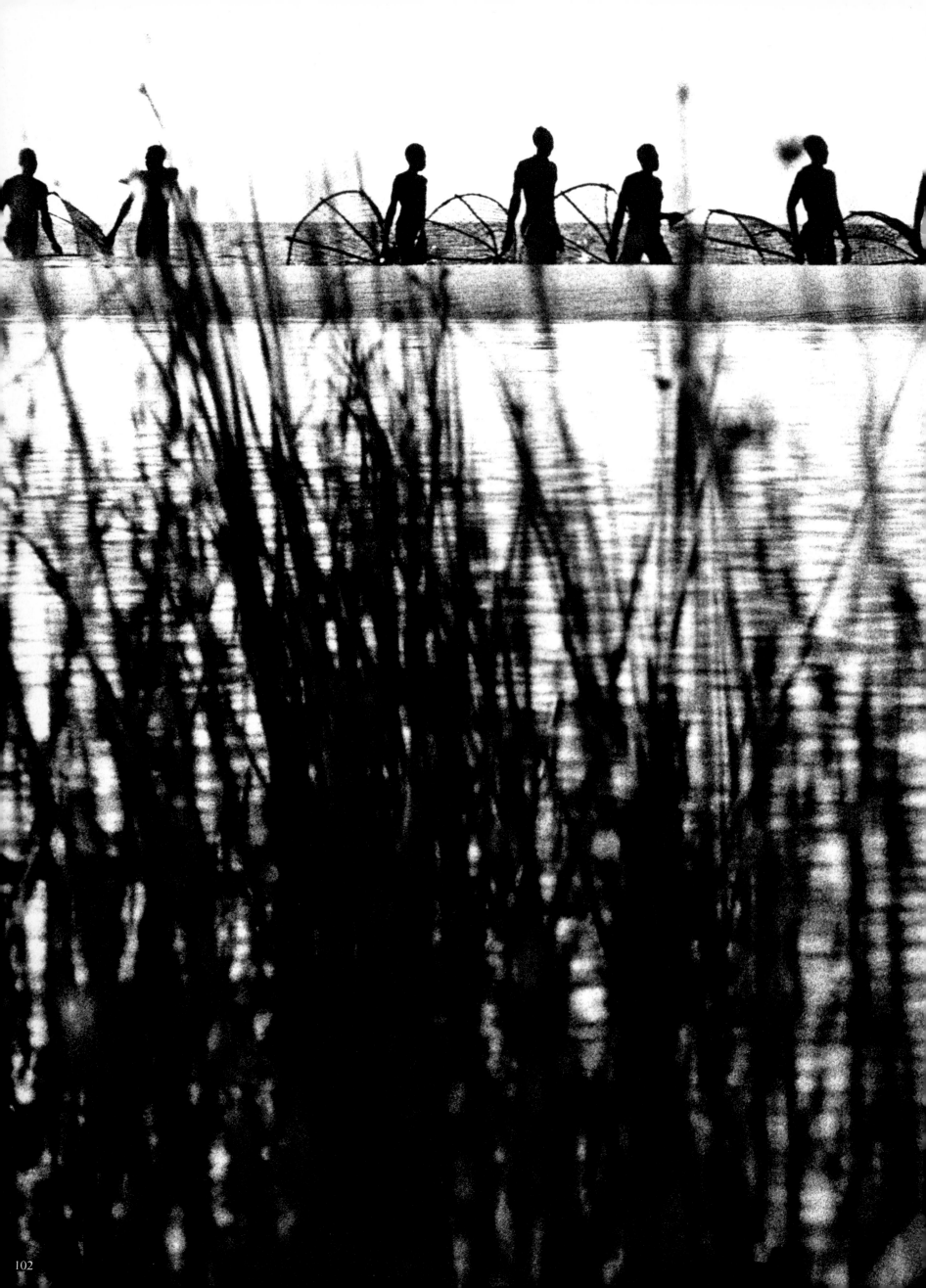

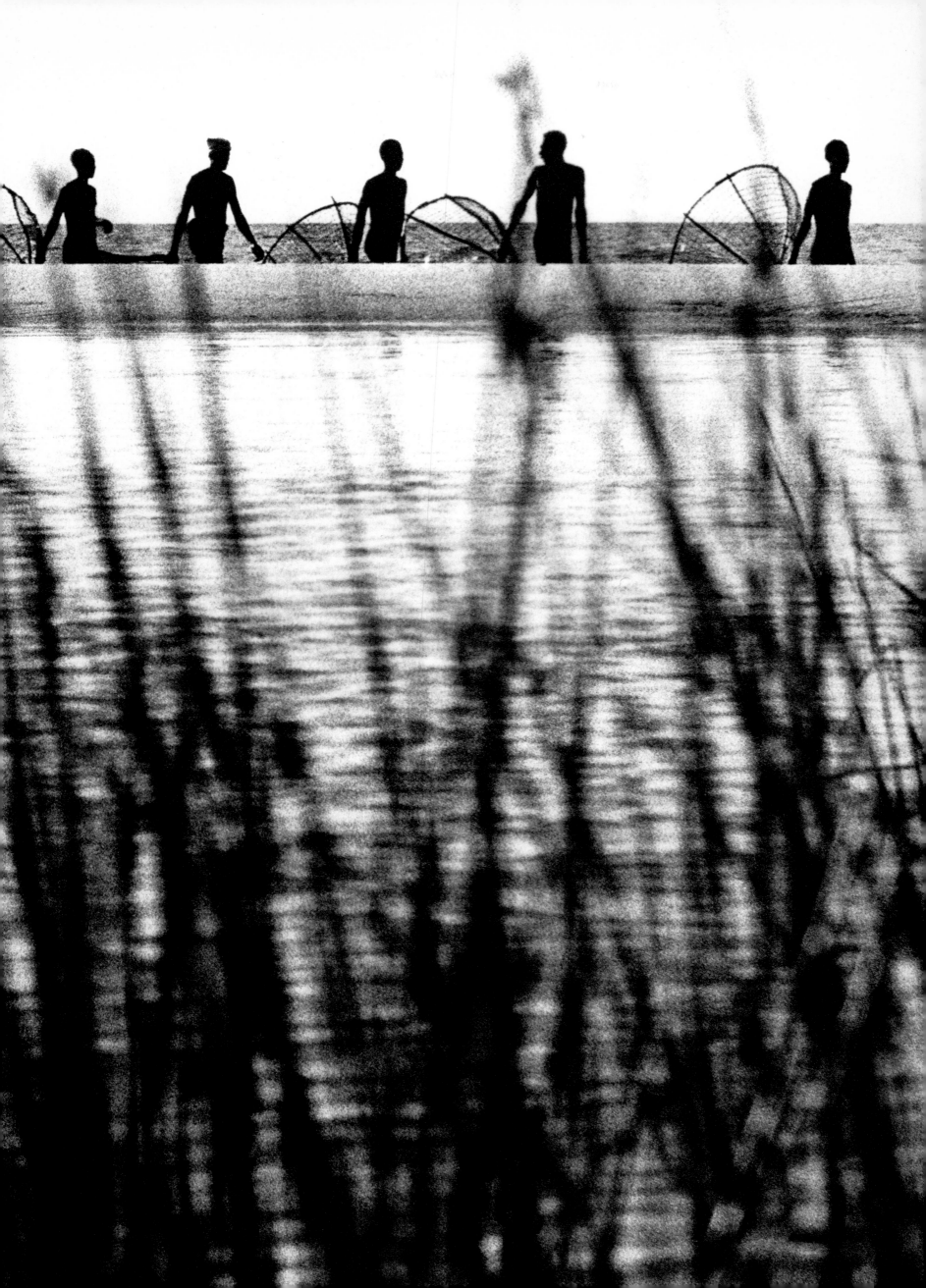

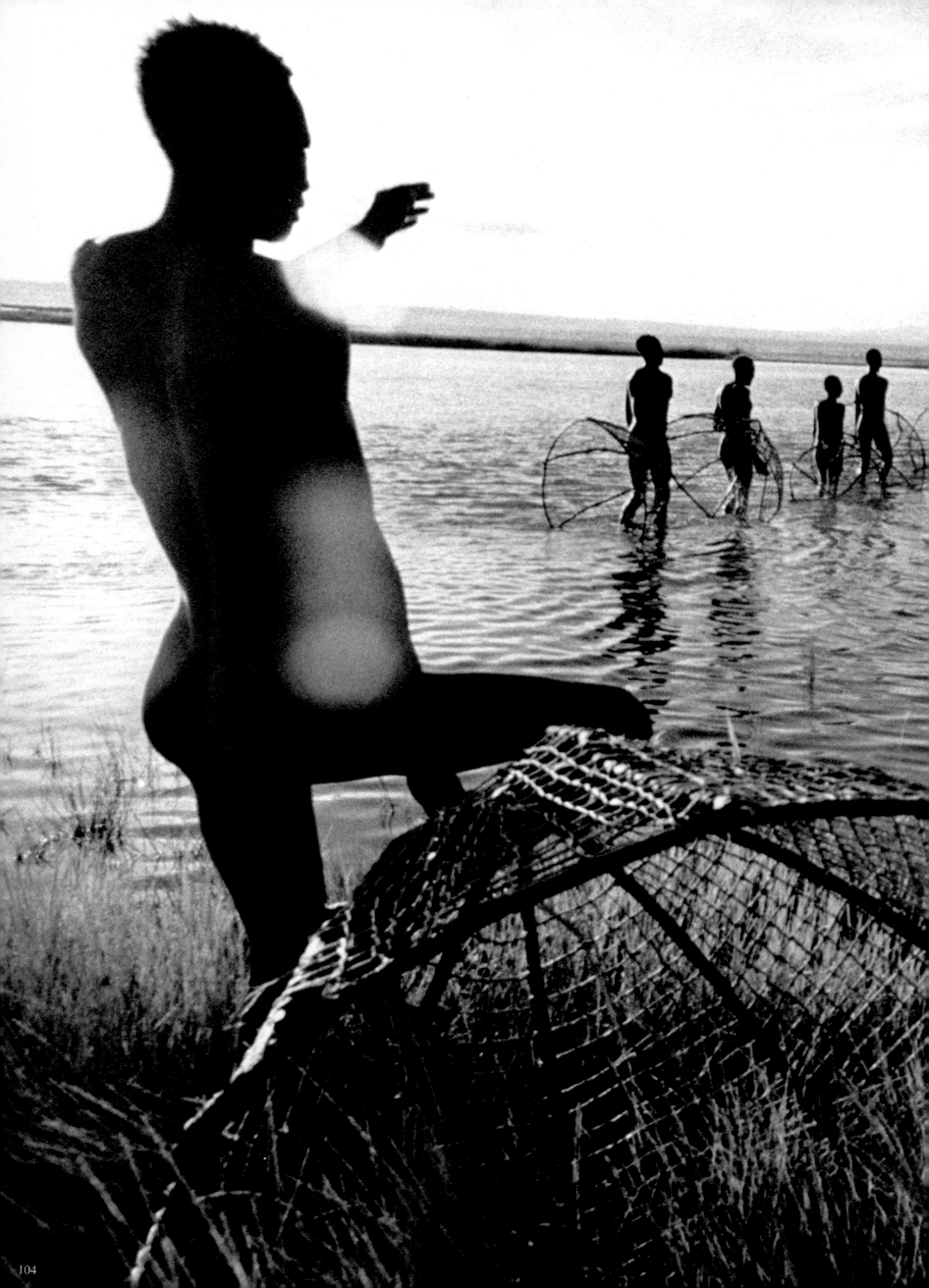

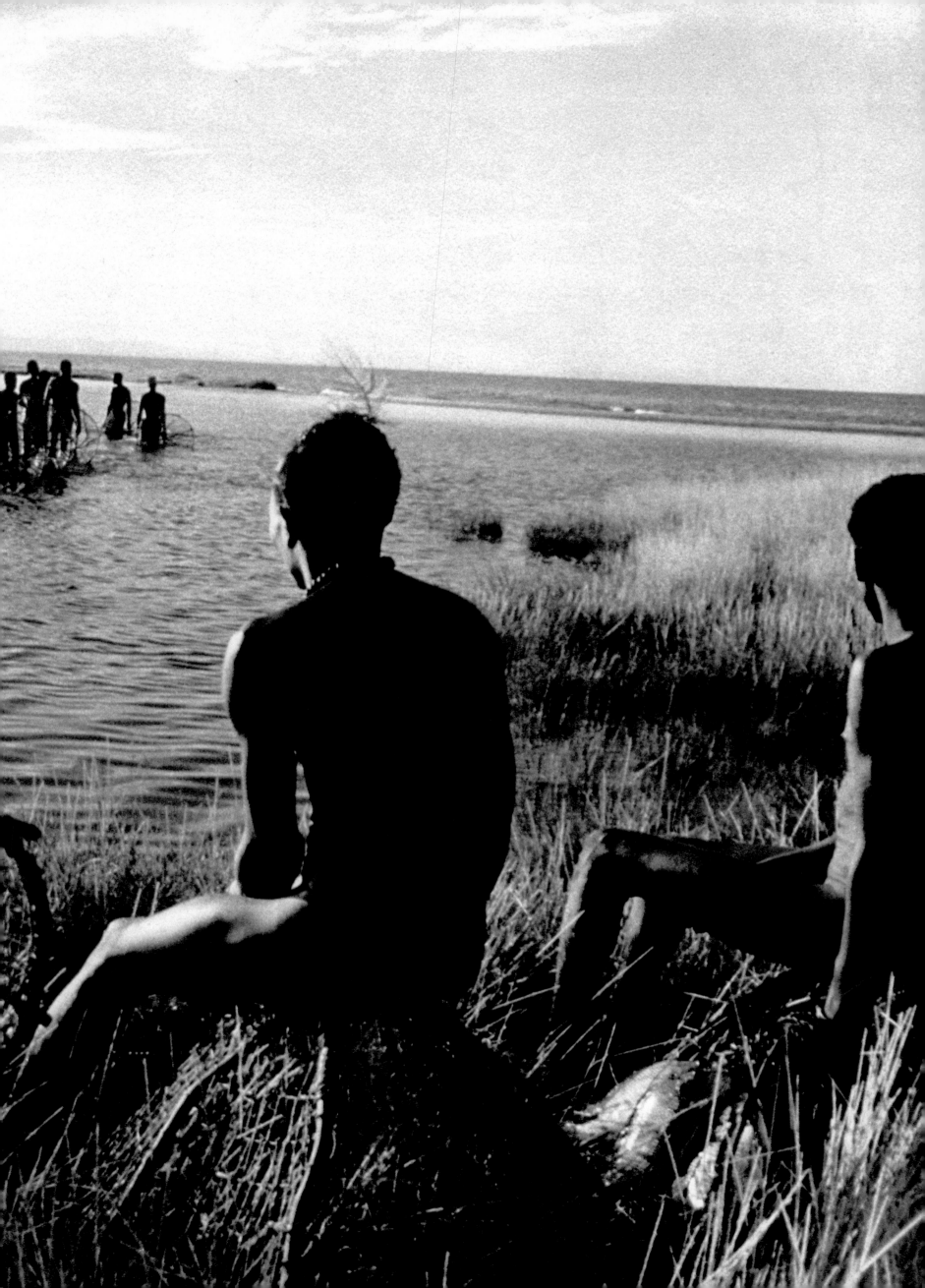

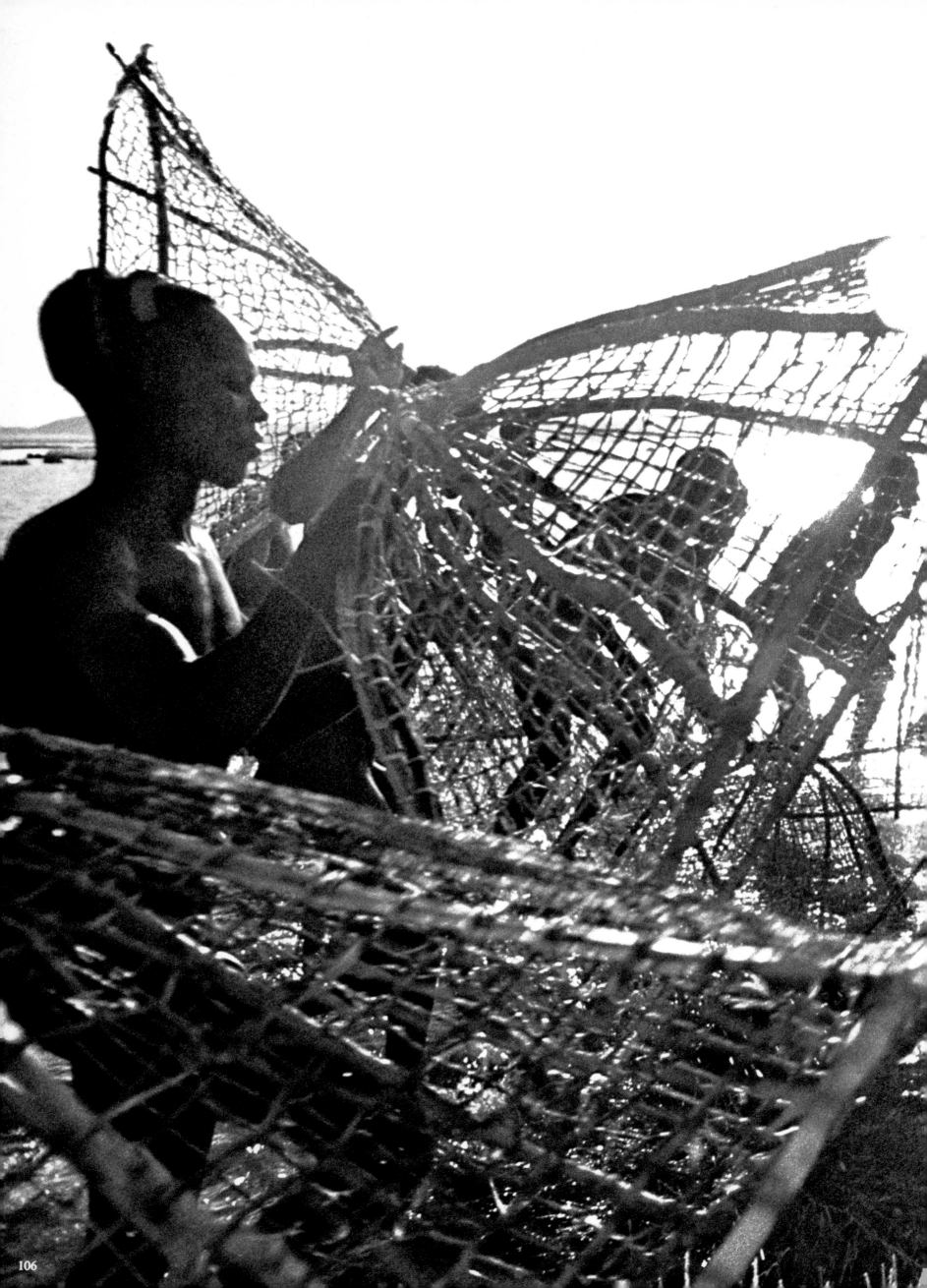

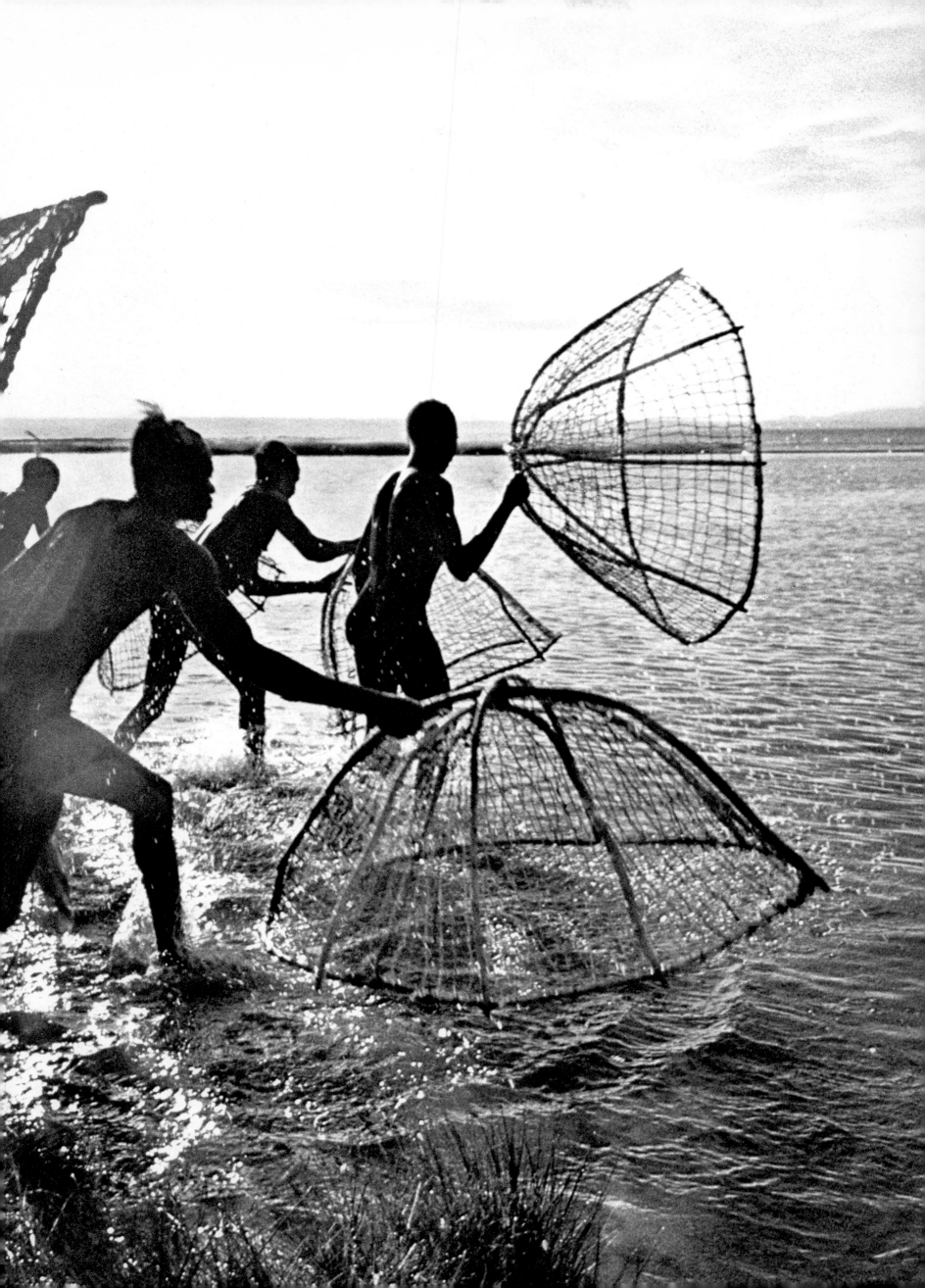

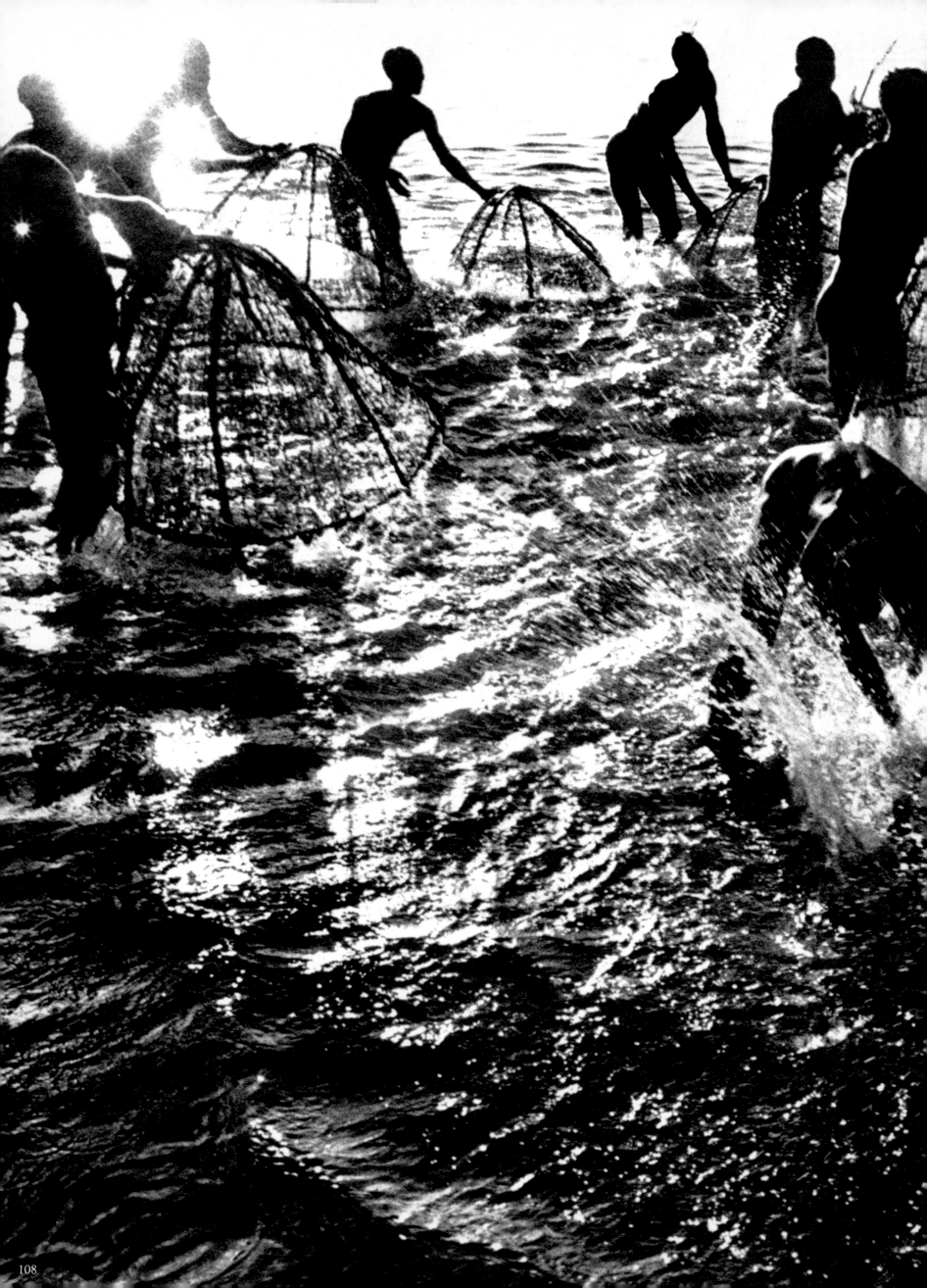

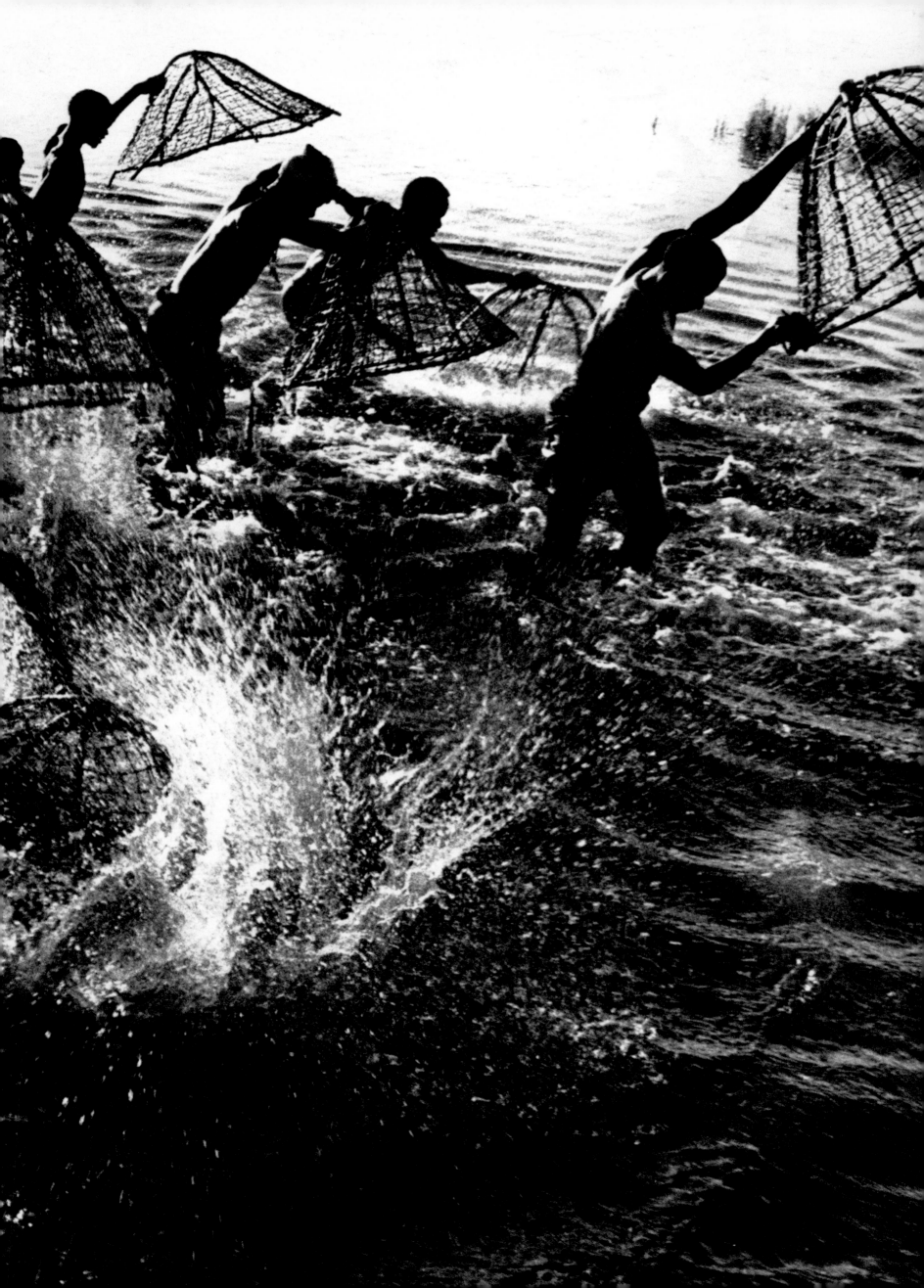

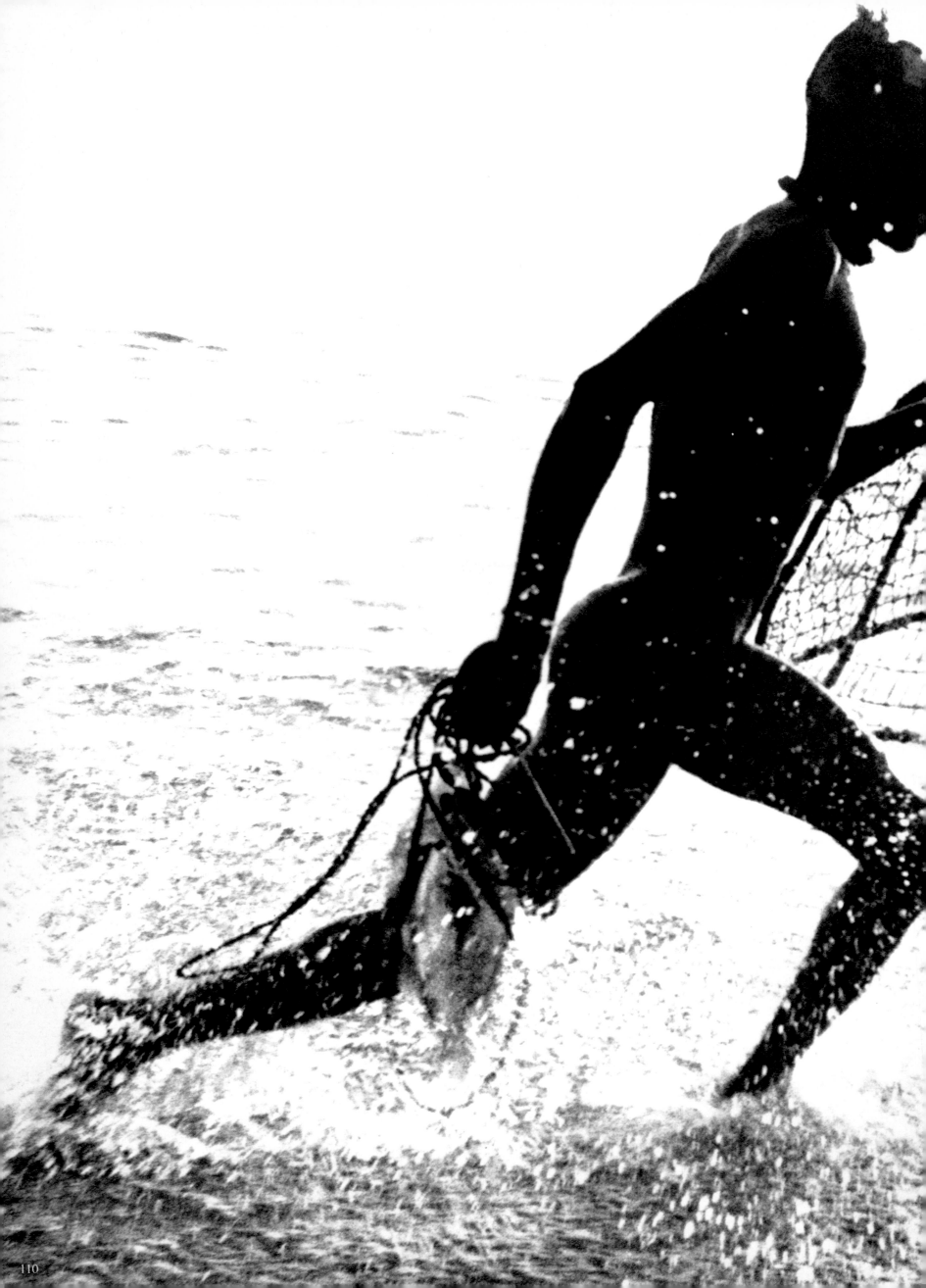

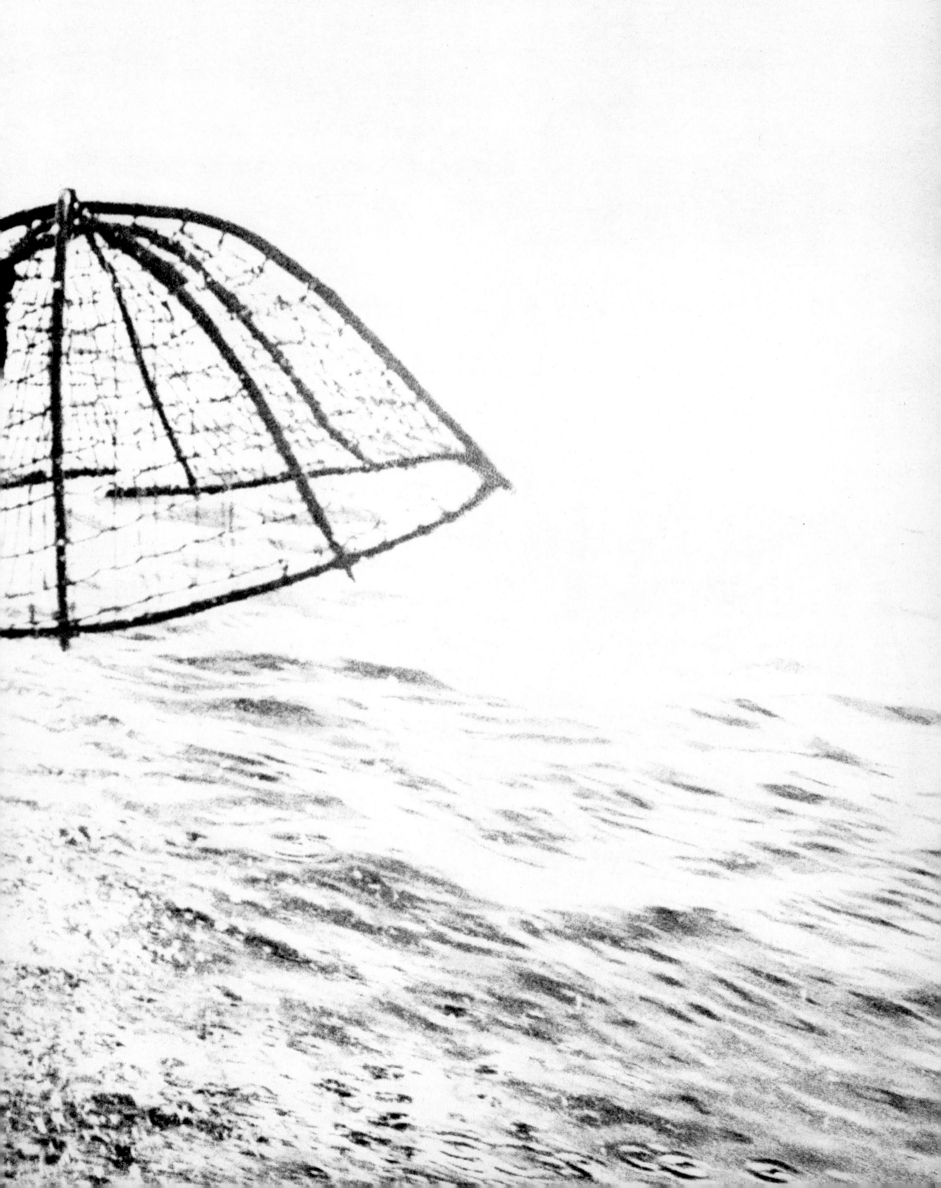

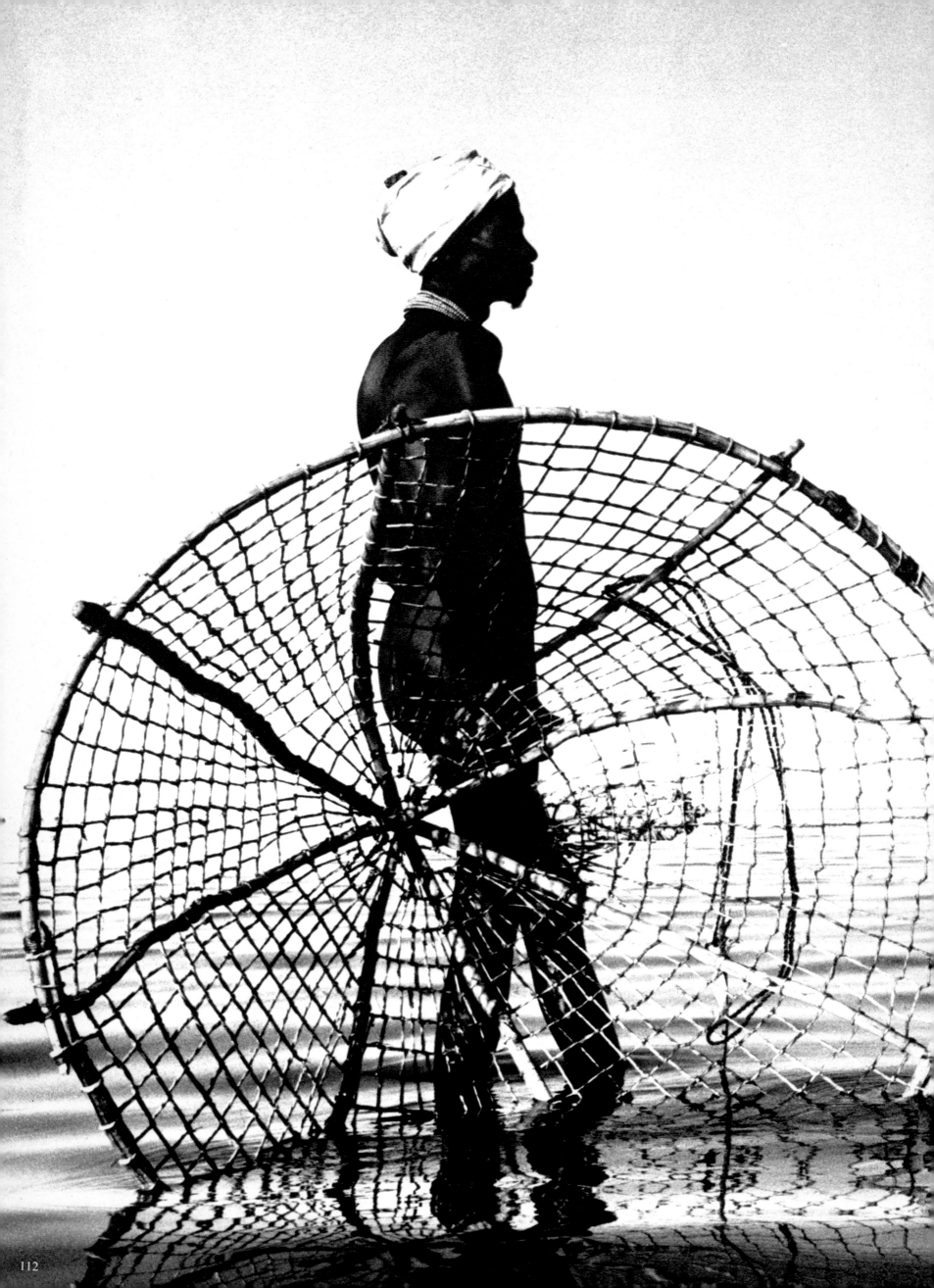

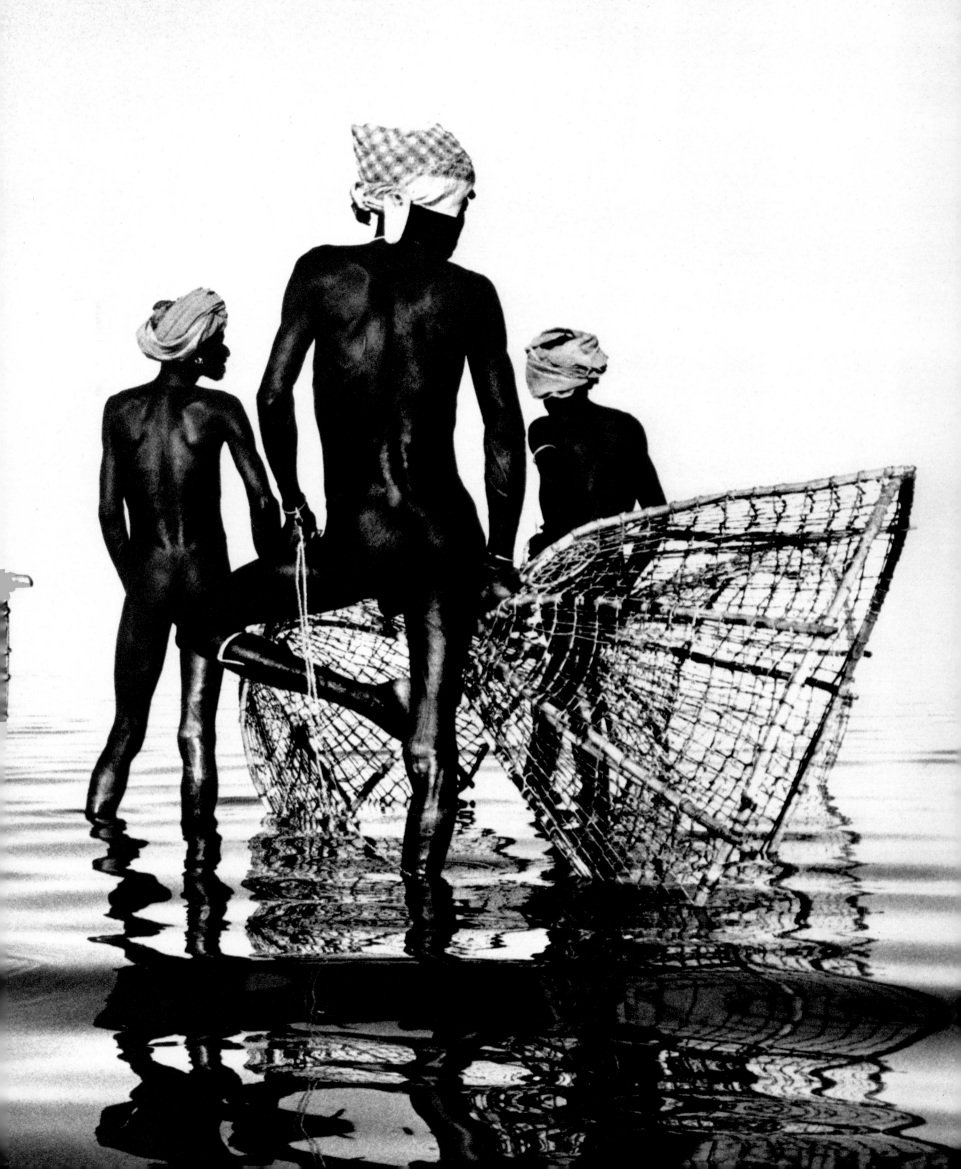

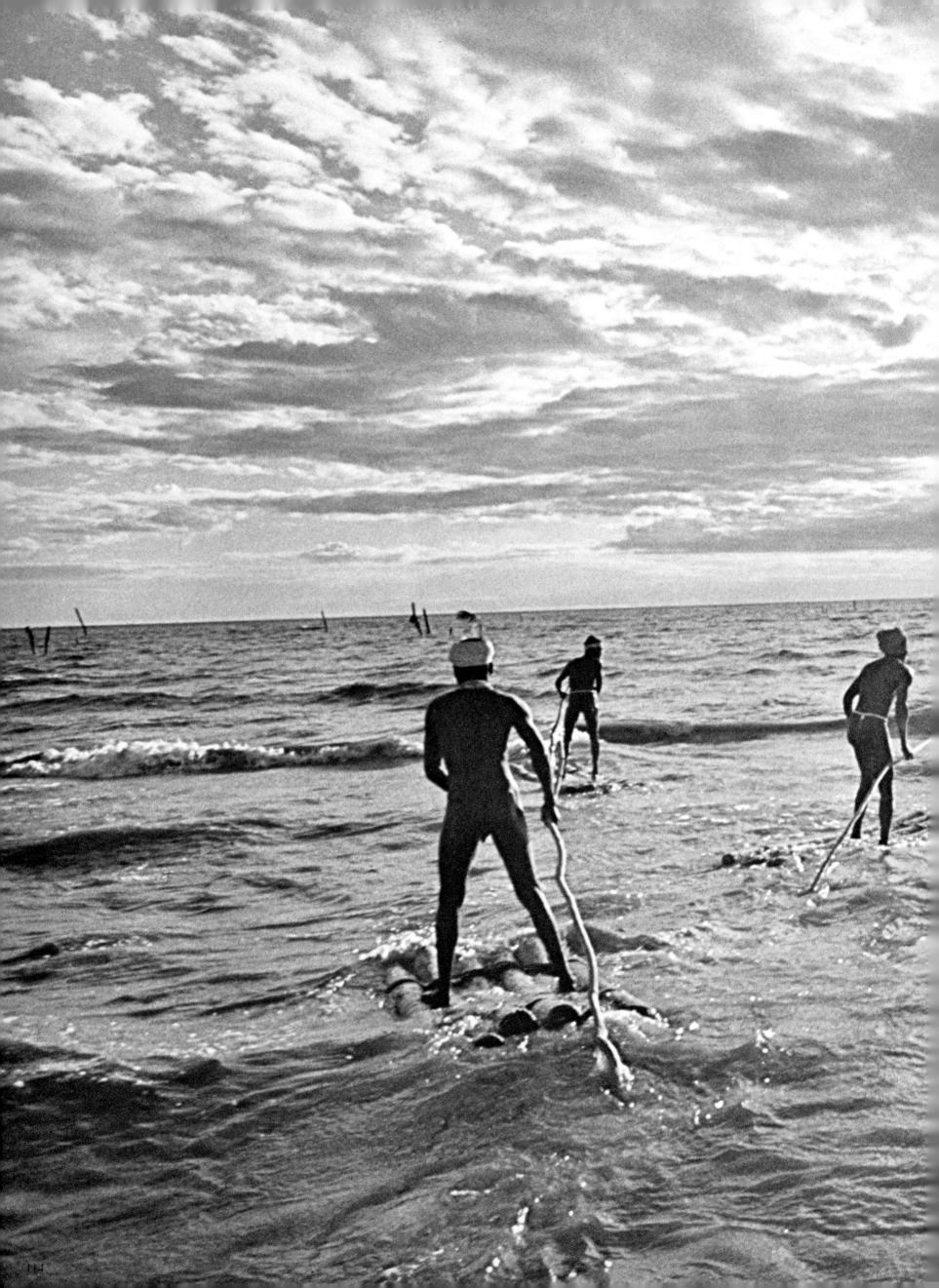

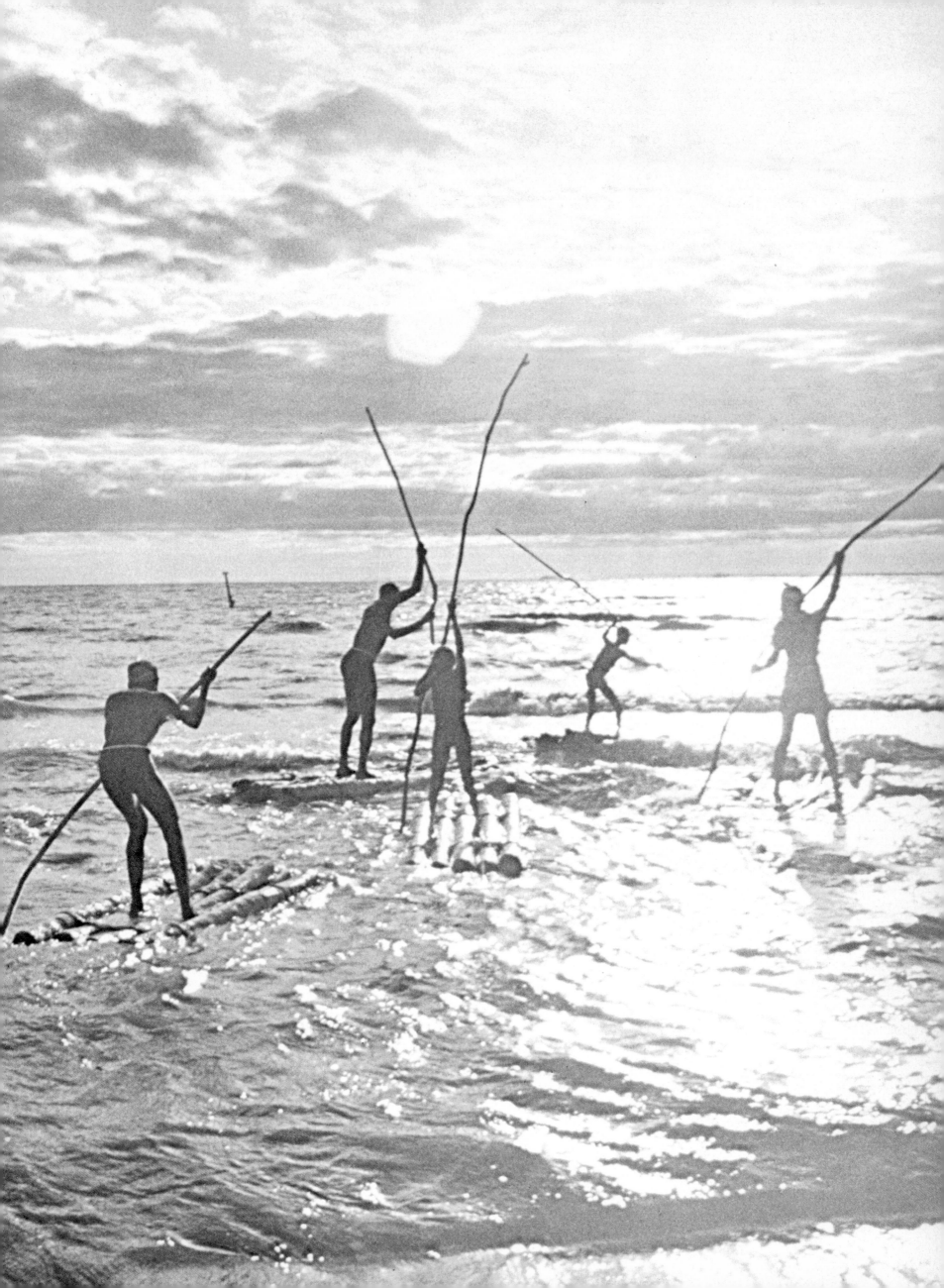

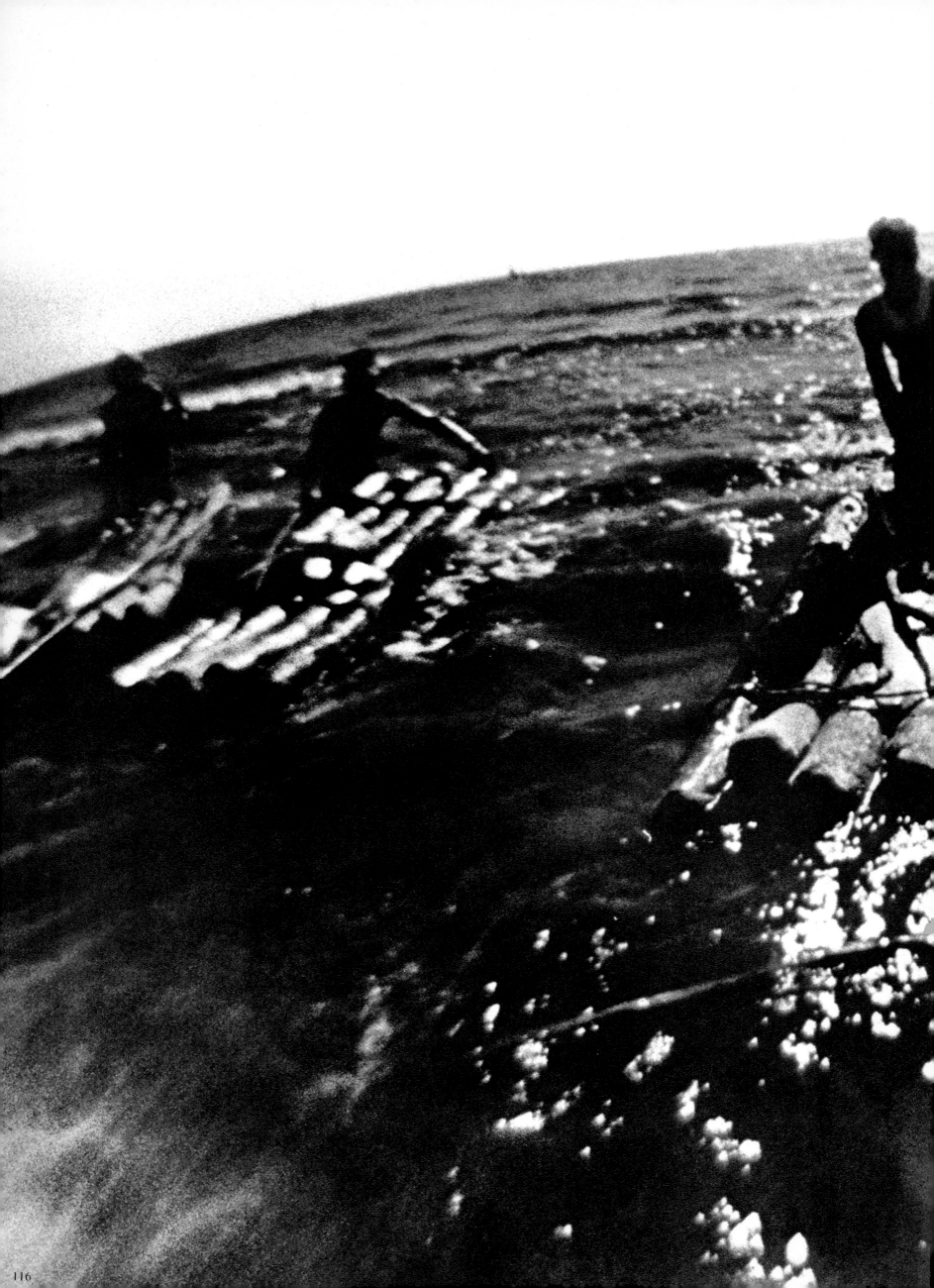

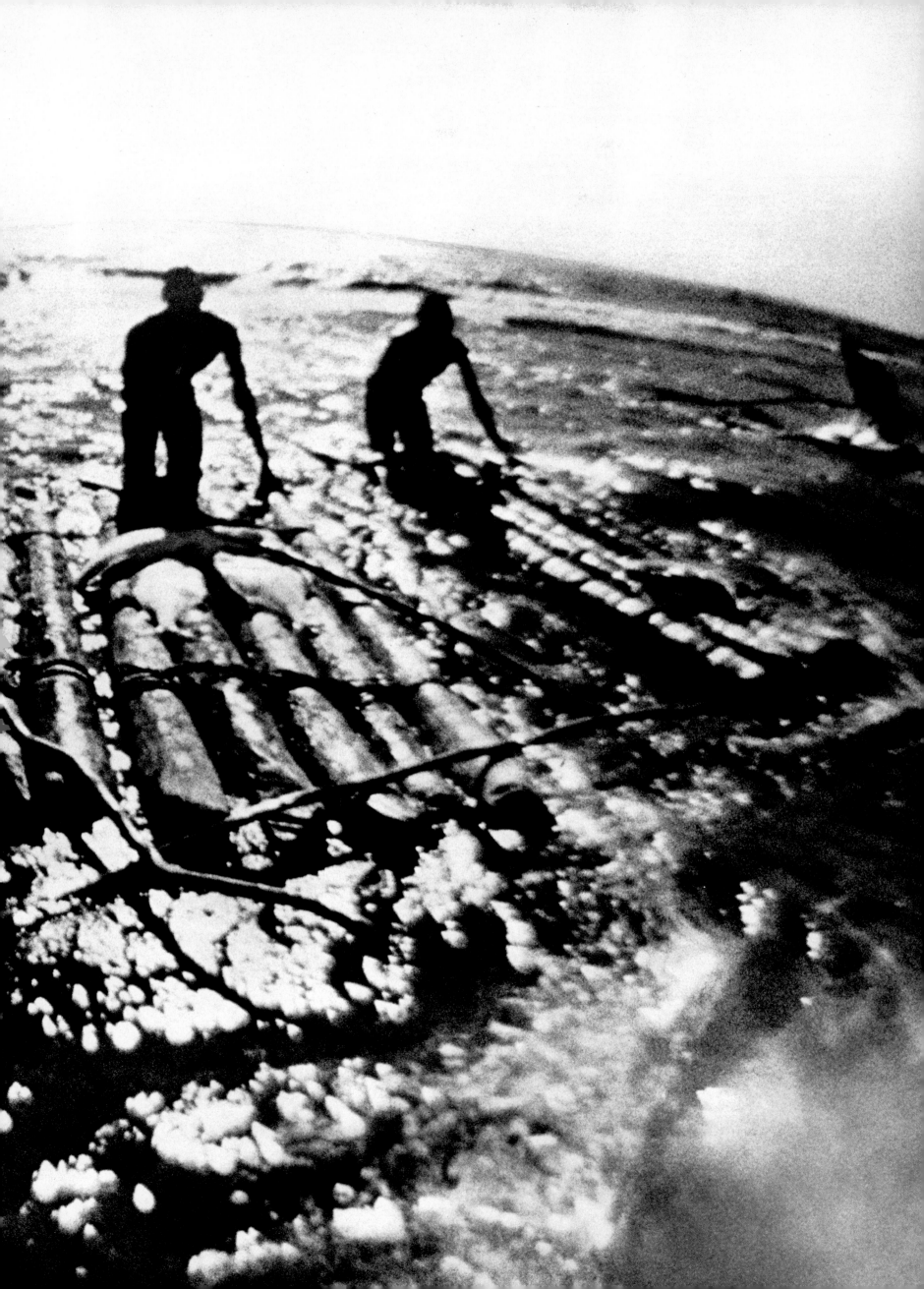

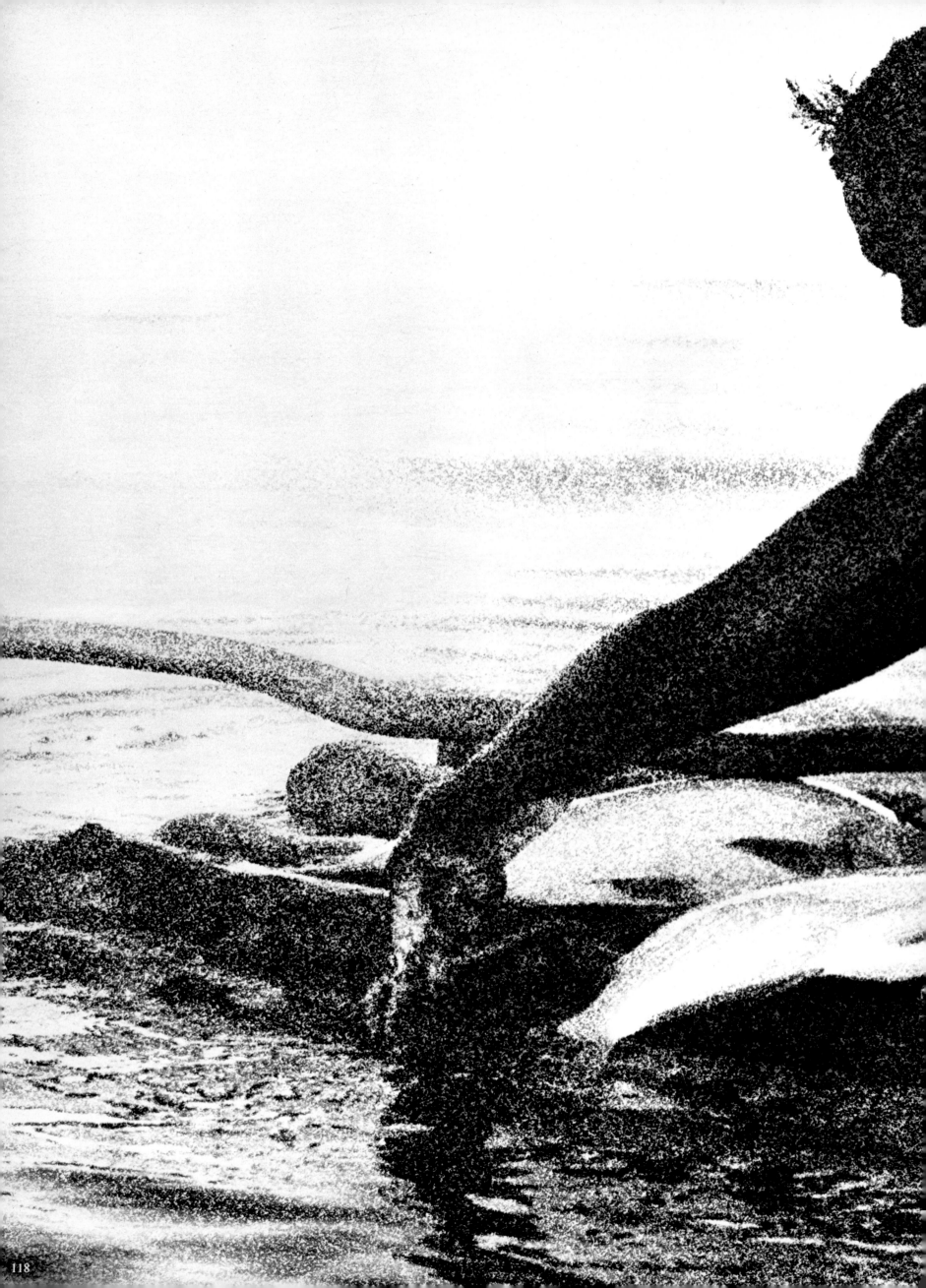

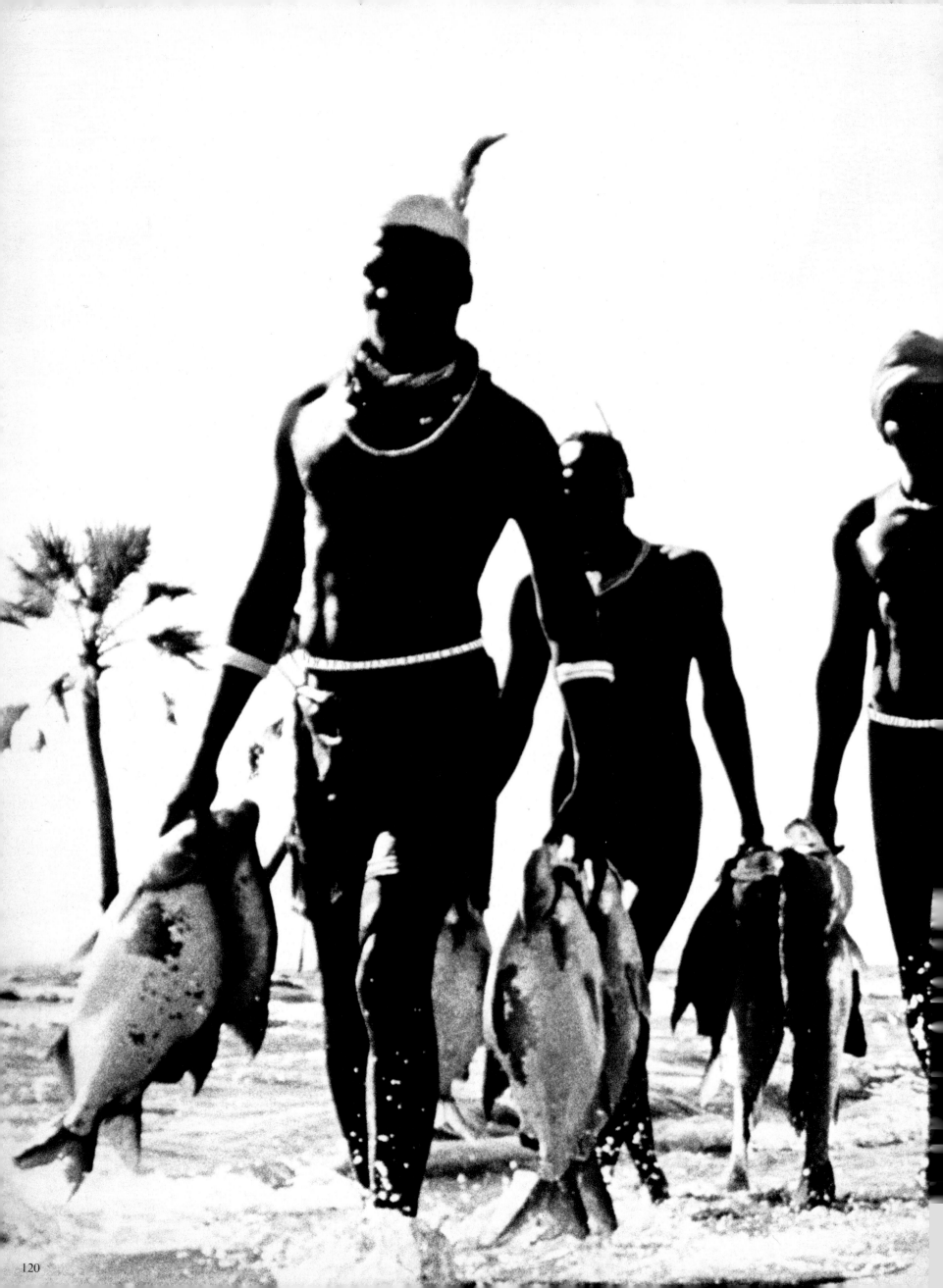

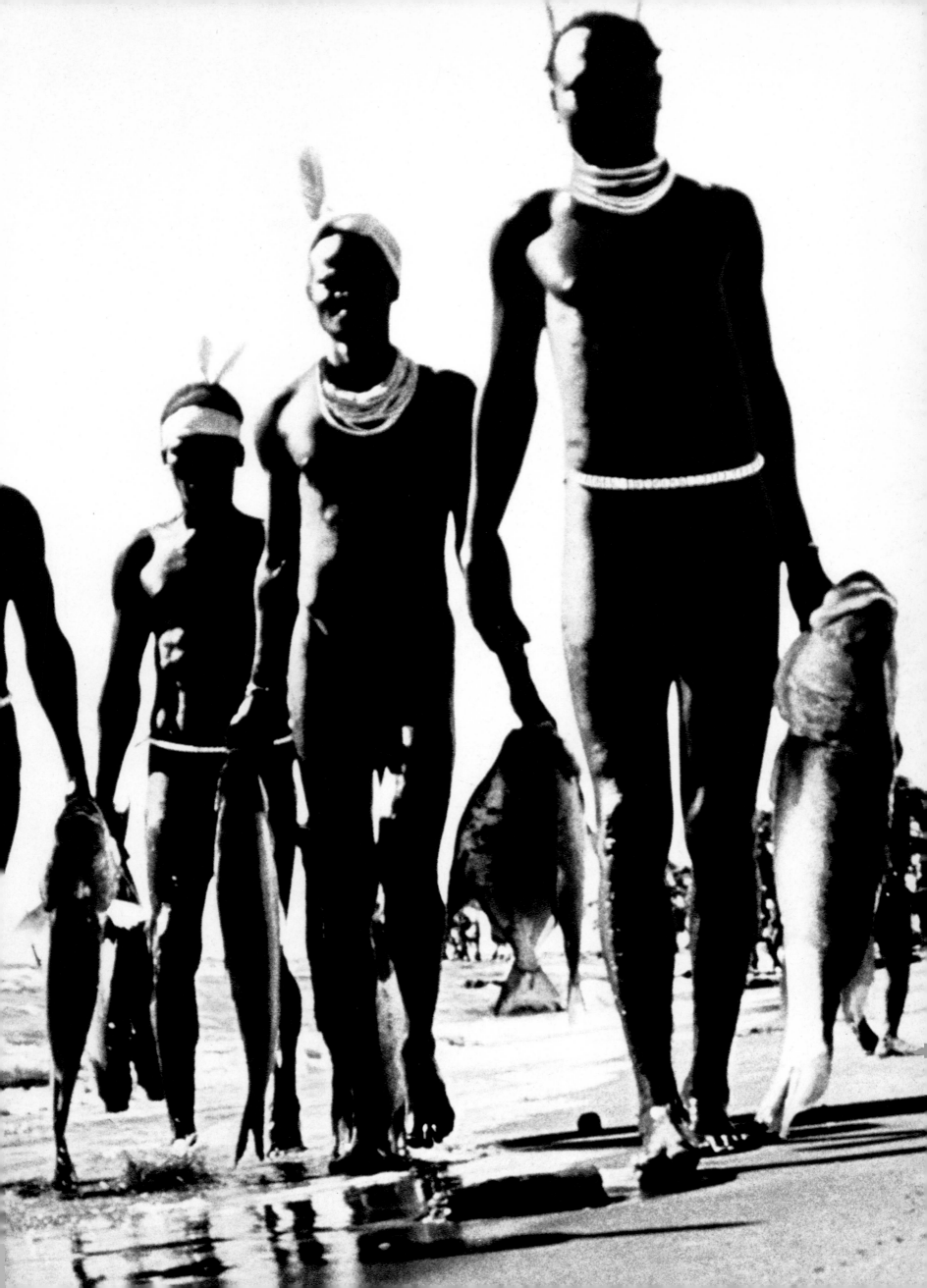

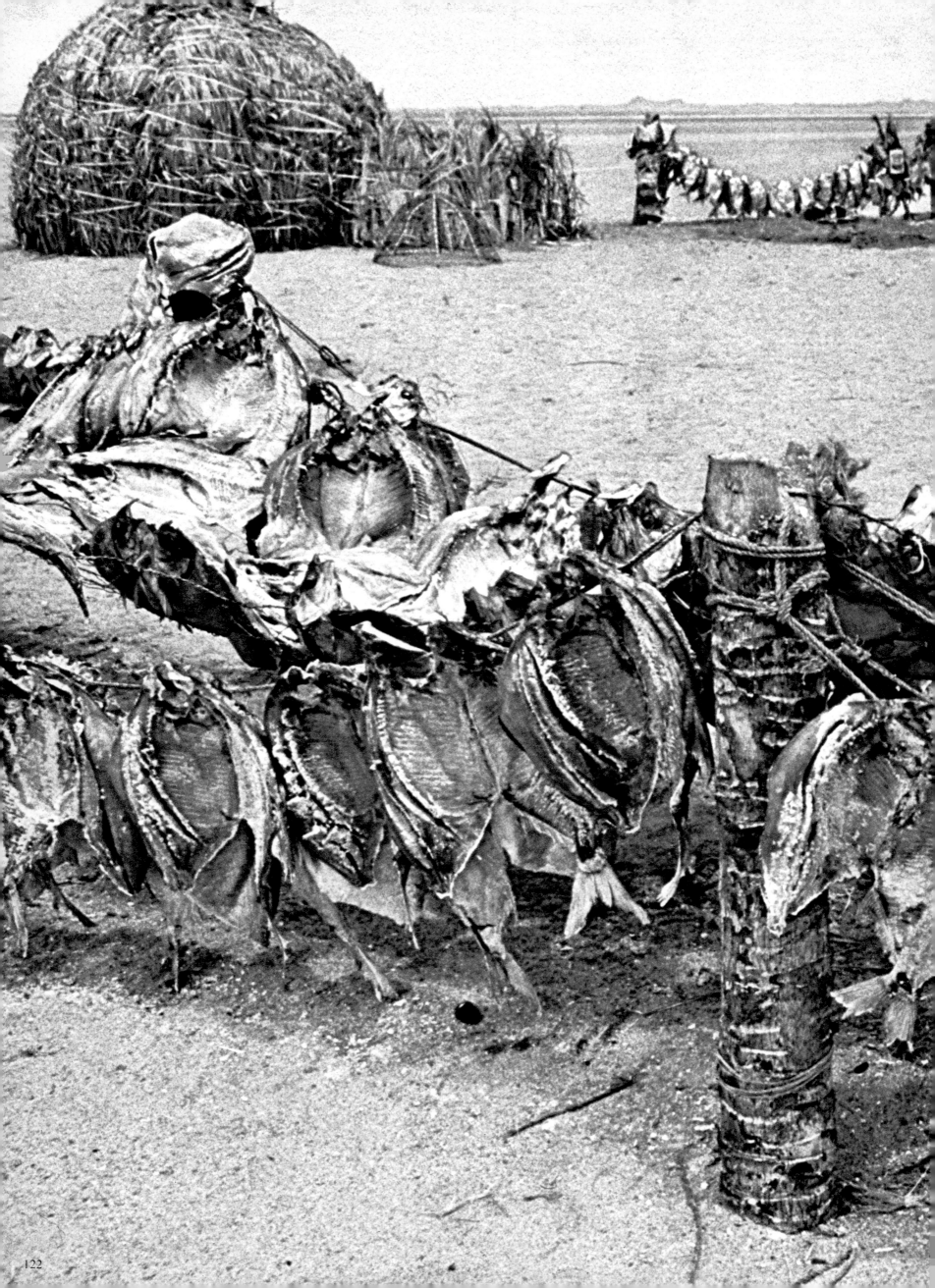

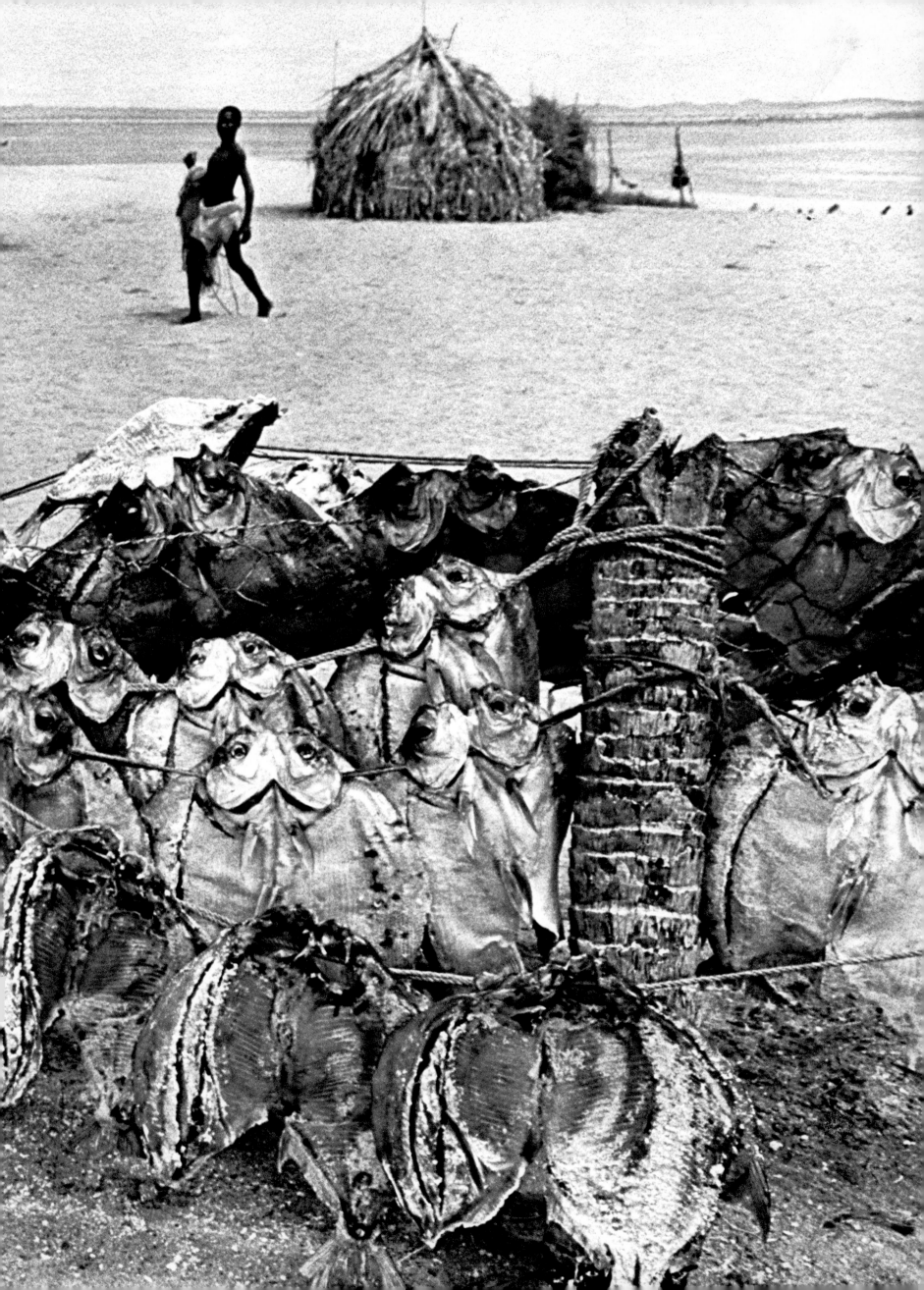

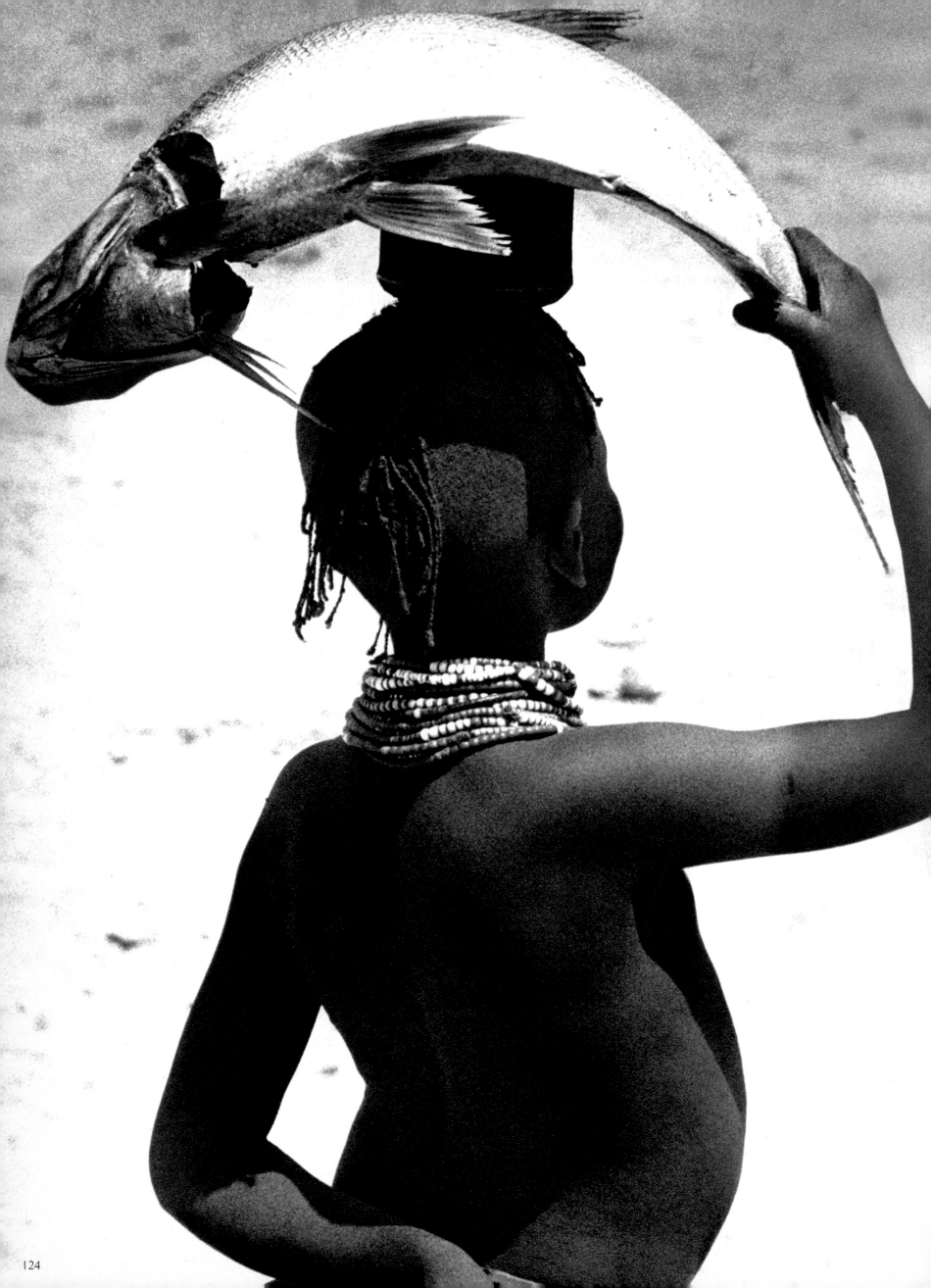

NOMADS

Life cannot exist without water. Nowhere in the world is this more dramatically apparent than among the pastoral nomads of the Northern Frontier District of Kenya.

Tribes who live here can have no settled homes. They must follow the rain clouds, wandering from water-hole to water-hole as their camels and livestock finish the grazing and move off to new pasture. Inevitably, the search for pasture and water becomes a way of life, all-consuming for both man and beast, and it is often the cause of warfare and inter-tribal raiding carried out with spears and *simis* (long knives).

Nomads are people with few possessions; everything they own, including their homes, must be carried by man or beast. Camels are among their most valuable assets, but it is really only in the N.F.D. that the climate is truly suitable for these animals. And it is only among the Rendille, Boran and Turkana that one finds camel owners.

Unlike cattle which must graze, the camel is a browser, and can exist on the same spiky leaves and rough bark fare as the goat. It can go for a fortnight or more without water, and when it does drink it can quench its thirst for another two weeks. Except in times of great need or for ceremonial occasions, nomads are reluctant to kill their camels for meat. But if obliged to do so, their flesh is eaten and their hide is used to cover huts. It is also cut into small strips to make thongs or to sew hides together.

The two most important functions which the camel renders is to provide milk and to act as a beast of burden. Fresh milk, unboiled and thus rich in vitamins as well as protein is the mainstay of the nomad's diet, and the camel's ability to travel as much as fifty to sixty miles a day to fresh pastures insures a regular supply of this milk.

One day when I saw a number of camels drinking in a muddy pool and rolling in the damp mud, I made friends with the women who were herding them and later watched the milking. A stuffed baby camel was shown to the camels, who, when they got its scent, let their milk flow. But as it was only for a few minutes, the women, one on each side of the beast, had to work quickly to collect as much as possible into the gourds. I saw a little girl of about seven take one of the camel's teats into her mouth and suck vigorously with a baby camel doing the same on the other side. Camels, who can give a fierce kick and are so shy and frightened of strangers, soon get to know the people to whom they belong and with them are tractable and friendly.

Once when visiting the Turkana of the interior, I saw a hundred camels walking down a dry river bed for their rare drink. Girls with huge wooden bowls on their heads walked in front of the herd. At a certain point they stopped and began to scrape at the sand with their fingers and sticks, digging holes so as to reach the bed of water which had disappeared several feet beneath the surface during the dry season. When they had reached the water one girl climbed to the bottom of the hole, holding a small bowl, and with this she scooped up the liquid, and then handed the bowl to another girl waiting above her. The water was poured into the large wooden bowl from which the thirsty camels drank themselves to saturation. The whole herd stood around the hole waiting to drink, three at a time, until

each camel had had its fill. Then came the goats and the donkeys. It took all morning. These beasts would not return to drink for about a week. Next day another herd would take its turn. Year in and year out for generations camels have been watered in this way. A primitive solution to the endless fight for survival, which the nomads never try to change, but accept with resignation.

Living in areas unsuitable for camels or too poor to own them, other nomads have to depend on cattle, sheep and goats.

The Maasai in particular are great cattle owners, perhaps the richest in the whole of Africa, and they live mainly off the milk, meat and blood of their herds. The blood is secured by shooting a blunt arrow into the jugular vein of a live steer which has been tied for this purpose, and drawing off up to one or two pints of blood. The wound is then smeared with mud or cow dung and the animal is allowed to run free again. However Maasai draw blood in this fashion only fairly rarely and primarily during the dry season to supplement poor milk yields.

The Orma, an off-shoot of the Galla Boran, are also important herdsmen. They are very wealthy, particularly in cattle, and it is not unusual to find thousands of head belonging to one of their villages. They, like the Maasai, tend to live entirely off the produce of their animals, their diet being almost exclusively milk. Only in case of an accident to one of their cattle, or in moments of great famine, when milk is scarce, do they slaughter their cattle. I was astonished to see how wonderfully strong and healthy the Orma keep on their exclusively milk diet. If milk is not boiled, destroying the vitamins, it is whole food.

Like most nomads the Orma roam the countryside for hundreds of miles looking for fresh grazing. However, unlike other pastoralists I have seen, their village does not follow the entire herd. Rather, the main herds are sent out to graze in mobile cattle camps for several months, under the direction of the young men and often young girls, while the older people remain in their settled villages subsisting on smaller numbers of the residual herd. Every few months the main herd returns for a week or two before being taken off again under a fresh group of young men.

One of their villages I visited lay beside a lovely lake, covered in giant white water lilies that stuck their heads out of a carpet of green reeds and water plants floating on the surface. The village stretched along the shore, looking like a group of giant yellow beehives.

Each family owned one of these houses which are very cleverly built out of hundreds of long pliable sticks woven into a domelike structure which is then covered with reeds taken from the lake. A tiny opening is left as an entrance, when not in use it is kept shut with a pile of reeds that hang in front of it like a curtain. This makes the hut warm at night, cool by day, and mosquito-proof. The Orma are very clean, and the insides of their huts are immaculate.

My stay was extremely pleasant and I was able to work in a wonderfully friendly atmosphere. Every morning and evening fresh milk was brought to my tent by lovely girls who used to hang around and talk. I was adopted by the village, and the Orma gave me one of their own names – "Garbitti" – a sign of my having been accepted into the tribe.

At the end of every day the cattle would come wandering home along the lake where they had been out grazing, and dry cow dung which had been piled by the children

into little mounds was set alight, so that soon the village was shrouded in a cloud of grey blue smoke which kept the mosquitoes away. The cattle clustered around the smoking mounds to get some relief from the hungry mosquitoes. The setting sun turned the sky into fabulous shades of orange and red and shot its rays through the smoke, transforming the cattle, the goats, the women carrying home pots of water on their heads, the men in their billowing robes, into strange grey and purple shadows that moved like a slow, silent ballet, to be finally swallowed up by the night.

Goats are also owned by all the pastoral tribes and, in fact, they frequently out-number animals of any other kind, since they are browsers as well as grazers. Their meat is eaten frequently and they are often milked. The ownership of sheep is restricted to areas where there is abundant grass.

125. *Maasai cattle on move to a water-hole.*

126. *Orma cattle herder.*

127. *Orma cattle.*

128–131. *Each evening small heaps of cattle dung are lit. The smoke from these fires protects both man and beast from the ever present mosquitoes. The cattle instinctively gather in the smoke.*

132 & 133. *Maasai children herding cattle in Amboseli park beneath Mount Kilimanjaro.*

134 & 135. *A Samburu youth.*

136 & 137. *A Samburu child herder – lambs are often carried, being too weak to follow the herd for long distances.*

138 & 139. *Camels on their way to a watering hole. They travel sometimes up to 100 miles and spend 2–3 weeks without water. When they drink they store from 15–30 gallons of water in their humps.*

140 & 141. *Orma cattle changing grazing lands. The chief's belongings are loaded on a special steer. Donkeys and women carry the other belongings.*

142 & 143. *Interior Turkana bush hut.*

144 & 145. *Rendille caravan on the move looking for fresh grazing grounds.*

146 & 147. *Rendille woman on the move. All the family possessions plus the skins and poles used to erect the houses are carried on the backs of the camels. Children and old people are packed among the belongings.*

148. *Pregnant Turkana woman.*

149. *Camel with newly born baby.*

150 & 151. *Turkana camels milling round a water-hole waiting to drink. The camels are kept in control by children who tap them on the nose if they start to get too restless.*

152–157. *The constant pursuit of water becomes a way of life. Both man and camel drink from a wooden bowl or directly from a hole in the ground.*

158. *Adolescent boy sits in the shade of his camels.*

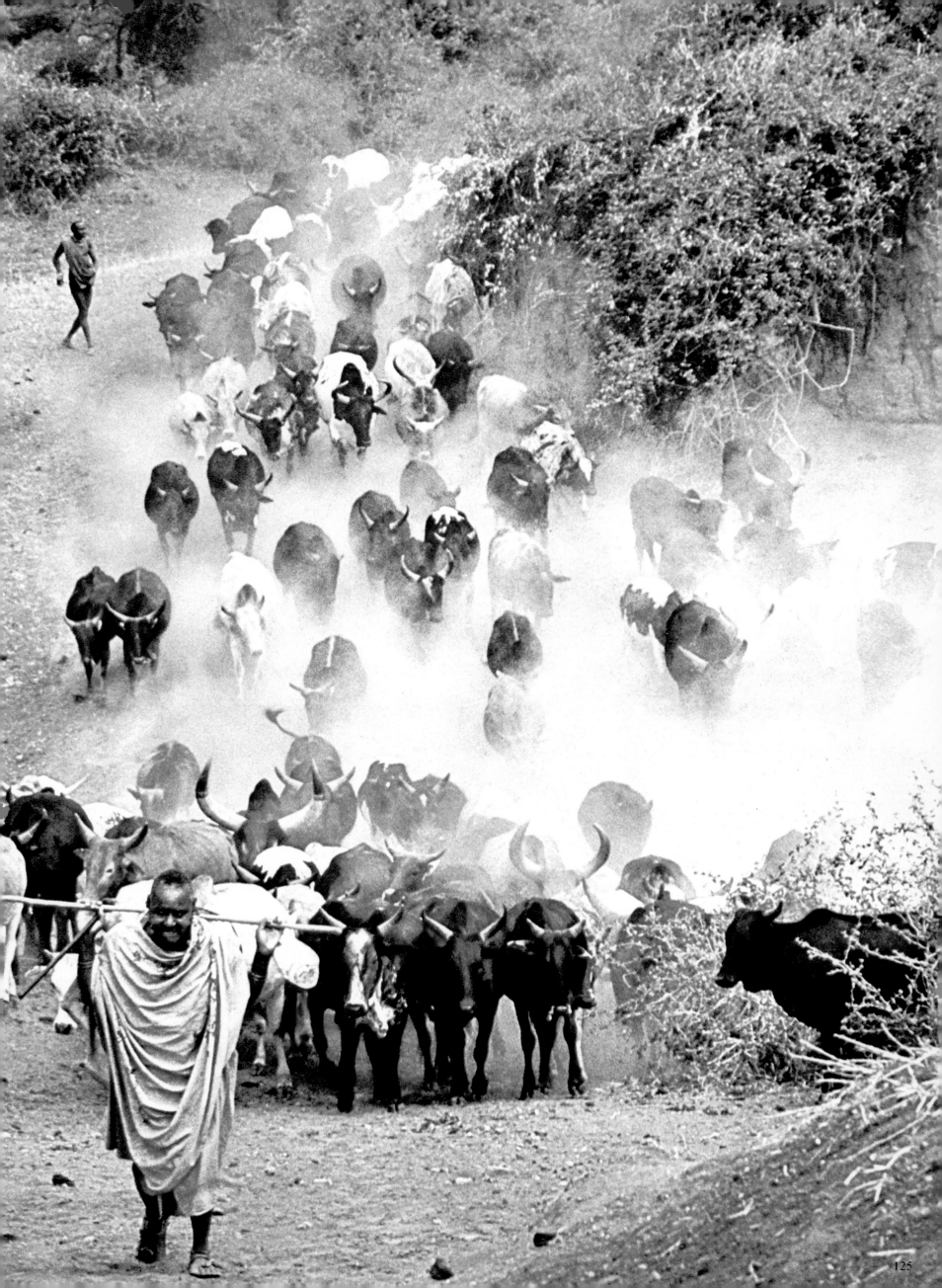

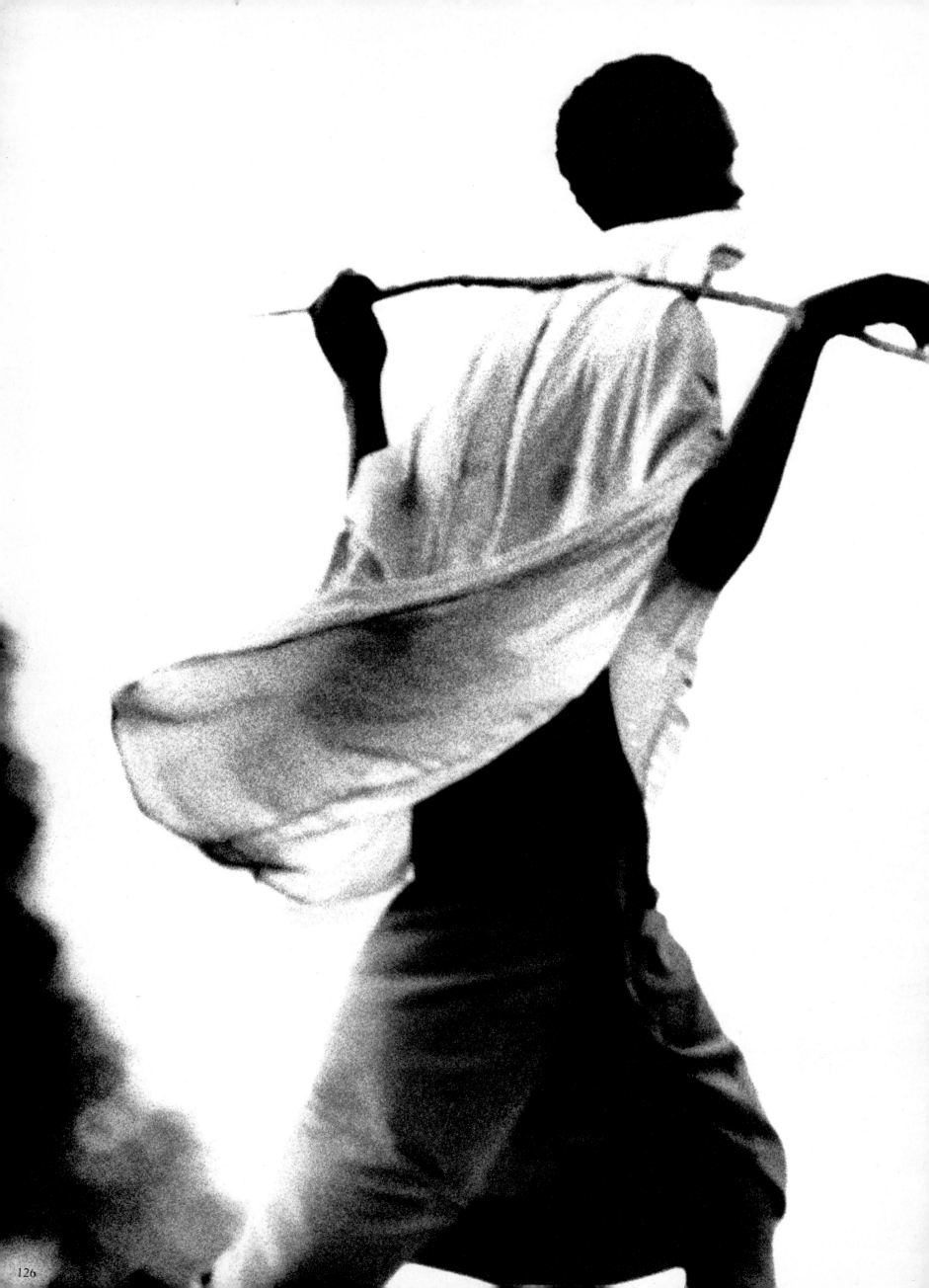

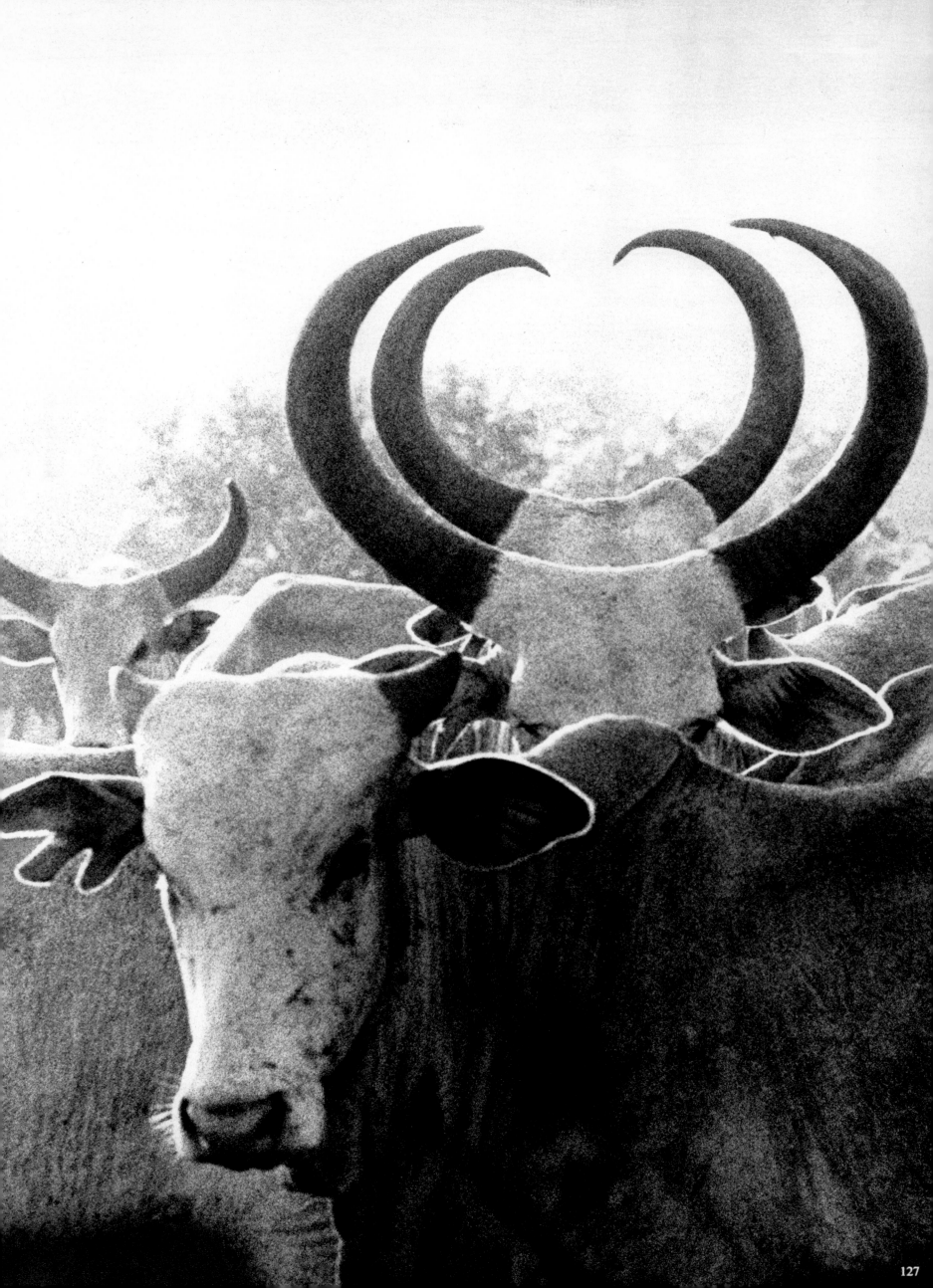

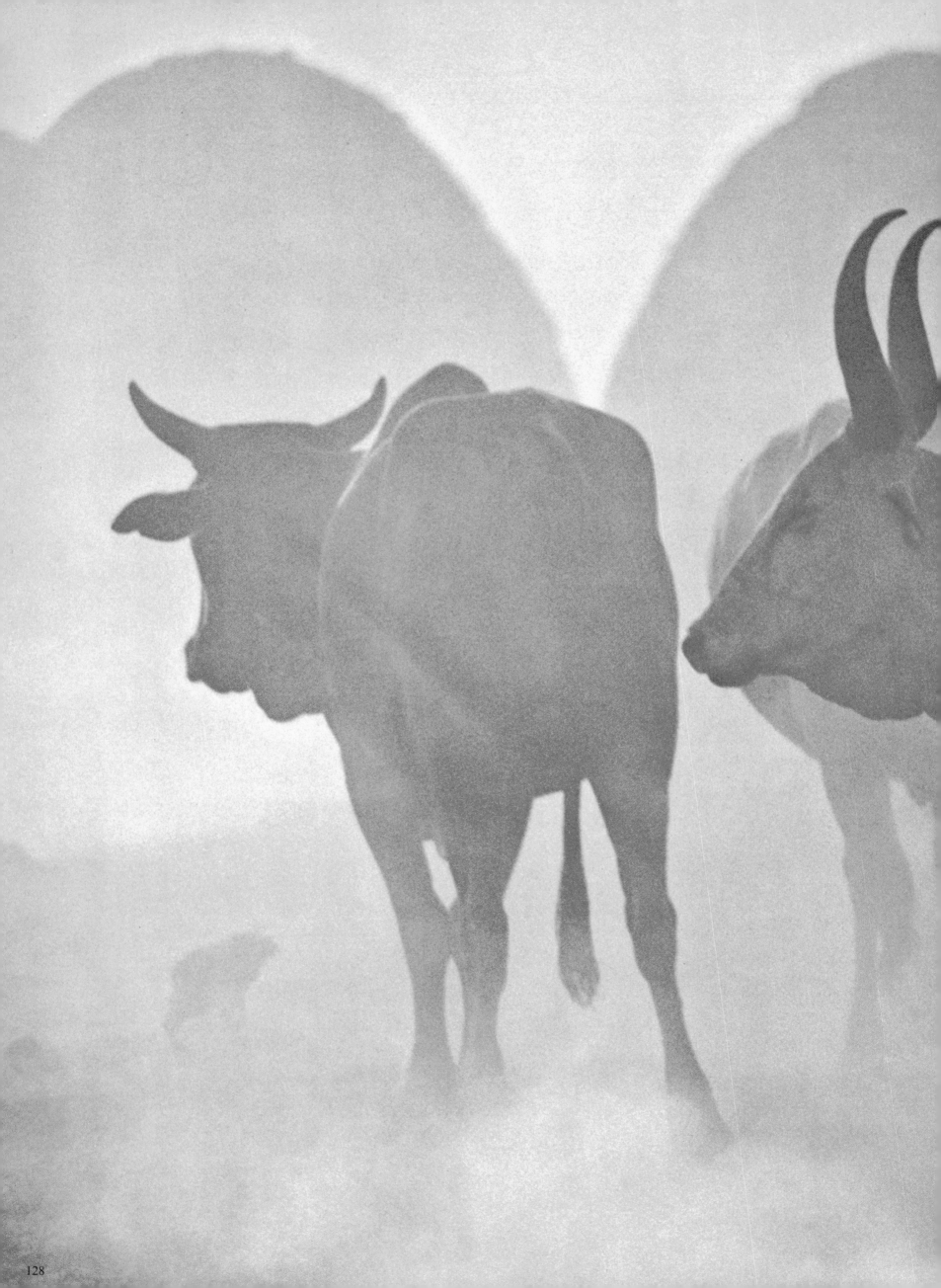

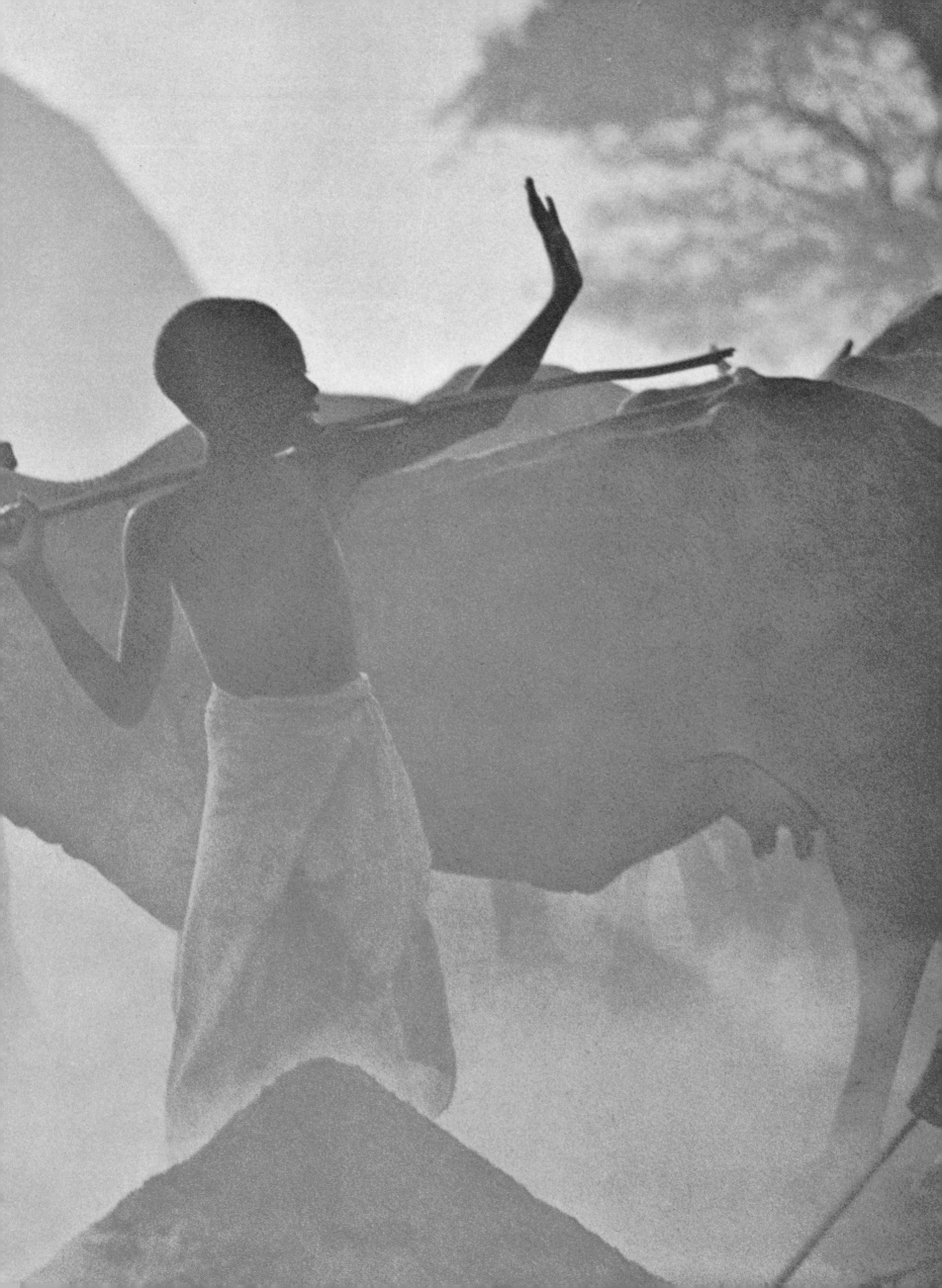

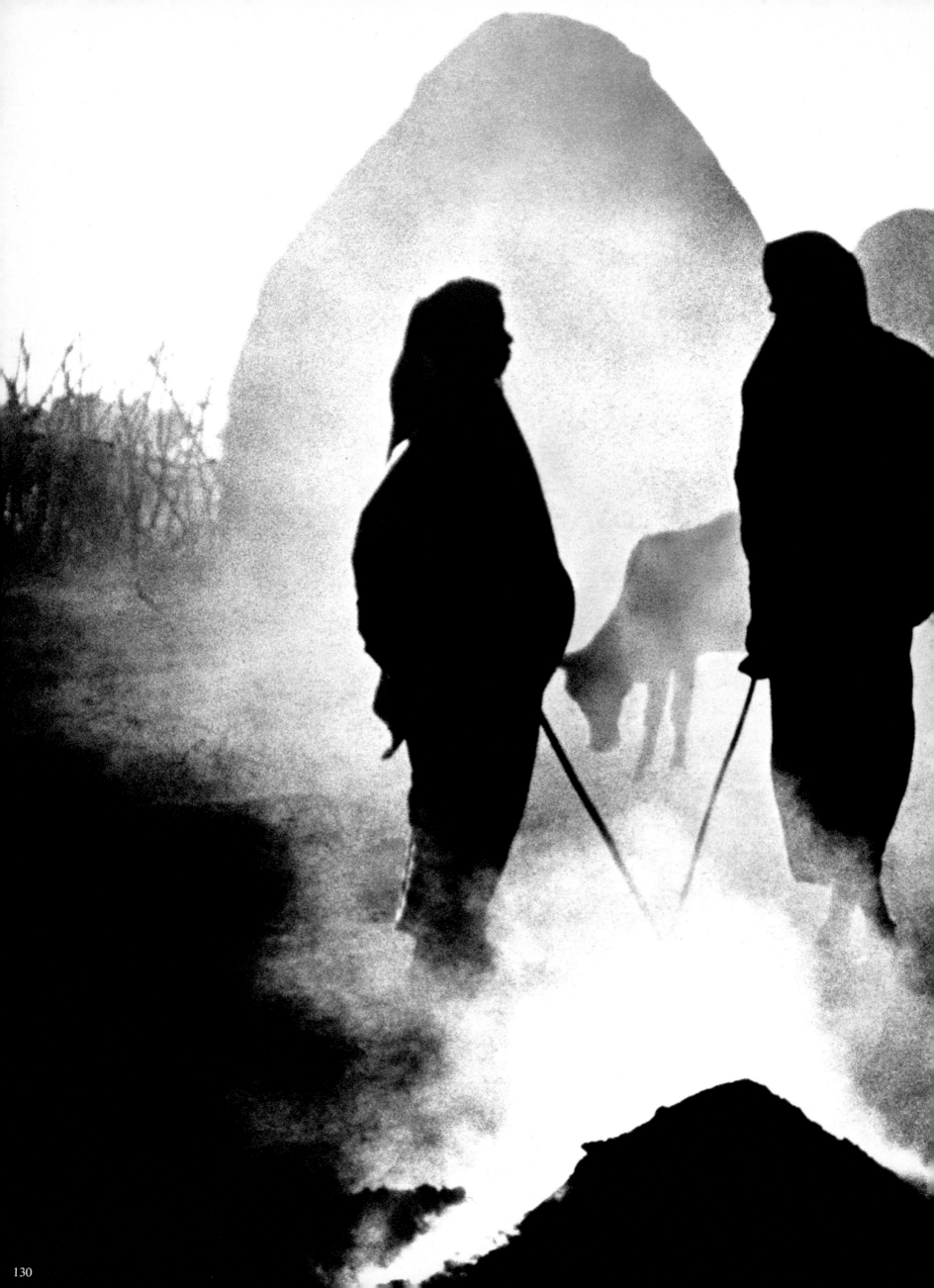

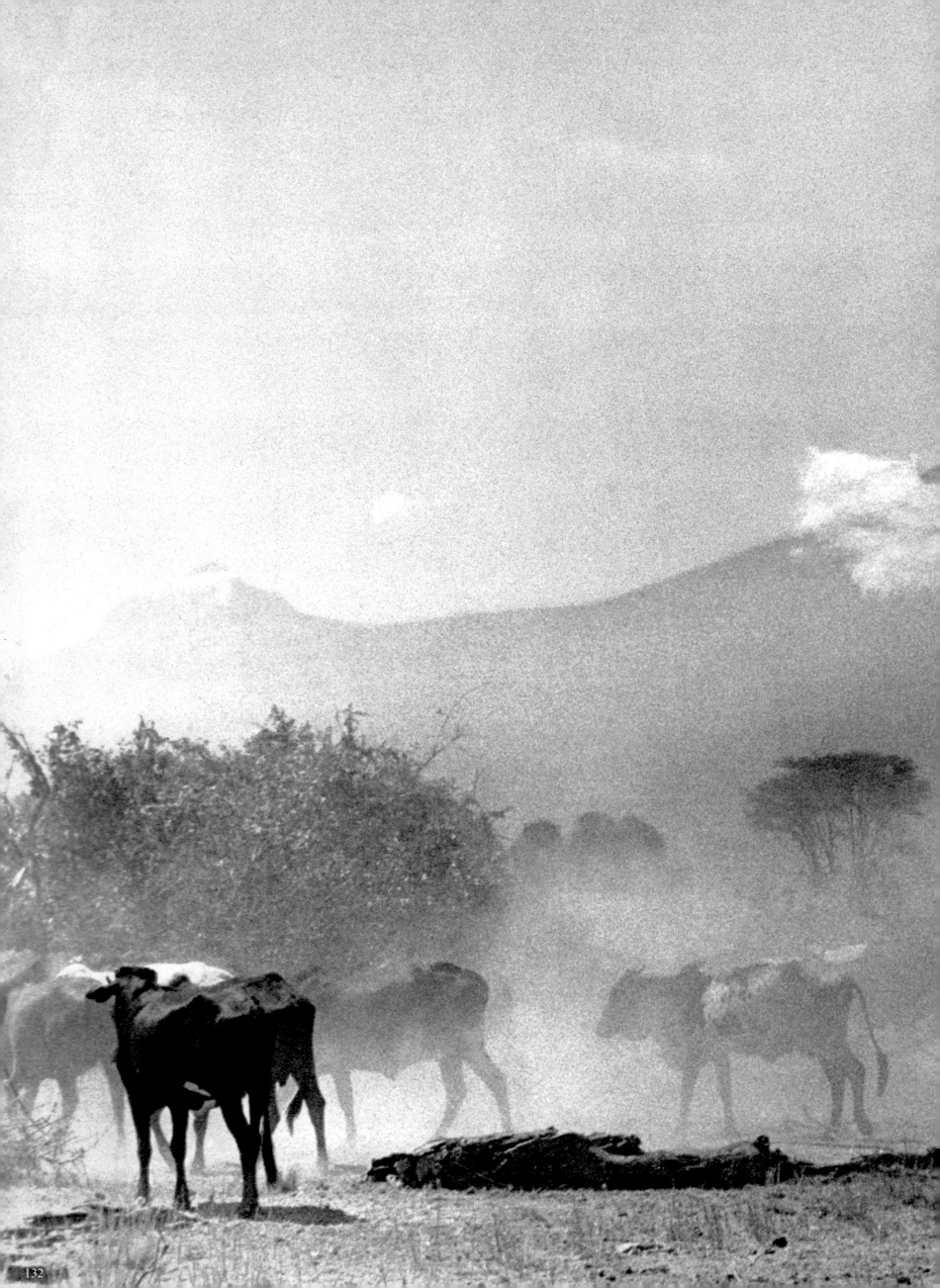

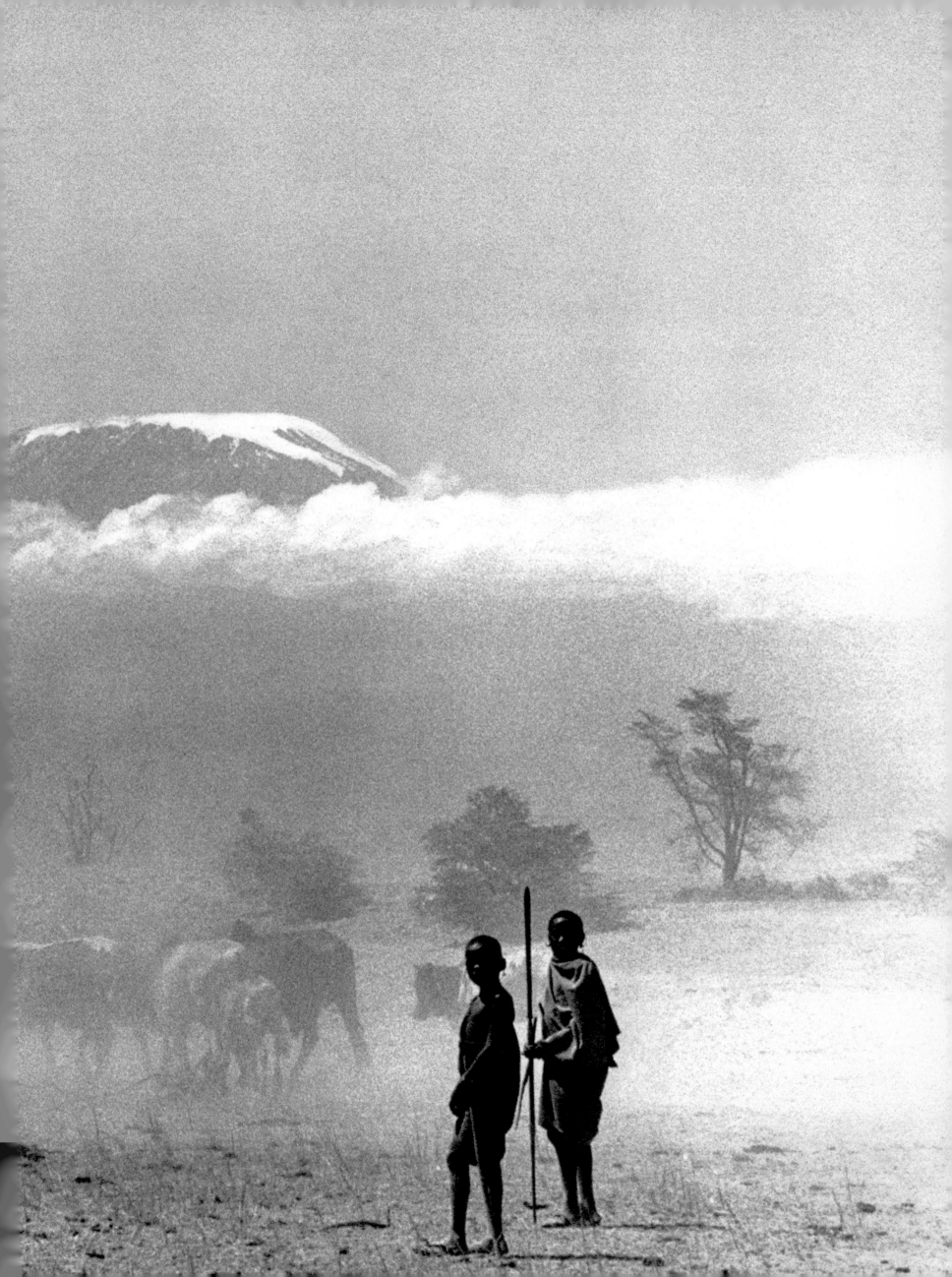

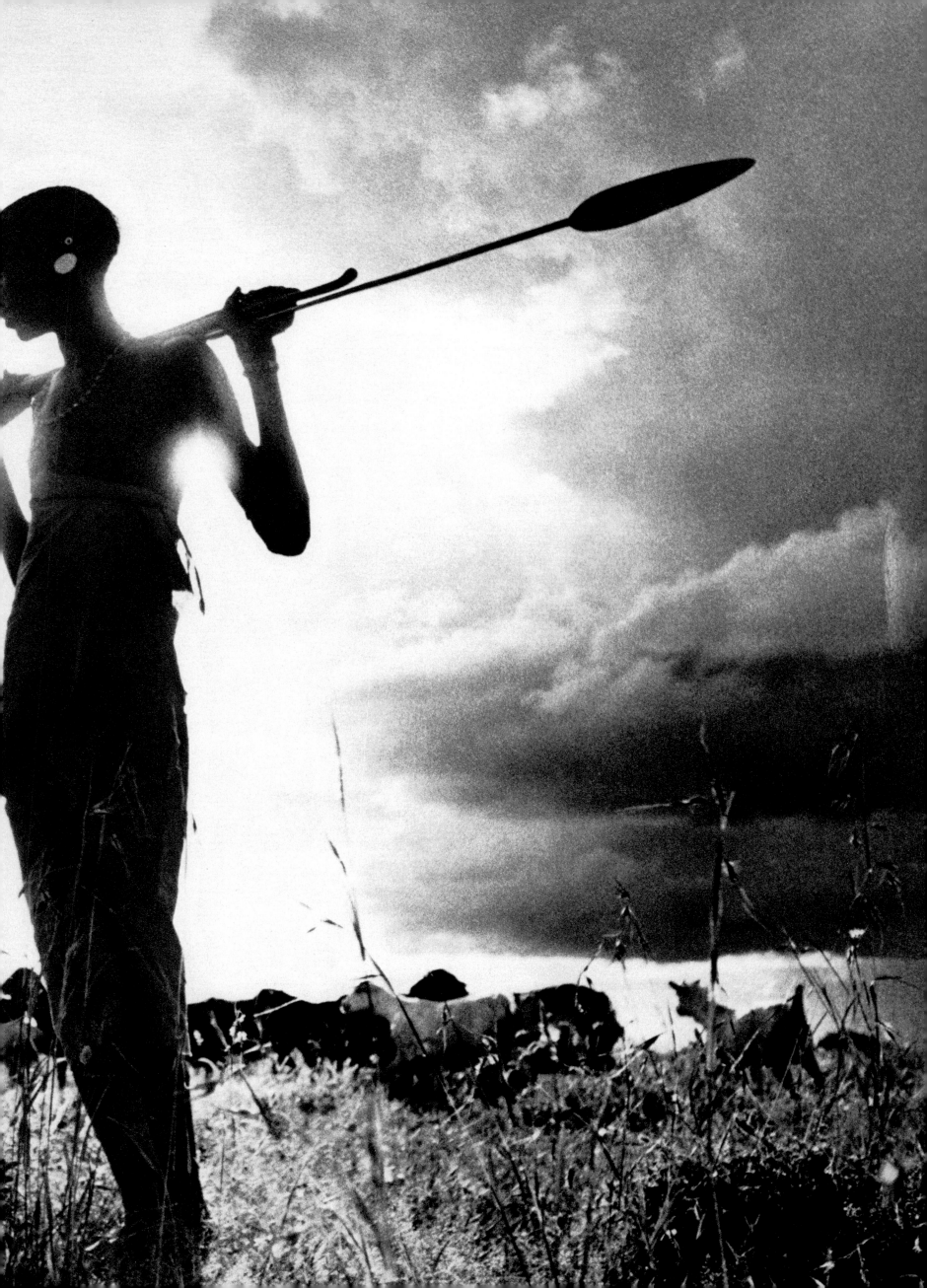

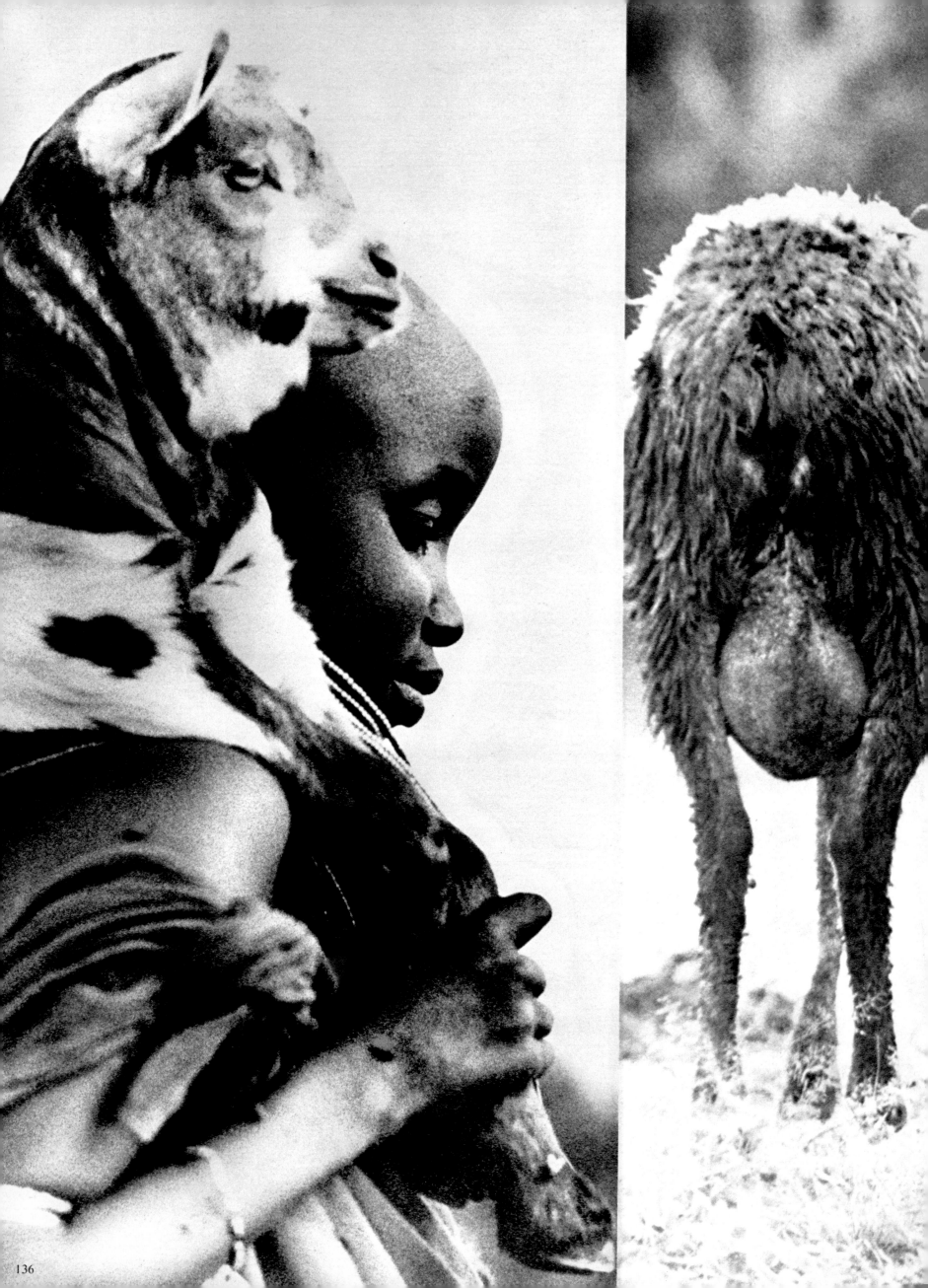

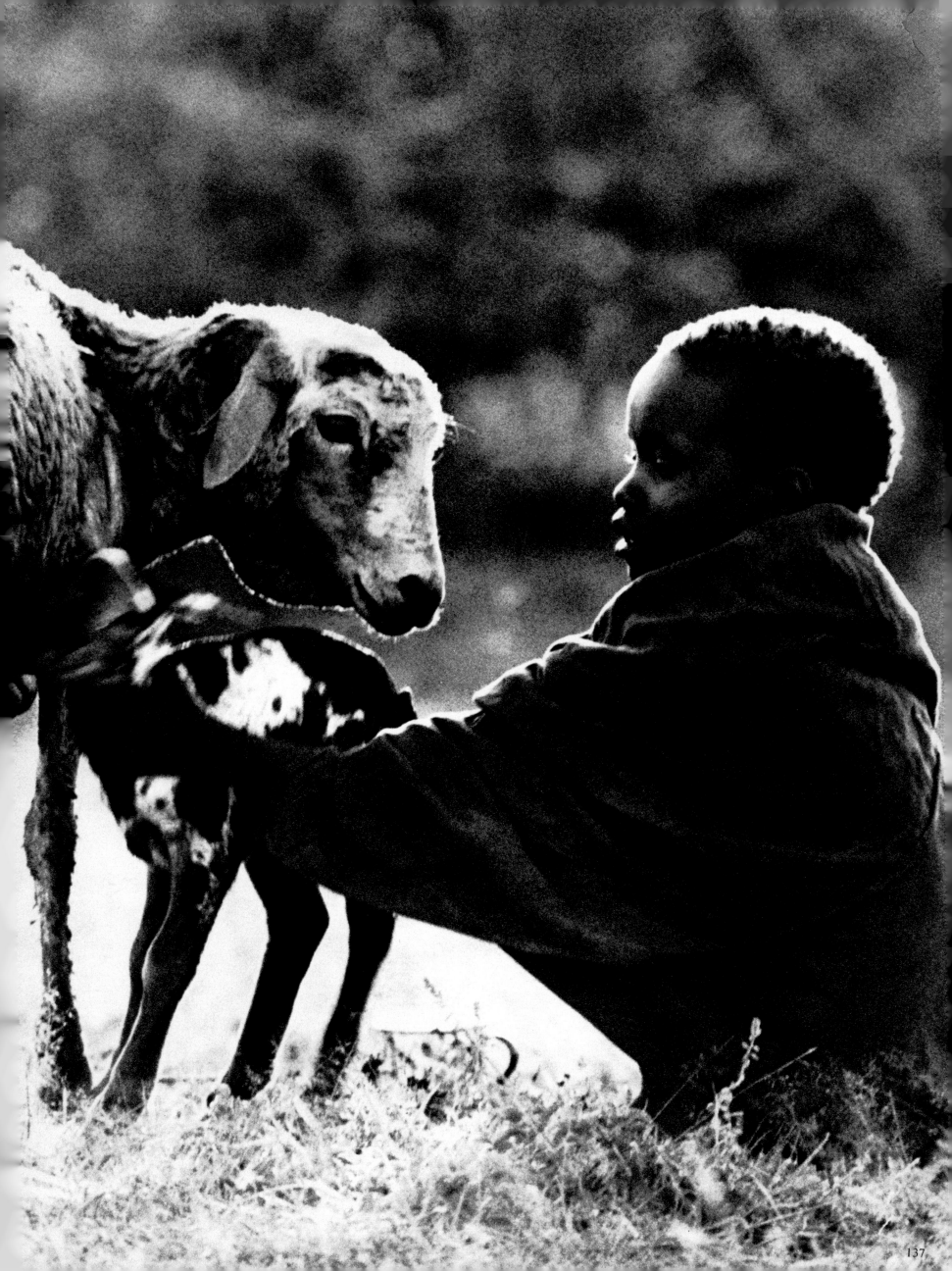

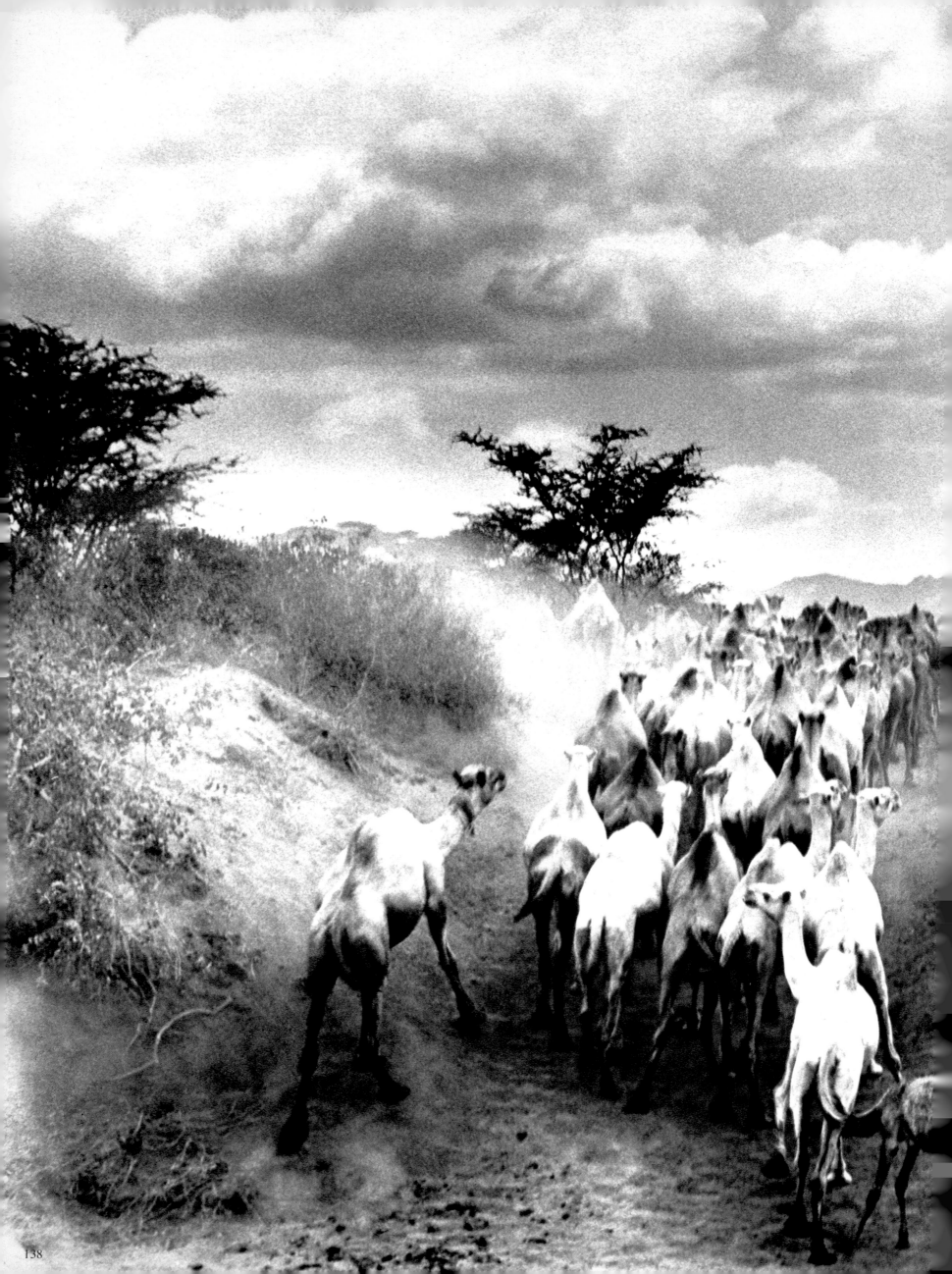

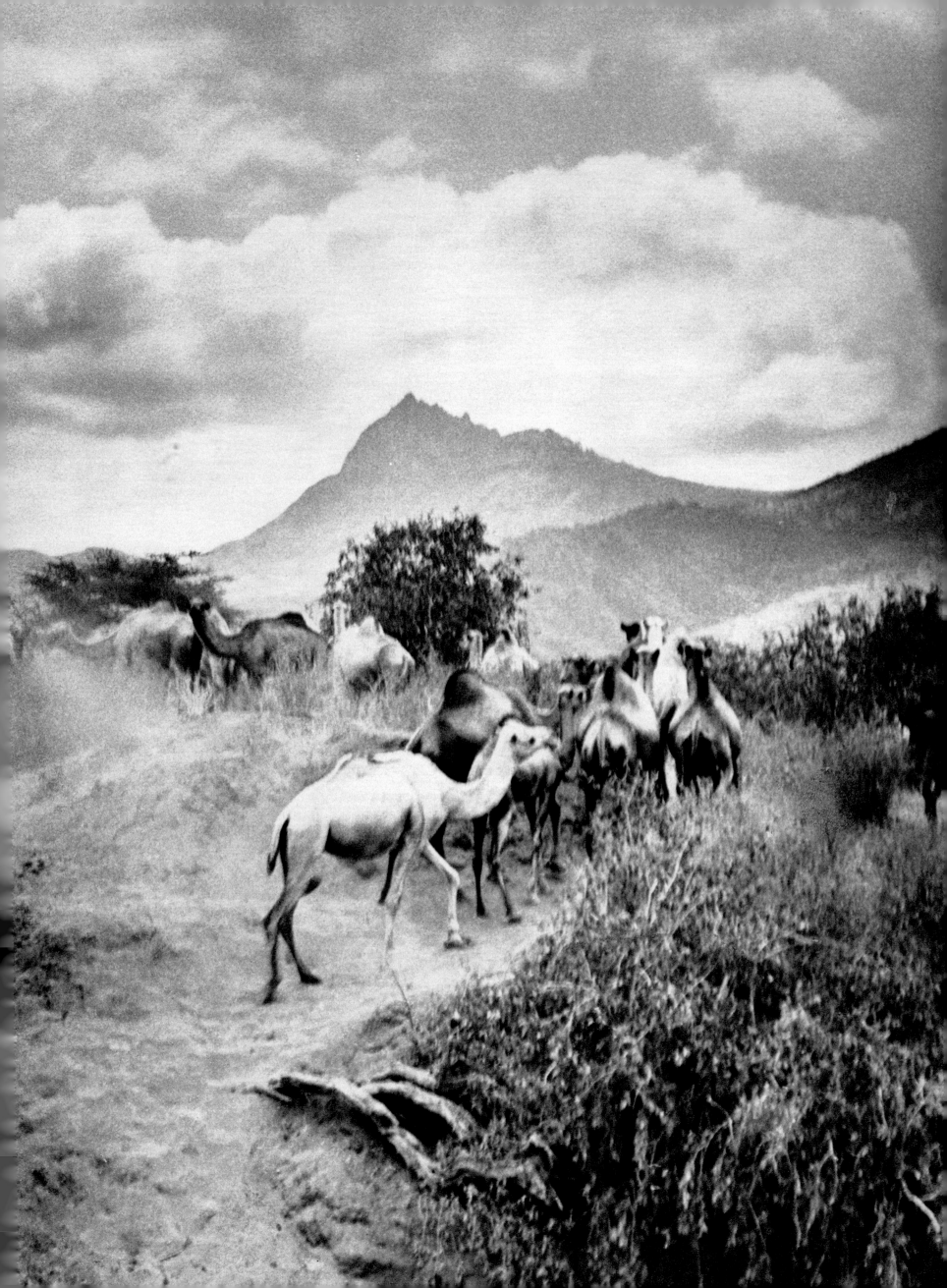

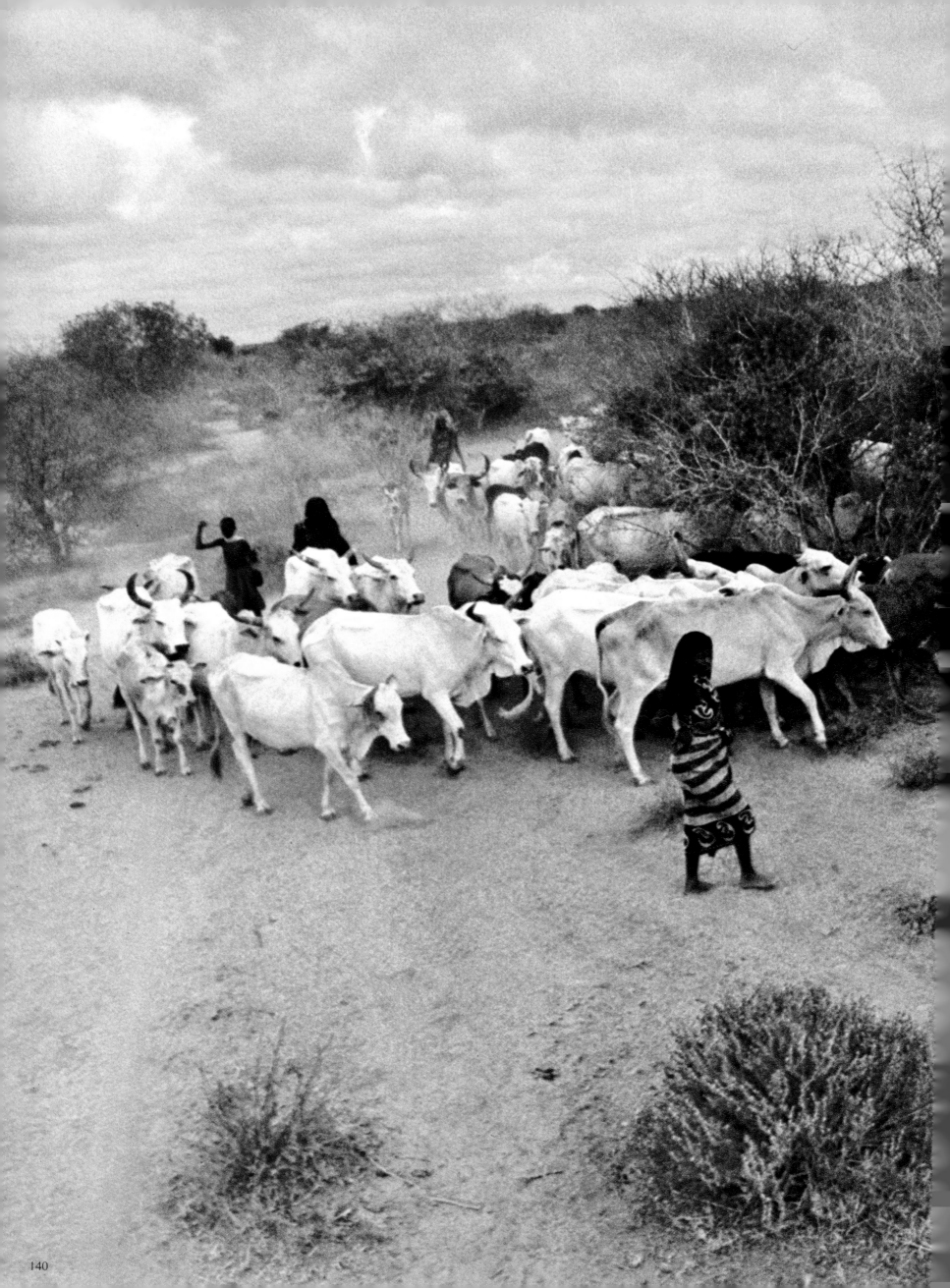

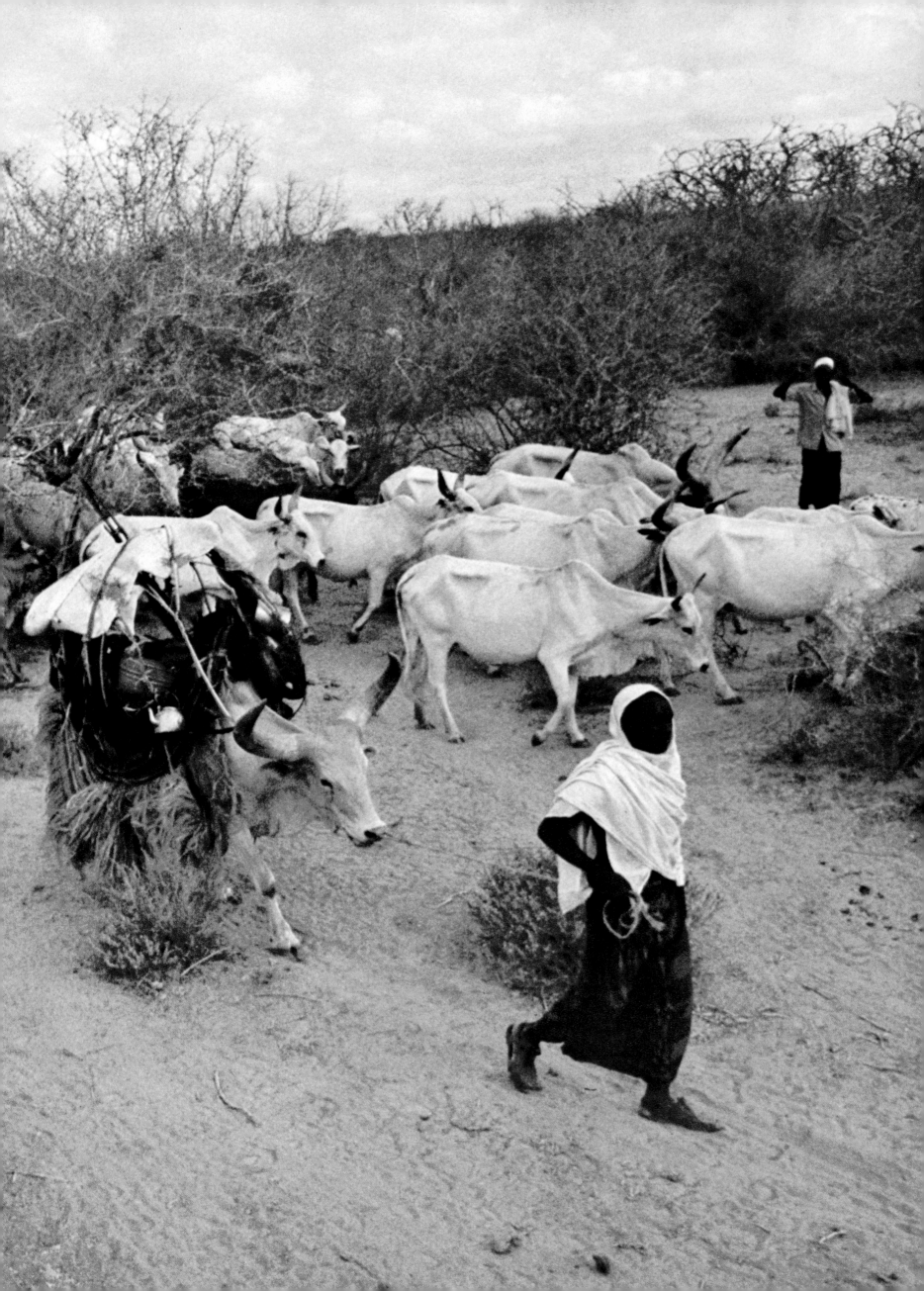

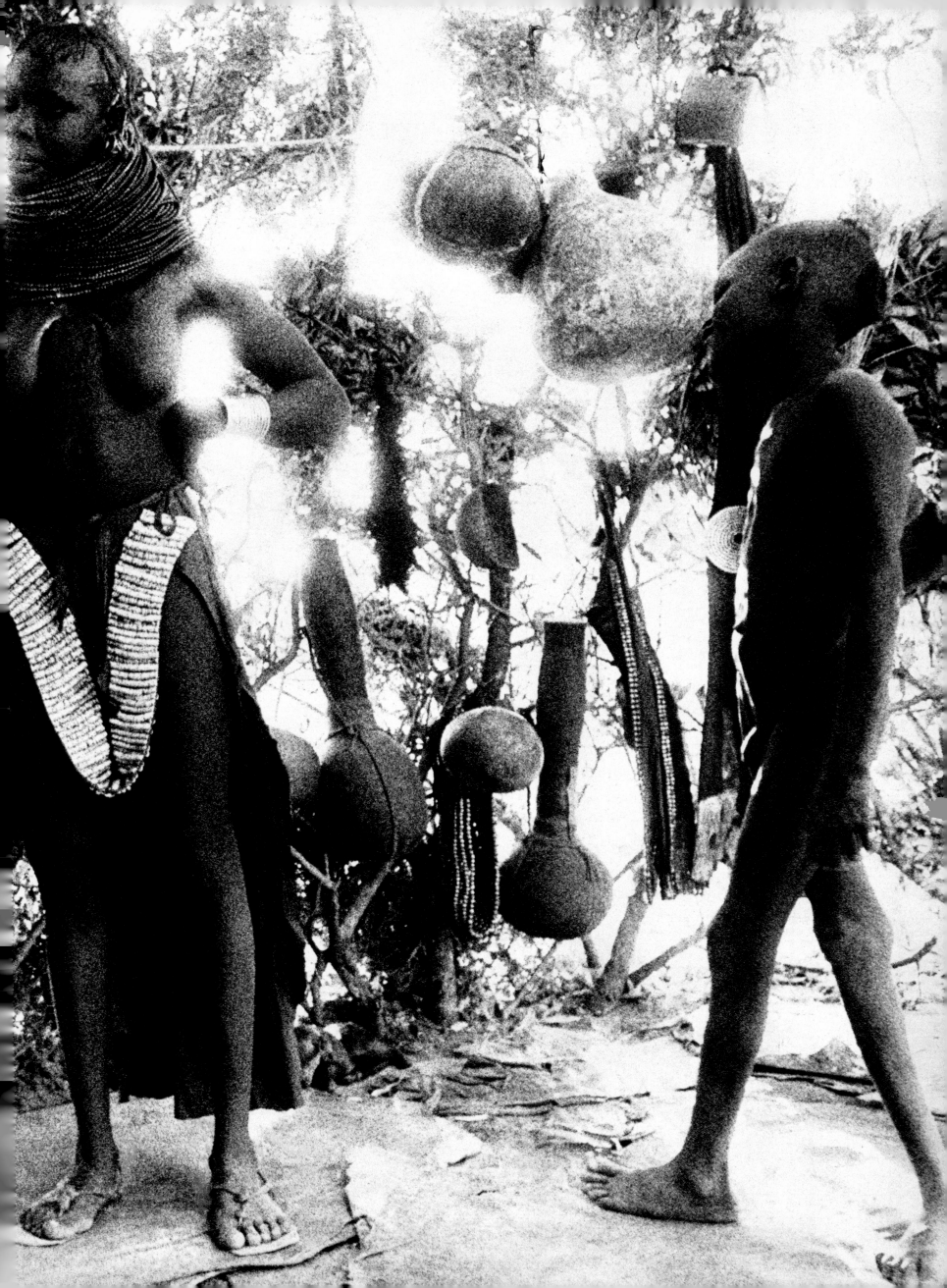

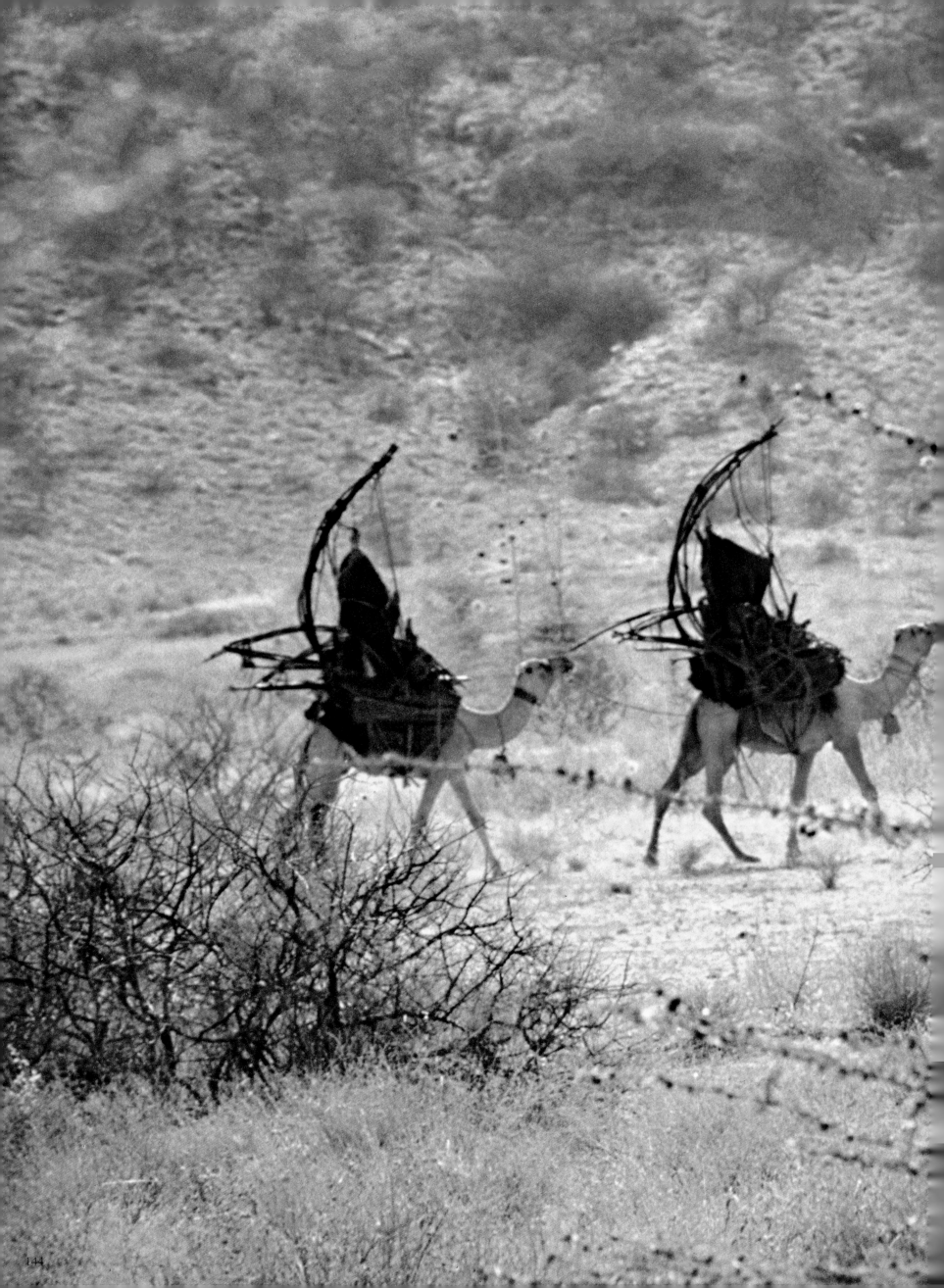

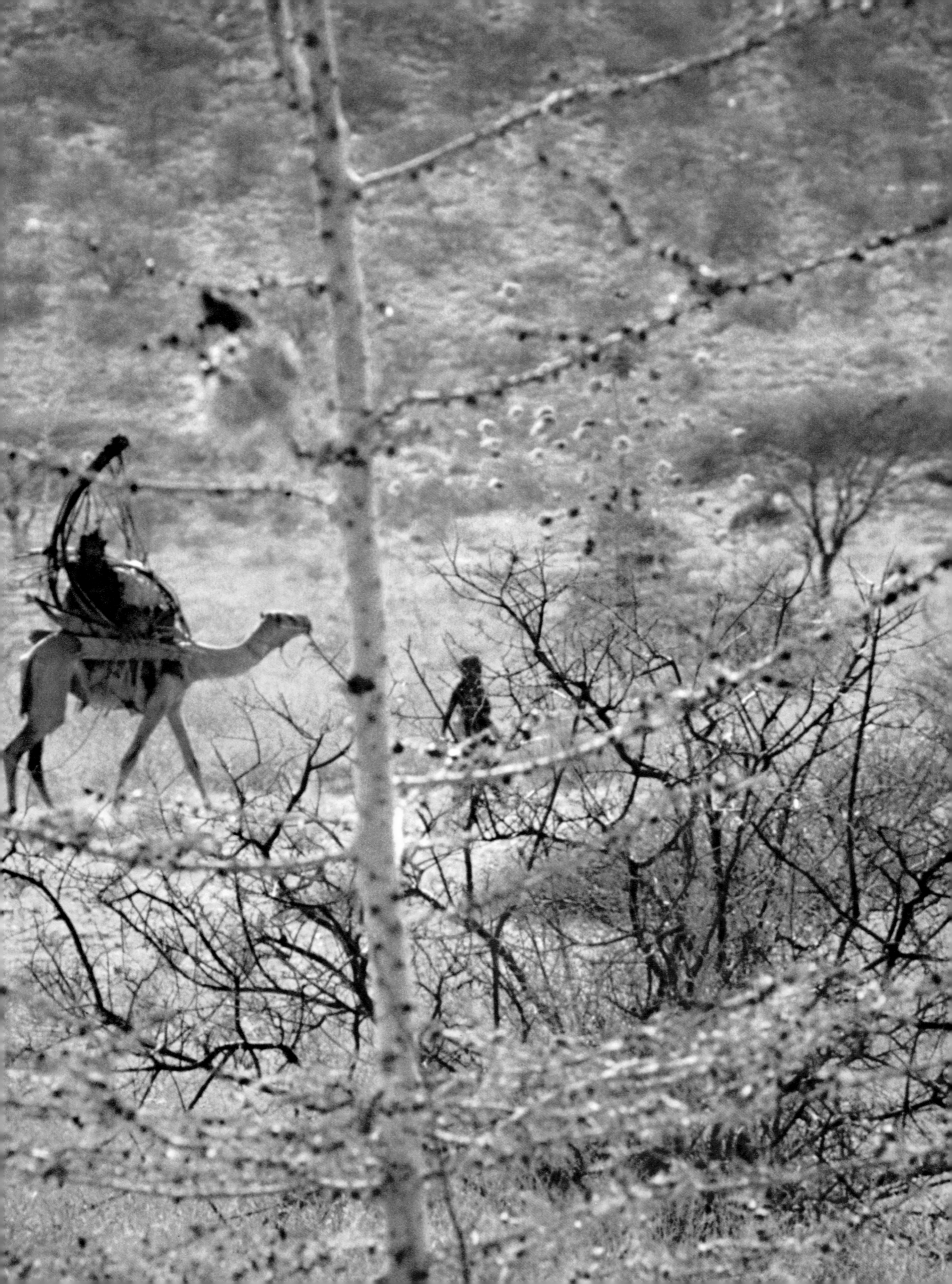

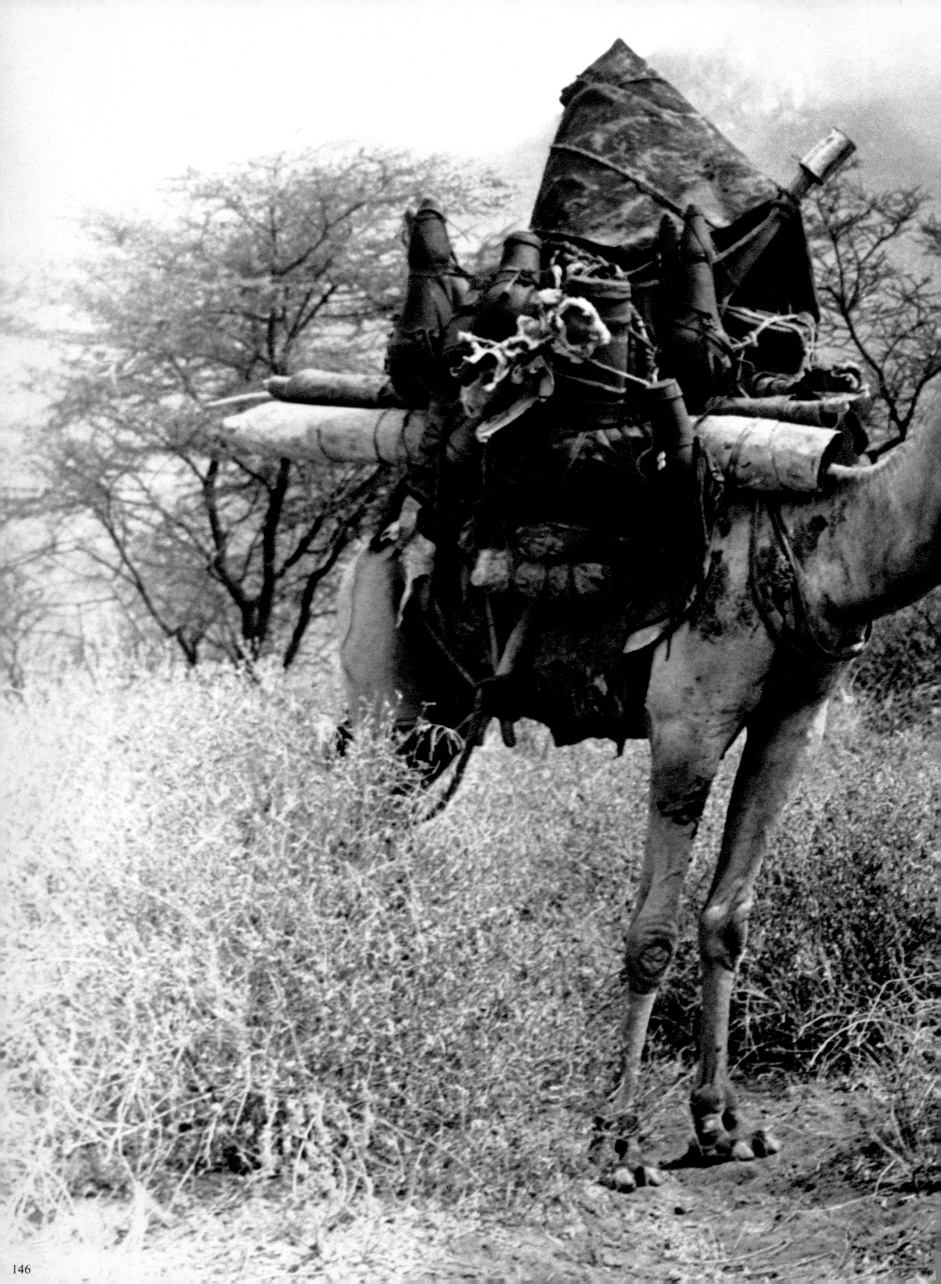

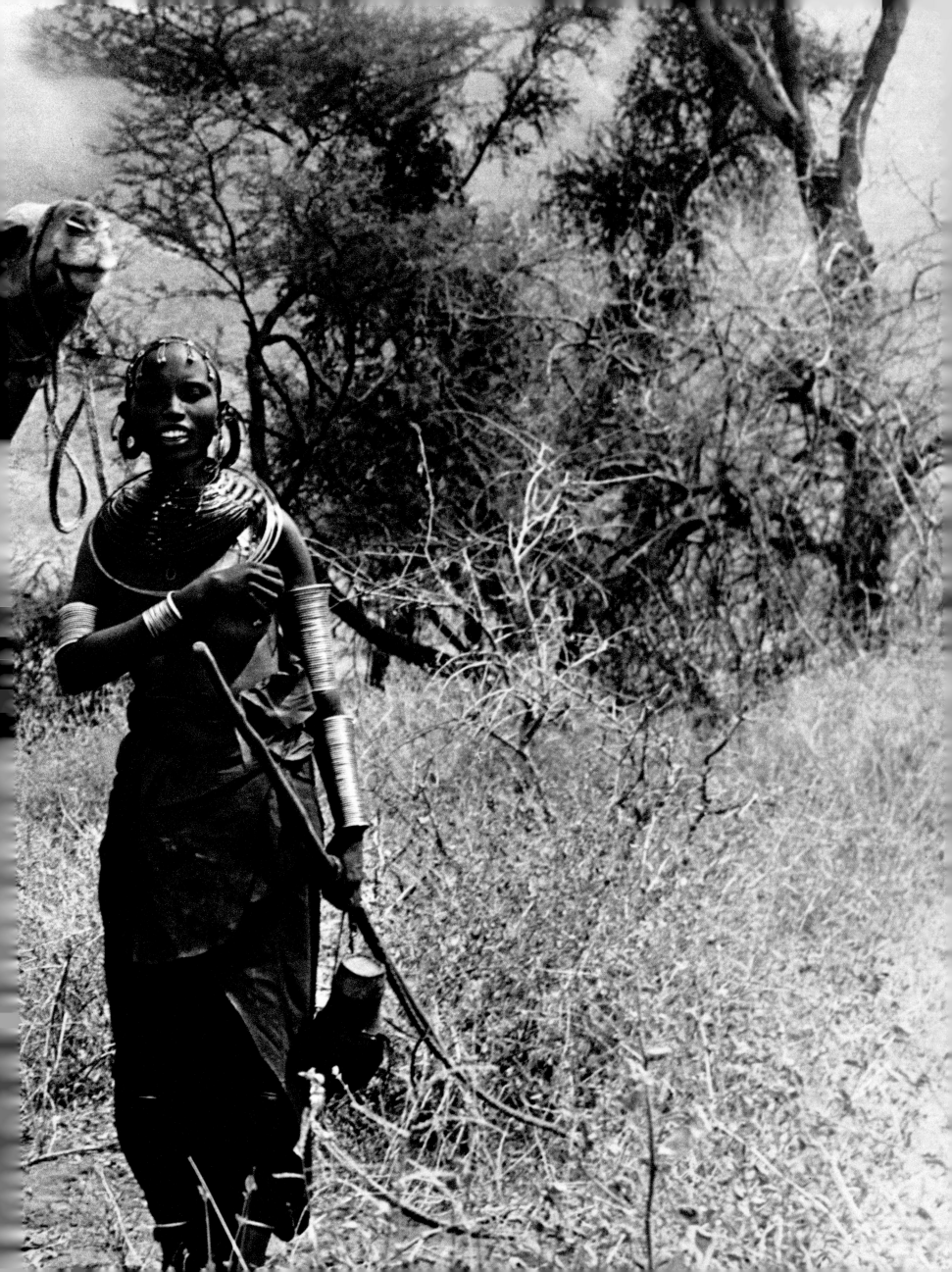

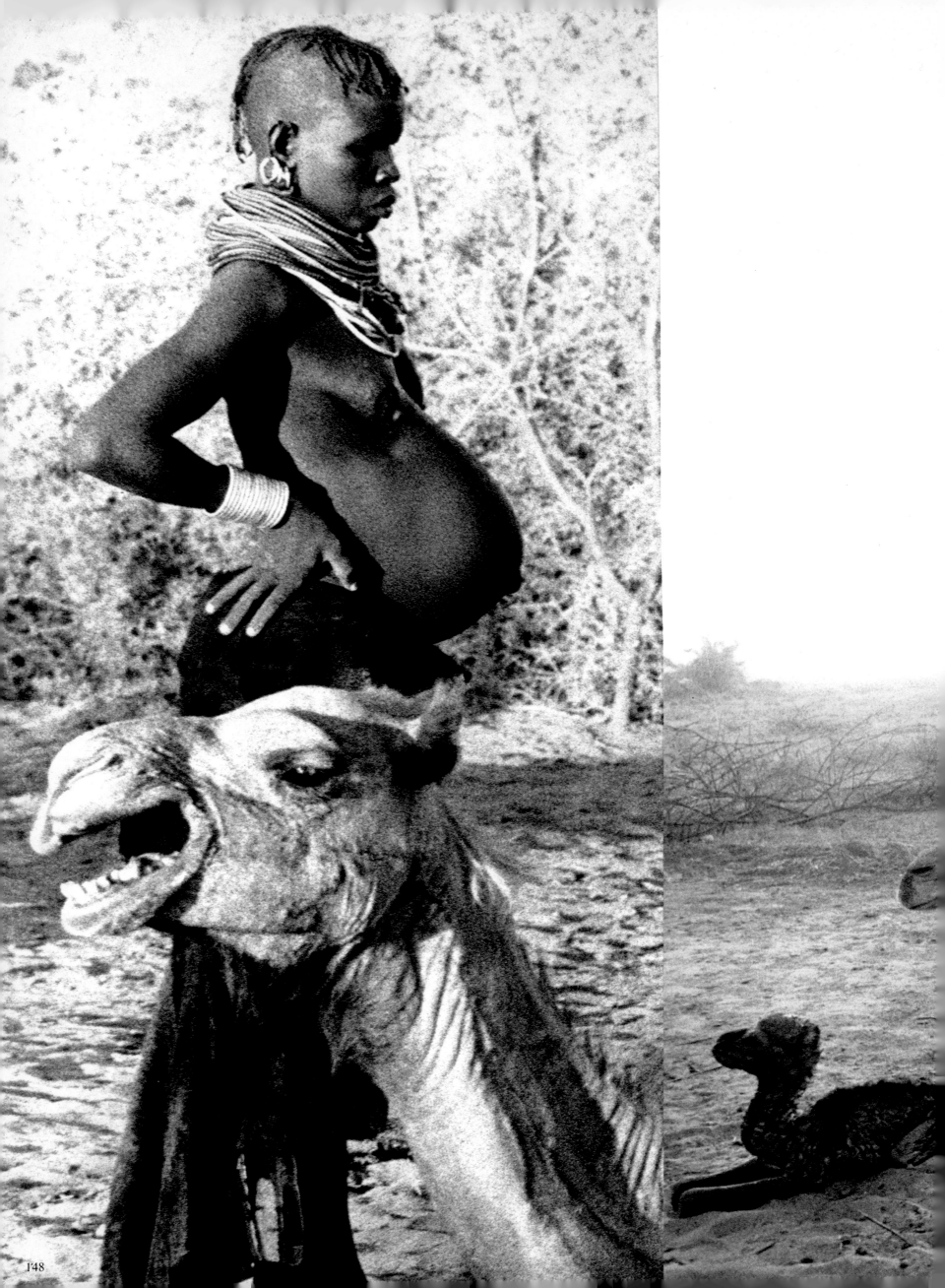

149

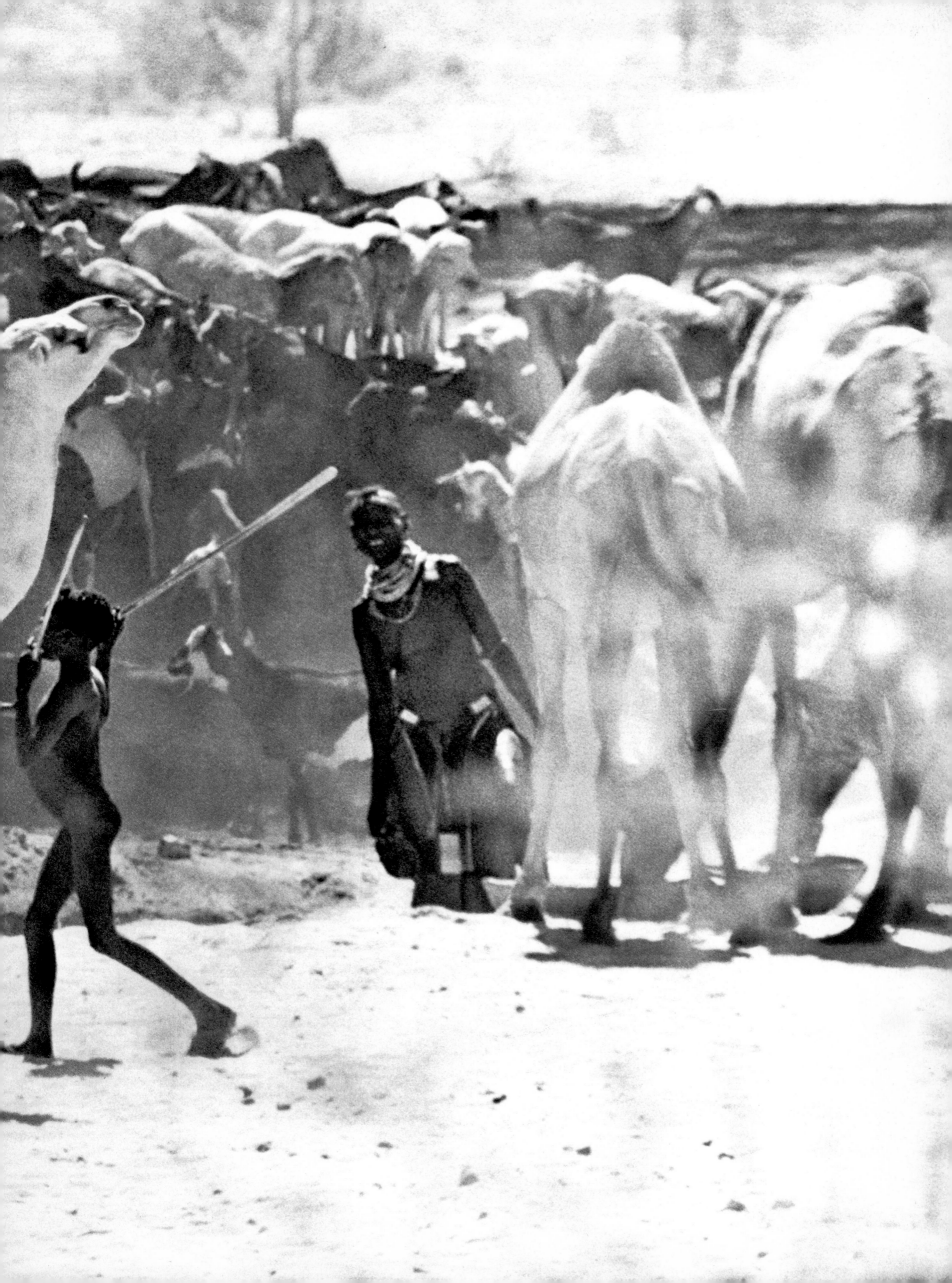

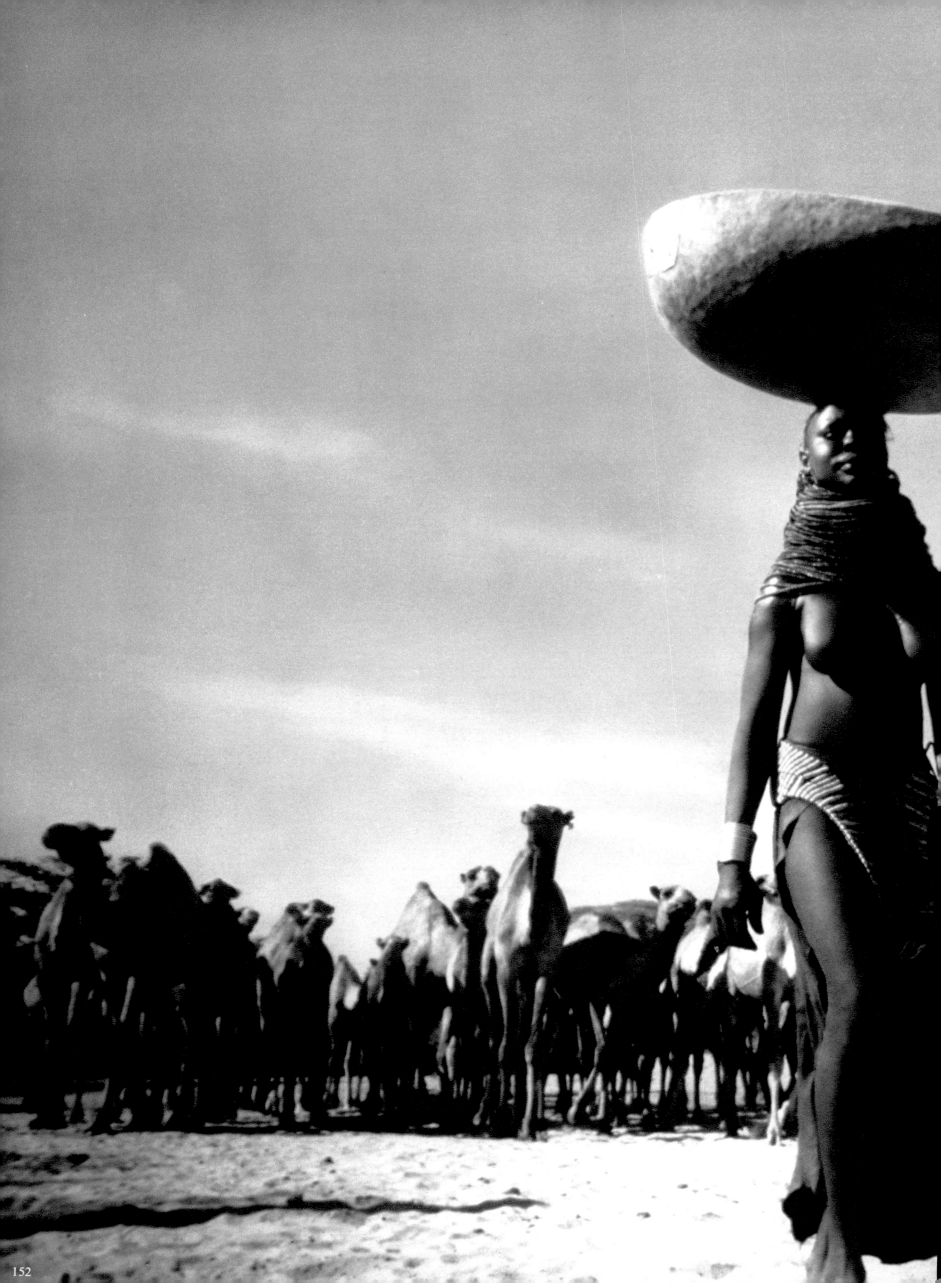

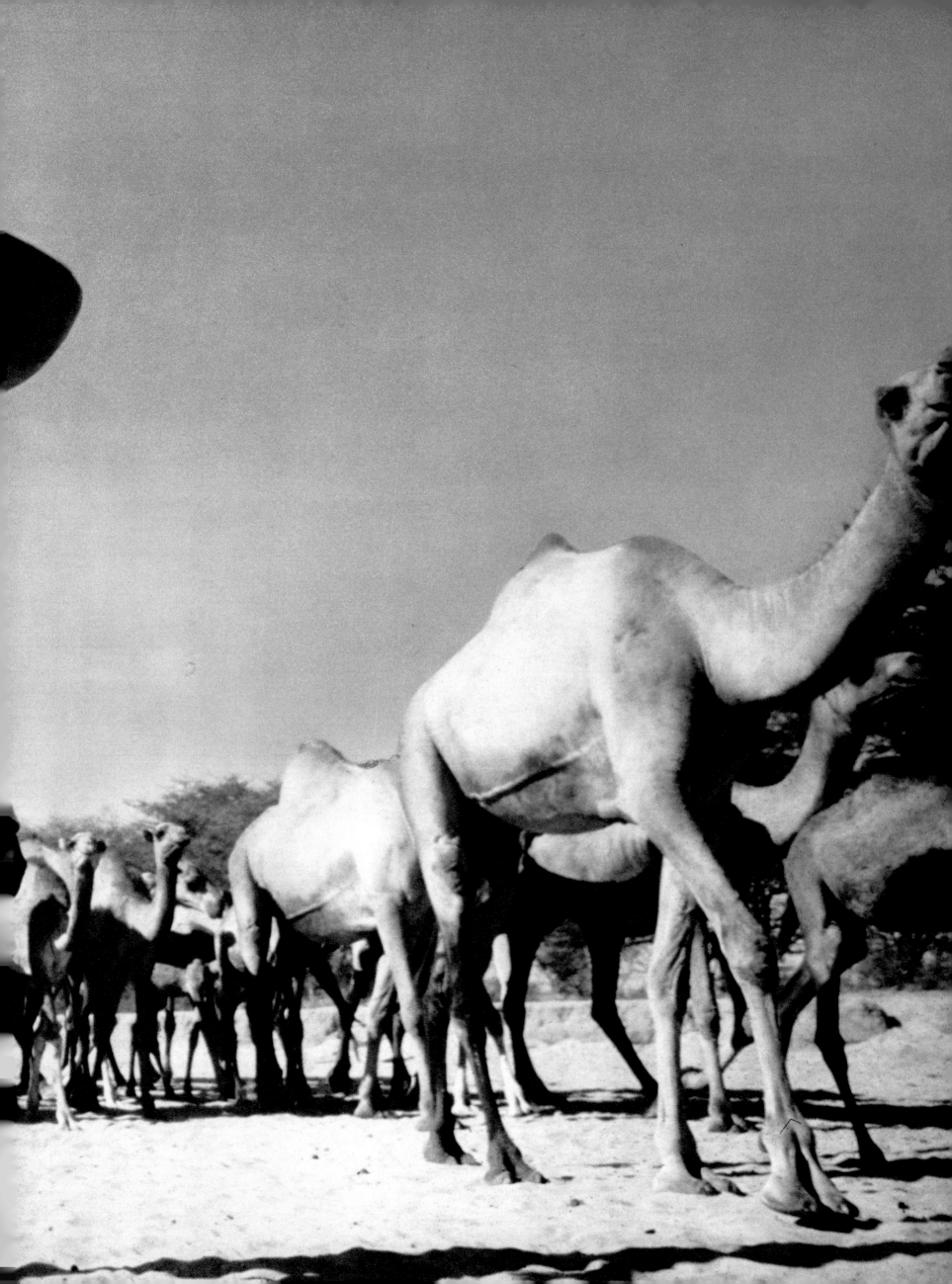

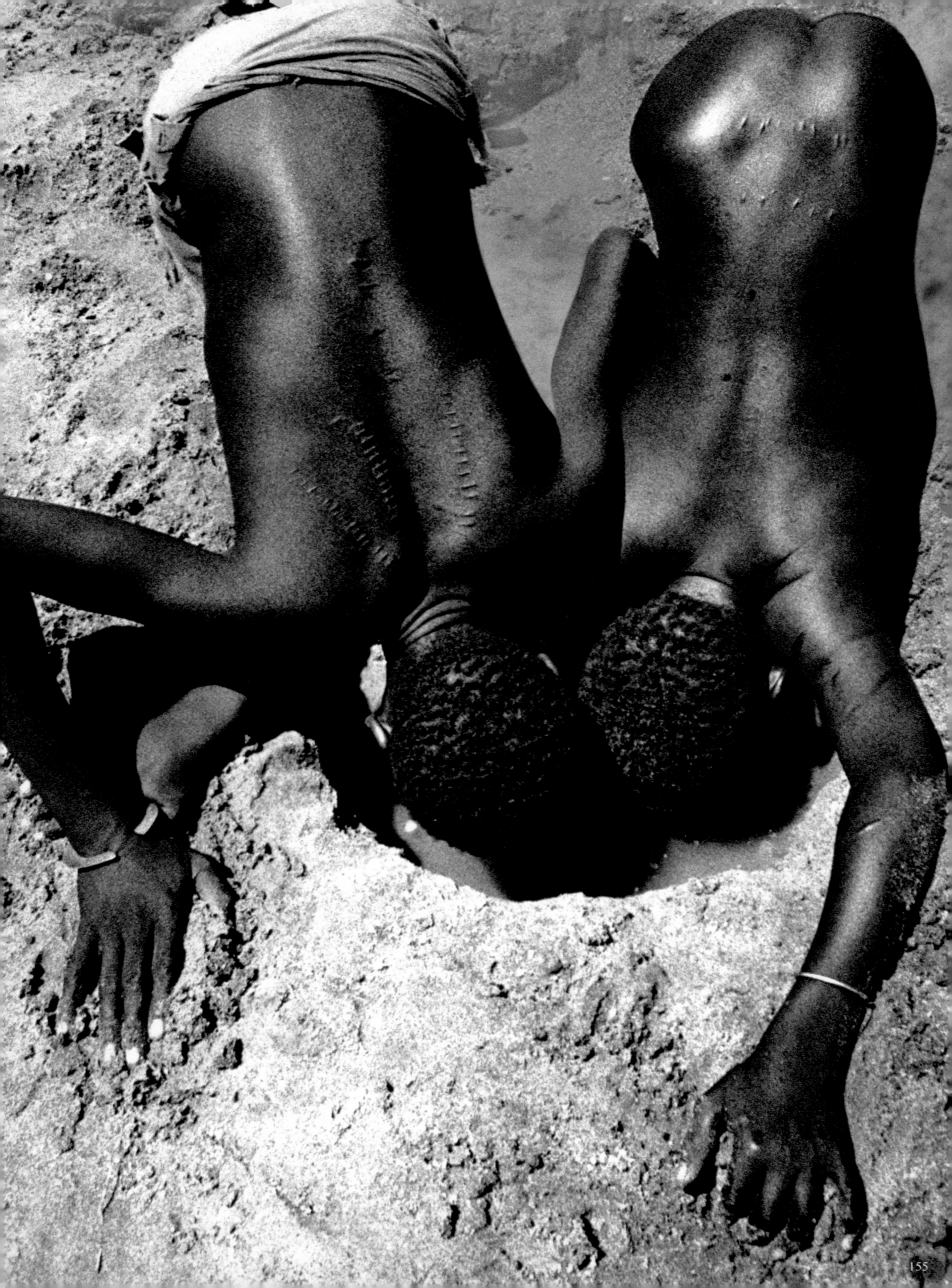

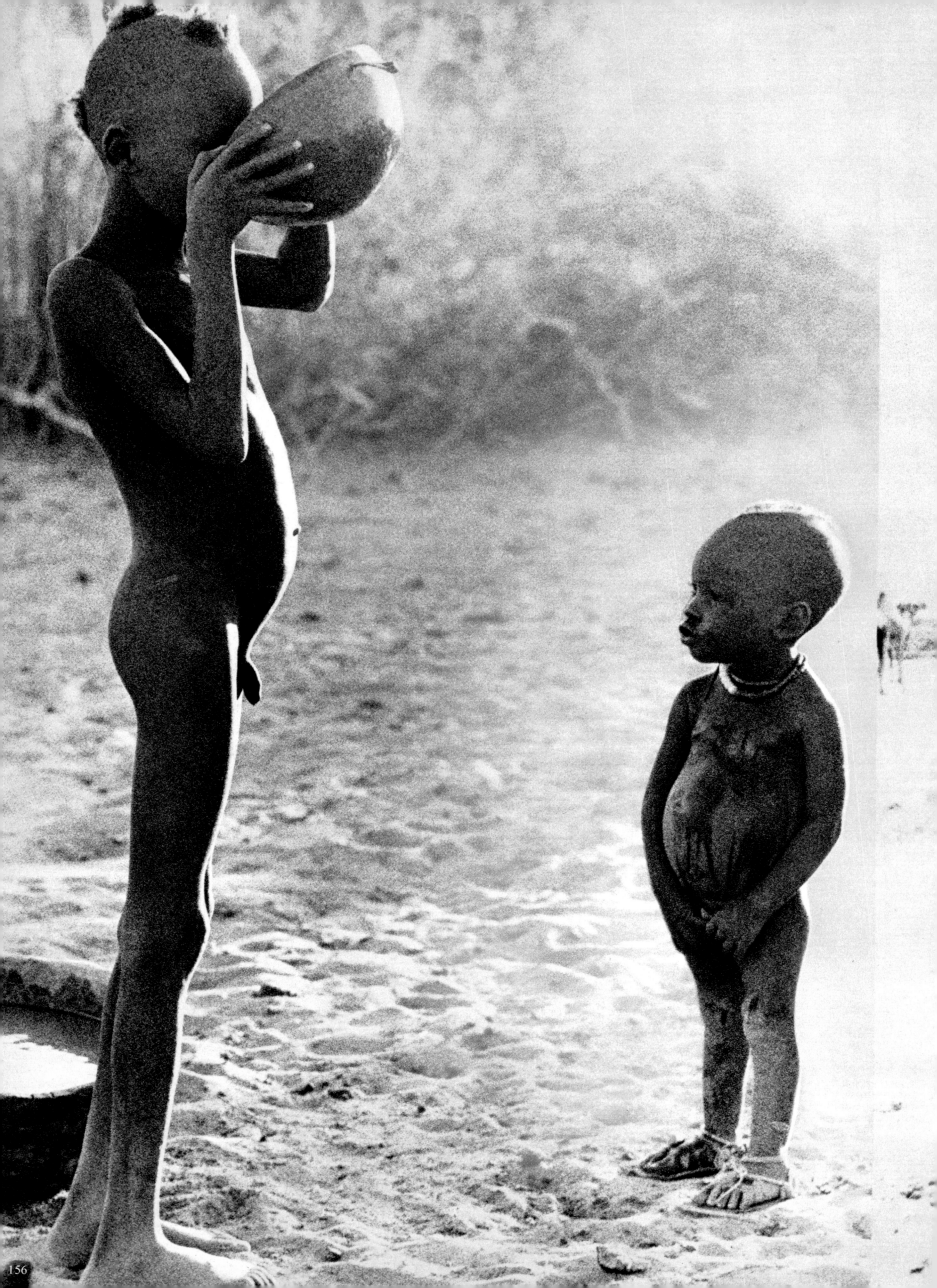

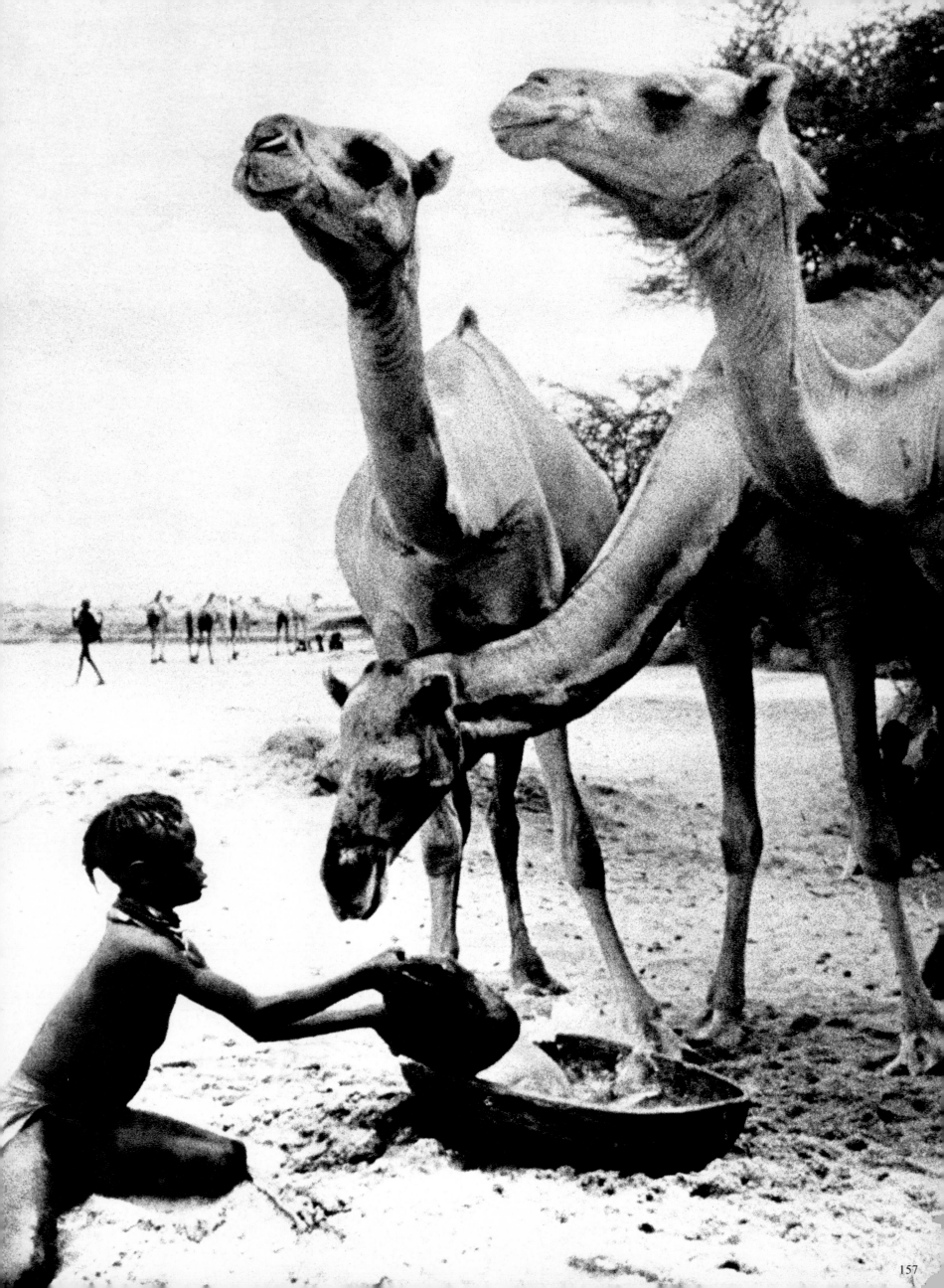

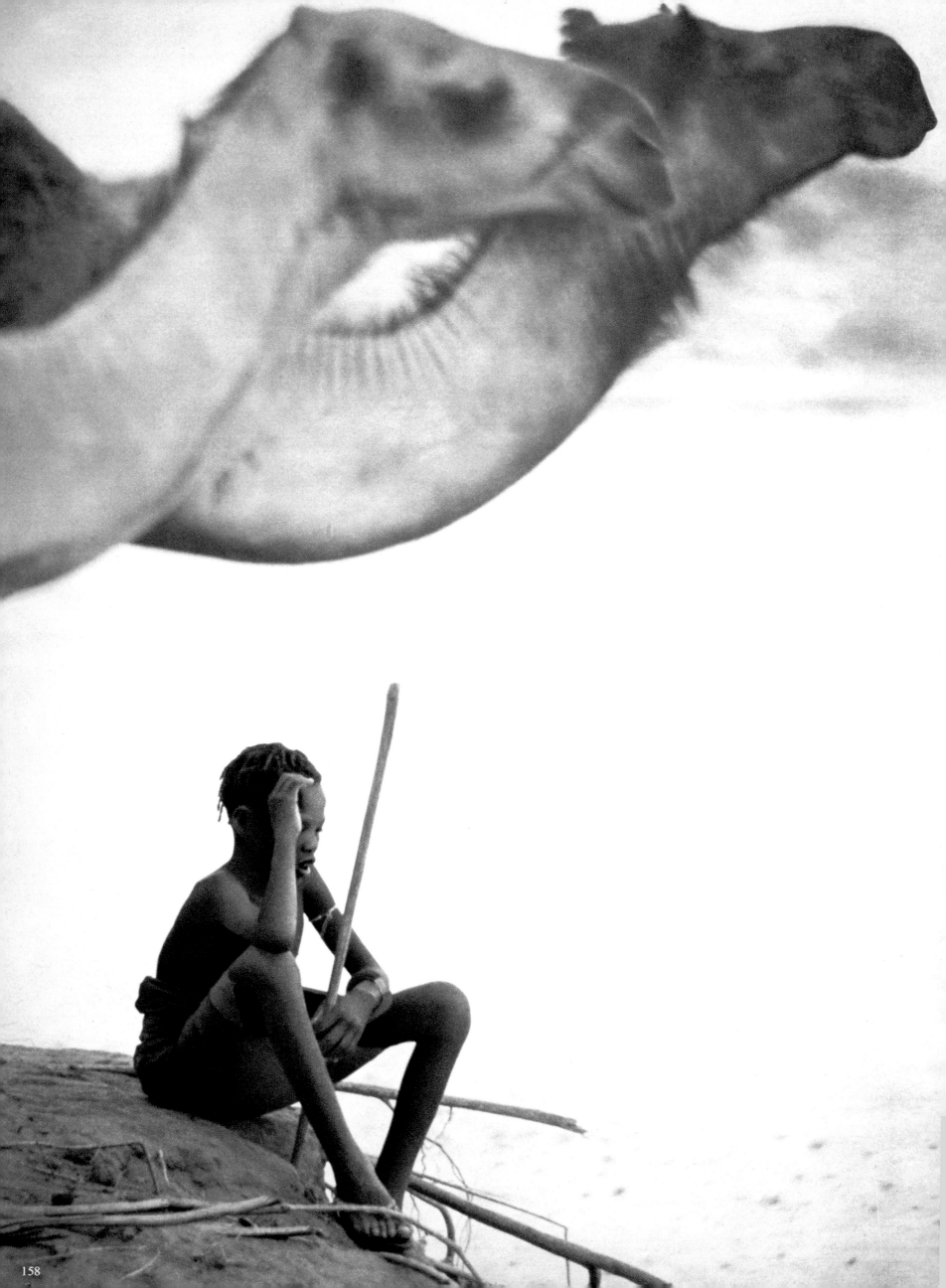

BAJUN ISLANDERS

BAJUN ISLANDERS

The Bajun Islands stretch out in an archipelago north of the old Arab trading port of Lamu, one of the most beautiful and picturesque settlements on the East African coast.

Like Lamu itself, the precise origin of the Bajun is still a historical puzzle, wrapped in numerous layers of mystery. From their own accounts, they would appear to be the direct descendants of Arabs who left the Sultanates of Yemen and Hejaz in Southern Arabia in about 750 A.D., because of religious wars at that time, and set sail for the East African coast where they settled and inter-married with the local Bantu inhabitants. But other accounts suggest that they may be of Persian or even Syrian origin, who came to East Africa to trade and who through the years inter-married with the local coastal Africans and gave rise to the Bajun.

Whatever the case the Bajun are more like Arabs than Africans; indeed in many of their habits and reactions I found them not unlike Spaniards or Sicilians. Being Moslems there are many mosques on the islands from which at six in the morning and again in the evening, the faithful are called to prayer. In the evenings the children of over five or six gather in the mosque to listen to readings from the Koran and to sing Arabic songs to the accompaniment of drums.

The men do all the manual work and the women remain at home. However, as a community they do little or nothing to improve their lot and accept with resignation the poverty and ignorance in which they live. Their social system and relationships are strictly traditional and are based on the Koran.

The Fast of Ramadan is carefully observed and for a month no food passes their lips from four in the morning until six at night. After this everyone eats a meal of chicken, fish or vegetables which must last them for the next twenty-four hours. One day I wanted to give a woman who was suffering from terrible bronchitis some cough mixture but until the *muezzin* had announced the end of the day's fast, I could not persuade her to take a drop.

As good Moslems the Bajun wash themselves before prayer and are exceptionally clean and the women cover their bodies completely in flowing robes. Their faces too are almost completely veiled revealing only their eyes. It was the appearance of the veiled women which I found the most striking feature of the island. Until they are married older girls are kept secluded before dark, after which they are only allowed out if they are covered from head to foot. In the presence of men they keep their eyes lowered.

The men are possessive and extremely jealous of their women. But although virginity and the fidelity of their wives is of supreme importance, the men, for their part, regularly deceive their wives but take care never to humiliate them in public; a highly sexual people they are almost as possessed by *machismo* as the Latins are. The women too are by no means always faithful, but whether or not the husbands are aware of this, no word is ever breathed in public about it.

Bajun women marry very young so as to avoid the possibility of pre-marital sex relations

and also so that they may be formed to their husband's wishes. On the day of the wedding the husband pays about 2000 Kenya shillings to the bride's father after which the marriage takes place in the mosque. The next morning the husband's family come to inspect the marriage bed to satisfy themselves that the girl really was a virgin. Until the birth of her first child the wife can only go out on her husband's arm. After that she is given more freedom and may occasionally use it to make up for lost time.

159. *Veiled Bajun women.*

160 & 161. *Bajun singers.*

162 & 163. *On the Bajun Islands, the low tide exposes immense expanses of sand.*

164 & 165. *Bajun women watching men dancers.*

166 & 167. *Messages are transmitted through the expression in their eyes.*

168. *Religious teacher on roof of the mosque before the midday prayers. The umbrella protects him from the strong sun.*

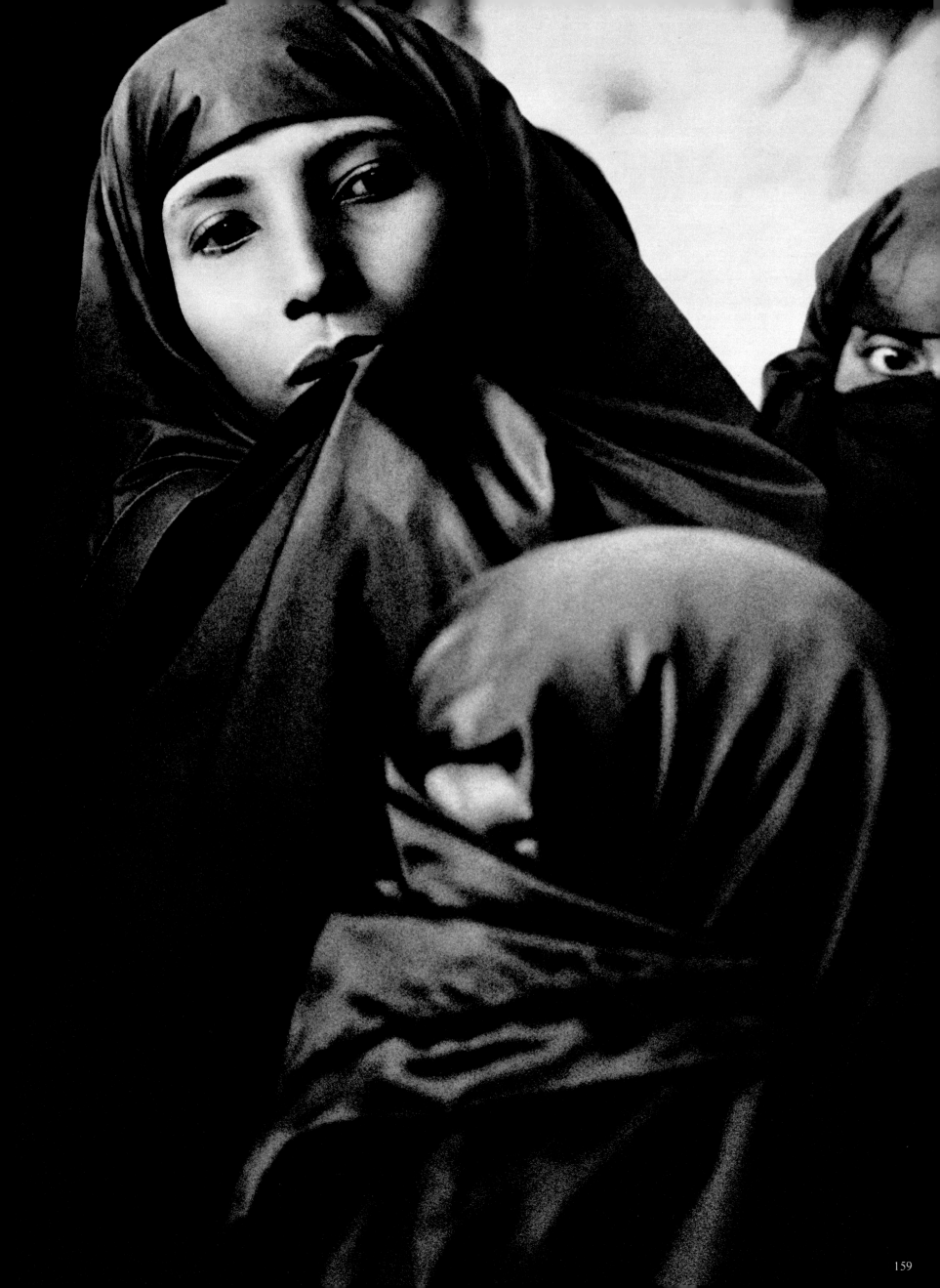

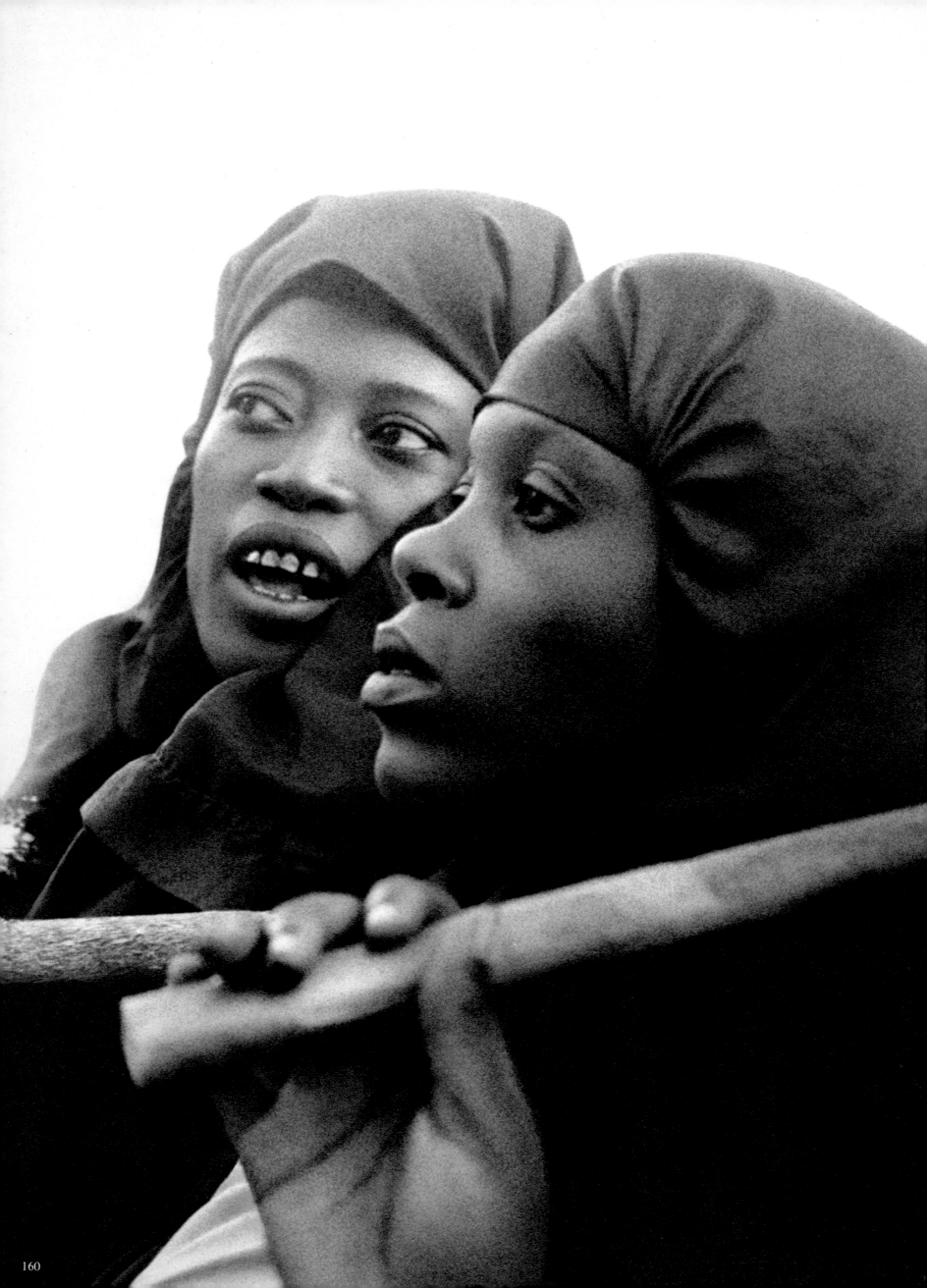

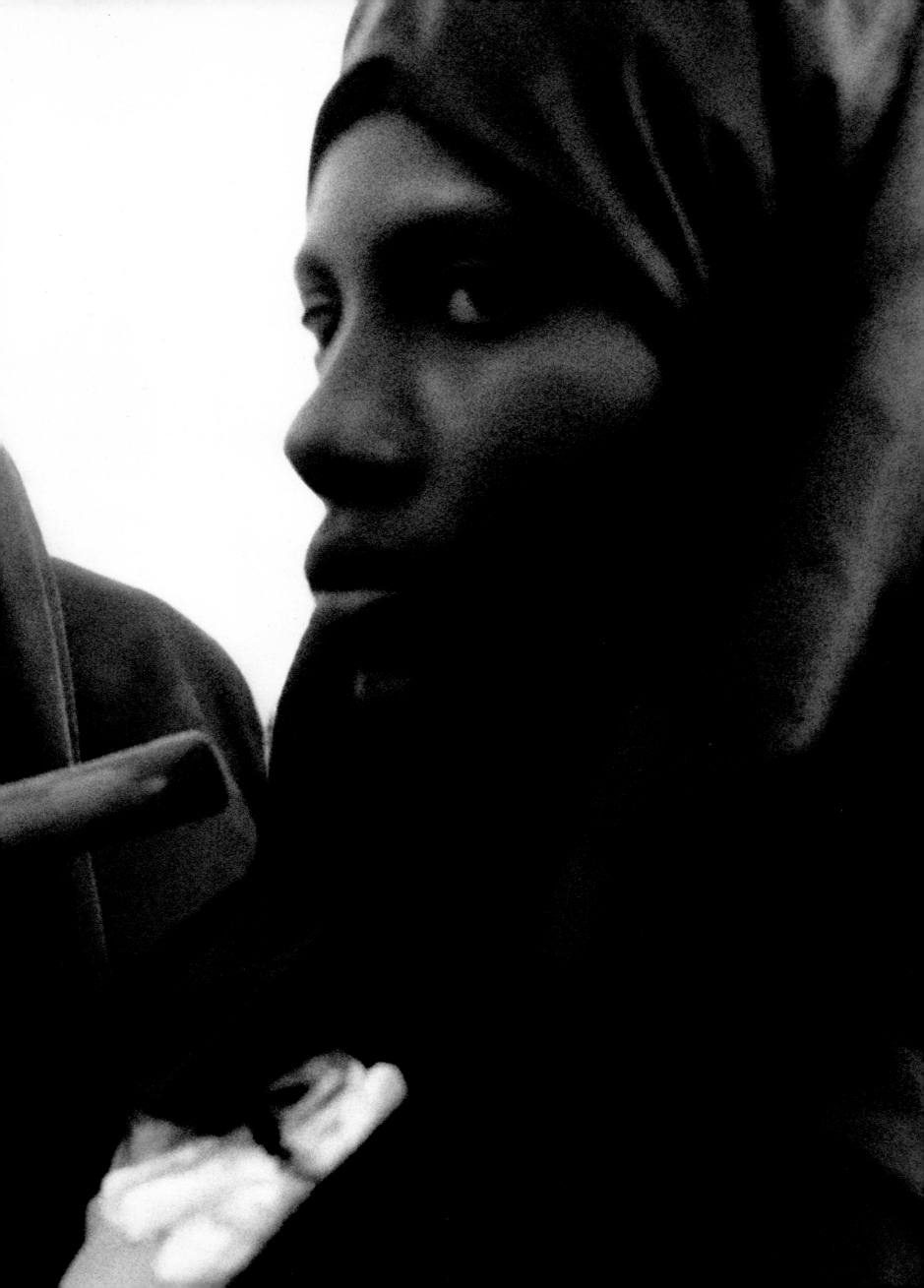

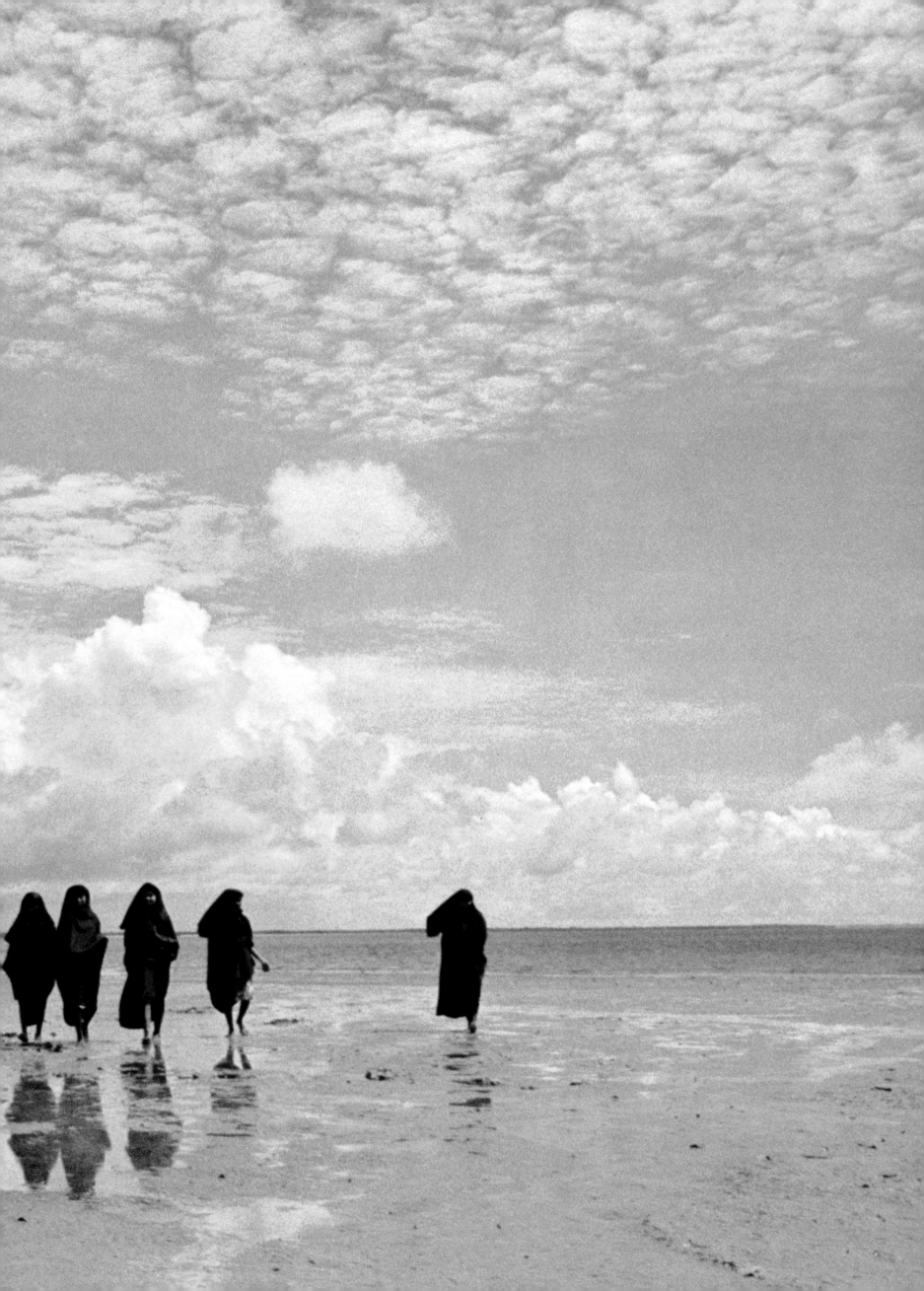

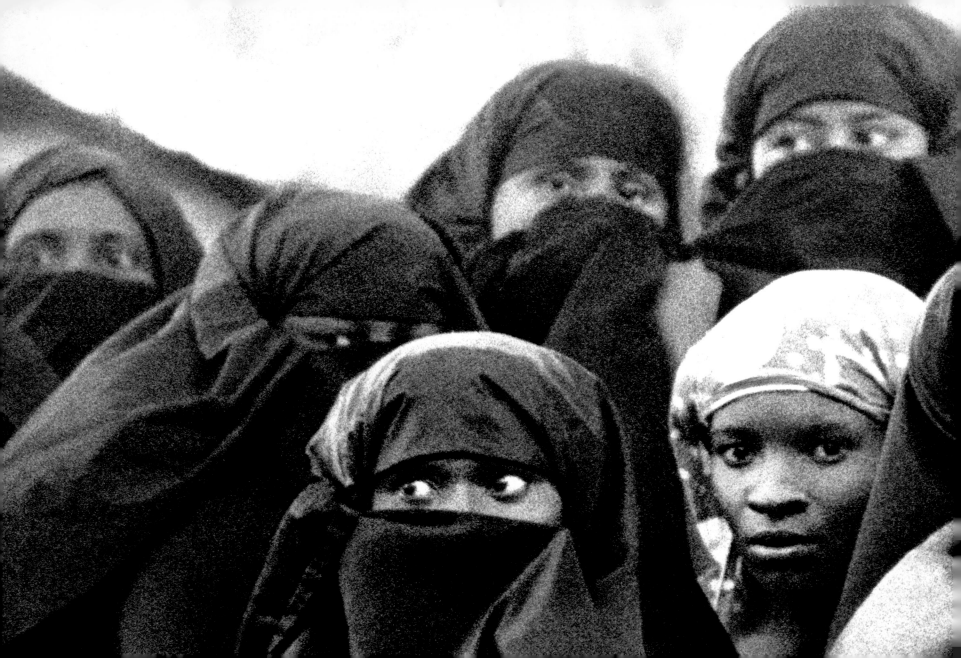

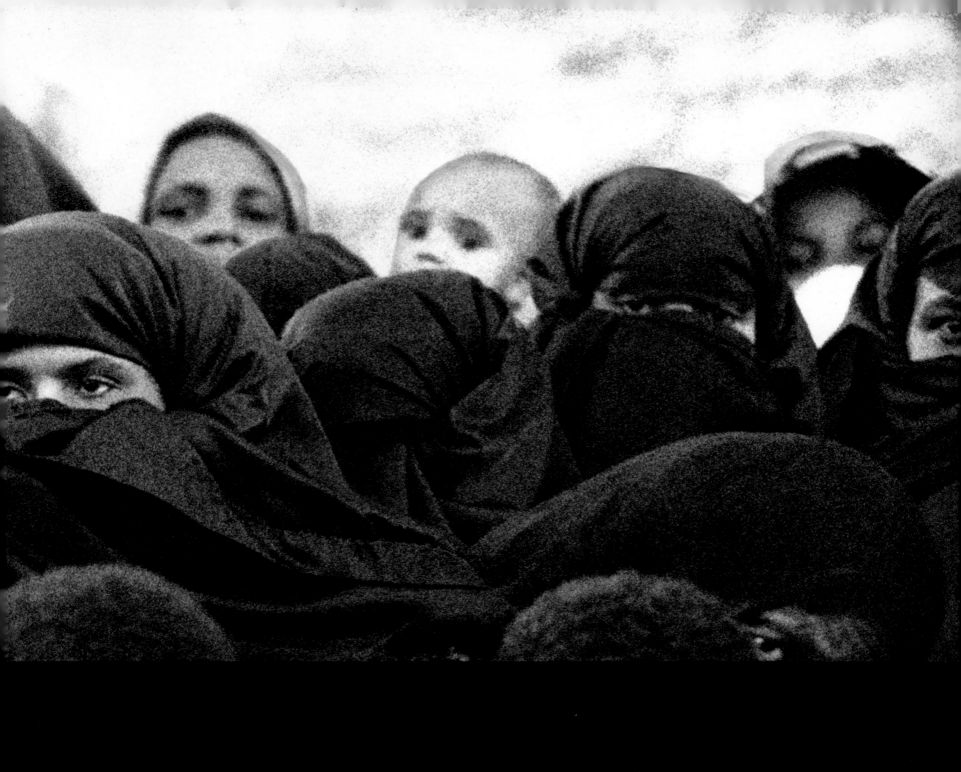

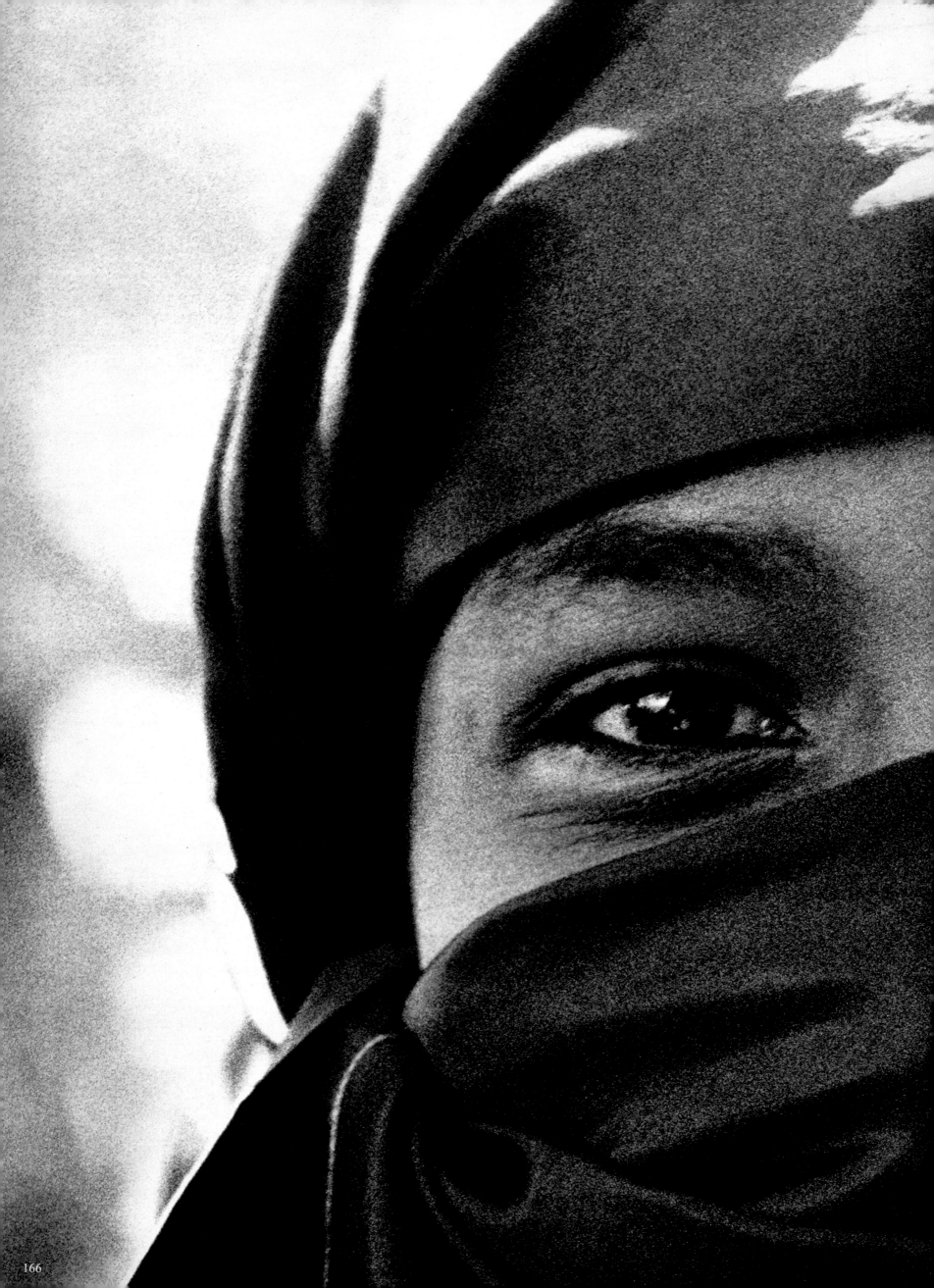

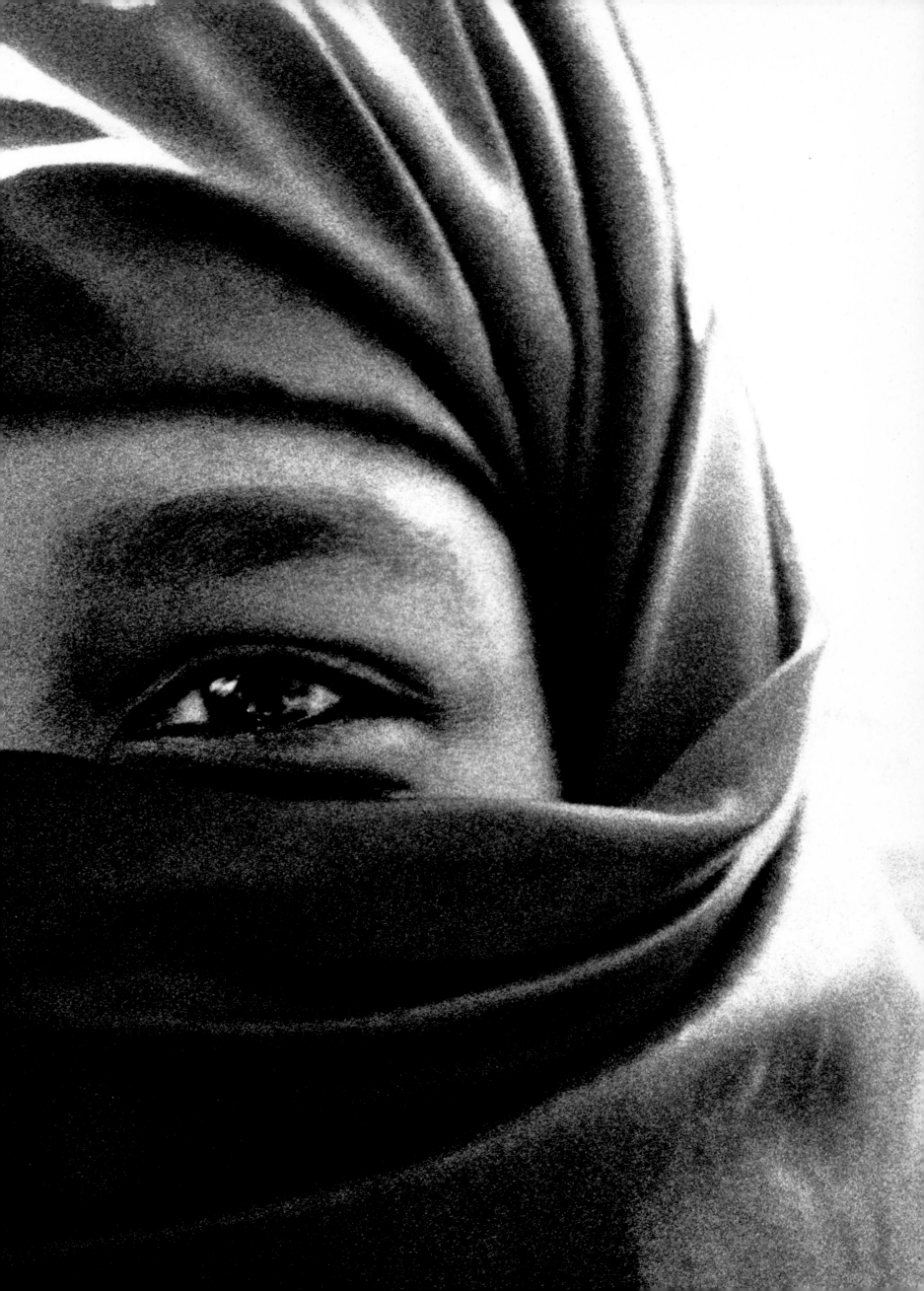

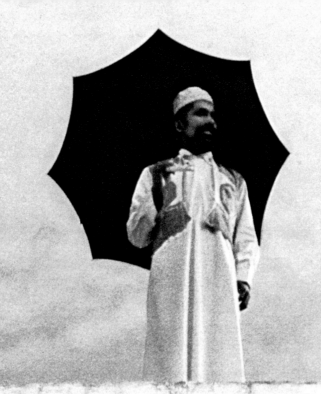

وقل جاء الحق وزهق الباطل
إن الباطل كان زهوقا

LOVE AND BEAUTY

LOVE AND BEAUTY

Children do not remain children for long among most African tribes. In certain groups, by the age of nine or ten, there is already considerable sex-play, and in all tribes girls are married off by the time they are fourteen to fifteen.

Although the African concept of human beauty often differs from European ideas, men in Africa look for it in their women and women aim to satisfy it. The hair seems to be their most difficult problem. Because it is so crinkly and thick, the head is usually shaven or kept very short with the exception of the Bajun women who often let their hair grow and braid it into two thick short plaits, and the Boran whose women wear their hair in hundreds of tiny thinly plaited braids which hang to the shoulders causing them to undergo a very painful process of hairdressing by which the hair is pulled and stretched so as to straighten it, enabling it to be braided right from the roots. They undergo this hairdressing once a month when the hair is washed and combed with a thick wooden comb. Each village has one women who acts as hairdresser.

Scars are a sign of beauty and are carefully placed on the body to form a definite pattern, usually on the belly or the back or under the eyes. They decorate themselves with grease paint which is made from mixing refined sheeps fat with red ochre, black or blue powder and used either in decorating the face and body or smeared on the hair – this prevalently among the men of the tribe.

Ornaments are varied and imaginative, including necklaces of all sizes and shapes made of either tiny woven beads or heavy chunky threaded ones which they wear in great layers around their necks – these are often covered in red ochre grease to stop the chafing of skin on the neck and shoulders and to protect them from parasites. Beads are sewn on to leather skirts and head bands and neck straps. The beads are bought in the local *duka* and are usually very brightly coloured – red, green, blue, white and yellow are the most favourite colours.

Clothes are made of pieces of cotton material wrapped around the hips, under the armpits or knotted on the shoulders. Women only wear leather skirts made from beaten sheep or calf pelts.

Among many of the tribes initiation into womanhood involves a clitoridectomy. The object of circumcision in women may be compared with that of the chastity belt – the inhibition of promiscuity. Boys, on the other hand, are circumcised towards the age of sixteen to eighteen, and only then allowed to engage in sexual intercourse.

Fertility is always an important consideration in the choice of a wife, for the growth and thus wealth of the family depends on it. But men also search for qualities of kindness and congeniality, and a girl who will make a stable marriage partner by not running off to live with other men. In addition, the state of her health and her ability to look after calves and till the land are an important consideration.

It is difficult to generalise about marriage or sexual practices among tribes for they differ so considerably. Some pay bridewealth or dowry in marriage while others give none

or perform jobs instead. What can be safely said, however, is that marriage and sexual relations are not as one-sided or unattractive as many Europeans, with their own peculiar beliefs and practices, make out. Indeed, most African women regard it as strange that European women do not want a second wife to help them in the house!

On one occasion I happened to witness the discussion that preceded a Turkana marriage. Akmet's riches came from his daughters. He had twenty-five. Now a suitor had appeared for one of them. For days he sat under a tree with several older men discussing the dowry and time of payment. While Akmet talked, the girl remained discreetly out of sight as is the custom. The discussion was long and hard. Finally the size of dowry was agreed upon: forty camels and fifty goats, to be delivered in two lots, one within a few days and the rest when the first child was born.

Obviously, in some cases, rich suitors are likely to be old and not very pleasing to the prospective bride. But an older husband in such cases often turns a blind eye to his younger wife's discreet affairs.

One day a daughter of Akmet came to talk to me; she was about twenty and had a pretty face but her front teeth were missing. I asked her how this had happened. She told me her father had chosen an old husband for her whom she did not like. She had refused to marry him, whereupon Akmet beat her into submission, knocking her teeth out in the process.

I asked her how she felt about her life. "I'm alright," she said, "I've accepted it. I have three children and live with the other women in the *manyatta*." "Are you happy?" "Oh yes, what else could I do?" And looking at Mzee Akmet walking about like a mighty lord, swathed in his multi-coloured blanket, the ostrich feathers of his head-dress quivering in the breeze, I could only agree. What else could she have done?

The Turkana are polygamous. After two children have been born by a man's first wife he can acquire a second wife but she must be approved by her predecessor. When the man has found the girl he wants he tells his wife to go and see her, then, if she agrees that the girl is suitable, she brings the new wife into her own hut until a second hut is built. The girl chosen may still be young, and if so, the man will have no intercourse with her until she begins menstruation and has completed her initiation operation, and she is able to bear a child.

169. *Giriama dancing girl.*

170 & 171. *Turkana girl wearing beaded skirt.*

172 & 173. *Boran girl (left); Rendille girl (centre); Orma girl (right).*

174 & 175. *Young Suk woman – the scars on the belly are obtained by tiny incisions made with a sharp blade in the skin. The juice of a certain tree is poured onto the cuts making them fester. A scab is formed which falls when it is healed, leaving a lumpy scar –*

this form of body decoration is very frequent among this tribe and the Giriama.

176 & 177. *Unmarried Turkana girls. The small beaded skirts are worn only by the unmarried. Beads are bought in the local shop and others are cut from ostrich shells and carefully sewn onto the skin skirts which hang down the back. The skins are dried and beaten with sticks until the leather is of almost cloth-like texture.*

178 & 179. *Extreme left and right unmarried Turkana girl's bead clothing. Centre, a Rendille girl.*

LOVE AND BEAUTY

180 & 181. *Running Samburu warrior.*

182 & 183. *Running Samburu girls. They have extra-ordinary grace of movement.*

184 & 185. *A young Maasai girl caressing the hair of her Murran.*

186 & 187. *Turkana lovers.*

188 & 189. *Young Maasai couple flirt under his blanket.*

190 & 191. *Suk lovers move towards the dance.*

192. *Pokot dancers.*

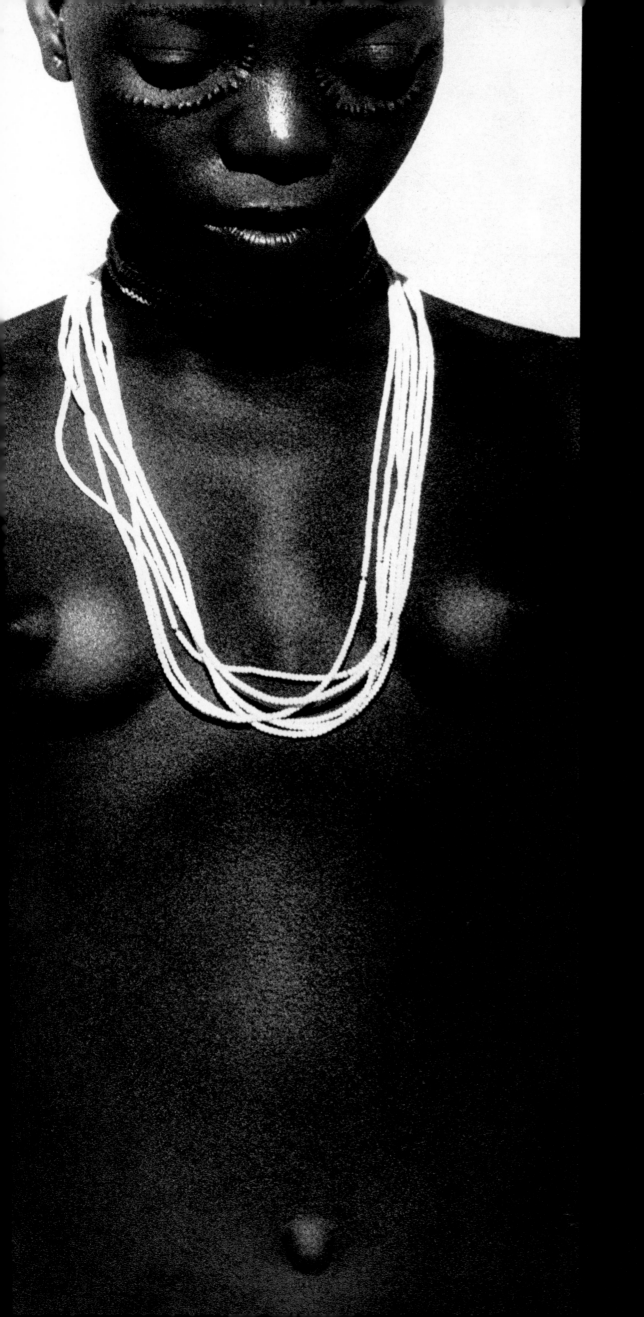

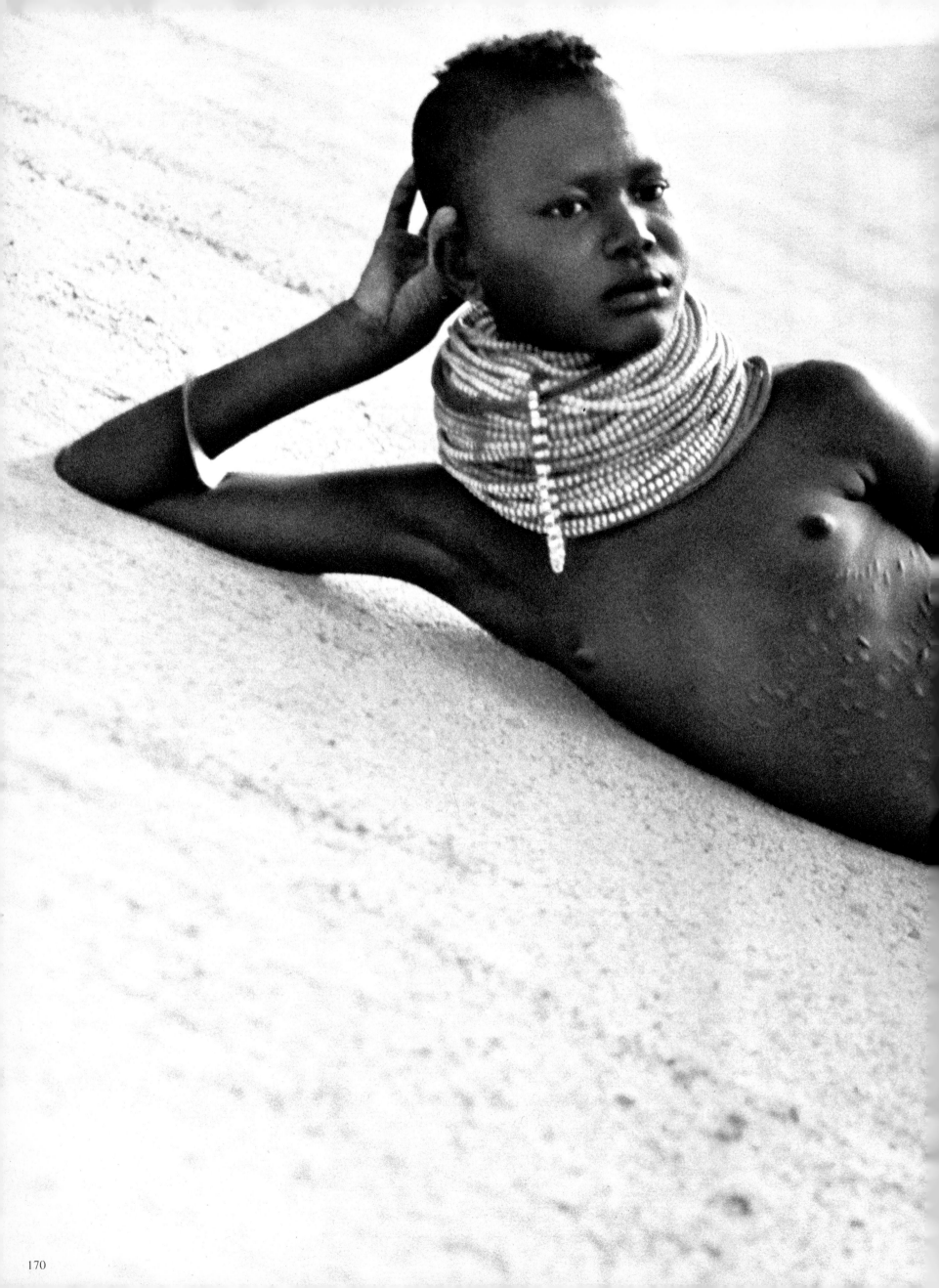

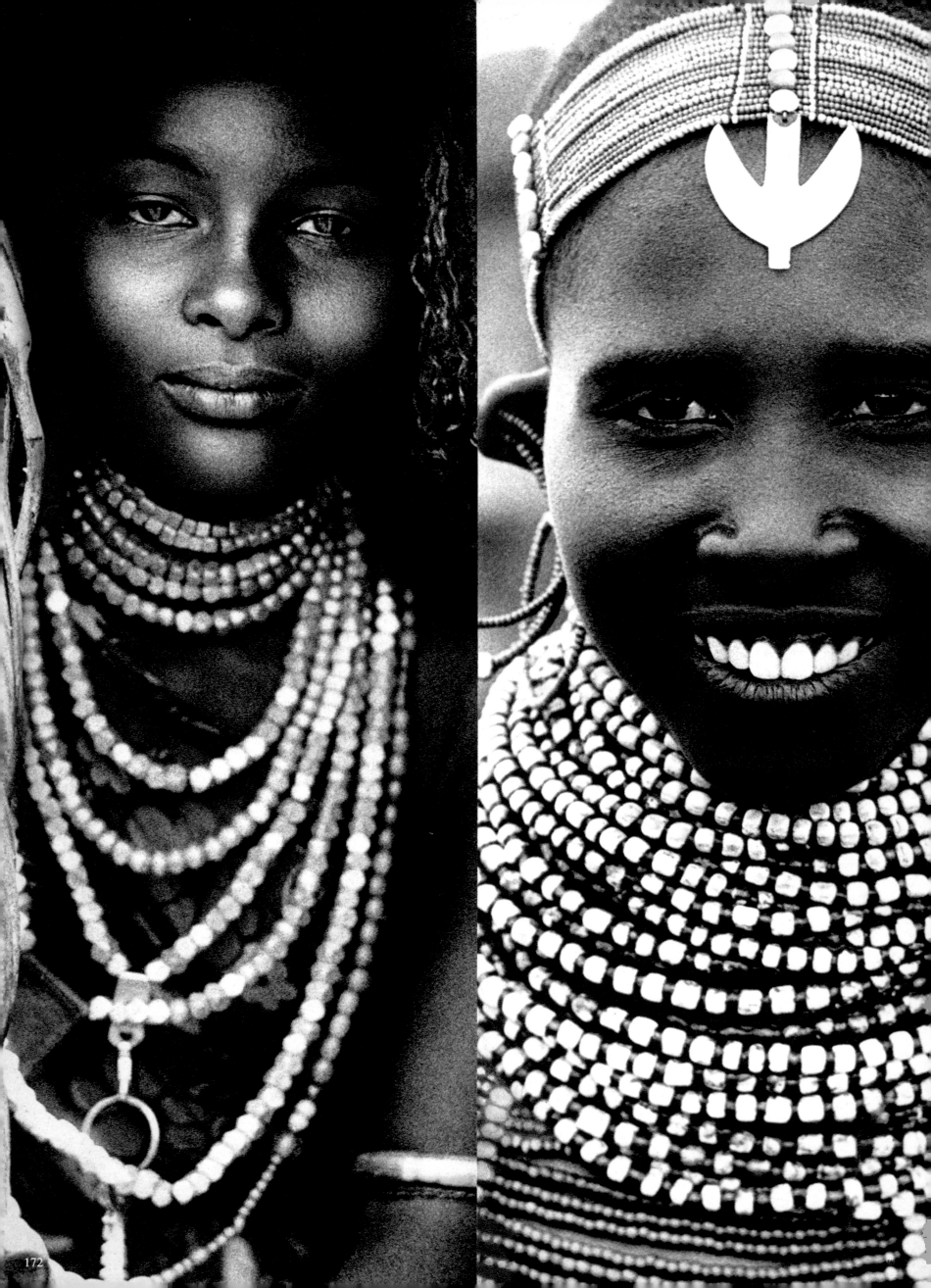

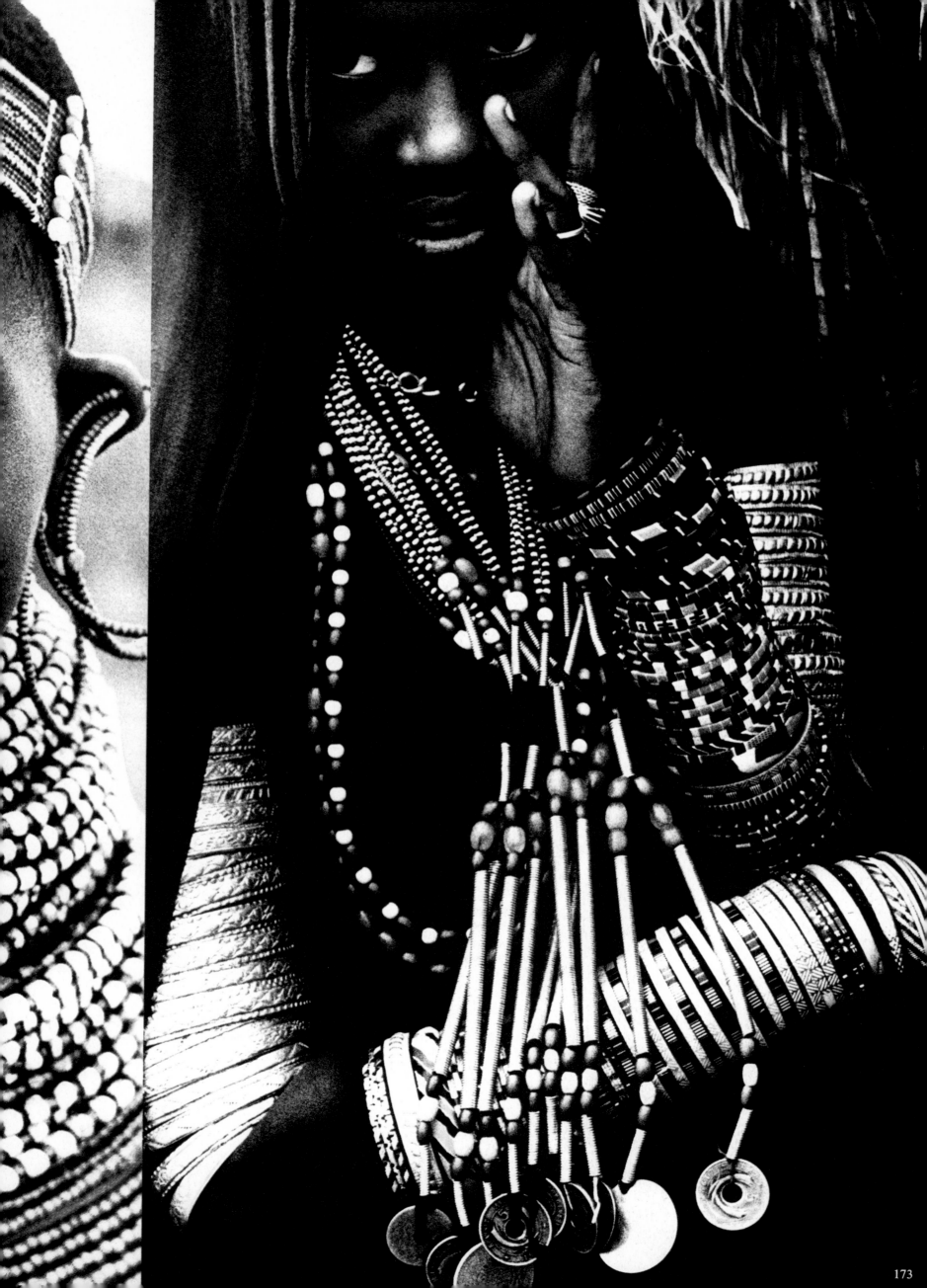

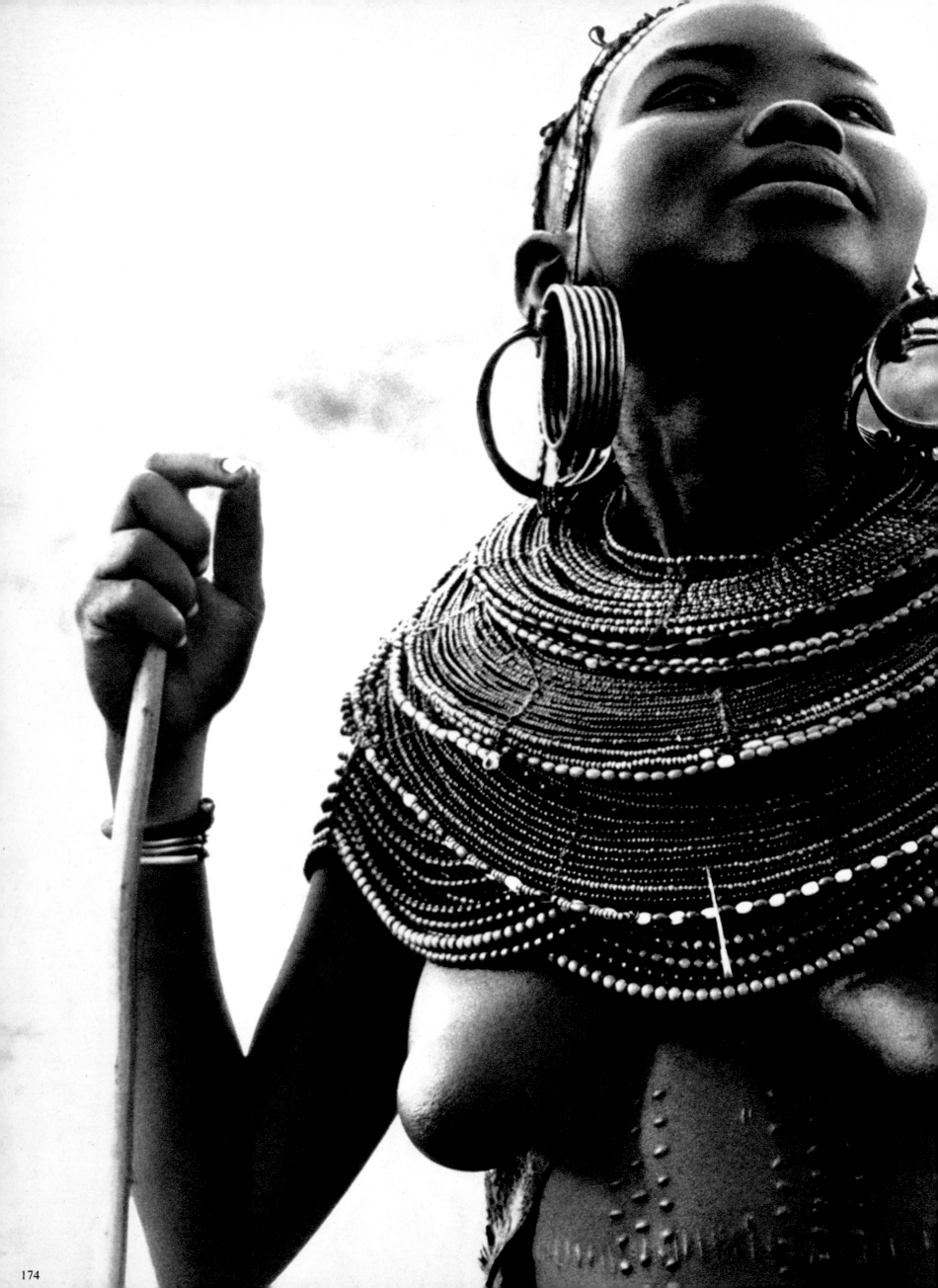

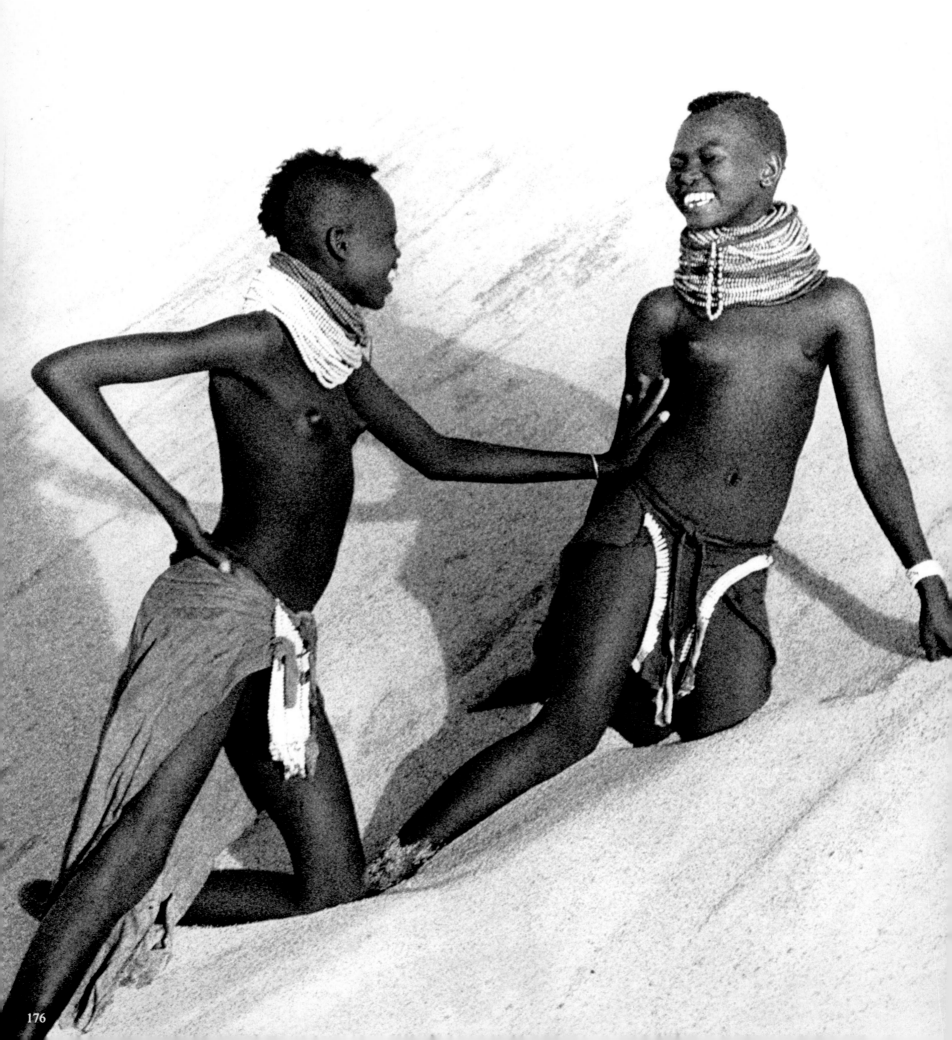

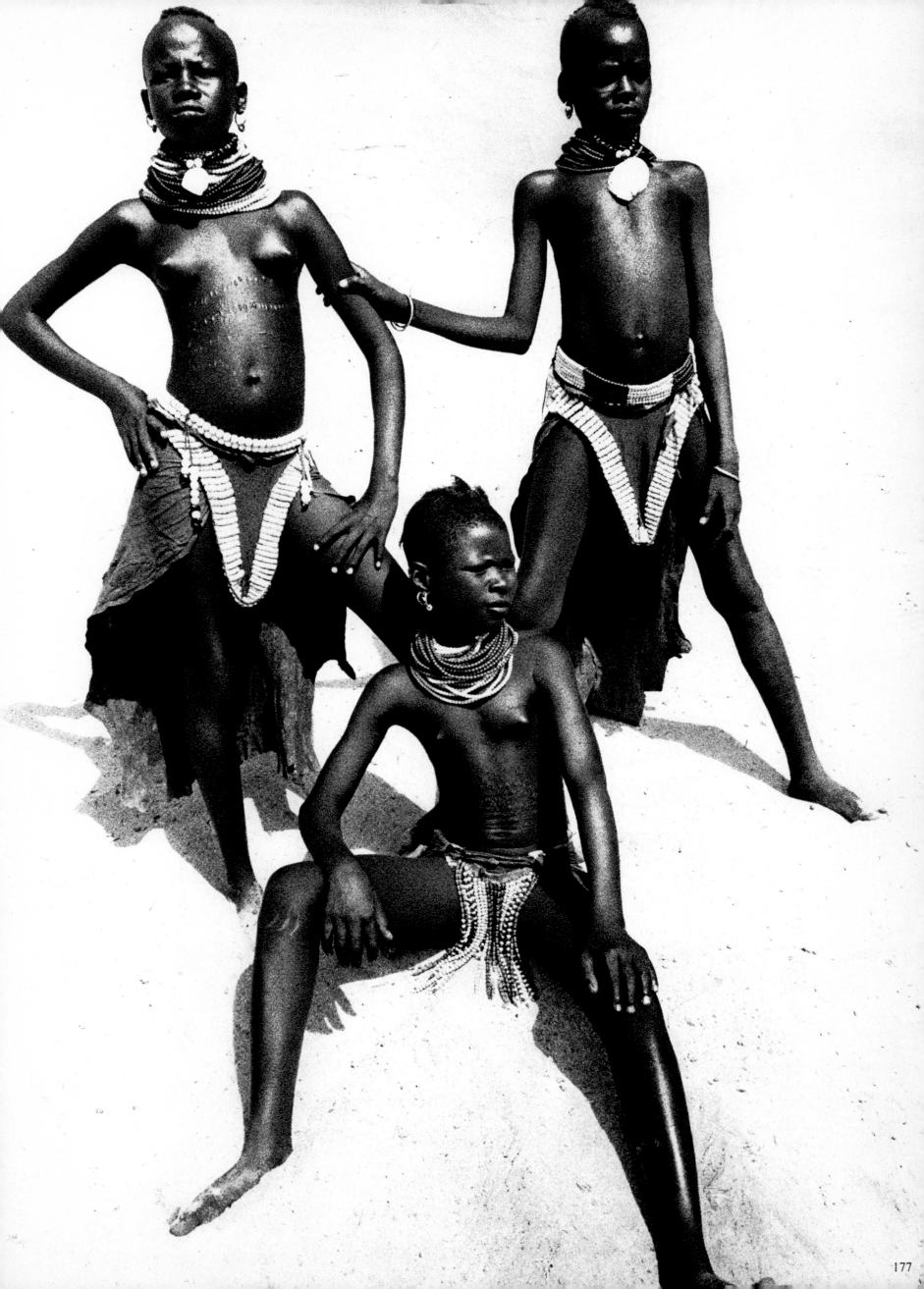

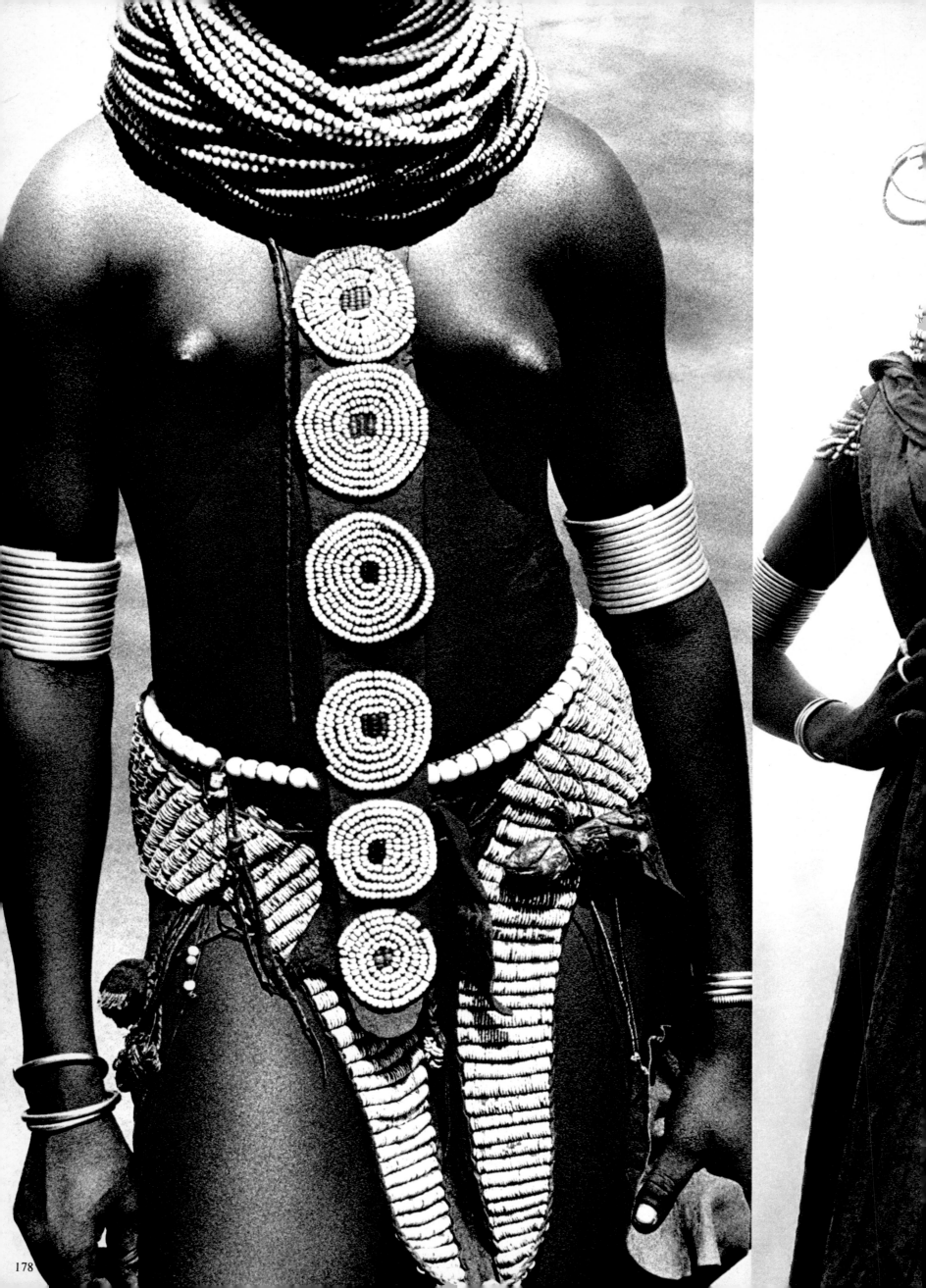

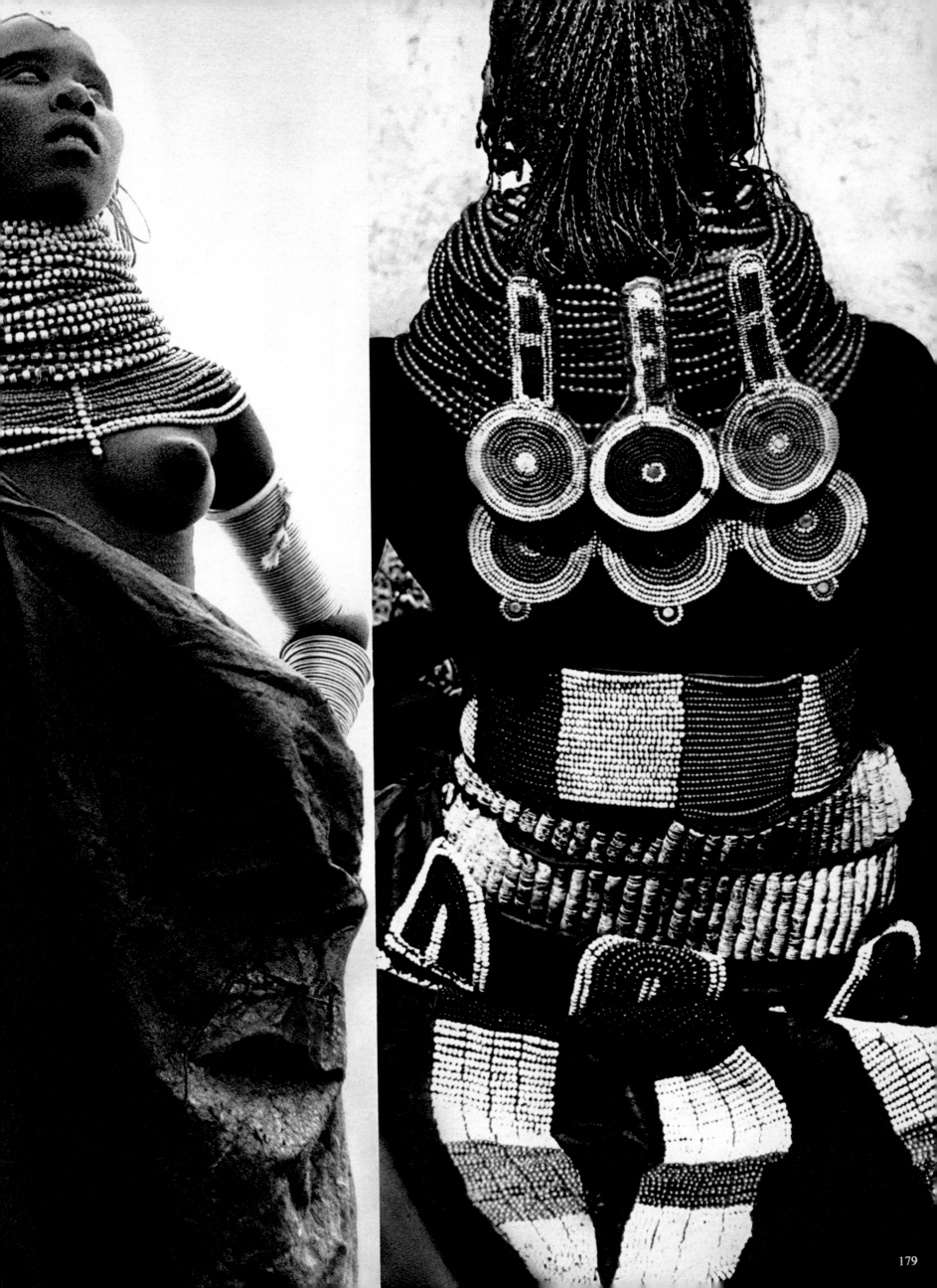

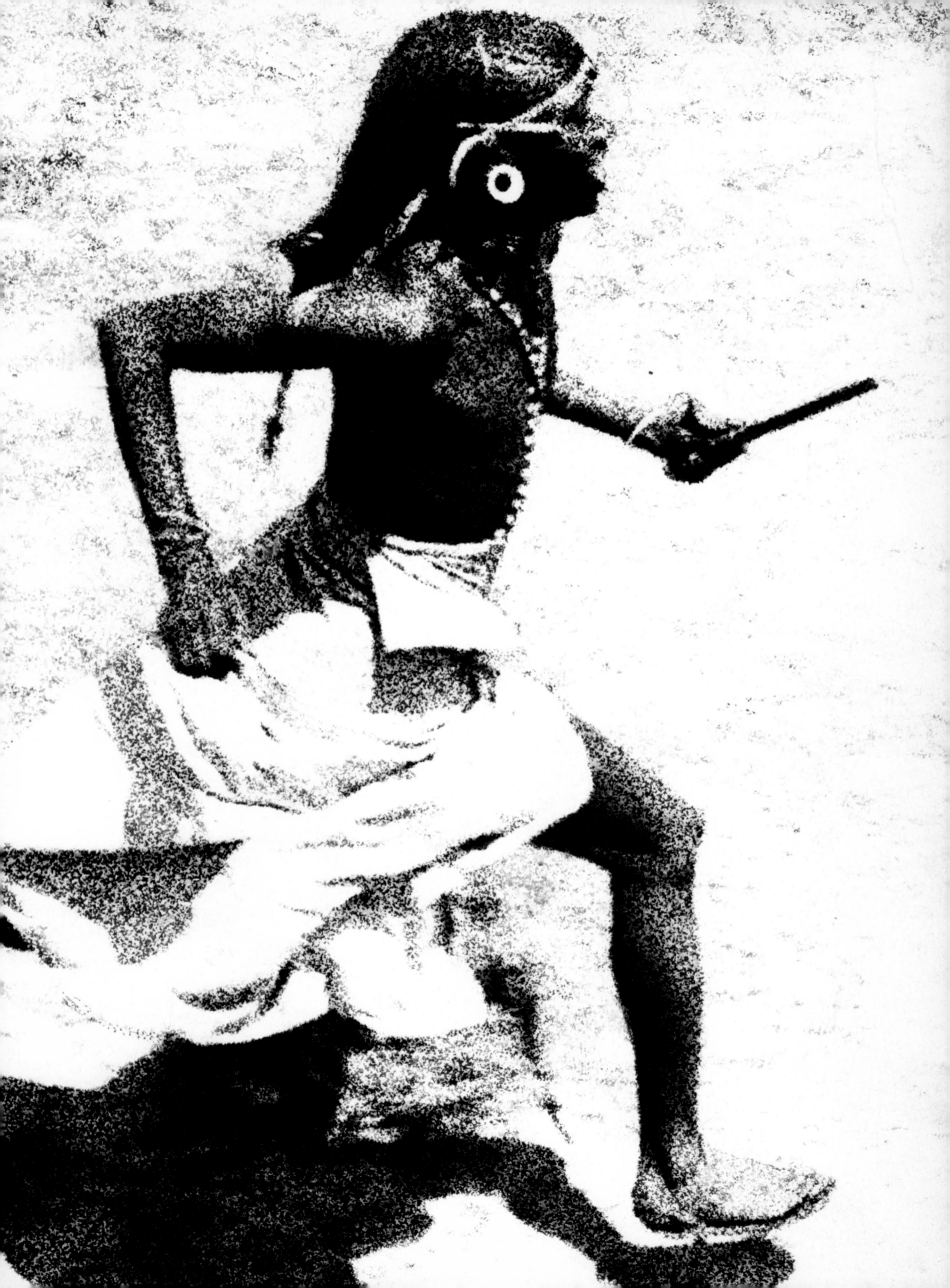

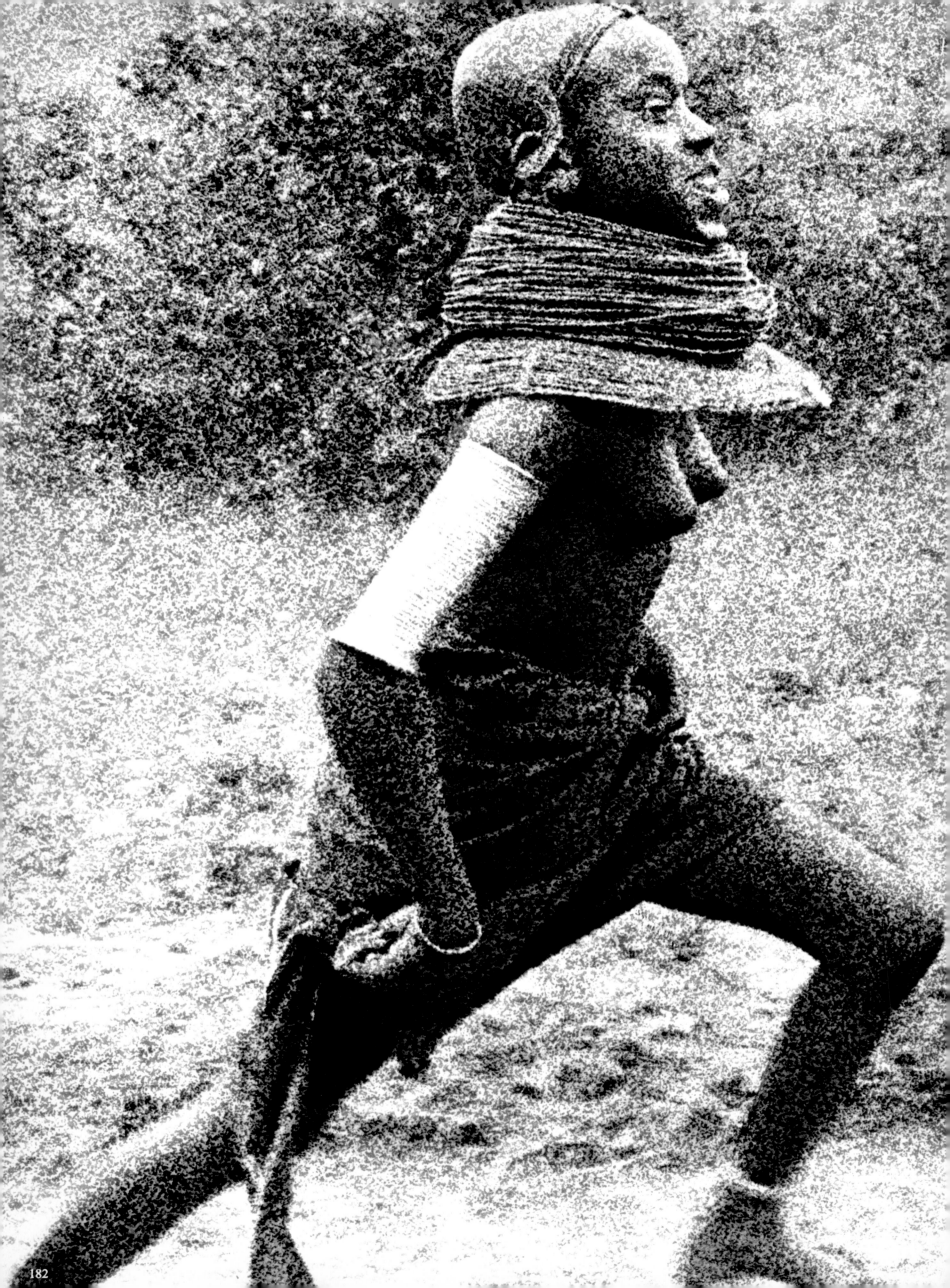

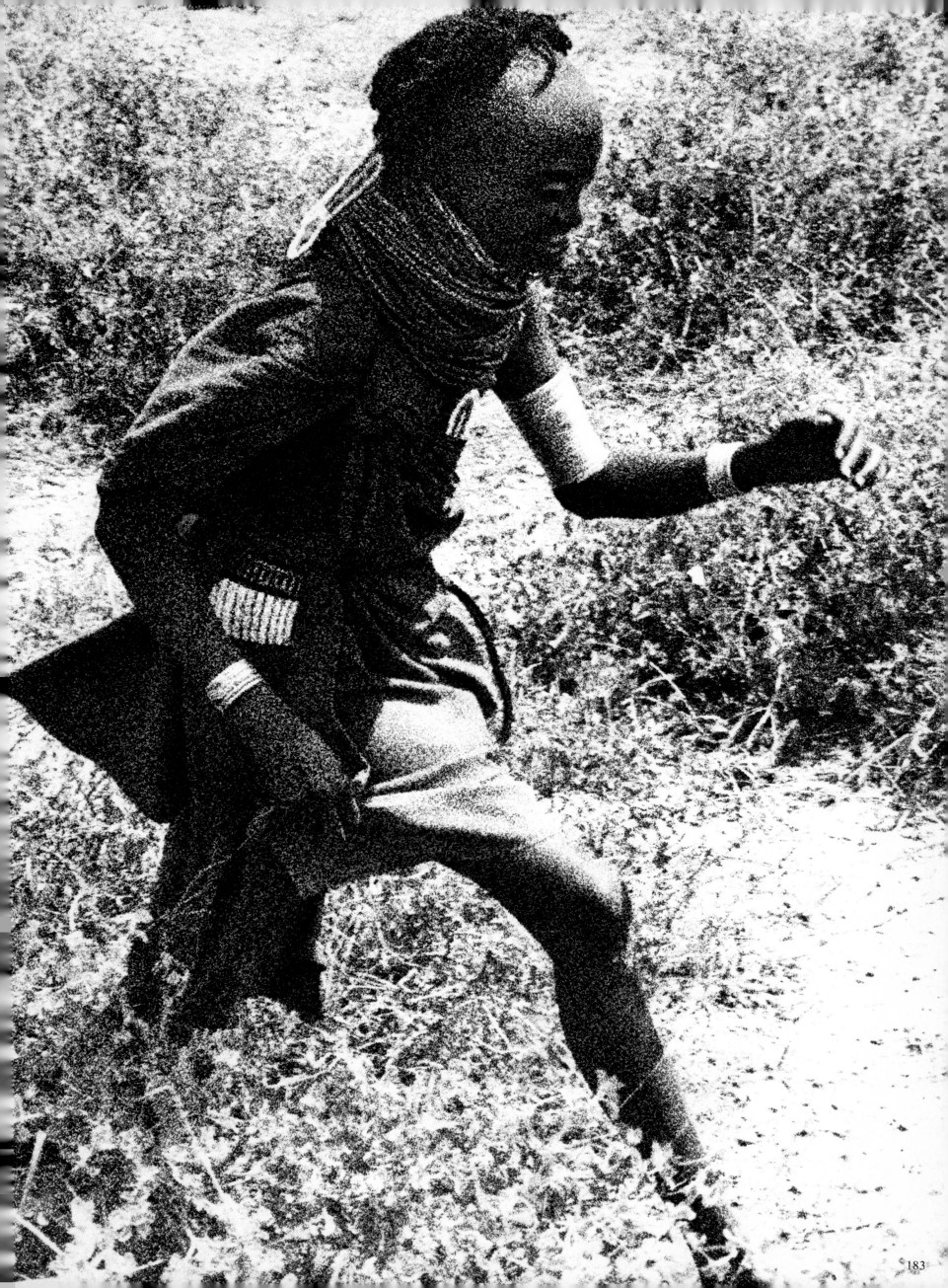

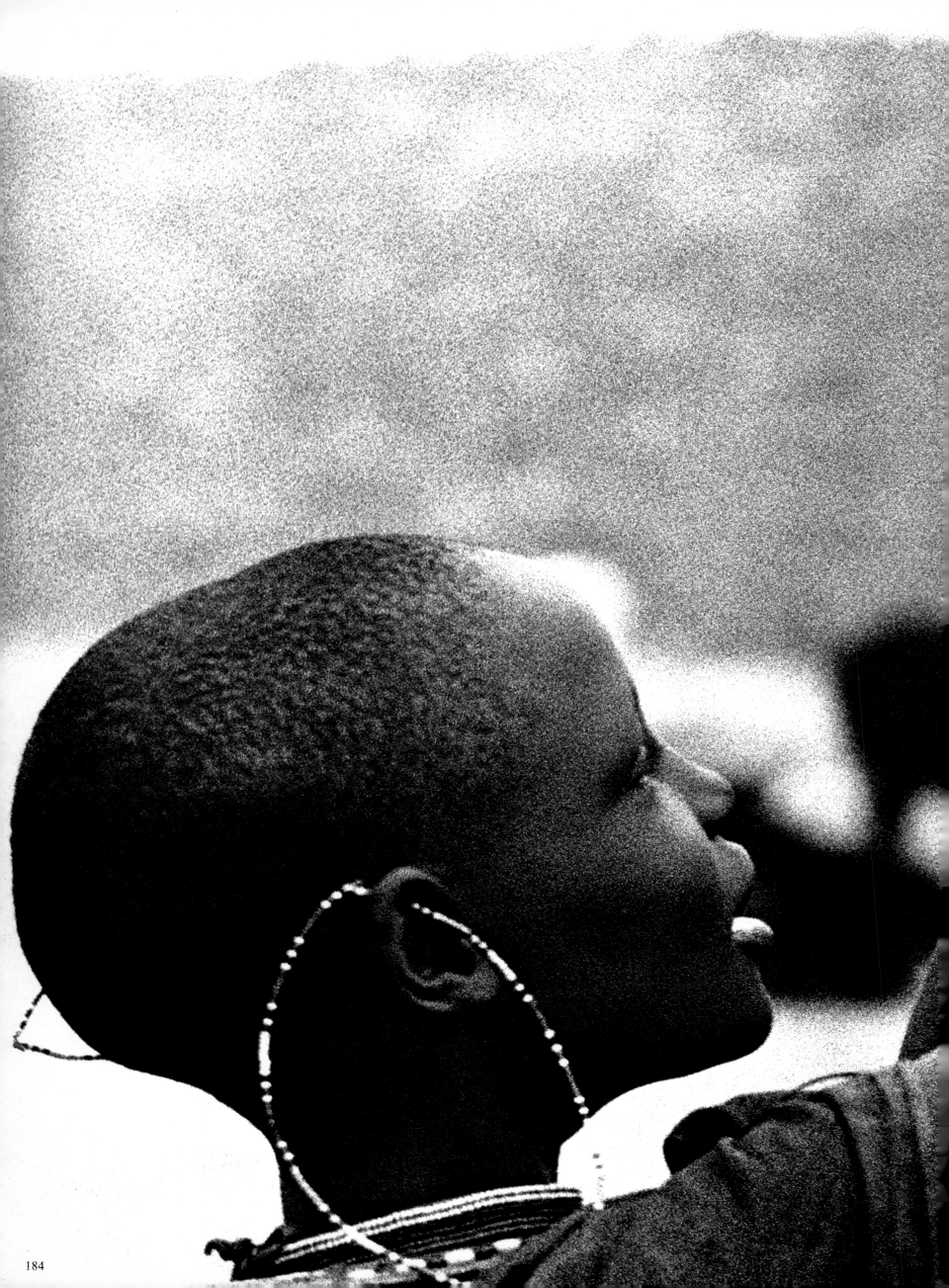

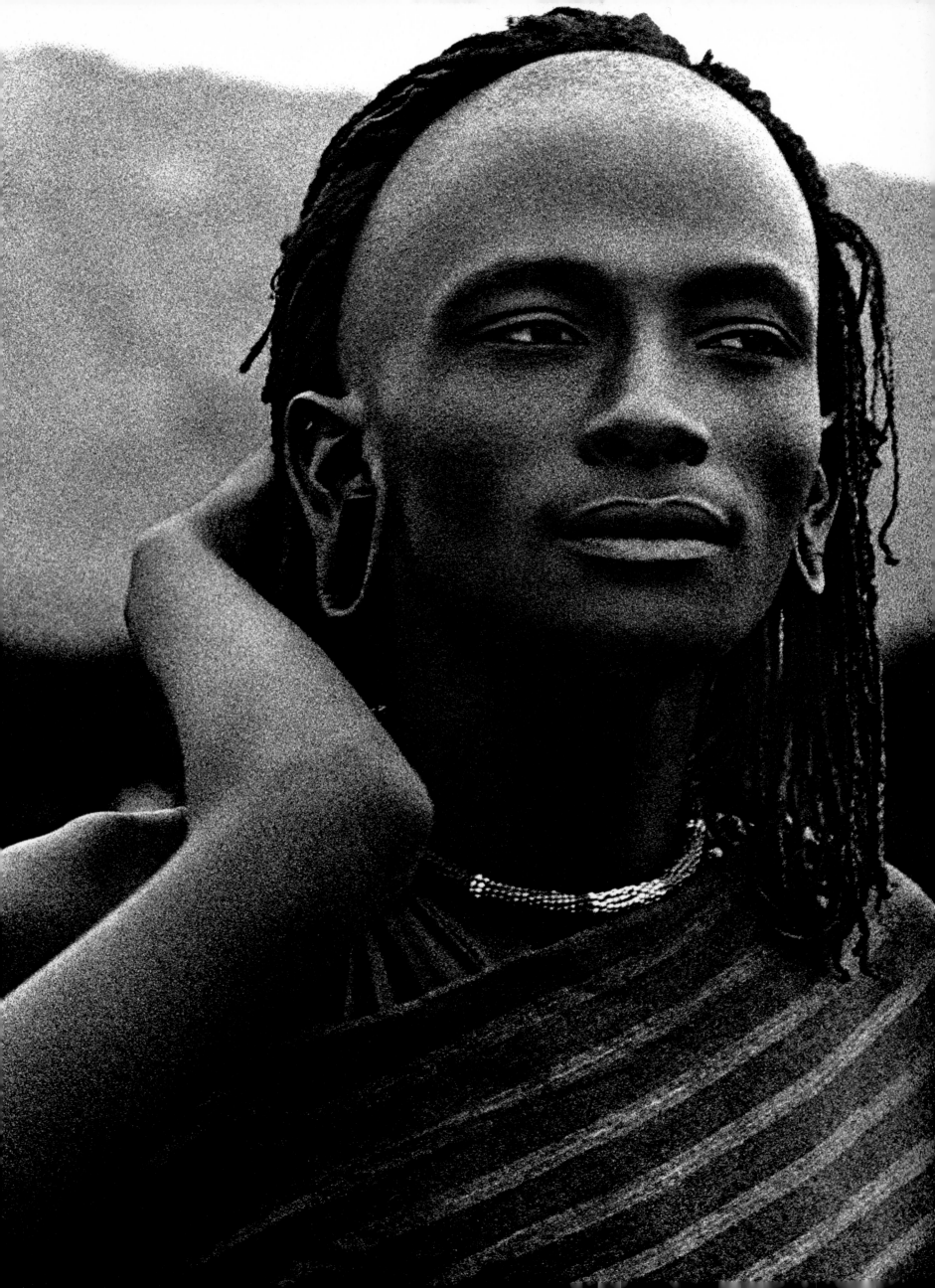

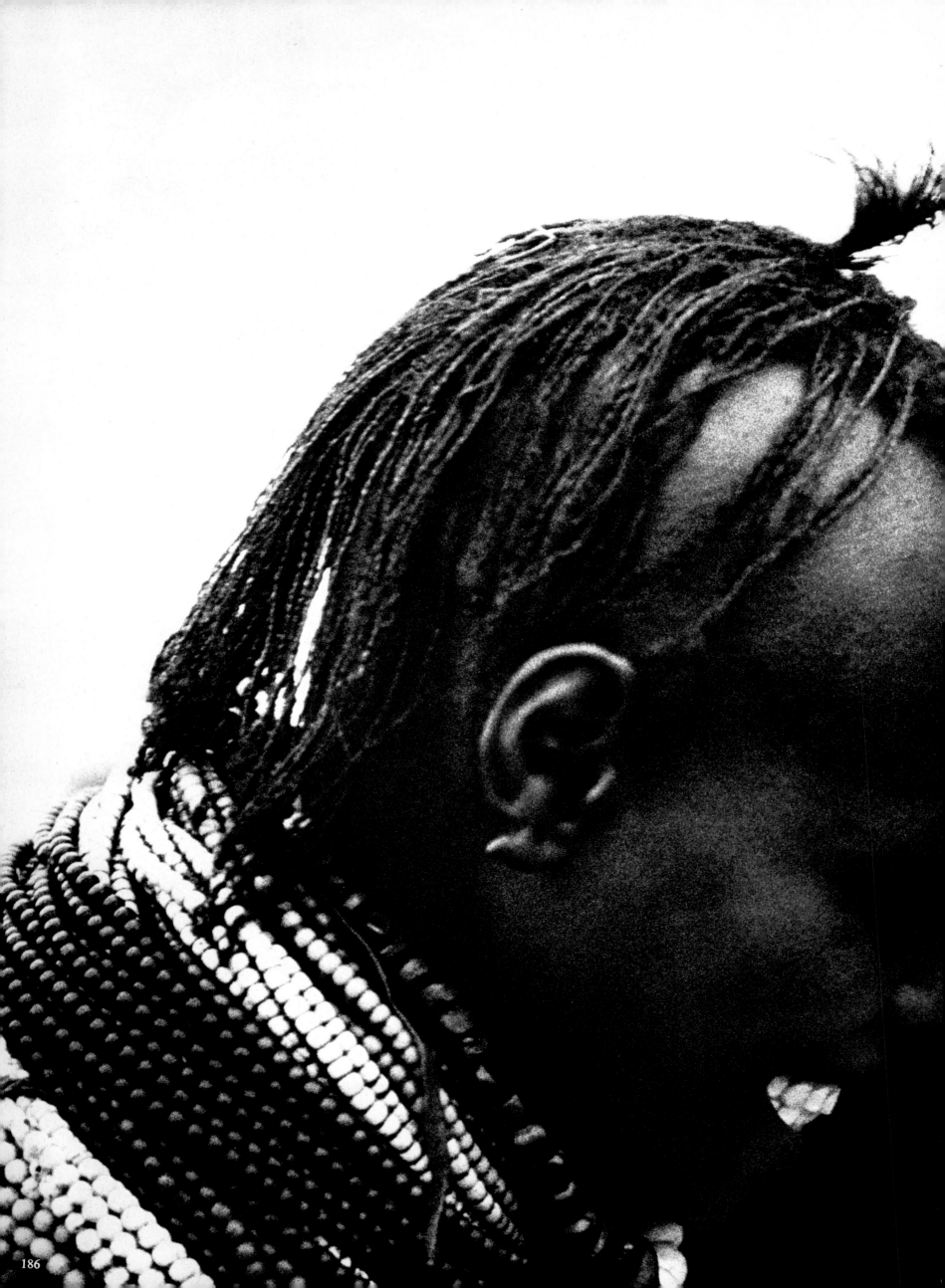

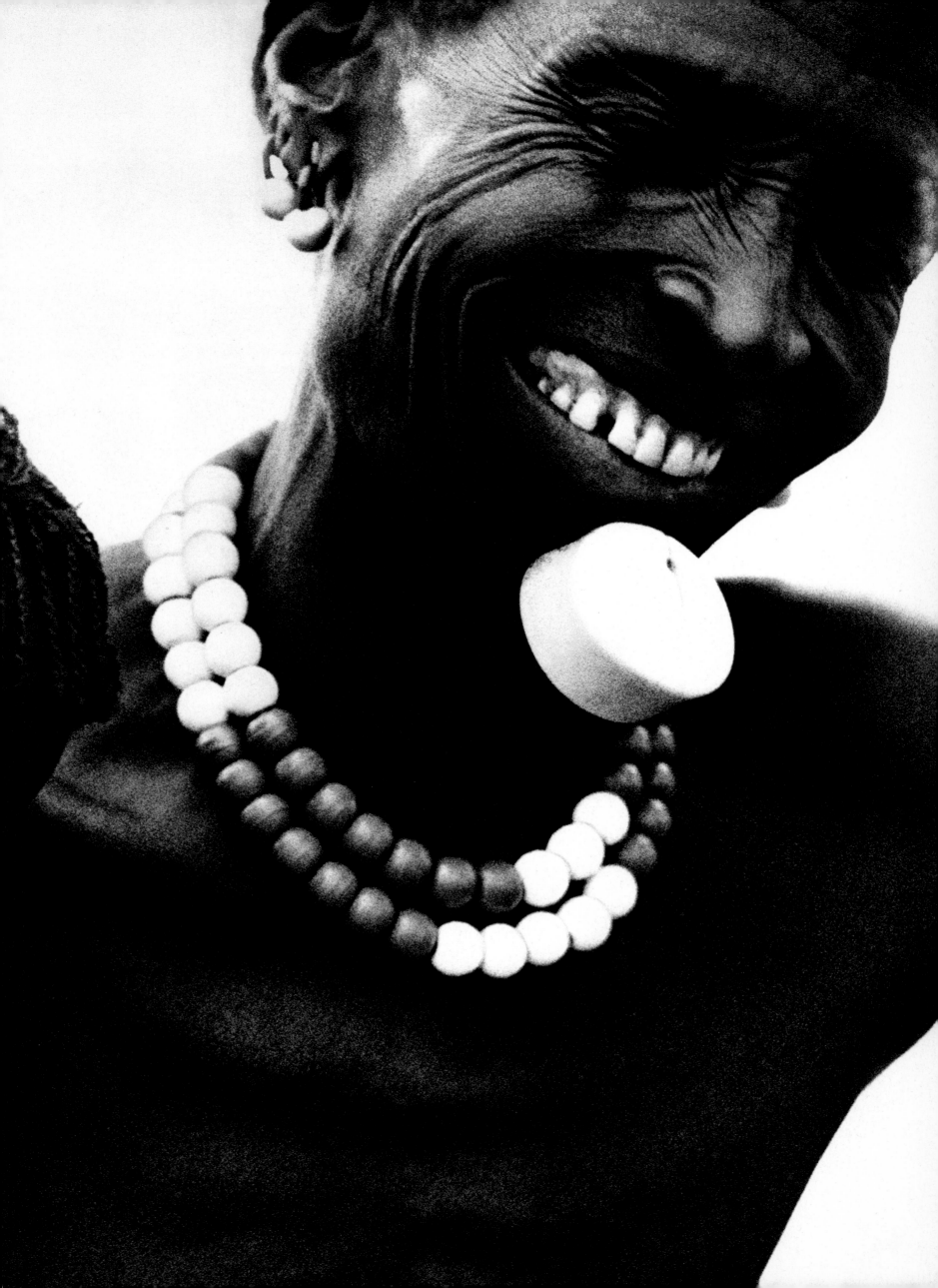

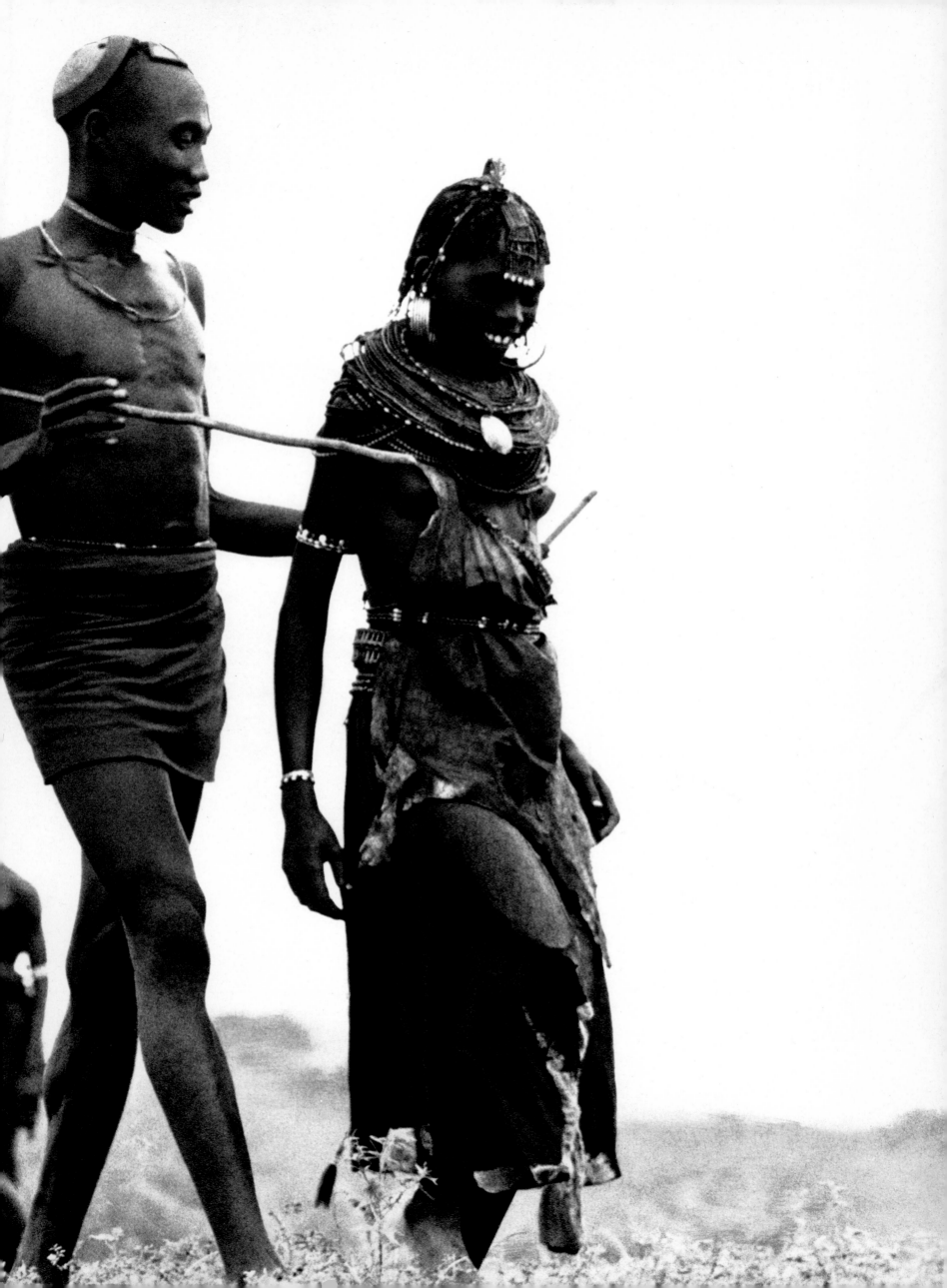

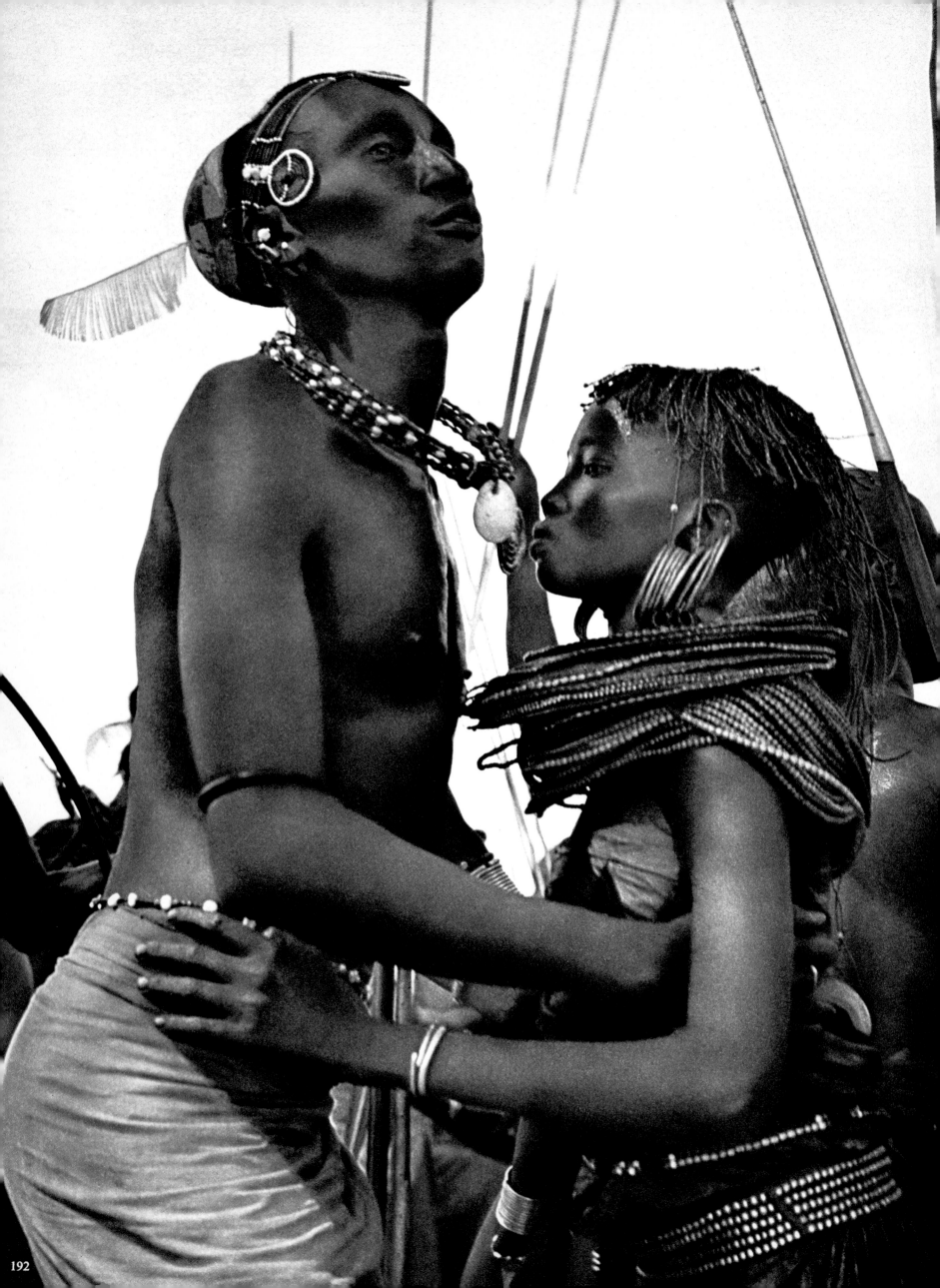

DANCE

DANCE

Dancing plays an important part in the lives of all the tribes. The principal occasions that call for *ngoma*, the Swahili word for dance, are circumcision, initiation, marriage, death, rain and war. But very often *ngoma* are held simply to kill time in the evening.

All tribes have their distinctive dances, chants and songs which vary according to the occasion. They dance in groups, pairs or alone and their inborn sense of rhythm manifests itself in the fantastic timing of their steps, the clapping of their hands or the stamping of their feet.

The choruses are sometimes male or female alone – or mixed – and are usually the main accompaniment to which they dance, though a background may be provided by string, wind and percussion instruments, hand clapping, solo singing or shrill bird-like cries.

I have described a Maasai initiation dance in an earlier section of the book. Another dance which I was lucky to see was at an Orma wedding. While I was at Didi Ouarede I attended a wedding which was very gay. It took place in a village on the other side of the lake which we crossed in fifteen canoes. Everyone was dressed in their best. The men wore emerald *kikois* tied round their waists which fell to their feet, on their heads white muslin cloths billowed like sails in the wind.

The girls had exchanged their black garments for multi-coloured ones of orange and yellow and red. We spent all day at the wedding but never saw the bride who was carefully hidden away in the husband's hut. The whole village came out to dance. The young men formed great circles, jumped high into the air and rushed forward towards a line of waiting girls. The girls dropped to their knees in front of them and bowed and swayed forwards and backwards to the rhythm of their hoarse shouts – then they got back onto their feet and a fresh lot of young men rushed at them. So they went on, until they dropped with exhaustion, panting and covered with sweat.

193. *Giriama dancing girl.*

194 & 195. *Giriama dancing girls.*

196. *Samburu chanting at dance ceremony.*

197. *Turkana dancer.*

198. *Pokot singing girl.*

199. *Samburu warrior singing at dance ceremony.*

200 & 201. *Turkana dancing ceremony.*

202 & 203. *Turkana dancer with chalk decorations on his face and shoulders.*

204 & 205. *Suk elder women dancing at a girl's circumcision ceremony.*

206 & 207. *Turkana dancers.*

208 & 209. *When dancing, Turkana girls who are normally shy, give way freely to the rhythmic chants of the singers.*

210 & 211. *Pokot dancers.*

212. *The frenzy of a Samburu girl.*

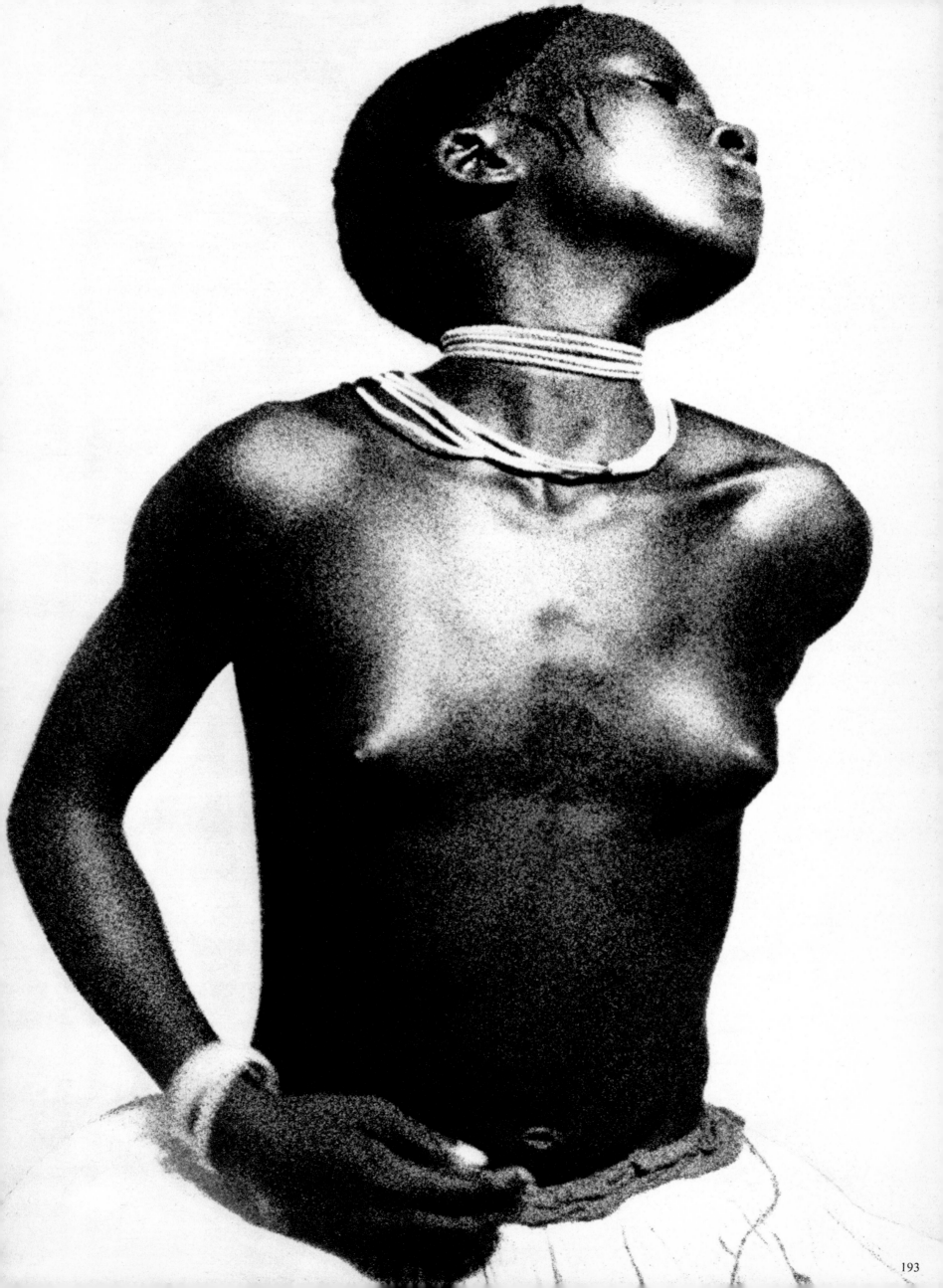

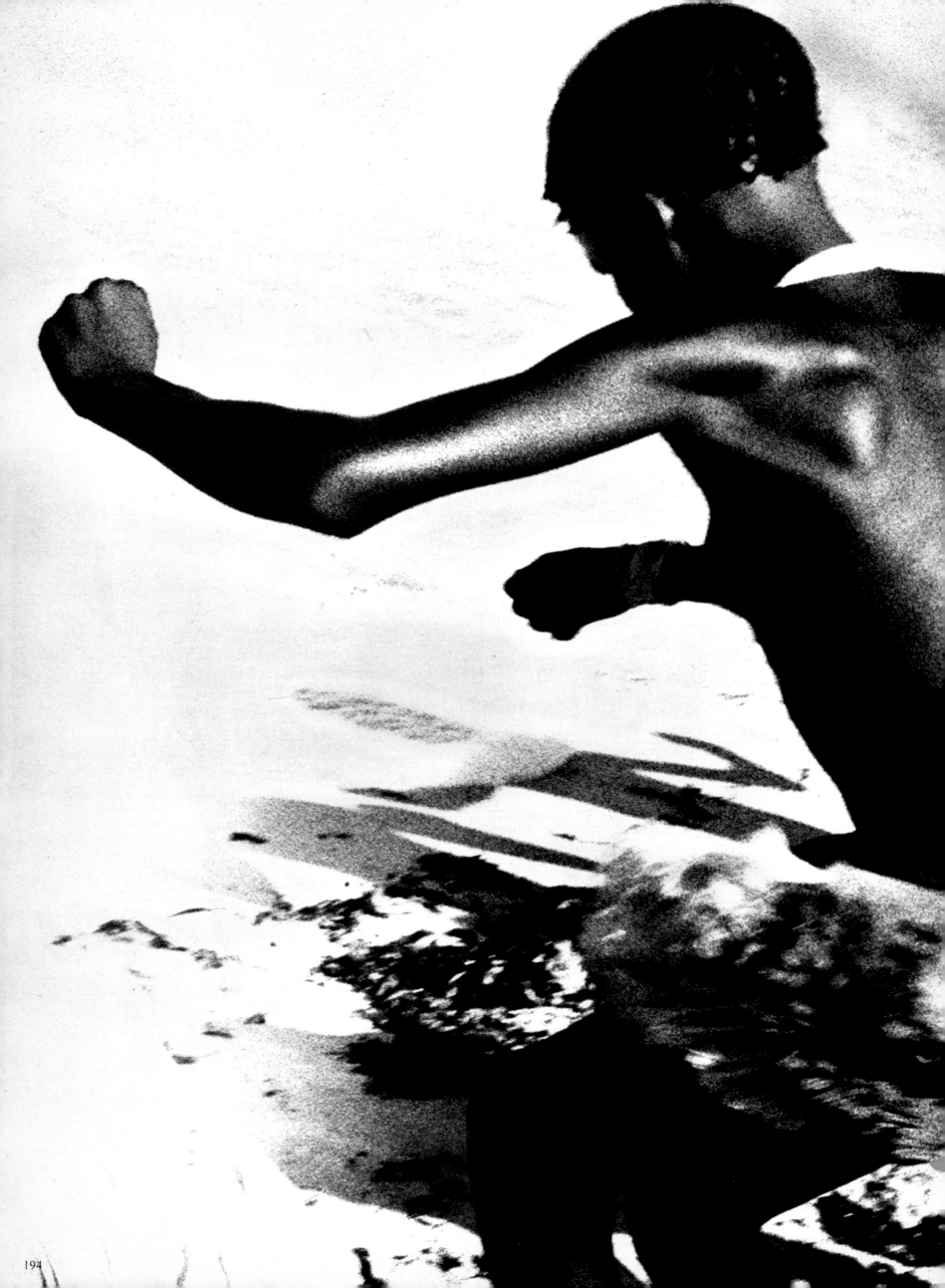

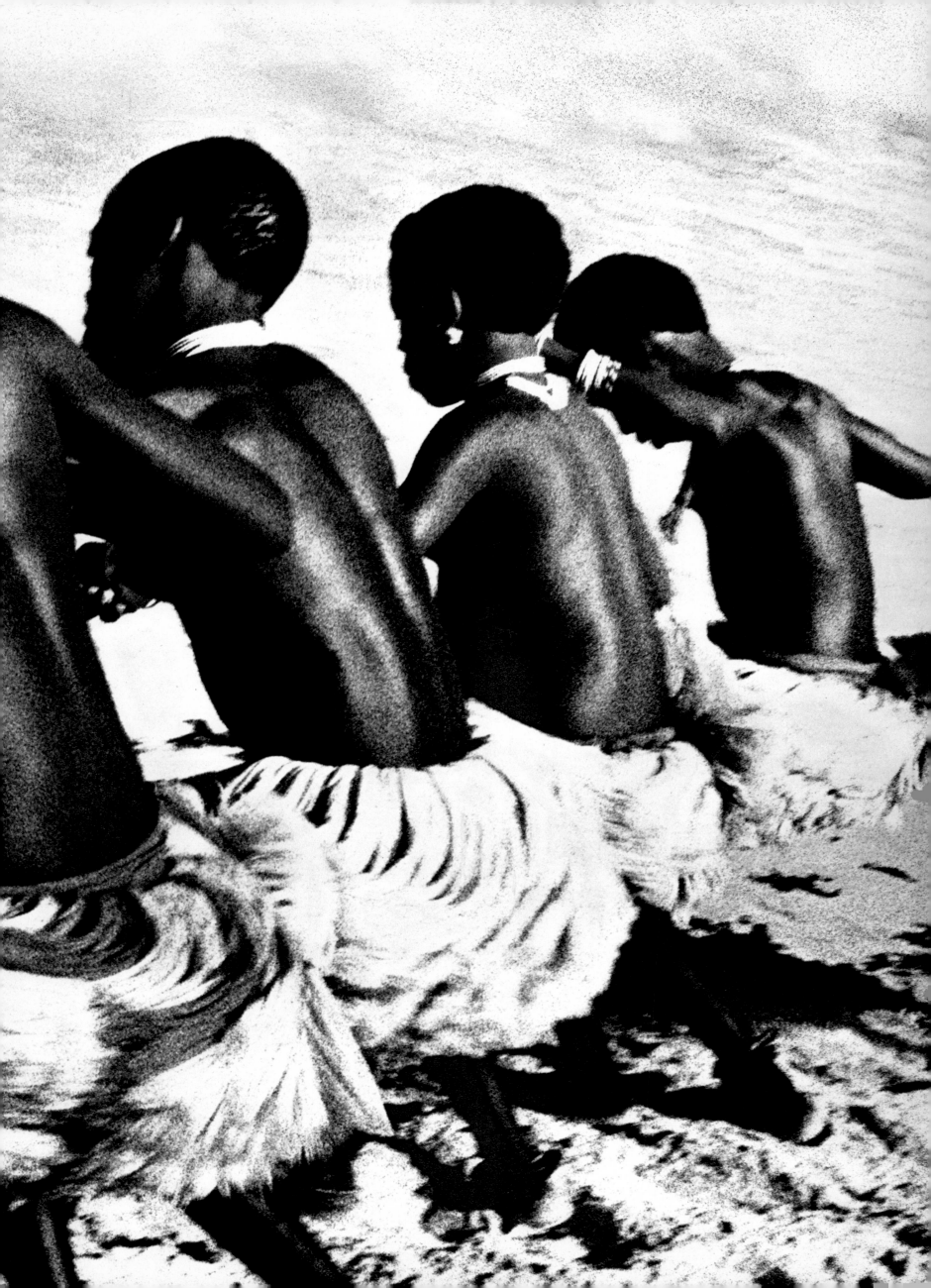

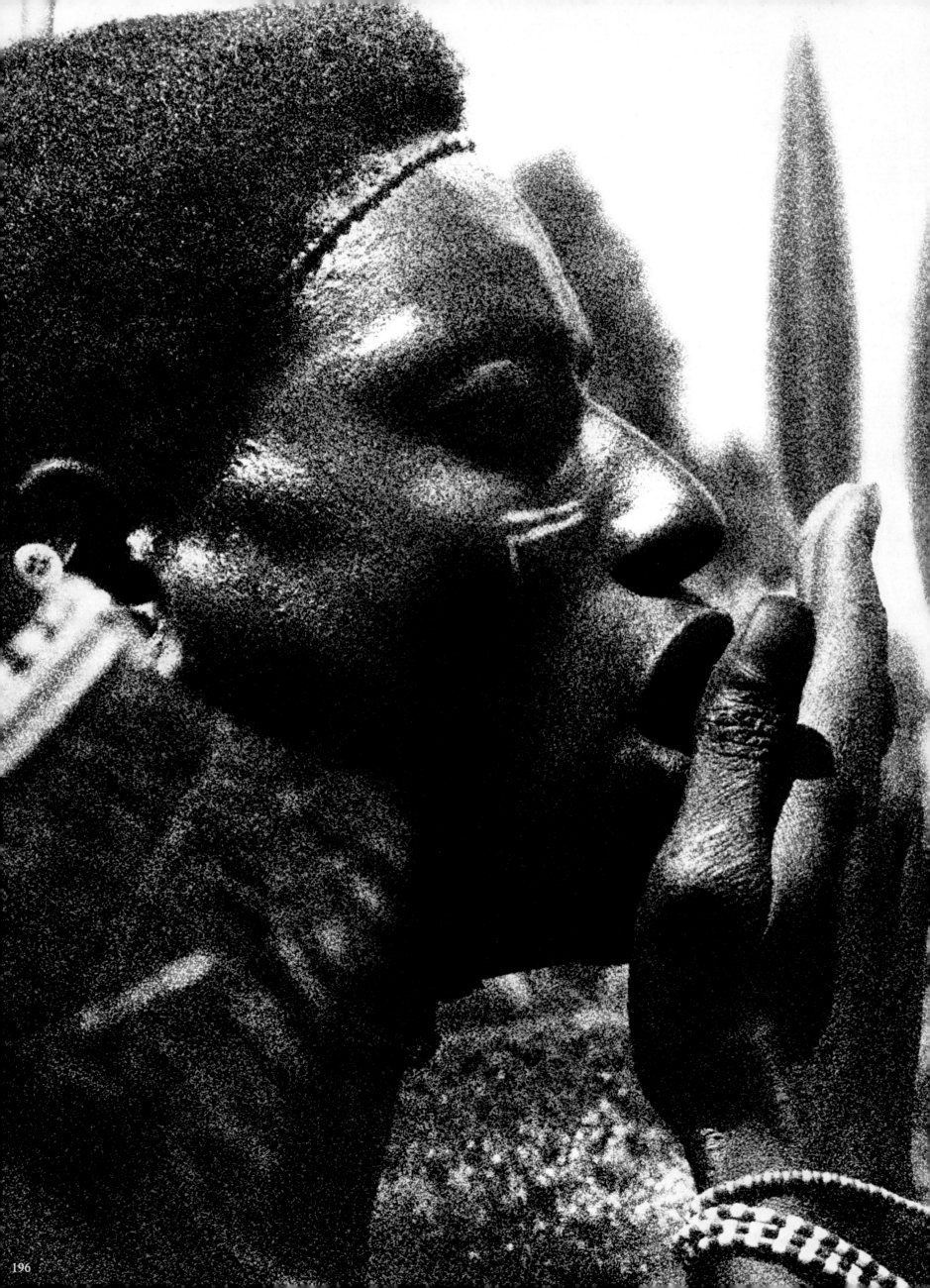

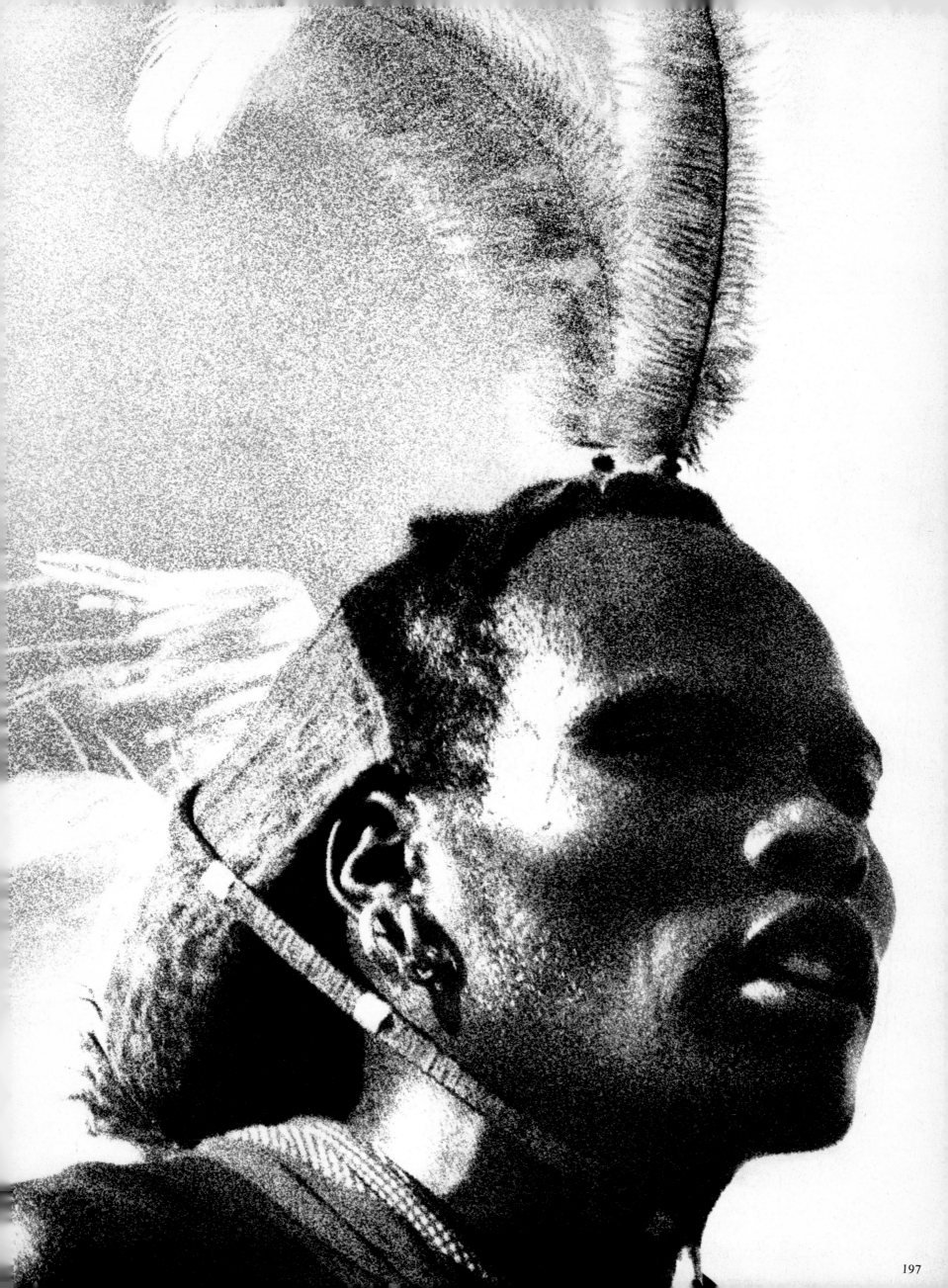

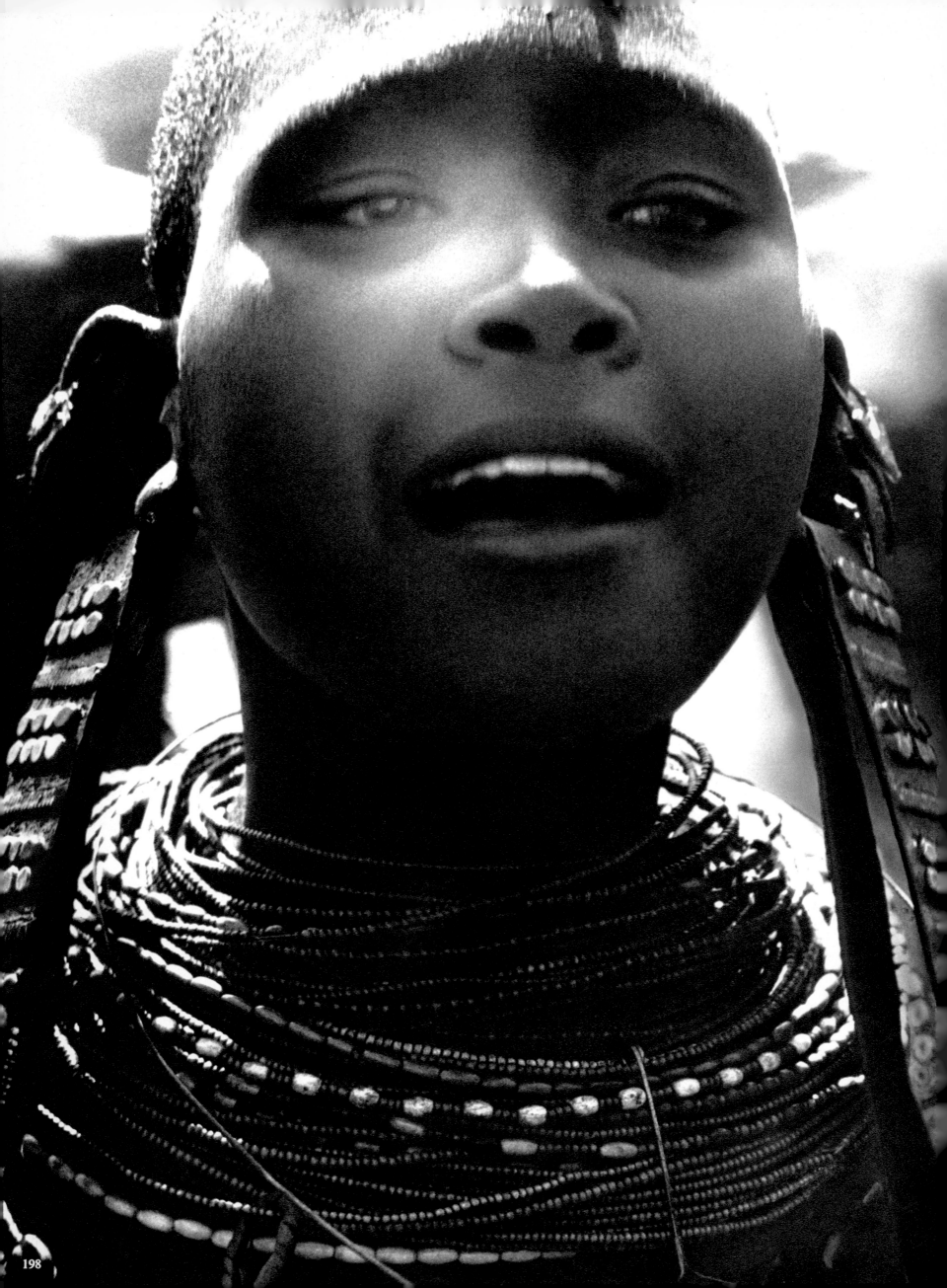

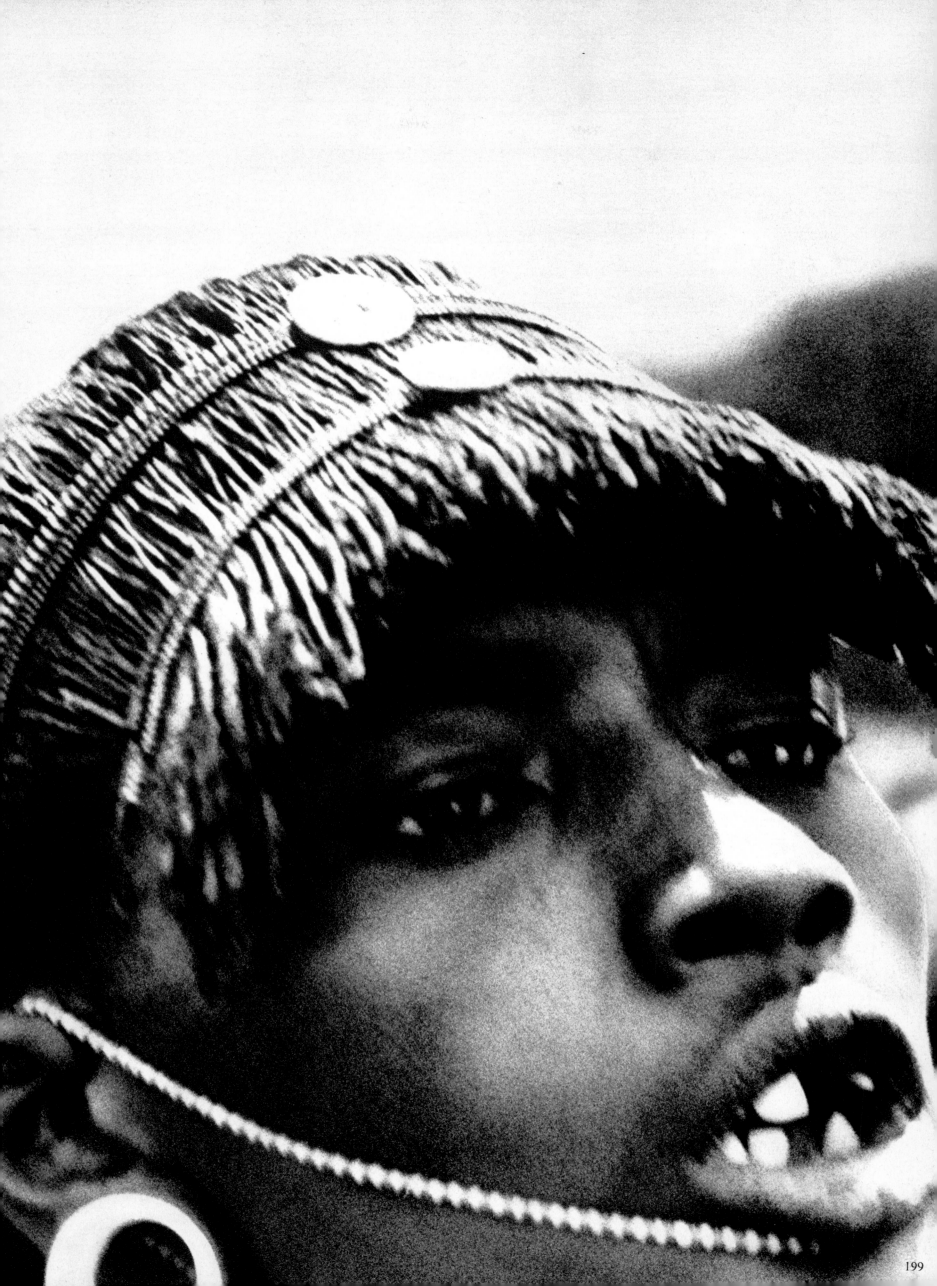

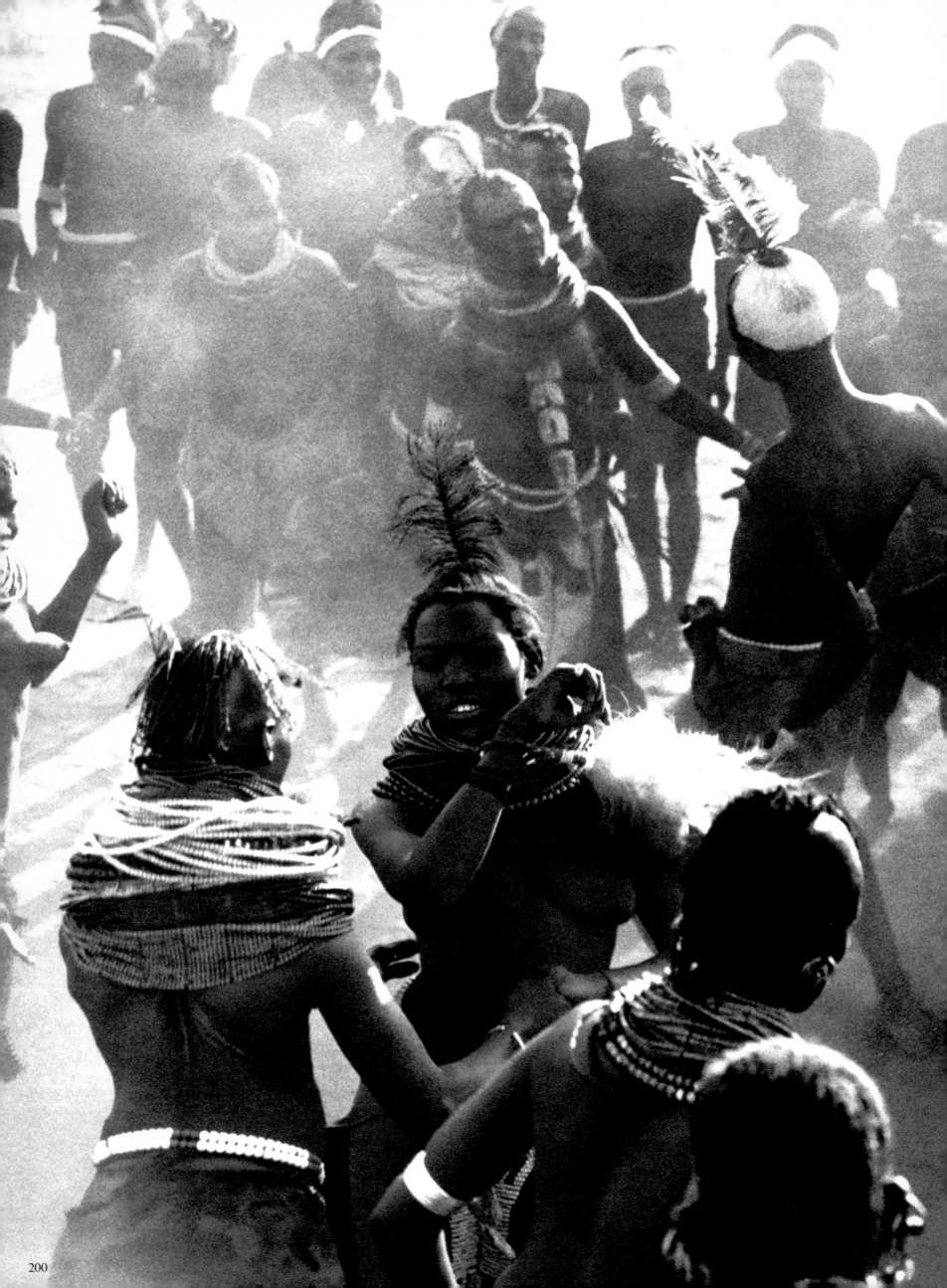

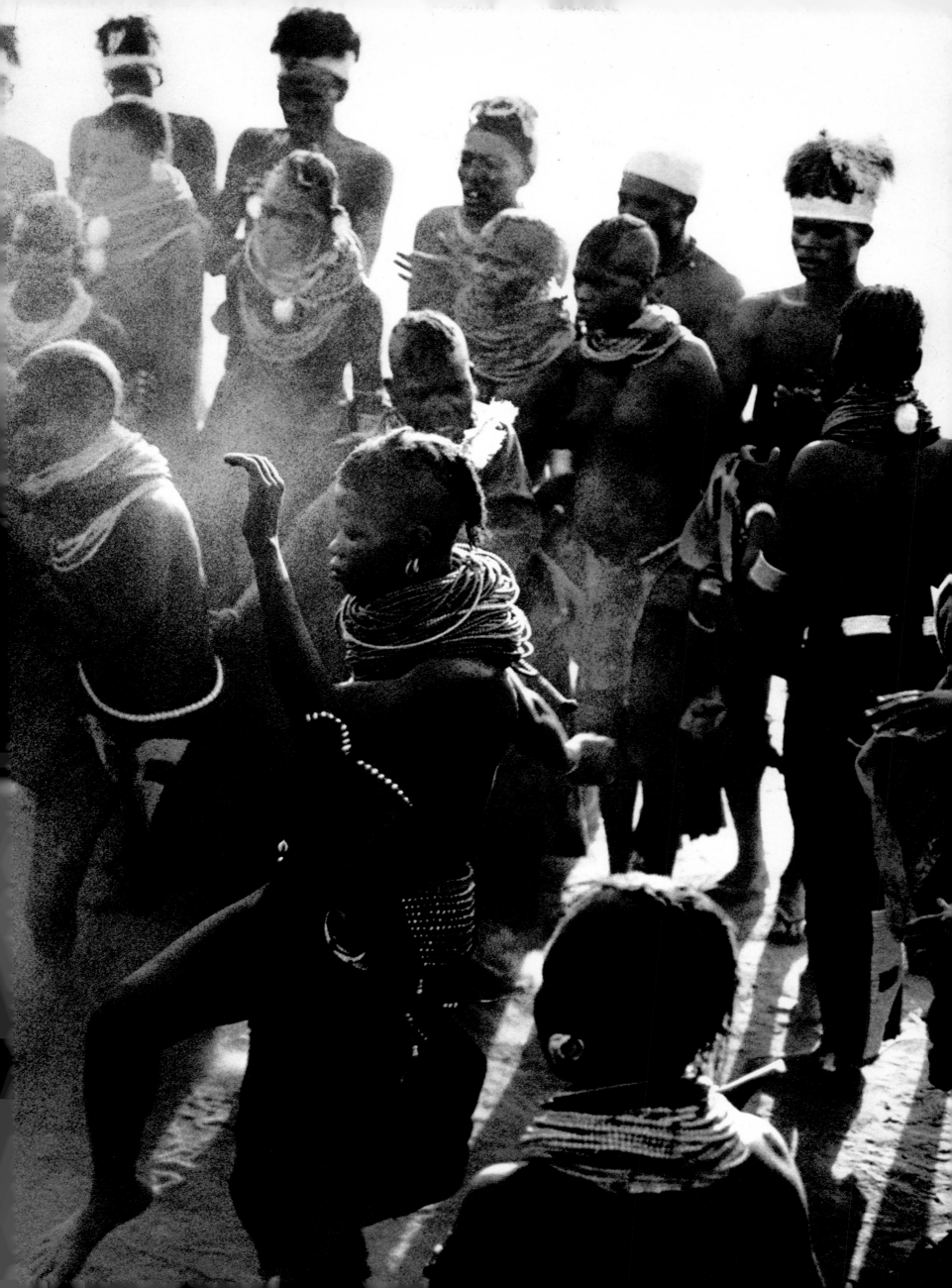

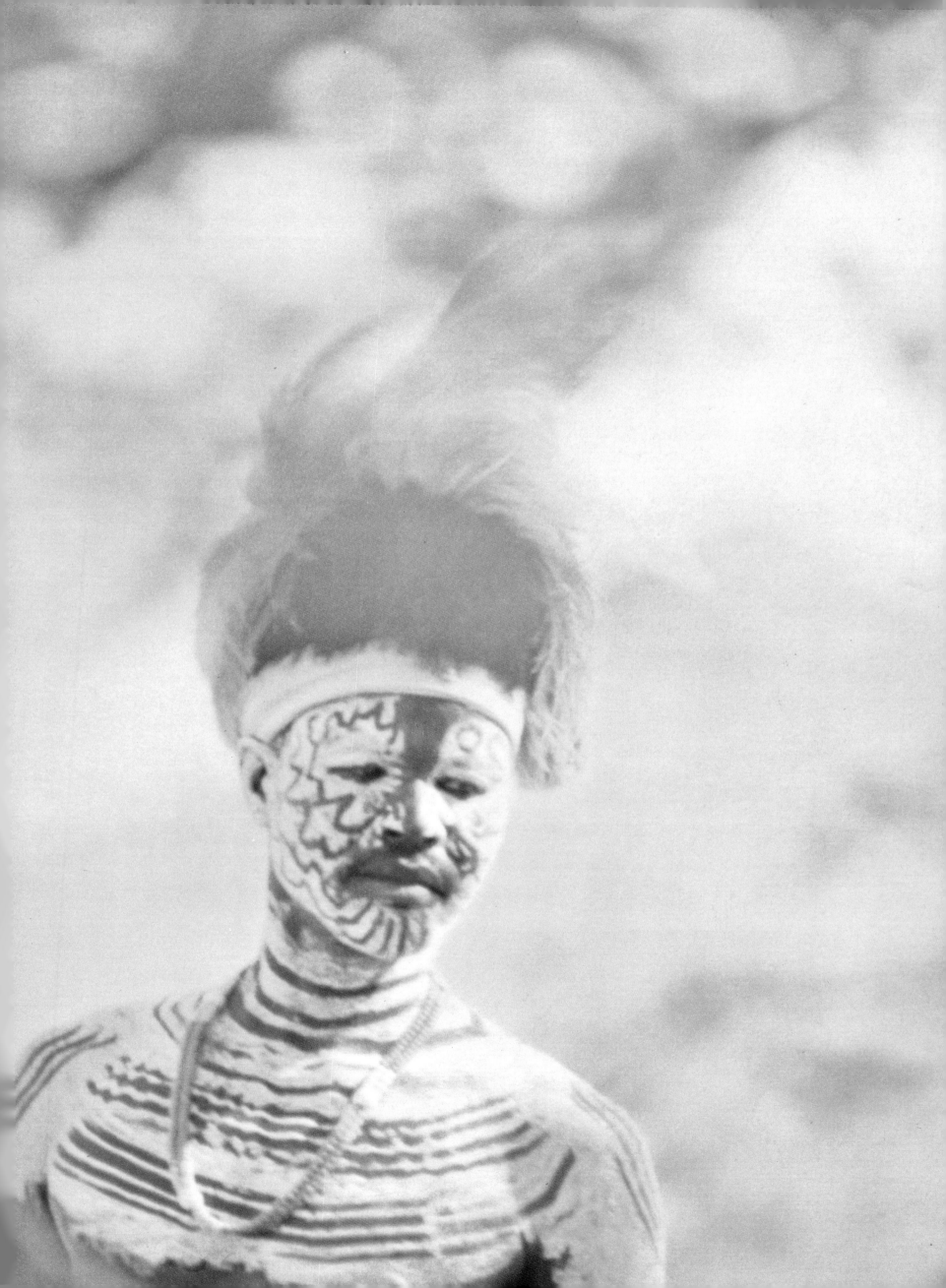

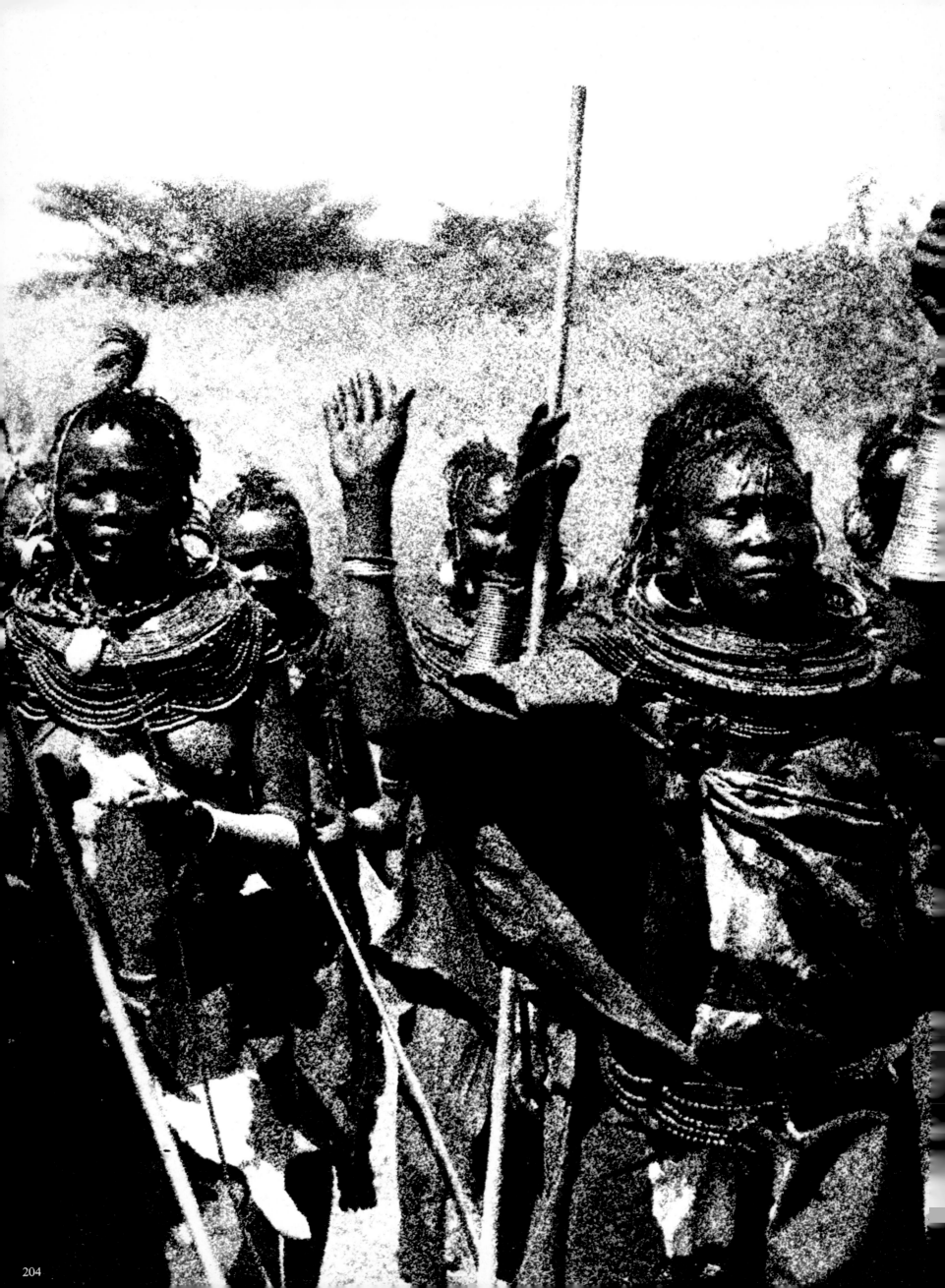

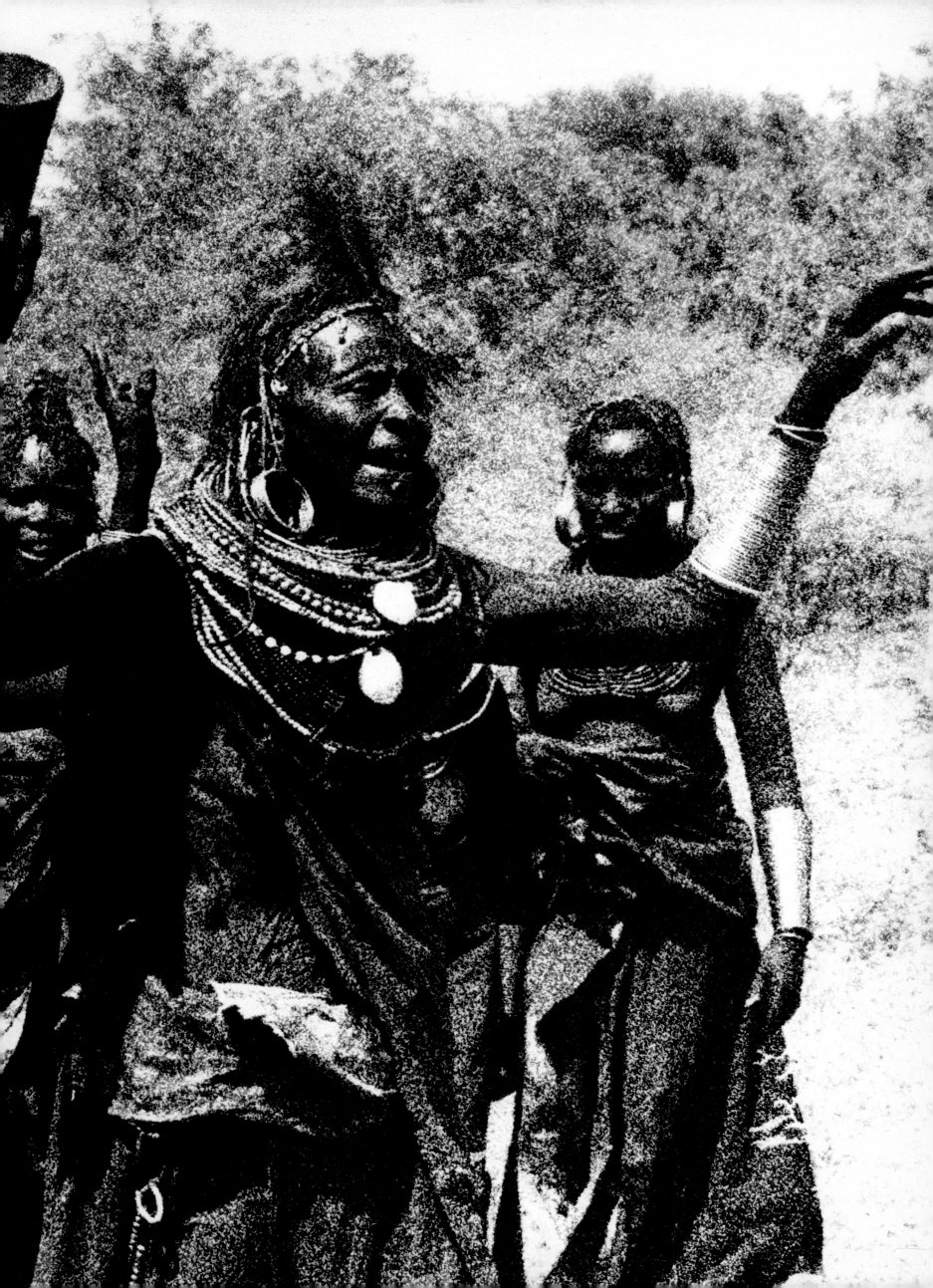

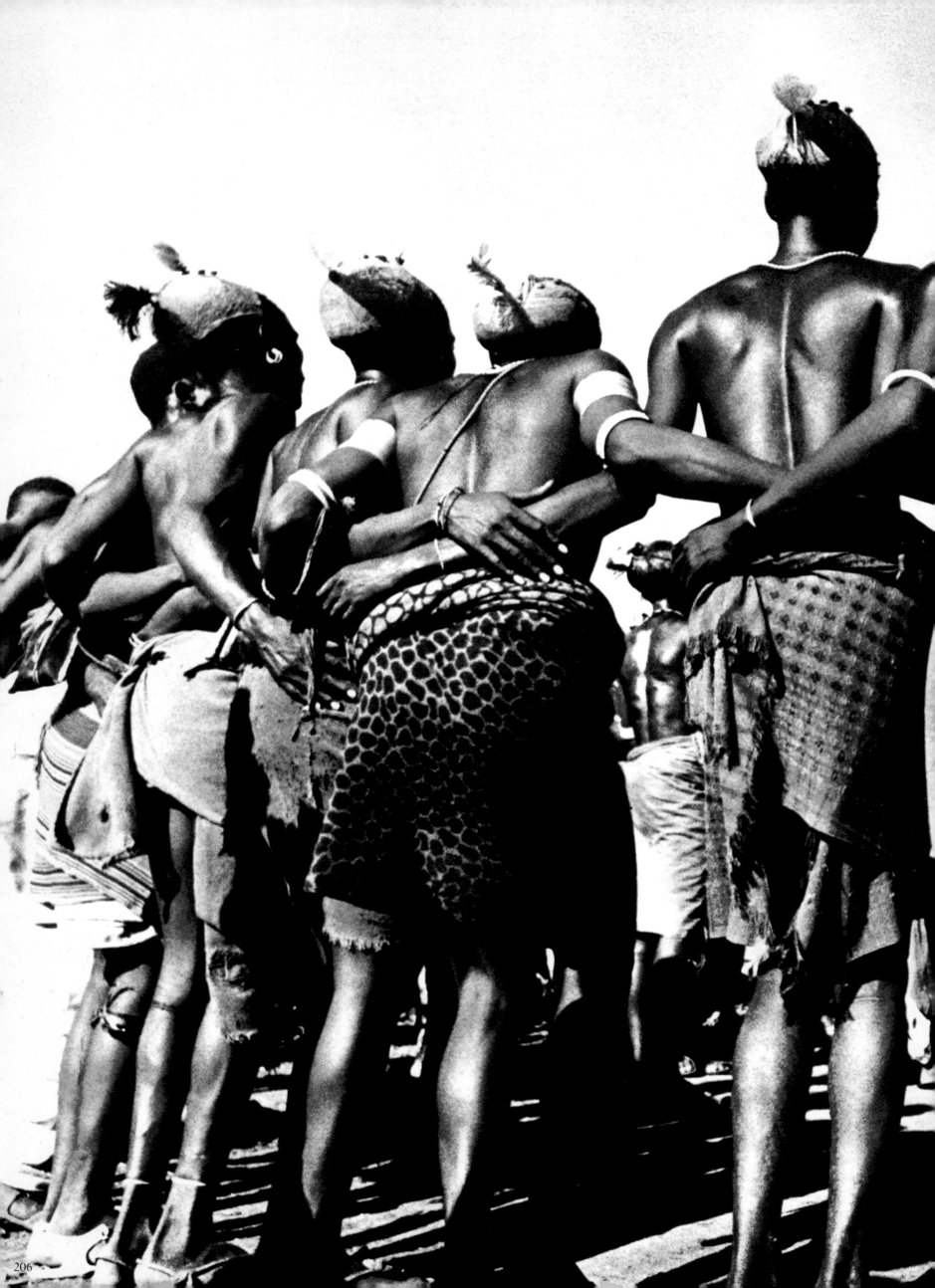

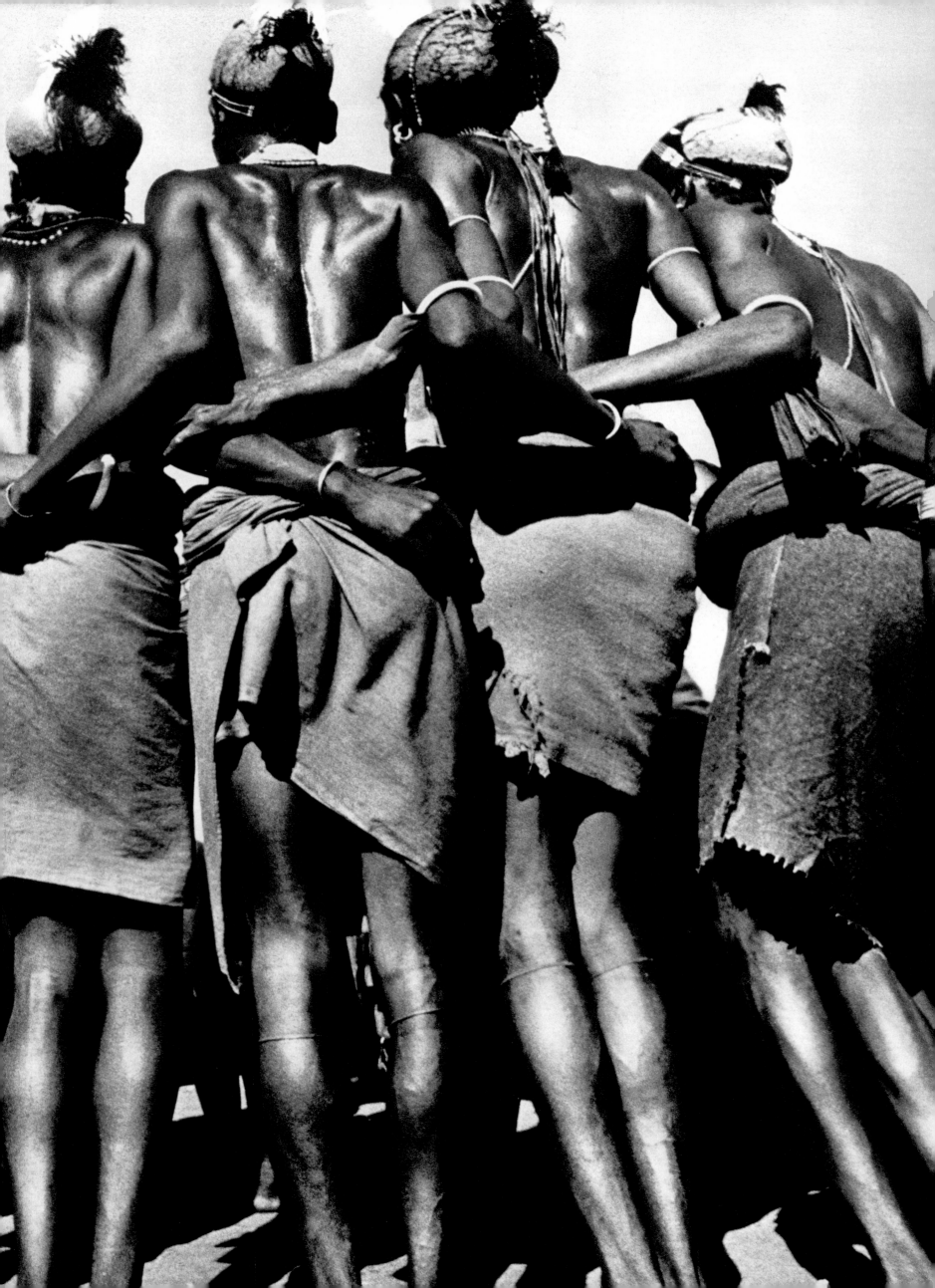

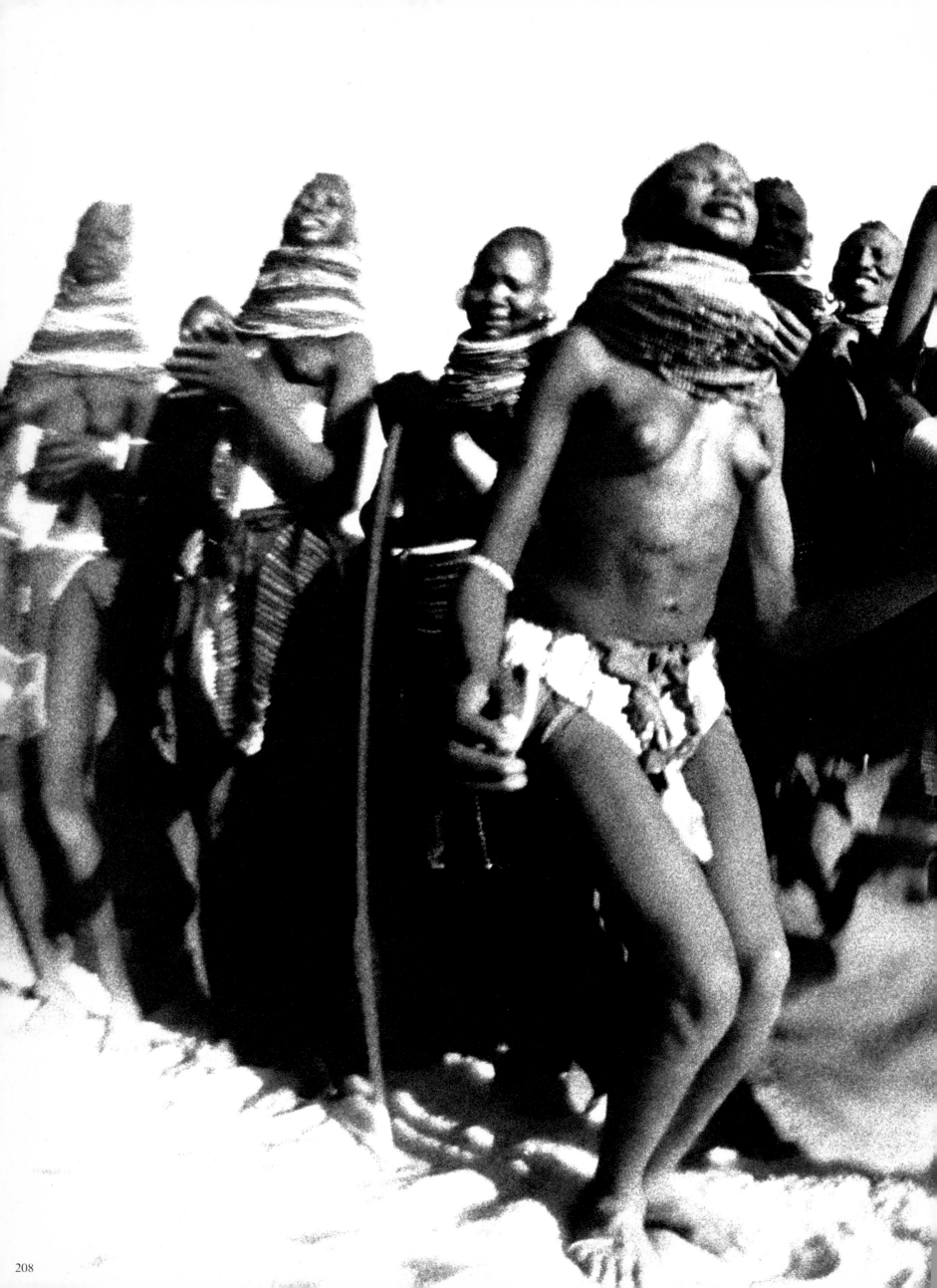

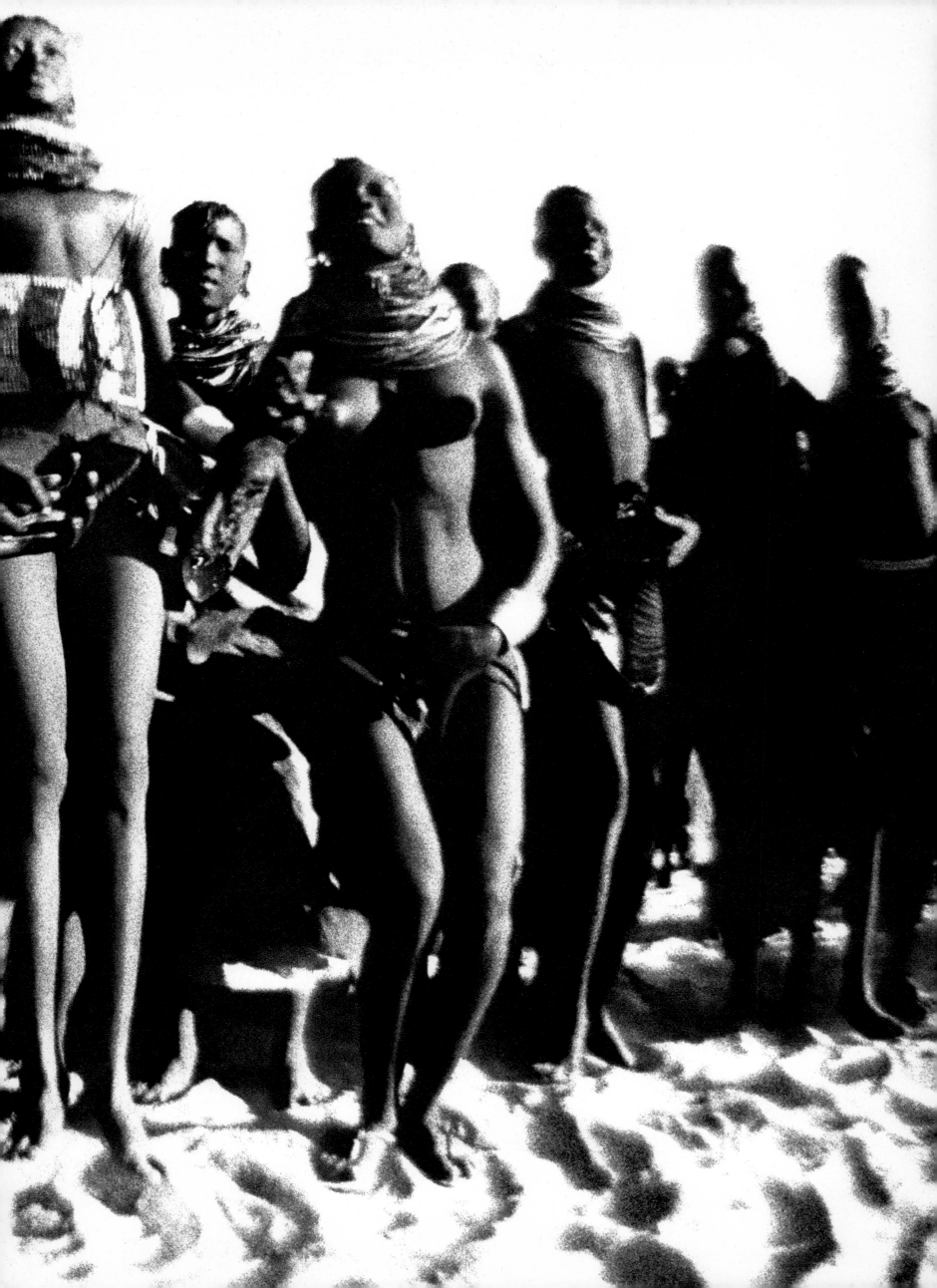

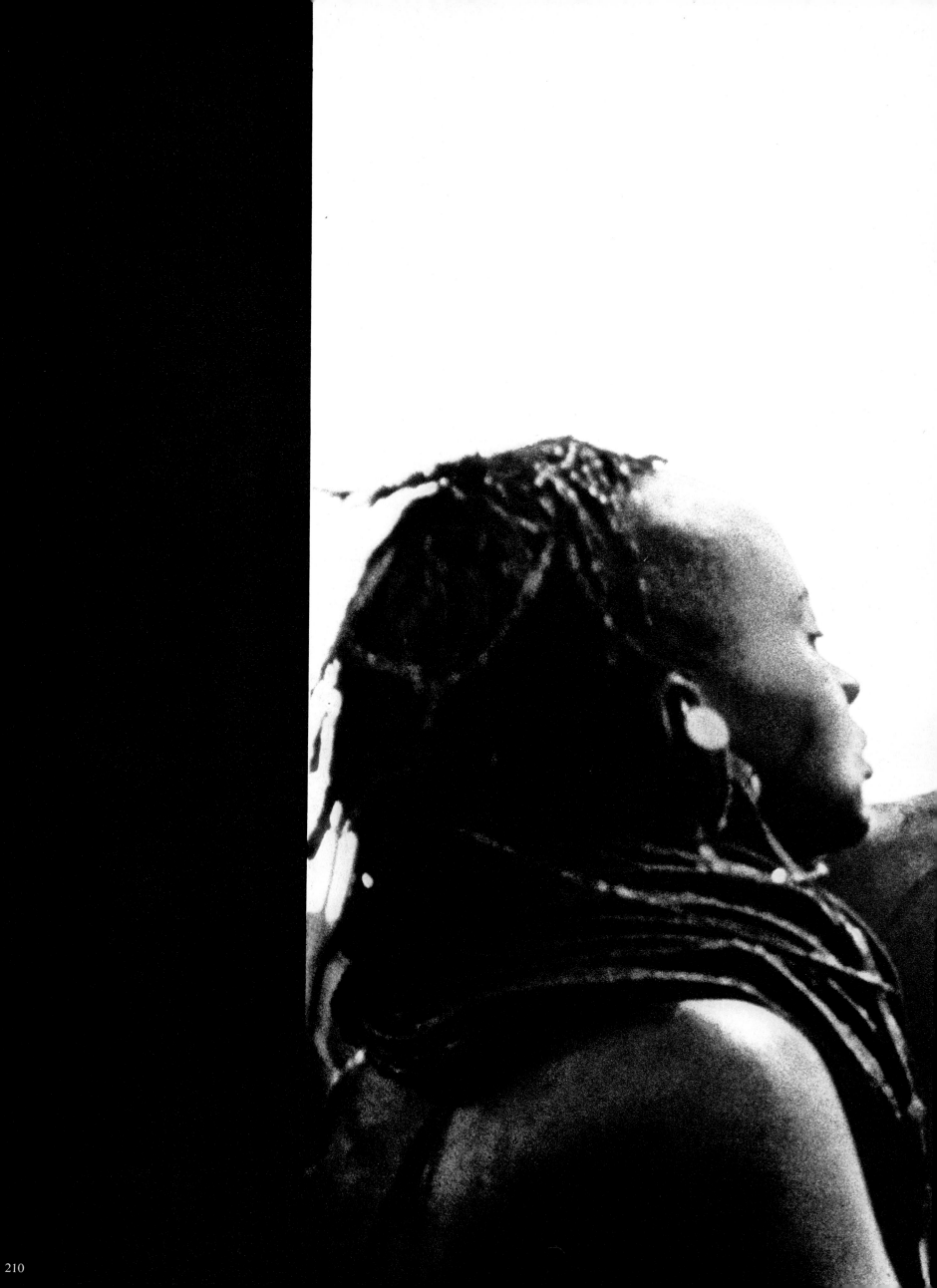

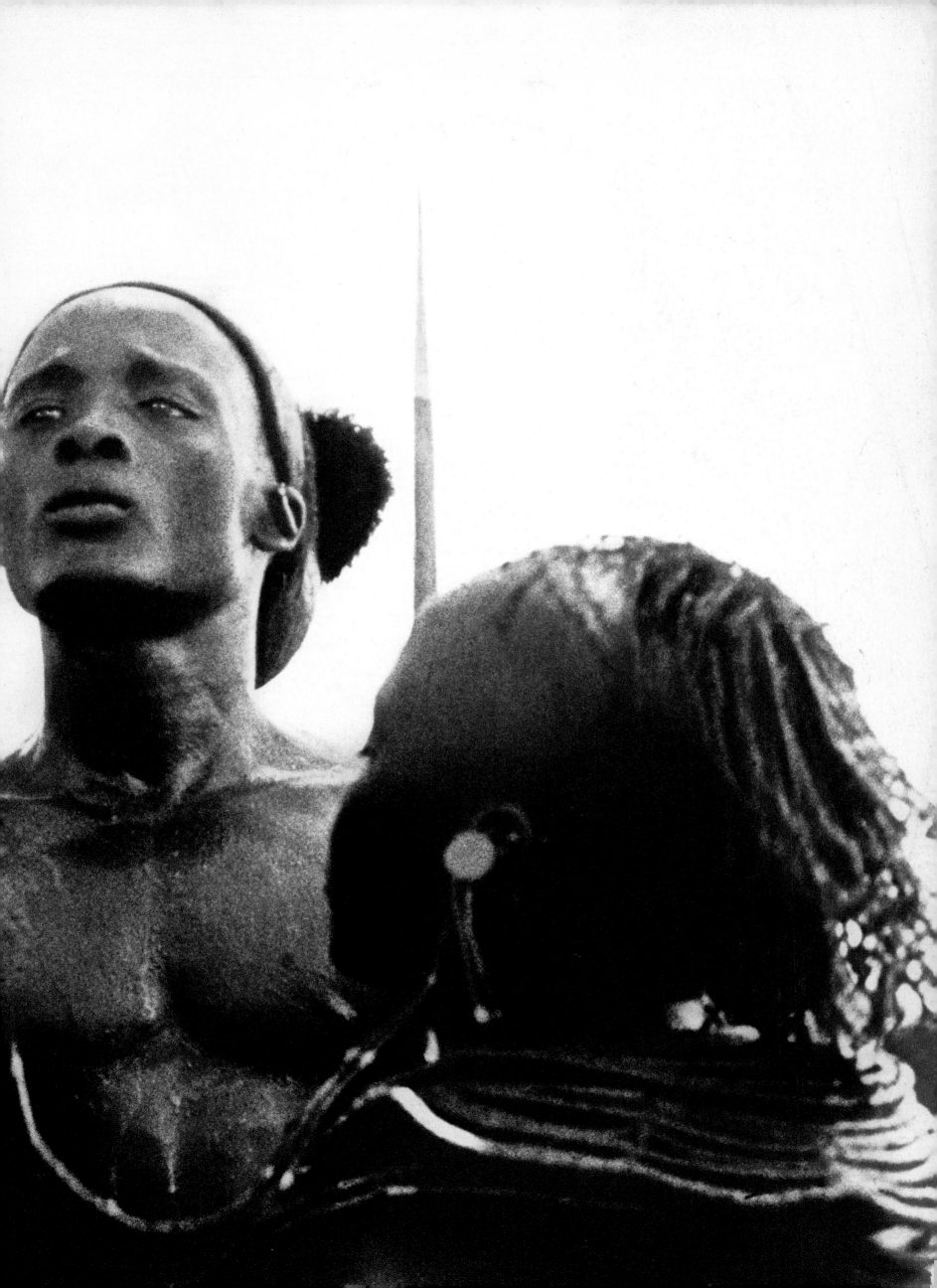

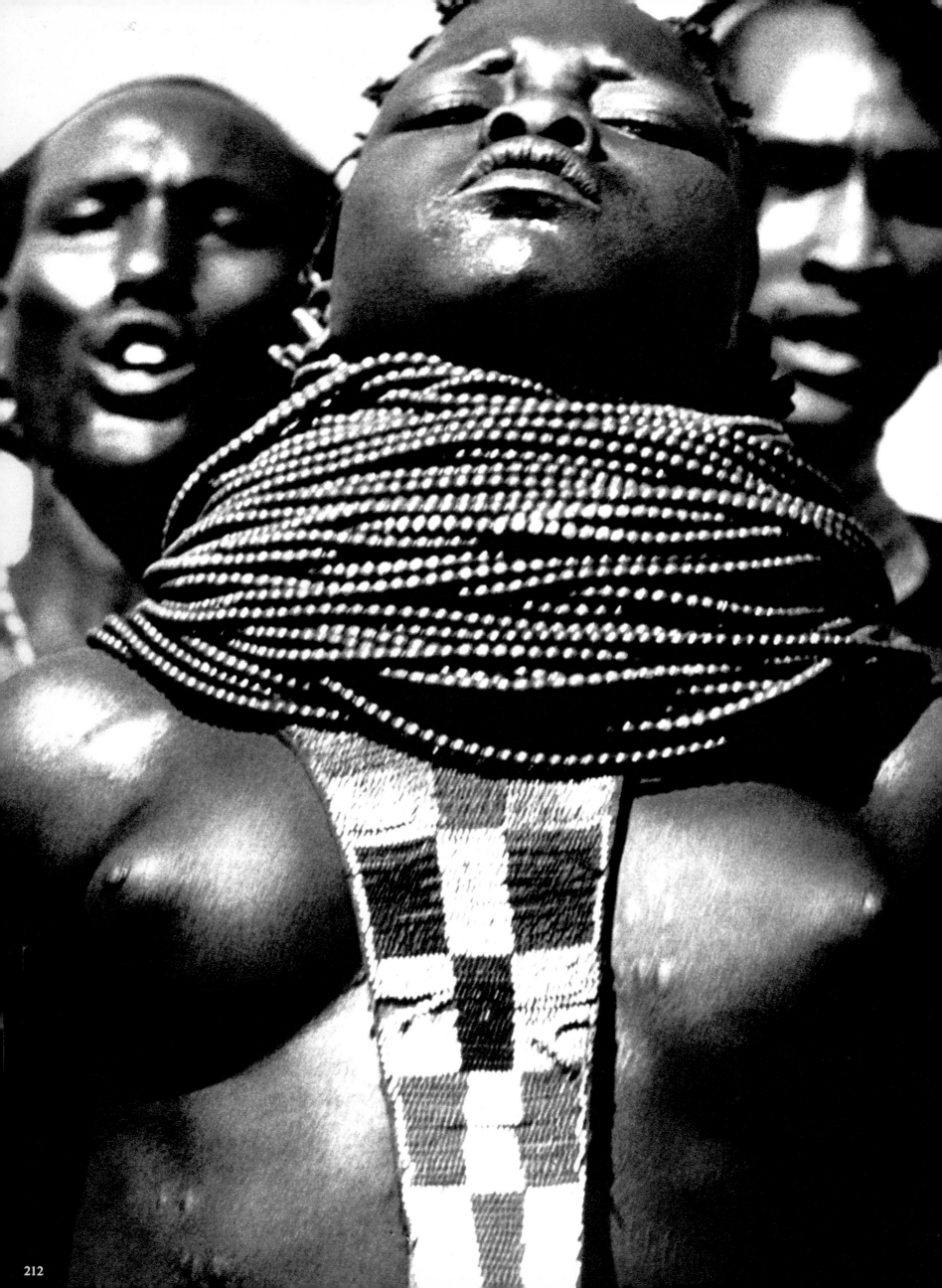

INDEX

INDEX

The ordinary numerals in this index refer to the text pages and those in bold type refer to plate numbers.

Bajun 27, 30–32, 76–77, 80; **82, 159, 160, 162, 164, 166, 168**
Boran 42, 43–44, 45, 80; **12, 69, 74, 75, 91, 172**

Faza 30–31, 34
Fergusson's Gulf 38, 41

Giriama 28; **169, 193, 194**

Kisingitini 31
Kitale 36

Laisamis 45
Lamu 29, 76
Lodwar 37, 38
Loiangalani 42–43

Maasai 11, 15, 17–19, 22, 23, 24, 56–61, 64, 73; **34–37, 39, 41, 42–45, 47, 49, 51, 53, 55, 57, 59, 61, 63–67, 125, 132, 184, 188**
Malindi 25
Maralal 10, 14
Marsabit 45, 48

Nairobi 16, 21
Narok 15
Nomads 72–73
Northern Frontier District 42, 72

Orma 29, 73, 84; **1, 2, 6, 7, 26, 27, 30, 32, 33, 86, 87, 90, 126, 127, 140, 173**

Pokot **192, 198, 210**

Rendille 42, 43, 45–47; **3, 13, 93, 144, 146, 172, 179**

Rudolph, Lake 38–39, 40–41, 43, 68; **96, 98–123**

Samburu 10–13, 14, 64; **8, 16, 17, 22, 24, 80, 81, 134, 136, 137, 181–183, 196, 199, 212**
Shifta 13, 42, 43
Sololo 43
Somali 42; **18, 20, 21, 88**
Suk **174, 190, 204**

Turkana 36–37, 38–39, 68, 72, 81; **4, 5, 9–11, 14, 19, 28, 29, 70, 72, 73, 76, 78, 89, 90, 96–121, 124, 142, 143, 148, 150, 170, 176–179, 186, 197, 200–203, 206–209**

Wamba 13
Watamu 26, 35